More Praise for
SAVING ITALY
A *New York Times* Bestseller

A *Boston Globe* Bestseller

"That the Monuments Men were able to do as much as they did, amid a war with more urgent priorities, is remarkable."—Hugh Eakin, *Wall Street Journal*

"[A] thoroughly researched gallop of a history book." —Noah Charney, *Daily Beast*

"[Edsel is] passionate about his subject." —Matthew Price, *Newsday*

"[A] lively narrative." —Andrew Nagorsky, *Washington Post*

"Gripping and moving. . . . [I]ntensely cinematic. . . . [A] rip-roaring story . . . carried off with verve and charm." —John Foot, *Times Literary Supplement*

"Told with style. . . . [A] very tangled but always fascinating tale. . . . [Edsel] tells it with both panache and precision." —Richard Morrison, *Times* (London), Book of the Week

"Edsel is very good. . . . He gives a vivid flavor of what life must have been like as they searched among the ruins." —Alsadair Palmer, *Mail on Sunday*

"Edsel has done extensive research in Europe and the United States. His book is an engrossing tribute to the Monuments Men."—Milton Esterow, *Art News*

"A compelling story, clearly fueled by the passion Edsel shares with his heroes for the West's cultural heritage." —Gene Santoro, *WWII Magazine*

"Vivid, keenly researched and sometimes heart-rending. . . . With unfailing narrative command . . . Edsel is judicious and even-handed."
—Jonathan Keates, *Literary Review*

"Thrilling. . . . A fascinating, fast-paced story." —*Publishers Weekly*

"Robert Edsel has written a poignant, fascinating story, bringing to life the heroic soldier-scholars who saved Italy's treasures." —Evan Thomas, best-selling author of *Ike's Bluff and Sea of Thunder*

"An amazing story, superbly told. The narrative and research are exceptionally well done. Edsel has done a great service . . . to tell the story of the Monuments Men and the work that they did in Italy." —Carlo D'Este, best-selling author of *Patton: A Genius For War*

"*Saving Italy* rescues an unlikely troop of American heroes from obscurity." —James D. Hornfischer, best-selling author of *Neptune's Inferno*

"A captivating, and at times hair-raising, book on the audacious Allied effort during World War II to save the priceless art treasurers in Italy. Edsel has written a gripping, heroic story of the Monuments Men who saved them from certain destruction." —Susan Eisenhower

"A remarkable and fascinating story. As more recent conflicts have shown, the havoc that war can wreak upon our artistic heritage has unfortunately not diminished and there are important lessons in this book for policy makers and all who care about the preservation of the world's artistic legacy for future generations." —Timothy Potts, director, the J. Paul Getty Museum

"A suspenseful tale worthy of an Indiana Jones plot. [Edsel] pulls you into a dangerous web of intrigue in which the Vatican, top German SS generals, American OSS operatives,and Italian officials are entwined in top-secret negotiations to end the war. A must-read for any WWII history enthusiast."
—Gordon H. "Nick" Mueller, president/CEO, National WWII Museum

ALSO BY ROBERT M. EDSEL

The Monuments Men:
Allied Heroes, Nazi Thieves, and
the Greatest Treasure Hunt in History
[with Bret Witter]

Rescuing Da Vinci:
Hitler and the Nazis Stole Europe's Great Art,
America and Her Allies Recovered It

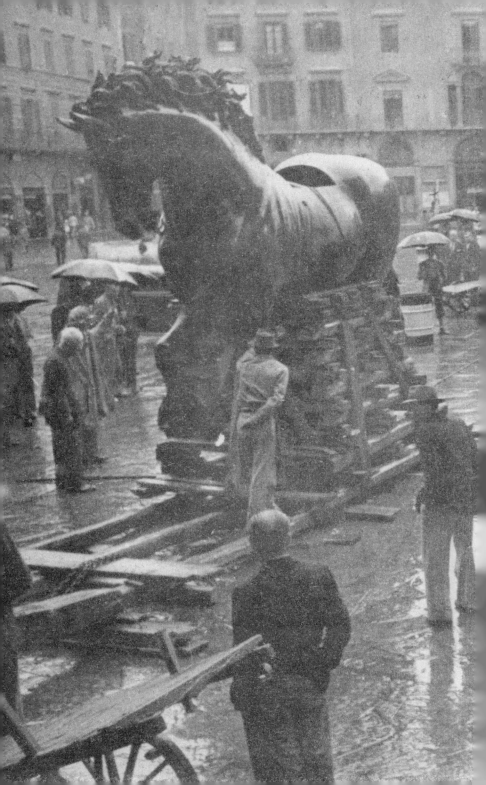

SAVING
ITALY

*The Race to Rescue
a Nation's Treasures
from the Nazis*

Robert M. Edsel

W. W. NORTON & COMPANY
NEW YORK LONDON

For information about permission to reproduce selections from this book,
write to Permissions, W. W. Norton & Company, Inc.,
500 Fifth Avenue, New York, NY 10110

For information about special discounts for bulk purchases, please contact
W. W. Norton Special Sales at specialsales@wwnorton.com or 800-233-4830

Manufacturing by Courier Westford
Book design by Dana Sloan
Production manager: Louise Mattarelliano

Library of Congress Cataloging-in-Publication Data

Edsel, Robert M.
 Saving Italy : the race to rescue a nation's treasures from the Nazis / Robert M. Edsel. — First
Edition.
 pages cm
 Includes bibliographical references and index.
 ISBN 978-0-393-08241-8 (hardcover)
 1. Allied Forces. Supreme Headquarters. Monuments, Fine Arts and Archives Section—History.
2. Art treasures in war—Italy—History—20th century. 3. World War, 1939–1945—Art and the
war. 4. Art thefts—Italy—History—20th century. 5. Cultural property—Protection—Italy—
History—20th century. 6. Keller, Deane, 1901—1992. 7. Hartt, Frederick. I. Title.
 D810.A7E234 2013
 940.53'45—dc23

 2013010708

ISBN 978-0-393-34880-4 pbk.

W. W. Norton & Company, Inc.
500 Fifth Avenue, New York, N.Y. 10110
www.wwnorton.com

W. W. Norton & Company Ltd.
Castle House, 75/76 Wells Street, London W1T 3QT

2 3 4 5 6 7 8 9 0

To all those who have ever dared dream a big idea and then dedicated themselves to see it through, come what may.

It is not the critic who counts; not the man who points out how the strong man stumbles, or where the doer of deeds could have done them better. The credit belongs to the man who is actually in the arena, whose face is marred by dust and sweat and blood; who strives valiantly; who errs, who comes short again and again, because there is no effort without error and shortcoming; but who does actually strive to do the deeds; who knows great enthusiasms, the great devotions; who spends himself in a worthy cause; who at the best knows in the end the triumph of high achievement, and who at the worst, if he fails, at least fails while daring greatly, so that his place shall never be with those cold and timid souls who neither know victory nor defeat.

—President Theodore Roosevelt

CONTENTS

SECTION III. VICTORY

SECTION IV. AFTERMATH

MAPS

AUTHOR'S NOTE

I moved to Florence, Italy, in 1996 and lived there for almost five years. At the time, I knew almost nothing about art or art history. My knowledge about World War II had come mostly from movies, a few books, and stories my father—a United States Marine Corps veteran of the war in the Pacific—began sharing with our family near the end of his life. But my passion for learning, and interest in these subjects, made up for lost time. Florence soon became my classroom; Europe was my school. In recent years, after returning to the United States, I have dedicated my life to sharing with others the stories of the Monuments Men, the people responsible for saving so much of the world's artistic heritage during a war that claimed sixty-five million lives. The United States played a leading role, one that should be a source of pride for all Americans.

Only during the course of my research for this book, nearly ten years after departing the city, did I discover how close I had been to the story of the Monuments Men. Our home in Bellosguardo, one of the hills overlooking Florence, had once been a part of the adjacent Villa dell'Ombrellino, which suffered shellfire damage during the battle for the city. Cecil Pinsent, a noted landscape architect who served as a British Monuments officer, designed its Italian-style garden.

Torre di Bellosguardo, a hotel located directly behind our home, had been commandeered by the German forces responsible for destroying Florence's magnificent bridges. Allies occupied the hotel after liberation. In fact, many of the places mentioned in this book are sites I frequented while living in Florence, unaware of the role they would later play in the writing of this book. In my research, I discovered that the Tuscan

treasures at one point had been destined for St. Moritz, Switzerland—a special place in my life, and one where I wrote a large portion of this manuscript. This reminded me of something a close friend of Monuments officer Deane Keller once said: "Life is full of mysteries in which unfathomable forces produce mystical results."

My journey has taken me from the Ponte Vecchio in Florence— where I first wondered how so many of Europe's great works of art survived World War II, and who saved them—to Washington, DC, where, on June 6, 2007, members of Congress passed a joint resolution that for the first time honored the service of the Monuments Men and women. Five months later, I stood beside four of those heroes in the East Room of the White House to accept, on behalf of the Monuments Men Foundation, the National Humanities Medal from the President of the United States.

Forty-eight men and women ultimately served with the Monuments, Fine Arts, and Archives (MFAA) Section in the Mediterranean theater (including Greece and North Africa). (A complete list of their names appears at the end of this book). Regrettably, only one of the Monuments Men who served in Italy, artist Salvatore Scarpitta, was still alive by the time of my involvement. My inability to include more of these heroes' stories, including his, is in no way a reflection on the merit of their wartime contributions or experiences.

I first met and interviewed Scarpitta on October 31, 2006. Although quite ill, Salvatore was still living at home, surrounded by some of the art he had created. We reminisced about Italy, then about his work as one of the late entrants into Monuments service. Like so many others I have interviewed, he apologized in advance for his failing memory, telling me, "I'm only sorry we didn't meet earlier." A few minutes spent examining photographs in my first book, *Rescuing Da Vinci,* prompted important observations:

> *I was a very critical young kid, but the attitude that we demonstrated was of terrific attachment to this history of the artists and of the people that*

respected their work. . . . I had a form of affection that's called love for these monuments. I felt that they represented real monuments of humanity, and they went through terrific tribulations. . . . So you'll find in our studies and our work the attitude of people who want to preserve this heartbeat, and we did it very well, I thought.

Our emotional meeting took its toll on his energy. As I departed I said, "I'm going to come back and see you, so you better take care of yourself." He smiled. "I'm waiting for you . . . thank you, brother." Unfortunately, that subsequent meeting never occurred. Salvatore Scarpitta died almost six months later, on April 10, 2007. But his memory remains close at heart through his daughter, Lola Scarpitta Knapple, and her family, who, like the other children of these great men and women, want to celebrate the rich legacy of their loved ones.

Saving Italy is part of a much larger project. In June 2007, I established the Monuments Men Foundation, which is dedicated to preserving these heroes' legacy and to reestablishing our nation's leadership in the protection of cultural treasures during armed conflict. Public awareness of the Monuments Men and their achievements is essential to accomplishing that mission. I believe that this book—plus the permanent Monuments Men exhibition being developed for the Liberation Pavilion at The National World War II Museum in New Orleans, and the feature film based on my last book, *The Monuments Men*, being produced by Oscar-winner George Clooney and Grant Heslov—will introduce the extraordinary work of the Monuments Men to an even larger global audience. I also hope the increased visibility will engage the public in our search for hundreds of thousands of still-missing objects taken during the war and thus lead to further discoveries. Readers are encouraged to contact the Foundation if they have information or questions about the provenance of a particular object—painting, document, or other cultural or historic item—removed from Europe during or shortly after the war. For more information, please visit www.monumentsmenfoun dation.org.

A NOTE ON THE TEXT

In writing this book, I relied on a team of researchers, each working in her native language—Dorothee Schneider in German, Anna Bottinelli in Italian—to translate thousands of pages into English. When a linguistic conflict arose, they translated the intent of the speaker, not the literal text, which might have risked missing the essential meaning. In the rush of their work and the chaos of war, the Monuments Men did not always have the time to check the spellings of Italian or German phrases and names. In places where the original sources misspelled words in foreign languages, I have taken the liberty of silently correcting the spelling without using *sic*. In those instances where such a correction risked changing the meaning of the statement, I used [*sic*].

Some of the documents we reviewed are privately owned and were made available exclusively to me by the owners. Such cases have been noted in the Notes. The use of the word *Allies* in most instances means "Western Allies"—i.e., it does not include the former Soviet Union. This should be evident in context. On those occasions when I confronted conflicting information, I gave priority to the most contemporary document or eyewitness account over a report or recollection written well after the event. In some cases, additional details or conflicting facts have been included in the Notes to provide the reader with the fullest picture.

The responsibility for errors is mine alone.

MAIN CHARACTERS

Note: Ages listed are as of 1943.

MAJOR CHARACTERS

Captain Deane Keller, Monuments Man for U.S. Fifth Army. Age 42. Born: New Haven, Connecticut. Portrait painter and Professor of Art at Yale. Keller volunteered so he could serve his country and put to use his knowledge of Italy. He left behind his beloved wife, Kathy, and young son, Dino. Introverted, sensitive, and extremely hardworking, Keller often felt alone and isolated in the army. *[Deane Keller Papers, Manuscripts & Archives, Yale University]*

Lieutenant Fred Hartt, Monuments Man for Tuscany. Age 29. Born: Boston, Massachusetts. Art historian. A rising star in his field. He worked as an assistant and cataloguer at Yale University Art Gallery before joining the military in 1942. Hartt was a go-getter, sometimes impulsive and naïve but passionate about Italy and his job. *[Walter Gleason Collection]*

General Karl Friedrich Otto Wolff, Supreme Leader of all SS Troops and Police in Italy. Age 43. Born: Darmstadt, Germany. For six years he worked in Hitler's headquarters as Chief of the Personal Staff to Reichsführer-SS Heinrich Himmler. After Italy's capitulation in September 1943, Wolff became the de facto leader of Mussolini's Social Republic. He often capitalized on his persuasive personality and the personal favor of Hitler. *[ullstein bild—Walter Frentz]*

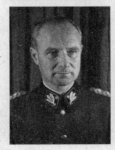

SUPPORTING CHARACTERS

Giovanni Poggi, Superintendent of Galleries of Florence, Arezzo, and Pistoia. Age 63. Born: Florence, Italy. He organized the evacuation of art treasures from the city's museums to repositories in the Tuscan countryside. Poggi was one of the most esteemed superintendents in Italy, having served in a similar capacity during World War I. [*Arianna and Elisa Magrini, and Edizioni Polistampa, Florence*]

Allen Dulles, Chief of the Office of Strategic Services Mission in Switzerland. Age 50. Born: Watertown, New York. In 1942, he assumed a post in Bern, Switzerland, with the title of Special Assistant to the Minister. This job was in fact cover for his activities as spymaster for the OSS. [*Central Intelligence Agency*]

Don Guido Anelli, Catholic Priest and Partisan Leader. Age 31. Born: Vigolone, Italy. Anelli was one of the first organizers of the armed resistance against the Germans and Fascists in the Province of Parma. [*Sergio Giliotti Collection*]

SS Colonel Alexander Langsdorff, Head of the German Kunstschutz in Italy. Age 45. Born: Alsfeld, Germany. An accomplished archaeologist who also worked at the Berlin State History Museum, Langsdorff joined Himmler's personal staff in 1935. His work protecting the art and monuments of Italy often conflicted with his devotion to the SS. [*Mareile Langsdorff Claus Collection*]

Captain Alessandro Cagiati, Italian American Intelligence Officer of the OSS. Age 34. Born: Rome, Italy. He immigrated to the United States in 1934. During the war, Cagiati arrived in Sicily alongside the first Allied soldiers. He served as a liaison between the OSS and the Italian resistance. [*Anthony Cagiati and Alessandro Cagiati*]

MONUMENTS MEN

Lieutenant Commander Perry B. Cott, USNR. Age 34.
Born: Columbus, Ohio. Associate Director and Cura-
tor of European and Asiatic Art at the Worcester Art
Museum, Massachusetts. Cott first worked in naval intel-
ligence, and was one of the earliest Monuments officers
assigned to Sicily in 1943. *[Pennoyer Papers, Department of
Art and Archaeology, Princeton University]*

Captain Edward "Teddy" Croft-Murray. Age 36. Born:
Chichester, England. Keeper of Prints and Drawings at the
British Museum. Croft-Murray first served in the Admi-
ralty and the War Office. He arrived in the Mediterranean
Theater via Tizi Ouzou, Algeria. *[Walter Gleason Collection]*

**Lieutenant Colonel Ernest Theodore DeWald, Director of
the Monuments, Fine Arts, and Archives Subcommis-
sion.** Age 52. Born: New Brunswick, New Jersey. Profes-
sor of Art at Princeton University. A World War I veteran,
DeWald first served in North Africa training soldiers about
the cultural treasures of Italy. *[Walter Gleason Collection]*

Major Paul Gardner. Age 49. Born: Somerville, Massachu-
setts. Museum Director. Gardner had served in the U.S.
Army during World War I. In 1933, he became the first
Director of the newly opened William Rockhill Nelson
Gallery and Mary Atkins Museum of Fine Arts in Kansas
City, Missouri. Gardner was the first Monuments Man to
reach mainland Italy. *[Walter Gleason Collection]*

Lieutenant Colonel Mason Hammond. Age 40. Born: Bos-
ton, Massachusetts. Professor of Classics at Harvard.
Appointed by President Roosevelt, Hammond served
as the first Adviser on Fine Arts and Monuments. He
landed in Sicily three weeks after the Allied invasion, the
first Monuments officer in the field. *[Elizabeth Hammond
Llewellyn Collection]*

Lieutenant Colonel Norman T. Newton, Monuments Man for British Eighth Army. Age 45. Born: Corry, Pennsylvania. Landscape architect. Newton was an aviation cadet in the U.S. Marine Corps Reserve during World War I. Like several other Monuments Men, Newton also spent three years as a Fellow at the American Academy in Rome. *[Walter Gleason Collection]*

Major Theodore "Tubby" Sizer. Age 51. Born: New York City. Director of the Yale University Art Gallery. Commissioned in 1942 as a major in Army Air Force Intelligence, Sizer served in Sicily. He recommended several individuals for work in the MFAA, including his good friend Deane Keller. *[Images of Yale Individuals, Manuscripts & Archives, Yale University]*

Lieutenant Colonel John Bryan Ward-Perkins, Deputy Director of the MFAA Subcommission. Age 31. Born: Bromley, England. British archaeologist. Ward-Perkins worked at the London Museum and the University of Malta prior to the war. As a member of the British Royal Artillery, in 1943 he was stationed in North Africa where he protected the ancient Roman sites of Leptis Magna and Sabratha in Libya. *[Walter Gleason Collection]*

SAVING ITALY

In wartime when the thoughts of men of fighting nations are concerned primarily with winning battles and the consequent fear, animosity, hatred, blood and death, it seems incongruous and inconsistent that the commanders of opposing armies should give attention to culture and the Fine Arts. Yet in both the Nazi-Fascist and Allied Armies, perhaps for the first time in history, there were men whose sole job it was to preserve the heritage and culture of nations being torn to shreds by the ravages of war. Italy was the first to know the men whose job it was to care for her cultural and artistic heritage in wartime.

—MONUMENTS OFFICER CAPTAIN DEANE KELLER

PRELUDE

Padre Acerbi, a veteran of the Great War, passed another humid night in a Milan air-raid shelter with his Dominican brothers. He hoped the terrifying events of previous evenings would not be repeated. It was Sunday, August 15, 1943. That day he and his fellow citizens had held celebrations for the Feast of the Assumption of the Virgin Mary, *Ferragosto*, one of Italy's most important national holidays. But the festivities had been muted. Acerbi prayed for a halt in the attacks, even if just for a few hours. The weary citizens of Milan needed sleep; so did his fellow friars.

At half past midnight, as the full moon began emerging from a partial lunar eclipse, the dreaded but familiar drone of the air-raid sirens began again. Previous raids had already caused hundreds of thousands of Milanese to evacuate. Twenty minutes after the sounding of sirens, they heard the airplanes overhead, then the muffled thunder of the first bombs. The ground tremored beneath them, louder and more violent as the initial wave of Royal Air Force Lancasters approached the city center. Flashes in the distance made the luminescent sky even brighter.

Fires charged the air with an acrid odor. A single four-thousand-pound bomb detonated near Acerbi's shelter with a deafening explosion.

Several nights earlier, bombs hit the Church of Santa Maria delle Grazie and its Refectory.* Surprisingly, none had damaged the jewel of Milan, the dining companion of the Dominican friars: Leonardo da Vinci's *The Last Supper*. It had been a centuries-old tradition that the friars would share their meals in front of the north wall on which Leonardo had painted the twelve apostles preparing to eat theirs. But as dawn emerged, Padre Acerbi could see that the explosion had suspended that tradition, perhaps forever.

Leonardo took a contemplative and deliberate approach to the painting of *The Last Supper*. Matteo Bandello, a young friar who later became a famous writer of novellas, observed Leonardo "go early in the morning to work on the platform before *The Last Supper*; and there he would stay from sunrise till darkness, never laying down the brush, but continuing to paint without eating or drinking. Then three or four days would pass without his touching the work, yet each day he would spend several hours examining it and criticising the figures to himself."

Upon its completion in 1498, viewers were astonished. The standard depiction of the subject, from the catacomb paintings in the fifth and sixth century through more recent works by Taddeo Gaddi (c. 1350), Andrea del Castagno (c. 1447), Domenico Ghirlandaio (c. 1480), and Pietro Perugino (c. 1493) had emphasized the story of the Eucharist. These and other artists typically placed the twelve apostles at the dining table as Christ prepared the offering of consecrated bread and wine. The setting of each work depicted figures that were static, void of emotion. Judas often had been placed alone, across the table from Jesus and his followers.

But Leonardo, a keen observer of nature with a physician's under-

* A February 14, 1943, air raid caused minor damage to the Church of Santa Maria delle Grazie and the vault of the Refectory. Another raid during the night of August 13–14, 1943, resulted in damage to the church but not to the Refectory.

standing of the human body, broke with tradition by fusing the ceremony of the Eucharist with the dramatic moment when Christ announced to those gathered: "Verily I say unto you, that one of you shall betray me." Having once noted, "the movement of men are as varied as are the emotions which pass through their minds," Leonardo thus portrayed the reaction of each apostle to this shocking news. Philip sorrowfully places his hands on his chest in a plea of innocence. James the Greater gestures wildly with indignation. Bartholomew, with his eyes fixed on Christ, leans forward with his weight on the end of the table, while the shadowy figure of Judas, having knocked over the salt, recoils defensively, clutching a small bag, perhaps of silver. The master's use of color, and the lifelike appearances of the apostles, engaged the viewer as a participant in Leonardo's dramatic storytelling. Now it appeared the painting might never be seen again.

The bomb had slammed into the center of the Cloister of the Dead, a small, grassy courtyard east of the Refectory and north of the church. The blast had obliterated a covered walkway through which the friars, garbed in white habits and sandals, passed each day. Had Padre Acerbi not relocated his fellow Dominicans from their refuge in the convent basement to a shelter outside the church walls several days earlier, they, too, would have perished.* The only clues that the long arcades ever existed were the stumps of wood that once supported the graceful arches and frescoed plaster leading to the main church buildings.

The explosion reduced the east wall of the Refectory to rubble, bringing the roof down with it. The wooden A-frame girders crushed the thin plaster vault of the Refectory ceiling like a hammer hitting an egg. In 1940, local art officials concerned about this very possibility had installed sandbags, pine scaffolding, and metal bracing on both sides of the north wall. Only this precaution had prevented Leonardo's masterpiece from

* The antiaircraft shelter used by the Dominicans can still be found today on Via Caradosso, across the street from Santa Maria delle Grazie and identified by two painted arrows on either side of "U.S.," meaning *Uscita di Sicurezza* or "Emergency Exit."

collapsing. While no one could immediately confirm the condition of *The Last Supper*, Padre Acerbi considered it miraculous that the painting might have survived a bomb that exploded some eighty feet away.

Leonardo painted *The Last Supper* using an experimental technique. Rather than applying pigment to wet plaster in the traditional manner of fresco painting, the master painted on a dry wall, hoping to achieve a more complex palette. This approach also complemented Leonardo's slow, meditative style of work. It took him about three years to complete the painting. When finished, it measured some fifteen feet in height by twenty-nine feet across, almost the entire width of the Refectory. But Leonardo's experiment failed; in less than two decades, the painted surface showed deterioration. By 1726, well-intended restorers had begun the first in a continuous series of documented and undocumented interventions. Too often, such efforts had less to do with reattaching Leonardo's work to the perpetually damp north wall than the restorer's desire to attach his work—and name—to the historic image. As one art expert in Milan observed, "There is no work in the entire world that has been more venerated by the public and [yet] offended by the scholars." The bomb blast of August 16, 1943, was only the most recent and certainly the most drastic offense.

The humidity of the north wall had always concerned caretakers. Now the sudden exposure to the elements created new risks. The loss of the east wall and roof dissipated the delicate microclimate inside the Refectory, and Milan's summer heat increased the moisture in the wall, causing portions of the painted surface to swell and then lift. The bomb blast had also dislodged sandbags, tossing some of them against the painted surface. A summer rainstorm could easily wash away whole sections of the work. A severely damaged low-rise building attached to the back side of the Refectory threatened to collapse. Just the vibration, much less a direct hit, from another Allied bombing mission might be enough to cause the north wall to crumble. Even if the north wall survived further damage or movement, Leonardo's signal work faced great peril.

―――――

ITALY HAS LONG been identified by its cultural treasures; Leonardo da Vinci's *The Last Supper* is but one. Its ancient cities—Rome, Syracuse, and Pompeii; jewel-box towns—Venice, San Gimignano, and Urbino; places of worship—St. Peter's Basilica, Florence's Duomo (Santa Maria del Fiore), and Padua's Arena (Scrovegni) Chapel; and iconic monuments—the Colosseum, Leaning Tower, and Ponte Vecchio, have been so studied and admired through literature, verse, and image that they have become the shared heritage of all mankind.

As events in Milan demonstrated, World War II and the new technology of aerial bombardment—in particular, incendiary weapons—posed history's most lethal threat to that heritage. When the Allies landed in Sicily on the night of July 9–10, 1943, another threat emerged: ground warfare. The Germans were determined to concede not an inch of Italian soil. How many more monuments, churches, libraries, and immovable works of art lay in the path of war? Even then, as the bombing of *The Last Supper* illustrated, the Western Allies were not immune from mistakes in judgment and execution.

War is many things, but above all, it is messy. Rarely does it unfold as planned. Prime Minister Winston Churchill once observed: "Never, never, never believe any war will be smooth and easy, or that anyone who embarks on the strange voyage can measure the tides and hurricanes he will encounter." Ethical dilemmas arise. Loyalties are tested, but loyalties to whom? Country, cause, or self? The effort to protect Italy's cultural treasures during war lived up to Churchill's admonition. Few wartime voyages provide such a strange and fascinating story.

During World War II, the task of saving Italy's artistic and cultural treasures fell to a diverse and often surprising cast of characters, including army commanders, Italian cultural officials, leaders of the Catholic Church, German diplomats and art historians, Nazi SS officers, OSS operatives, and partisans. Motives ran the gamut. Not everyone behaved as expected—far from it.

But there was also a little-known group of American and British

men—museum directors, curators, artists, archivists, educators, librarians, and architects—who volunteered to save Europe's rich patrimony. They became known as "Monuments Men." This middle-aged group of scholar-soldiers faced a seemingly impossible task: minimize damage to Europe's single greatest concentration of art, architecture, and history from the ravages of a world war; effect repairs when possible; and locate and return stolen works of art to their rightful owners. Their mission constituted an experiment dreamed up by men who at the time occupied offices far away from war. Nothing like this had ever been tried on such a large scale.

At the core of the group were two men whose destinies became intertwined not just with the fate of a nation but also with the survival of civilization's cultural heritage. Deane Keller, a patriotic forty-two-year-old artist and teacher with a wife and three-year-old son, seemed to be everywhere and nowhere, constantly on the move from town to town. Fred Hartt, an impetuous but brilliantly gifted twenty-nine-year-old art historian, became so deeply entrenched in the cultural heartbeat of Florence that saving the city's art became his personal quest, the mission of a lifetime. Thrust together by the democracy of military service, they struggled to survive war, its destructiveness, and, at times, each other.

SECTION I

INCEPTION

Works of art are not like diamonds. However valuable a diamond may be, you can always get another like it. But the Mona Lisa or the Sistine Chapel in the Vatican are unique. Their creators are dead, and no money could ever replace them.

—GENERAL SIR H. MAITLAND WILSON,
SUPREME COMMANDER, ALLIED FORCES
MEDITERRANEAN THEATER

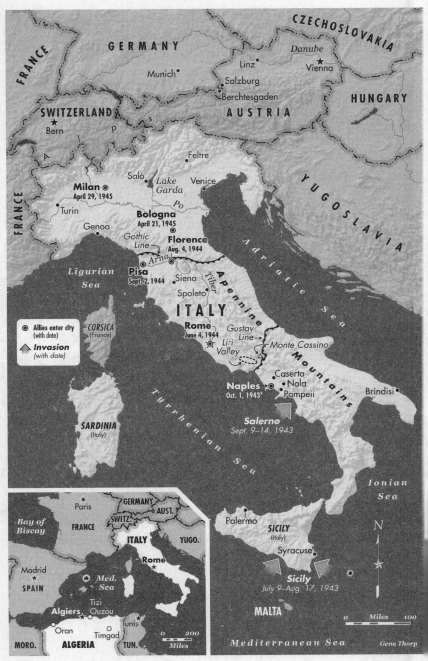

Mediterranean Theater of Operations (partial)

1

CHANGING OF THE GUARD

Meetings of heads of state, even in an emergency, normally require days if not weeks to arrange. Scheduling the July 19, 1943, meeting between the leader of Nazi Germany, Adolf Hitler, and Italian Fascist dictator Benito Mussolini took less than twenty-four hours.

Alarming news on the situation in Italy had reached Hitler two days earlier. Only seven days had passed since American and British forces had fought their way onto the beaches of Sicily, yet German brigade commanders had already begun receiving reports of Italian troops abandoning the front lines—surrendering in such numbers that it burdened the Allied advance. Generalfeldmarschall Albert Kesselring, Commander-in-Chief South, griped that "half-clothed Italian soldiers were careening around the countryside in stolen lorries." Germany's Fascist partner seemed unable, or—worse—unwilling, to defend its own homeland from the Allied invaders. Hitler and his general staff knew that even in the best of scenarios Mussolini's public bluster did not match the actual military capacity of his country; more German forces would be required to defend this newly opened second front. Given the mind-numbing loss of one million German soldiers the previous winter—many killed at

Stalingrad, the "most catastrophic defeat hitherto experienced in German history"—something had to be done, and quickly.

The meeting took place at Villa Gaggia, near the town of Feltre, some fifty miles north of Venice. After spending the night at his Alpine home in Berchtesgaden, Germany, Hitler arrived by plane in the Italian town of Treviso, where Mussolini greeted him. Together they boarded a train for the short distance to Feltre. It would be Hitler's last trip to Italy.

In 1926, Hitler wrote about Mussolini in *Mein Kampf*, expressing his "profoundest admiration for the great man south of the Alps who, full of ardent love for his people, made no pacts with the enemies of Italy, but strove for their annihilation by all ways and means." In fact, Hitler's admiration extended to Mussolini's self-proclaimed title, *Il Duce* (The Leader)—so much so that he chose for himself the same title, *Führer*. During the latter half of the 1920s, Hitler considered Mussolini's successful leadership of Fascist Italy a model for National Socialism in Germany. Editors of *Time* magazine placed Mussolini's image on its covers in 1923 and 1926, calling attention to his "remarkable self-control, rare judgment and an efficient application of his ideas to the solving of existing problems." Pope Pius XI referred to Mussolini as a man "like the one that Providence has provided us with."

Initially Mussolini had no interest in forming an alliance with Germany, a nation weakened by sanctions after World War I. He considered Hitler's racial theories of Aryan supremacy ludicrous. But in 1936, the two leaders developed a closer relationship following Italy's and Germany's interventions in the Spanish Civil War (1936–39) in support of General Francisco Franco and his Nationalists. By November 1 of that year, impressed by Hitler's consolidation of power and the remarkable turnaround of German industry, Mussolini delivered a speech in front of Milan's towering cathedral, the Duomo, in which he hitched the future of Italy to the ambitions of the German leader. He boldly predicted that the rest of Europe would soon revolve around the "axis" of Europe's two most powerful countries.

In the early years of their alliance, Mussolini believed that he could

manage Hitler, but by 1943, any question about who managed whom
had been laid to rest. Hitler had militarized Germany, building it into a
war machine with state-of-the-art technologies. The nation and its peo-
ple existed to serve the Führer in whatever manner he determined; no
sacrifice would be too great.

Fond of delivering grandiose speeches but less skilled at long-
term logistics, Mussolini made no such provisions to prepare the Ital-
ian people and its industry for the hardships ahead. Food riots began
in southern Italy as early as January 1941; food rationing began nine
months later. Government disorganization resulted in misallocation
of resources. Labor shortages coexisted with unemployment. Pov-
erty increased in the countryside as the war "tore their sons from the
plough." Time and again, Mussolini's leadership proved inadequate.
But like an apprentice whose allegiance to his mentor endures even
after recognizing his elder's failings, Hitler maintained his affection and
admiration for Mussolini.

The German High Command had urged Hitler to demand control
of all Italian ground and air forces. Any hope of stopping the Allied
advance in Sicily depended on it. The Italian High Command, *Comando
Supremo*, expected Mussolini to explain Italy's predicament to the Füh-
rer using words from a telegram they drafted for him the previous day:
"The sacrifice of my country cannot have as its principal purpose that
of delaying a direct attack on Germany. . . . My country, which entered
the war three years earlier than was foreseen and after it already had
engaged in two wars, has step by step exhausted itself, burning up its
resources." Of the two, Mussolini had the more difficult assignment.

At 11 a.m., Mussolini, accompanied by General Vittorio Ambrosio,
Chief of Staff for the Italian Army, and two government representatives,
entered the main lounge of the villa with Hitler and his four-man entou-
rage. The meeting began with a lengthy monologue by Hitler, without
translation, about the progress of the war, the outcome of which would
"determine the fate of Europe." Sometime after 11:30 a.m., Mussolini's
personal secretary burst into the room carrying an urgent message,

which the Duce then read aloud in German: "At this moment the enemy is engaged in a violent bombardment of Rome." Hitler resumed his one-sided narration with barely a pause.

After Mussolini failed to convey the message his generals had drafted, General Ambrosio took advantage of a short break before the private lunch between the two leaders. He insisted to Mussolini that Italy exit the war within fifteen days. Mussolini replied: "It sounds so simple: one day, at a given hour, one sends a radio message to the enemy . . . but with what consequences? . . . What attitude will Hitler take? Perhaps you think that he would give us liberty of action?"

Although Mussolini later pleaded for additional German military support, the shame of admitting that Italy's resources had been exhausted was simply too great. Under his leadership, Italy had entered the war aligned with Hitler and the Nazis. There would be no easy way out, especially now, after the Allies had attacked Rome. At that moment, the Italian leader could only think about how his absence during the attacks would be seen by Romans.

THE FIRST PLANES of the formation appeared over Rome at 11:03 a.m. on a cloudless summer morning. Aircraft soon filled the sky above the Eternal City. An enormous formation of more than five hundred B-17 Flying Fortresses and B-24 Liberators—virtually the entire Northwest African Strategic Air Force (NASAF) of the United States Army—skirted the Vatican to begin their bombing run. From an altitude of more than twenty thousand feet (twenty "angels"—American pilots referred to every one thousand feet of altitude as one "angel"), the bombers released their payload, some two million pounds of explosives targeting the Littorio and Ciampino Airdromes and the railway marshaling yards at Littorio and San Lorenzo. Each bomb took seventy seconds to fall to the earth.

The risky mission reflected the importance Allied leaders placed on disrupting enemy communications and interdicting the supply of Ger-

man and Italian forces from Florence and Genoa into Rome. They also wanted to avoid the resupply from Rome to Sicily via Naples farther south. Littorio and Ciampino posed the lesser problems; both were located more than five miles from the city center. But the San Lorenzo rail yards lay less than a mile and a half from Rome's most famous monument, the Colosseum, and immediately adjacent to one of the Seven Pilgrim Churches of Rome, the *Basilica di San Lorenzo fuori le Mura* (Basilica of St. Lawrence Outside the Walls).

Plumes of smoke rising from the southeast disturbed the normally splendid view of the city from the open-air gallery of the Vatican's Loggia di Raffaello. Even as the sound of nearby antiaircraft fire and distant explosions echoed across the hills, Monsignor Giovanni Battista Montini, Vatican Deputy Secretary of State for Ordinary Affairs, could not believe that the Allies would bomb Rome.*

The smoke seen by Montini originated from the San Lorenzo rail yards and the surrounding densely populated neighborhoods. While the raid devastated the marshaling yards, some bombs missed their target and hit adjacent university and hospital buildings, the nearby Verano Cemetery, and the Basilica of San Lorenzo, where the body of Pope Pius IX, the longest-reigning pope in history, had been reinterred in 1881. More than two thousand people lay dead—most were civilians from working-class neighborhoods. A large number of the victims had been packed in streetcars in the piazza facing the church. One woman noted in her diary: "death . . . comes from where we look when we pray to God."

The Allies had acted despite numerous pleas by Eugenio Pacelli—Patriarch of the West, Successor of the Chief of the Apostles, Primate of Italy, Vicar of Jesus Christ, but most commonly known as His Holi-

* Ordinary Affairs generally referred to internal affairs. Monsignor Domenico Tardini, Deputy Secretary of State for Extraordinary Affairs, handled foreign relations. Both men were deputies to Vatican Secretary of State Luigi Maglione. As Owen Chadwick pointed out (p. 54) in *Britain and the Vatican during the Second World War,* "the distinction had never been clear. Often the Pope simply decided whether he preferred Tardini or Montini to deal with the question." Montini would become Pope Paul VI in 1963.

ness, Pope Pius XII—that Rome be spared. Aware of his concerns, President Franklin D. Roosevelt wrote the pope on July 10, 1943. Even while Allied forces were landing in Sicily, he restated his previous assurances: "Your Holiness. . . . Churches and religious institutions will, to the extent that it is within our power, be spared the devastations of war during the struggle ahead."

The Holy Father's refusal to publicly criticize Nazi Germany's devastating bombing of London, Coventry, and other culturally rich European cities made his preoccupation with protecting Rome and the Vatican appear hypocritical to some. Britain's Minister to the Holy See, Sir Francis D'Arcy Osborne, commented, "The more I think of it, the more I am revolted by Hitler's massacre of the Jewish Race on the one hand, and . . . the Vatican's apparently exclusive preoccupation with the . . . possibilities of the bombardments of Rome." Informed of the raid shortly after it commenced, Churchill replied, "Good! Now also our old Mussolini will understand how it feels to have a ceiling about to collapse on your head at any moment."

For the duration of the two-and-a-half-hour raid, the pope stood at a window in his private study and watched the bombing through binoculars. Upon learning the extent of the damage, he decided to "carry out his pastoral duties as the Bishop of Rome" and comfort the survivors. Ignoring security concerns, the pope departed Vatican City for the San Lorenzo area in the papal vehicle, a black Mercedes, accompanied only by Monsignor Montini and their driver.

They arrived to find a bloody and chaotic scene. Many of the bodies, dragged from the rubble, had been lined up, side by side, and covered with newspapers. Desperate cries of *"Santità"* and *"Pace"* ("Holiness" and "Peace") filled the air. Seeing the yellow-and-white papal pennants attached to the front fenders of the vehicle, throngs of people began to gather around the car. The pope emerged. "His face pale with grief, he stood up on his car to contemplate the damaged Basilica, and then he walked in the street to mingle with his flock. The Pope knelt down in the rubble and prayed for the victims of this and other raids." More than

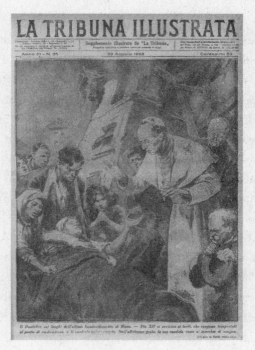

This watercolor drawing, printed in the weekly Italian paper
La Tribuna Illustrata, shows Pope Pius XII blessing victims
of the second Allied bombing attack of Rome on August
13, 1943. Note the blood stains on his cassock. [Biblioteca
Comunale Centrale "Palazzo Sormani," Milan]

words were dispensed: the pope and Montini distributed some two million lire* to survivors of the attack.

The papal trip to San Lorenzo marked the first time in three years that Pius XII had left the safety and isolation of Vatican City. He returned late that evening with his white cassock stained with dirt and blood. War had engulfed Rome. As the person vested with the responsibility of protecting Vatican City, the pope now had to attend to the safety of its thousands of inhabitants as well as an immense trove of church documents, works of art, and other priceless relics.

* About $267,400 in 2012.

EFFORTS TO REMOVE Mussolini from office began immediately upon his return to Rome late on the evening of July 19. On Thursday, July 22, the Duce met with Italy's King Vittorio Emanuele III for his routine twice-weekly audience. The seventy-three-year-old monarch, ruler of Italy for almost forty-three years, had already been briefed on the Feltre conference. He knew that Mussolini had obtained neither what his country needed (German troops, aircraft, and equipment) nor what it wanted (an exit from the alliance once proclaimed as the "Pact of Steel"). Twenty years after appointing Mussolini, the king realized his prime minister had to go.

At 5 p.m. on Saturday, July 24, after more than three years without a meeting of the Grand Council, the Fascist Party's governing body assembled. The tension heightened after some of the leaders realized that others were concealing pistols and grenades. Mussolini's lengthy opening statement did little to assuage their concerns or the discordant mood. For nearly ten hours, the men heard impassioned speeches, reasoned presentations, and even sobbing as the chaotic meeting stretched into the early hours of Sunday. At 2:40 a.m., by a margin of nineteen to seven, the Grand Council returned full executive power, including command of Italy's armed forces, to the king.

Late that afternoon, Mussolini arrived at Villa Savoia, the royal residence, for a specially arranged audience with Vittorio Emanuele. After listening to the Duce's brief report on Italy's military situation and his meeting with the Grand Council, the king asked for Mussolini's resignation. He informed him that arrangements had already been made for seventy-two-year-old Marshal Pietro Badoglio to become Italy's next prime minister. "There was a silence in the room, 'broken only by a phrase which the King had repeated several times during the course of the conversation: "I am sorry, I am sorry, but the solution could not have been otherwise."'" The meeting lasted less than thirty minutes.

The leader who had entered the royal residence departed in shocked silence, aware that he had failed his nation. Taking no chances, the king had arranged for fifty *Carabinieri* (military police) officers to hide in the

bushes in case a gun battle erupted with Mussolini's private guards. As Mussolini exited the villa, he was led not to his car, which had been moved, but to an ambulance where an officer of the Carabinieri said, "His Majesty has ordered me to protect your person." In an instant, the ruler of Italy disappeared.

That evening, a national radio address announced the king's acceptance of Benito Mussolini's resignation and Badoglio's appointment as the new leader of Italy. Within hours, tens of thousands of joyous people gathered in St. Peter's Square. As celebrations erupted throughout Italy, an observer in Rome wryly noted, "The supply of wine was exhausted."

But the Duce's removal from office didn't alter the reality that Italy remained the principal ally of Nazi Germany. The United States and the United Kingdom had every intention of conquering Sicily and then attacking the Italian mainland. The war in Italy, even without Mussolini, was just beginning.

NEWS OF MUSSOLINI'S resignation reached Hitler at the *Wolfsschanze,* his Eastern Front headquarters in Rastenburg, Germany, sometime after 9:30 p.m. on Sunday, July 25. Hitler told those gathered: "The Duce has resigned. It is not confirmed yet. Badoglio has taken over the government." Because of Hitler's order barring spying on the soil of its trusted ally, the German security services had no idea of the Duce's location or the circumstances of his disappearance. Certain the Duce's removal was a prelude to Italy's switching sides in support of the Allies, Hitler added, "Undoubtedly, in their treachery, they will proclaim that they will remain loyal to us; but that is treachery. Of course they won't remain loyal."

The failure of the German offensive at the Battle of Kursk in the Soviet Union in early July put Hitler's forces on the Eastern Front on the defensive; they would stay that way for the remainder of the war. News worsened with the early morning commencement of the Allied bombing of Hamburg, Germany. Over the next eight days, these air attacks would result in the deaths of more than forty thousand citizens and destruction of the city. Losing Nazi Germany's most important ally

at this low moment would deal a significant blow to the morale of the German people and its fighting forces, especially the sixty thousand *Wehrmacht* (Germany's armed forces) troops already fighting alongside Italian forces in Sicily.

Morale alone didn't explain the seriousness of the problem. Hitler needed Fascist Italy's 2.1 million soldiers. With the exception of two armored divisions stationed in Calabria (in the "toe" of Italy's "boot"), there was no other major concentration of German forces in Italy to block an Allied invasion of the Italian mainland. Until significant reinforcements arrived, the buffer zone on Germany's southern border lay exposed. A successful invasion would allow the Allies to use Italian airfields to launch bombing missions that could reach Nazi Germany's allimportant oil supply—the lifeblood of any army—in the Balkans.

The Führer reacted to the news of Mussolini's resignation by telling Generalfeldmarschall Wilhelm Keitel, head of Armed Forces High Command (OKW—*Oberkommando der Wehrmacht*), and General Alfred Jodl, OKW Chief of Operations Staff, that he wanted to "give the commander of the 3rd Panzergrenadier Div. the order to drive into Rome with a special group and immediately arrest the entire government, the king, the entire bubble, especially to arrest the crown prince and to get hold of this mob, especially Badoglio and all this rabble. Then you will see that they give up and in 1 to 2 days there will be another upheaval." However, Generalfeldmarschall Kesselring believed that Italy would continue the fight alongside its German ally, just as Badoglio had promised. Why unsettle things further by rushing troops into Rome? Waiting would provide time to determine the king's true intent.

Many leaders of the Nazi Party shared Hitler's hatred of the Vatican and its leader. Hitler had long attacked the Catholic Church for its influence in the internal politics of Germany. Although they'd not met, Hitler knew of Eugenio Pacelli from his service as Papal Nuncio to Germany from 1917 to 1929. Subsequent dealings with Pacelli led to the signing of the *Reichskonkordat* (treaty) between Nazi Germany and the Vatican in 1933.

Convinced that the pope had somehow played a role in Mussolini's removal, the Führer flashed with anger and impatience: "I am going into the Vatican immediately. Do you think the Vatican bothers me? They will quickly be packed up, especially the entire diplomatic corps. . . . I could not care less. . . . We'll remove every one of these bunch of swines. . . . Then we'll apologize afterwards. . . . We'll find plenty of evidence inside [the Vatican] to document their treason!"

Dr. Joseph Goebbels, Reichsminister of Propaganda, who referred to the Italians as "macaroni eaters," urged restraint. Goebbels knew that even the savviest media campaign couldn't silence the outcry that would surely follow any action taken against the pope. Most of Hitler's advisers agreed.

Hitler ultimately decided not to send a special detachment of troops into Rome, but he did issue an order for crack German paratroopers to rescue Mussolini. With the Duce at his side, he calculated, a newly formed Fascist state would be announced, one that Hitler could manage and closely monitor. Reestablishing the appearance of a strong Axis partnership now became an urgent concern. But who would watch over the weakened Duce once the paratroopers rescued him? Reichsführer Heinrich Himmler, feared leader of the Nazi *Schutzstaffel* (SS) and "master of all the concentration camps," had a man in mind.

"The *Signores* [*sic*] get another reprieve," Himmler told SS General Karl Wolff during a phone call on July 27, "but postponed is not abandoned." Wolff was a high-ranking SS member, an *Obergruppenführer* and General of the Waffen-SS, the armed-combat division of the SS. He had joined the Imperial German Army at the age of sixteen, serving on the Western Front during World War I, where he received two Iron Crosses for bravery. Following the war, Wolff trained as a banker in Frankfurt for two years and eventually found employment at Deutsche Bank in Munich from July 1923 until June 1924. After a brief stint in the advertising business, he started his own firm. Those jobs served him well; one honed his political skills, the other his ability to sell himself and his ideas. He was opportunistic but also pragmatic, a survivor.

Although Wolff did not come from an aristocratic family, his human-

istic education, which included literature, music and the arts, placed him among the high-society youth of his hometown. Later, during World War I, Wolff's selection to serve on the protection detail for the Grand Duke of Hesse, alongside other officers from aristocratic families, added to his self-image of nobility. Some of his SS peers sneered at the new, more charming and cultured Wolff. They considered him a "Septemberling," a derogatory term used to refer to those who hadn't joined the Nazi Party until after the successful elections in September 1930. Wolff, in fact, waited more than a year after the power shift to become a Nazi Party member, but he joined the SS the next day. His "Aryan" features—six feet tall with blue eyes and blond hair—suited him well for the SS. Motivated by his ambition to be a member of the elite, he embraced Nazism as a calculated choice, in contrast to many of his new colleagues' passion for extremist Nazi ideals.

Beginning in November 1936, Wolff became Himmler's Chief of Personal Staff, with responsibility for several departments of the SS, including the *Ahnenerbe*, the Ancestral Heritage Research Unit founded by Himmler to attempt to prove "the connection between the modern German people and the ancient Germanic tribes."* Wolff served as "Himmler's eyes and ears" at Hitler's headquarters. In a 1939 letter, the extent of his devotion to the SS and Himmler emerged: "Faith has put me next to a unique man, the Reichsführer-SS, as his closest assistant. . . . Our joined work, which satisfies me profoundly . . . roots in the belief in Race. My entire being and aiming is with the SS and its future goals." In July 1941, Wolff accompanied Himmler on a visit to an SS command post near the Soviet city of Minsk, where he witnessed one hundred innocent Jews being murdered, eight to ten at a time. The following summer, he interceded to resolve some of the railway bottlenecks resulting from the transport of Jews to the death camps. "I notice

* The *Ahnenerbe* (Ancestral Heritage Research Unit) was founded by Himmler in 1935 as "a cultural branch of the SS devoted to archaeological, historical and racial investigations that 'proved' the connection between the modern German people and the ancient Germanic tribes."

with particular pleasure your report that for fourteen days a train has been going daily with members of the chosen people to Treblinka. . . . I've made contact with the participating agencies, so that a smooth implementation of the entire action is ensured."

During their late-July meeting, Wolff listened as Himmler ordered him to Italy to serve as a diplomatic link between Kesselring's forces in southern Italy and other German Army groups in the north. Wolff had fourteen days to prepare a plan for the "seizure of power of the civilian sector" in Italy and present it to the Führer. Maintaining infrastructure and production facilities in Italy would be essential to a successful occupation.

Wolff was the obvious choice for this assignment. Hitler and Himmler each trusted him, a man they considered a true "specimen of a noble German and 'knight in shining armor.'" Wolff had also won favor with Mussolini while acting as an honorary escort during his state visit to Munich in 1937 and on numerous subsequent trips to Italy. In his new position, Wolff "was to consider himself the Führer's governor" in an area extending from Italy's northern border to the rear of Germany's troops on the front.

NOT EVERYONE DISCOUNTED Hitler's threat to enter the Vatican and seize the pope. Admiral Wilhelm Canaris, chief of the *Abwehr* (German military intelligence); General Erwin von Lahousen, chief of *Abwehr* Section 2 (German sabotage section); and others in his immediate circle shared strong anti-Nazi sentiments and had been intimately involved in various plans to remove Hitler from power. When Canaris's deputy informed them that he had just received a report "that those fellows intend to liberate Mussolini; to liquidate the Pope and King," they were stunned. One of his aides became incensed: "Such a dirty trick. We should really tell the Italians about it." Canaris agreed and instructed Lahousen to set up an emergency meeting with his Italian counterpart, General Cesare Amè.

On July 29, Canaris and Lahousen flew to Venice to meet General Amè at the famed Hotel Danieli. For Amè, exchanging information about the war, including the recent fast-moving changes in the leadership of Italy—and Germany's reaction to them—was normal business; doing so alongside three of the Reich's highest-ranking intelligence officials was not. The presence of Amè's staff initially limited what Canaris could say, but Lahousen, who was sitting next to Amè, clearly heard his boss state: "Be careful and watch out, because something might happen." After lunch, Canaris and Amè took an excursion to the Lido, where they walked—alone—and continued their conversation.

On August 4, six days after this meeting of intelligence officials in Venice, Vatican Secretary of State Cardinal Luigi Maglione summoned the cardinals residing in Rome "to review the political situation in Italy and discuss the threat to the Vatican." During that meeting, Maglione "warned his audience that official Italian circles feared that German troops were moving to seize Rome, invade the Vatican, and carry the Pope to Munich." In the tense days that followed, key Vatican staff members were instructed to have their suitcases ready, prepared to travel on a moment's notice. Sensitive documents were hidden, including those of the Holy Father, placed beneath the marble floors of the Papal Palace.

Nineteen days later, Harold Tittmann, special assistant to Myron Taylor, President Roosevelt's personal representative to the pope, spoke with his colleague, British Minister Francis Osborne. Tittmann had vacated the U.S. Embassy in Rome upon Italy's declaration of war on the United States and, like other members of the diplomatic corps, moved into the Vatican. Osborne informed Tittmann that, "according to reliable sources, the Germans were most likely to take over Rome and possibly the Vatican City within the next few days. At Osborne's request, my sons used the fireplace in our living room, the only one available to diplomats in the Vatican, to burn the British Legation's confidential documents."

As Lahousen later explained, Hitler did not just intend to kidnap the pope. He "wanted to kill him."

2

A NEW TYPE OF SOLDIER

LATE JULY–AUGUST 1943

In a classroom at Yale University in New Haven, Connecticut, some forty-two hundred miles from Rome, Professor Deane Keller began another in his series of lectures to soldiers bound for the Mediterranean theater, all part of the university's Education for War and Reconstruction program. The observations on his subject—"American Impressions of Italians and Italian Customs"—derived from Keller's experience as a student and artist living in Rome from 1926 to 1929. There he had learned firsthand how to deal with Italians, something he shared with his students: "The via del cuore (way to the heart) and success will be found through tolerance and understanding of a high-minded sort. And I might add, with <u>infinite patience</u> on your part."

Nearing his forty-second birthday, Keller was already a man of achievement. A school publication described him as a "short, stocky blond chap with wide shoulders developed by his constant swinging of the paint brush . . . teaches at the Yale Art School and has a studio up in the tower there. He puts in long hours on his compositions, makes lots of sketches and studies of the model before a brush touches the canvas. Once he is ready to march, the work proceeds like any well-planned

project." Hardly an imposing figure at five feet seven and 170 pounds, Keller's round, wire-rimmed glasses and brushed, light-colored hair gave him a resemblance to Woodrow Wilson, twenty-eighth president of the United States, who had led the country through World War I. But Wilson had been a Princeton man; Keller was Yale to the core.

As Keller's students prepared to depart for war in 1943, they took some comfort in knowing that momentum had finally swung in favor of the Allies. Although the merciless German siege of Leningrad (now St. Petersburg) continued, the Soviet Red Army had forced a surrender of the German Sixth Army in Stalingrad in January, a battle that claimed 1.1 million Soviet casualties alone. By May, the Western Allies had their first major victory with the surrender of German and Italian forces in North Africa. Planning for an Allied invasion of Europe was underway.

The war effort dominated life in the United States. Rationing of all rubber products, gasoline, and other petroleum derivatives began in 1942. Sugar and coffee were next. By 1943, the ration list expanded to include canned soups and juices as well as meat, fish, and dairy products. Wanting to contribute to the war effort, Americans planted more than twenty million "Victory Gardens" that, by 1943, accounted for one-third of all vegetables consumed in the country. The military deployment of so many men created masses of job openings and virtually eliminated unemployment. Three million kids aged twelve to seventeen took up the slack and went to work. On May 29, the cover of the *Saturday Evening Post* featured "Rosie the Riveter," illustrated by Norman Rockwell, in recognition of the millions of women comprising almost a third of the nation's work force.

Keller was the middle child—and only boy—of three born to Professor Albert Galloway Keller and his wife, Caroline. During World War I, Albert had been stationed with the army in Washington, DC. He and his wife instilled in their children the importance of national service. After his high school years at the elite Taft School, Keller followed in his father's footsteps and enrolled at the college whose campus had been his childhood playground, Yale University. During his senior year at Yale,

he began studying art at the legendary Art Students League of New York, an atelier-type school founded in 1875 by artists, for artists, without degree programs or grades, but one that provided a richly creative environment and self-directed course of study.

In 1926 Keller received a Rome Prize fellowship from the American Academy in Rome, an honor awarded annually to fewer than a dozen of America's most gifted emerging artists and scholars. Such recognition placed his name among past greats—architect John Russell Pope and art historian Charles Rufus Morey—and others who would follow, including composer Aaron Copland; writers William Styron, Archibald MacLeish, and Robert Penn Warren; architects Louis Kahn and Richard Meier; and artists George Biddle and Chuck Close.

For the next three years, Keller lived and studied at the academy, where the learning environment was intoxicating. He became proficient in Italian and traveled throughout the country. Some of his acquaintances within the American Academy later developed into lasting friends, including two men who would play prominent roles in his life: Norman Newton, an accomplished landscape architect, and Walker Hancock, a gifted sculptor.* By the end of his term, Keller had advanced his knowledge and skill as an artist and fallen in love with the country and its people.

After returning home in 1929, Keller accepted the position of Assistant Professor of Drawing and Painting at the Yale School of the Fine Arts. In 1936, he rose to Associate Professor. While he continued developing his skills as a painter, drawing—a discipline he once said "leads an artist to all the possibilities"—was the medium that sustained him throughout his career.

Of the many joys that drawing provided, none outweighed the chance meeting with Katherine Parkhurst Hall, a student in Keller's life

* Both Newton and Hancock would also become Monuments officers. Newton would serve with Keller in Italy; Hancock, whom Keller nicknamed "Camminatore" (Italian for his first name, Walker), served in northern Europe.

drawing class at Yale. At thirty-five, he was the distinguished professor and artist; she was ten years his junior, pursuing her interest in the restoration of decorative arts. Their courtship lasted two years; they married in 1938. Two years later, they had their first child, Deane Galloway Keller, named after his grandfather and affectionately called "Dino." Perhaps because Keller had become a father relatively late, dad and son, each with piercing blue eyes, bonded instantly.

By the summer of 1943, Keller had established a career, married a woman he loved, and fathered a son who had become the pride and joy of his existence. But the world had changed. Just a year after little Deane's birth, the Japanese had attacked Pearl Harbor. With the nation at war, Keller wanted to join the more than two hundred members of the Yale faculty already in military service. Yale, like all universities, underwent severe changes not just to redefine its relevancy during war but also to survive. Ninety-eight percent of Yale's students continued their studies through the summer, reducing the normal four-year course work to two years and seven months. Military and physical training became a part of the curriculum. Yale officials even transformed parts of the campus— sandbags covered the windows of Wright Hall to protect the university's central telephone switchboard.

Keller knew that his lectures to departing soldiers, now down to just two per week because of the dwindling number of stateside volunteers, fell far short of what he could and should be doing. Keller wanted to get into the fight. He first tried the Marines, but they turned him down, blaming poor eyesight. With the news that the Allies had bombed Rome a second time, on August 13, and the battle for Sicily at an end, Keller predicted that the invasion of the Italian mainland would soon follow. The riches of thousands of years of civilization—some of mankind's greatest creative achievements—lay directly in war's path. Italy would soon become a combat zone. And here he was, an expert on Italy and its cultural treasures, stuck in a classroom, lecturing.

Three months earlier, Keller's friend and mentor, Theodore Sizer, Director of the Yale University Art Gallery, had written to suggest that

he take a different path to serve his country, one that matched Keller's experience with the military's needs. Apparently a new unit was being formed to protect art. "Tubby," as he was known to his friends, wasn't so much suggesting Keller apply as he was demanding it:

> *Dear Deane:*
>
> *. . . Suffice it to say that after a week here [US Army School of Military Government in Charlottesville, Virginia] . . . this above all else is the place for you. You are over 35 (requirement #1), know several foreign languages—Italian is very badly needed (requirement #2). . . . On receipt of this sit down & draft a letter to War Department . . . and apply. Stress your knowledge of Italy the country, of the people, their habits, etc. Language people are easy to get but they want those who understand the psychology of our enemies. . . . Most important—don't be so damned MODEST—put it on thick. After the draft rewrite twice & boil down a bit—mail—forget about it. In this you have nothing to lose & a lot to gain. Don't let the former disappointments blunt this necessary initiative. Do it NOW.*
>
> *Yours, T. S.*

Keller wrote the letter, but his continued lectures made it hard to take Tubby's advice and just "forget about it." Waiting made him anxious. After all, his poor eyesight hadn't improved, and he wasn't getting any younger. By August, however, Keller had become cautiously optimistic, informing his parents that if he passed the physical exam, he hoped to be shipped off to Italy to serve as a Monuments officer. "This is all very much might, for there is no word as yet."

AS INFORMATION SPREAD about the new art protection unit, another man from Yale ached to enlist. Deane Keller vaguely knew him, but he was considered a rising star within the community of art historians. On July 24, 1943, this tall, gangling scholar received his commission as a lieutenant in the United States Army. His name was Frederick Hartt.

Whereas Keller had grown up in a stable and nurturing family, Fred Hartt had endured a miserable childhood. Fred's father, Rollin, was a Congregational minister and journalist in Boston. The first child born from his marriage to Jessie Clark Knight was stillborn. In 1914, almost forty years old, Jessie gave birth to Fred. In 1917, shortly after the family relocated to Staten Island, New York, Jessie died. Her death proved a crushing and formative loss for Fred, who "longed for her the rest of his life."

Two years later, Rollin remarried, to a Miss Helen Harrington, whose kind demeanor offset Rollin's rigidity and abusive behavior. Fred's emotional connection with his stepmother improved his teenage years considerably, but then she too died, of cancer. This triggered a depression, aggravated by Rollin and Helen's adoption of a French boy, Jack, that had Fred in and out of therapy for many years.

Fred commuted daily from Staten Island to attend Birch Wathen, a private school on New York City's Upper East Side. Already six feet tall, his awkward appearance, accented by dark, heavy-rimmed glasses, set him apart from other boys his age. While most of his schoolmates longed to be on the athletic fields, mimicking the New York Yankees' newest sensation, former Boston Red Sox pitcher-cum-hitter Babe Ruth, Fred Hartt was lost in a world of French Gothic cathedrals, Italian Renaissance sculpture, and Oriental silk screens. His gift for the arts was apparent almost from the day he arrived at Birch Wathen—as a student, he designed the school logo. Soon his talent as a draftsman led to an interest in sculpture.

Fred's career as an artist ended abruptly, however. Despite his obvious ability and enthusiasm, his therapist expressed concern that "working with his hands in such materials as clay would trigger a very negative response from [his] subconscious. These negative responses would bring about thoughts of, if not [actual,] self-destruction." The death of that dream proved a crushing blow. Fred's later efforts to resume drawing produced more frustrations than results. Often he would begin a drawing only to stop early in the process and tear it apart. Any thought of becoming an artist was abandoned.

In addition to being an exceptionally gifted student and voracious reader, Fred impressed teachers and classmates with his photographic memory. Fred decided to apply those skills to the study of art history, specifically Asian art. At just seventeen years of age, he enrolled at Columbia University, where he received his Bachelor of Arts degree. Graduate studies at Princeton soon followed. He then earned a Master of Arts degree from the Institute of Fine Arts at New York University. By this time, his interests had shifted to Italian Renaissance art. Not surprisingly, his thesis focused on the master sculptor Michelangelo, his favorite artist. Despite the brilliance of Fred's academic work, and his growing reputation in the field, Rollin remained critical of his son's achievements.

In 1942, while working as an assistant and cataloguer at the Yale University Art Gallery and studying for his doctoral degree, Fred met Margaret DeWitt Veeder, known as "Peggy." As a fellow art historian, she and Fred shared a love of education, art, and travel. Their relationship provided Fred with the encouragement and support lacking from his earlier years, and they soon married. In many ways, she was the perfect partner for Fred, but Fred had one need that was beyond her ability to satisfy—he was interested in men.

America in the 1940s was structured around a norm of heterosexuality. A homosexual man seeking employment, especially at a prominent American museum or college, had to keep his sexual preference closeted. Fred Hartt, like millions of Americans who lived through the Great Depression, was acutely aware of the difficulties of getting a job, so marrying a woman he truly loved, who was a friend and companion, was an ideal solution for the times.

Hartt, like Keller, had a comprehensive understanding of Italy. What Hartt lacked in time spent living in Italy he made up for with his research on the country's art and monuments. More than half of his young life had been spent studying Italy—its artists, its culture, its history. He first traveled there in 1936, arriving in Milan on August 15, *Ferragosto*, the Feast of the Assumption of the Blessed Virgin Mary: "I lost my heart

to Italy at the time of my very first visit to that beautiful land." Seven years later to the day, the city of Milan was ablaze and the survival of Leonardo da Vinci's *Last Supper* in question. Much of what had brought meaning to Fred Hartt as an adolescent, and provided a career for him as an adult, was at risk of being destroyed. He had been denied the chance to create art, but nothing was going to keep him from saving it.

3

"BOMBS AND WORDS"

LATE JULY–AUGUST 21, 1943

Prime Minister Winston Churchill, long the champion of an invasion of Italy, began strategizing the next phase of the campaign even before the battle in Sicily had been won. He wrote to General Dwight D. Eisenhower, Commander-in-Chief, Allied Forces in North Africa, expressing his determination to turn the Italian population against "the German intruders" who had caused Italy such misery: "We should stimulate this process in order that the new liberated anti-fascist Italy shall afford us at the earliest moment a safe and friendly area on which we can base the whole forward air attack upon South and Central Germany . . . the surrender of, to quote the President, 'the head devil [Mussolini] together with his partners in crime' must be considered an eminent object."

"Stimulating the process" became the responsibility of the Psychological Warfare Branch (PWB), which developed a campaign informally referred to as "bombs and words," based on the premise that the morale of Italy's citizens could be broken through a combination of forceful propaganda and punishing bombing. The plan called for targeting those cities containing the better-educated populations and greatest number of industrial workers. The resulting misery and fear caused by these

attacks would eventually lead to a series of demonstrations and strikes designed to embarrass Marshal Pietro Badoglio and his new government and force them to capitulate and join the Allies.

On July 29, General Eisenhower delivered the "words" to the Italian populace through a radio address translated into Italian: "We are coming to you as liberators. Your part is to cease immediately any assistance to the German military forces in your country. If you do this we will rid you of the Germans and deliver you from the horrors of war."

Many Italians believed that Mussolini's removal from power had signaled that the war in Italy would soon be over. The Allies' temporary suspension of the bombing of Italy's northern cities only added to that mistaken confidence. Without new bombings, the Badoglio government felt a diminished sense of urgency to finalize a surrender agreement. This dithering frustrated Allied leaders. Three days later, another Allied broadcast criticized the Badoglio government, noting that it had "played for time and thus helped the Germans." A blunt warning followed: "The respite is over. The bombing of military objectives will resume."

PWB compiled a list of bombing targets—including Rome, Milan, Turin, Genoa, Bologna, Naples, and Florence. Precautionary language noted that ". . . [Allied command] should attack the cultural centres always bearing in mind that accidental destruction of cultural monuments may have an adverse effect on our campaign." PWB also recommended advance notice of bombings by leaflet drops and radio warnings. But this was a footnote to the larger directive. The Allies wanted Italy to surrender. Any target that might help achieve that objective would be considered.

Several days earlier, Churchill had written Eisenhower: "We have not bombed Northern Italy for the last two days because we wanted to give them a taste of relief but unless they formally ask for an armistice in the immediate future, we intend to give them all manner of hell." On August 1, Churchill was even more specific. In a memo to his Foreign Secretary, responding to yet another appeal from the Holy See that Rome not be subjected to further bombing, Churchill wrote: "I cannot

see any reason why, if Milan, Turin and Genoa are to be bombed, Rome should be specially exempted."

Although the British and the Americans operated under a unified command structure, there existed a significant divergence of opinions about the role of precision bombing versus area bombing. Britain's head of Bomber Command, Air Chief Marshal Sir Arthur Harris, and the commander of the U.S. Eighth Air Force, Lieutenant General Ira Eaker, each held distinct views. General Eaker believed in precision bombing, normally limited to daylight operations for greater visibility. Bomber pilots received orders to aim for military targets, including industrial plants, railroad marshaling yards, and airfields. This generally precluded the use of incendiaries, or firebombs. Civilian casualties were to be avoided.

The July 19 daylight raid on the Littorio and San Lorenzo Airdromes and marshaling yards in Rome by the U.S. Air Forces provided a perfect illustration of the American approach. Allied leaders knew the decision to bomb Rome posed an enormous risk. Damaging or destroying the city's great treasures—St. Peter's Basilica, the Pantheon, the Colosseum—wouldn't just be exploited by the Nazi and Fascist propaganda machines. The destroyers would also face the judgment of history. Roosevelt's repeated assurances to the pope were, in part, tacit acknowledgment of that fact.

Extraordinary measures were taken to avoid damaging the highest-profile monuments in Rome. The pre-mission orientation of pilots was extensive. "I never briefed [air]crews quite as carefully and flew a bombing run through flak as meticulously as on this raid," one commander later wrote. The night before the bombing, RAF Wellingtons dropped some 864,000 leaflets warning Romans of an impending attack and urging them to seek shelter or evacuate the city. PWB also aired radio messages before the raid to intensify fear and chaos among citizens. While the Basilica of San Lorenzo did sustain damage, the bombing mission successfully destroyed the intended targets and avoided the restricted areas.

In contrast to General Eaker, British Air Chief Marshal Harris believed in the use of area bombing, not precision bombing. By bombing at night, British aircrews were at less risk from antiaircraft flak and

enemy fighters. Harris and his commanders understood that greater safety for their pilots and preservation of precious aircraft by definition meant a far higher degree of imprecision in the results. In order to ensure that targets were hit, vast areas, often entire cities, were bombed in massive raids. "It should be emphasized that the destruction of houses, public utilities, transport and lives, the creation of a refugee problem on an unprecedented scale, and the breakdown of morale both at home and at the battle fronts by fear of extended and intensified bombing, are accepted and intended aims of our bombing policy. They are not by-products of attempts to hit factories." According to the U.S. Ambassador to Great Britain, John Winant, Churchill said, "Night bombing does not lend itself to accurate bombing. . . . It would not be honest to state that bombing would be confined to military objectives only."

The basis for their differing perspectives was rooted in the ways England and the United States had each entered World War II. Hitler's relentless bombardment of England during the Blitz, from September 1940 to May 1941, claimed the lives of thirty thousand Londoners alone. Marshal Harris, commonly referred to as "Bomber Harris," had witnessed its devastating consequences. Standing on the roof of the British Air Ministry building during one of the worst nights of the Blitz, he looked out over London: "The old city [was] in flames. . . . St. Paul's [Cathedral] standing out in the midst of an ocean of fire—an incredible sight. One could hear the German bombers arriving in a stream and the swish of the incendiaries falling into the fire below."

England was fighting for its survival in a war it did not start. In Harris's view, "The Nazis entered this war under the rather childish delusion that they were going to bomb everyone else, and nobody was going to bomb them. At Rotterdam, London, Warsaw, and half a hundred other places, they put their rather naïve theory into operation. They sowed the wind, and now they are going to reap the whirlwind." The late July 1943 bombings of Hamburg, which deliberately created a firestorm through the combined use of incendiary and high-explosive bombs, aided by ideal weather conditions, fulfilled Harris's promise: forty-six thousand people lay dead and the city was destroyed.

The hundreds of tons of high explosives carried by a bomber fleet could inflict severe damage on a city and everything in it, but nothing on the scale of what occurred when such ordnance was dropped in conjunction with incendiaries. These cylinders contained highly flammable material that acted like kindling on a fire, providing an extended source of fuel. "The [4,000-pound blockbuster] bomb could crash through three or four floors with its weight, then ignite on the wooden floors. All that was missing was a draft. After the [bomb] blew away all the roofs and windows for miles around, the buildings became chimneys, and the incendiaries dropped in."

The result was horrifying. "Small fires united into conflagrations in the shortest time and these in turn led to fire storms. . . . the overheated air stormed through the street with immense force taking along not only sparks but burning timber and roof beams, so spreading the fire farther and farther, developing in a short time into a fire typhoon such as was never before witnessed, against which every human resistance was quite useless."

Ensuring target destruction held greater priority than limiting collateral damage. In Harris's words, "The idea was to keep on at small targets for their strategic importance but, to put it crudely, not to mind when we missed them, or at any rate to regard a miss as useful provided that it disturbed morale." British military leaders accepted the grave consequences that followed—civilian deaths, destruction of cultural monuments, and entire cities engulfed by "fire typhoons"—although not without criticism.

The first bombs dropped on Italy had landed in Turin on June 11, 1940, the day after Italy declared war on Britain and France. From the beginning, the British believed "the Italian 'psychology' was considered 'not suited for war.'" By applying "maximum political and military pressure" on local populations, Allied leaders hoped that the people would revolt against their government.

By autumn 1942, the British increased the frequency and intensity of bombings on the industrial centers of northern Italy. Bombs fell on Genoa six times; on Turin seven. An October 24 daylight raid on Milan

caused thirty large fires and killed 171 citizens. Mussolini's order for evening civilian evacuations only increased the anxiety of those living in northern Italy. After his removal from office in late July 1943, "the Milanese ignored martial law and posted anti-war posters and freed political prisoners, as thousands of armament factory workers went on strike. The trams got so crowded they could not circulate and people shouted, 'Peace, Peace, Badoglio will give us peace!' Ironically, an angry crowd of Milanese even attacked German anti-aircraft gun crews."

Allied leaders believed that stepping up bombing attacks on Milan and other northern cities would be instrumental in forcing an Italian surrender. By August, the "bombs and words" campaign culminated in punishing RAF bombings—including the use of incendiaries—in northern Italy. Harris had once said that "the aim of the Combined Bomber Offensive . . . should be unambiguously stated [as] the destruction of German cities, the killing of German workers, and the disruption of civilized life throughout Germany." But did this policy cross a moral divide by unleashing the Allies' anti-Nazi fury against Fascist Italy, especially after Mussolini had already been removed? If so, did it warrant targeting the center of art-rich cities such as Milan?

On August 8 at 1:10 a.m., the first of four near-successive nights of attacks commenced. The raids provided no time for citizens and military installments to recover. Targets included the Breda armaments facilities and several train stations, but the primary objective was the city center of Milan.

As Churchill had promised, Milan suffered "all manner of hell." By mid-August, it had become an inferno. Damage to its water mains left the city burning for a week. Citizens of the Swiss city of Lugano could see the glow of the fires and hear the explosions some thirty-five miles away. While the wall supporting *The Last Supper* still stood, many other renowned buildings suffered damage, few more famous than Milan's opera house, La Scala. Embers from a nearby incendiary bomb ignited its roof; soon the "building was gutted by fire."

Milan's two principal art museums—which before their evacuation contained hundreds of masterpieces by Leonardo, Raphael, Mantegna, and many other revered Old Masters—were pummeled. The Brera Picture Gallery, a seven-minute walk north of La Scala, had burned, leaving only its brick walls and stone columns. The Ambrosiana Picture Gallery, home to Caravaggio's stunning still life *Basket of Fruit* and Raphael's drawing for the epic *School of Athens* fresco (which he later painted on the wall of the Stanza della Segnatura at the Vatican), was severely damaged by fire.

The British strategy hadn't targeted the city's monuments and museums, but no one in Bomber Command could credibly express surprise that these central landmarks—historic buildings including the Duomo, Palazzo Reale, and Castello Sforzesco—had been damaged. In all, the raid killed more than seven hundred Milanese; forty churches, ninety-nine schools, and 3,200 homes were "razed to the ground [or] badly damaged."

In early 1941, Mussolini had told his countrymen that "the hardships, suffering, and sacrifices that are faced with exemplary courage and dignity by the Italian people will have their day of compensation when all the enemy forces are crushed on the battlefields by the heroism of our soldiers." By August 1943, the rapid success of the Allied invasion of Sicily and the devastation of Milan and other northern cities had confirmed just the opposite. The *Regia Aeronautica*, the air force of the Kingdom of Italy, had proven feckless.* Allied bombing raids had exposed gaping holes in Italy's defenses. Civil preparations were laughable. Too few anti-aircraft batteries, a near-absence of radar warning, and air-raid sirens that sounded *after* casualties began arriving at the hospitals exposed shortcomings in Fascist organization. The great industrialist and Fiat heir, Gianni Agnelli, later observed that he had witnessed "public services in disarray, the responsible members of the [Fascist] Party incapable of establishing order amongst the rank and file."

* Mussolini was a pilot; both his sons, also pilots, served in the Regia Aeronautica.

In some instances, the ways of life in Italy undermined their own defense. The Italian inclination to ignore rules proved self-destructive when blackouts for air raids went unobserved. "RAF planes crossing the Alps were welcomed by the sight of Milan and Genoa fully illuminated. . . . Bologna houses were brightly lit and cars and bicycles drove with full lights." The inability—and, at times, unwillingness—of some Italians to defend themselves was evident even to a Royal Air Force navigator looking down on the very city his crew was bombing. Don Charlwood, an Australian with the mixed crew of the 103rd Squadron, based out of Elsham Wolds, England, described the macabre scene:

> Under the light of the moon the city [Turin] was mercilessly exposed— houses, churches, gardens, even statuary along the streets. The crews wheeled and dived, exulting as the Germans exulted over lightly-defended Britain in 1940. And yet, perhaps the minds of the attackers would have been easier if the Italians had attempted to defend their city. As it was, we blew women and children to pieces, unopposed by their men.

But the ghastly sight Charlwood described provided just one perspective. Many of the crews of these bombing missions had endured their own hell:

> Smaller [British RAF] forces attacked Turin and Genoa. During the second of these attacks, Flight Sergeant Aaron of No. 218 Squadron, flying a Stirling, was severely wounded in an encounter with a night fighter whose fire hit three out of the four engines, shattered the windscreen, put both turrets out of action and damaged the elevator cables. With his jaw smashed, part of his face torn away, a lung perforated and his right arm broken, the flight sergeant sat beside the bomb-aimer, who had taken over the controls and showed him by means of directions written with the left hand how to keep the crippled aircraft in the air. By so doing he brought it safely to Bone in North Africa, where, dying of his wounds, he was awarded the Victoria Cross for "an example of devotion to duty which has seldom been equaled and never surpassed."

The newspaper *Corriere della Sera* criticized these raids: "The frequent and intense bombing by the Anglo-American aviation on the Italian territory, with the subsequent destruction of the cities and the massacre of helpless population, goes way beyond the normal practice of war. For our enemies, it is no longer about the pursuing of military targets and to hit military objects. What do they want then? . . .Their purpose is obviously a terrorist one." Therein lay a question for another time, a question involving the efficacy—and morality—of "morale bombing" and the messy nature of war. For now, the only way for Italy to escape the horror of further bombing, moral or not, was to negotiate for peace.

ON AUGUST 21, 1943, *The New York Times* headlined the major war stories: from the Eastern Front: RED ARMY SLASHES DEEPER IN UKRAINE; from the Pacific: JAPANESE ABANDON RIDGES AT SALAMAUA; from the Mediterranean: AMERICAN FLEET TAKES ISLES OFF SICILY; and from Italy: FOGGIA BLASTED IN ITALY'S HEAVIEST RAID. The front page carried an article about a new "gasoline famine" in New York City; another reported the end of the blackout in Cairo, where, for the first time since the early part of the war, the city was "again brilliantly lighted." There was also a prescient report from a Western Union Telegraph Company vice president who stated that, "after the war, a method of beaming telegrams by light waves might make present-day wire transmission look as obsolete as the horse and buggy."

Buried on page nine was a small item about a press release issued by the U.S. State Department: U.S. GROUP IS NAMED TO SAVE EUROPE'S ART. The commission's official title comprised almost fifteen percent of the article's word count: American Commission for the Protection and Salvage of Artistic and Historic Monuments in Europe.* Named for its chairman, Justice of the Supreme Court Owen J. Roberts, the Roberts Commission included some of the nation's foremost cultural and political leaders: Francis Henry Taylor, Director of the Metropolitan Museum

* The word *Europe* in the commission's name later was changed to *War Areas*.

of Art; Paul Sachs, Associate Director of the Fogg Museum of Harvard; Archibald MacLeish, Librarian of Congress; Secretary of State Cordell Hull; Chief Justice of the Supreme Court Harlan F. Stone. The press release itself—State Department Release no. 348—proclaimed: "The Commission may be called upon to furnish museum officials and art historians to the General Staff of the Army, so that, so far as is consistent with military necessity, works of cultural value may be protected in countries occupied by the armies of the United Nations."

By the time the article was published, Allied forces had already bombed Rome twice and Milan six times. While American bombers had demonstrated their ability to avoid hitting Vatican property and the most recognizable monuments during both bombings of Rome, they had accidentally damaged an important church and killed thousands of innocent civilians. Herbert Matthews, veteran correspondent for *The New York Times* and no stranger to the destruction of war, attended the briefing before the July 19 mission. "No one there could point out anything for anyone," he later commented. "There was no mention whatsoever of San Lorenzo." Matthews believed that "San Lorenzo could have been saved along with the other buildings indicated had anyone on the staff been aware of its importance." His observation would prove prophetic.

The Allies were just weeks away from landing an invasion force of 189,000 troops on the Italian peninsula. Even with formal protection procedures, damage would be inevitable. Once troops arrived, who would be responsible for the protection of the richest concentration of cultural treasures in the world? The Roberts Commission seemed an unlikely savior. At that moment, it had yet to place even a single "specialist in planning for [the] protection of historic monuments" among the invasion force.

4

THE EXPERIMENT BEGINS

JULY–SEPTEMBER 1943

Although the announcement of the Roberts Commission took place just days after the near-destruction of *The Last Supper*, President Roosevelt had, in fact, signed the order establishing the group two months earlier, in June 1943. Aware that the commission would not be operational before the invasion of Sicily, Roosevelt suggested that the army assign an "Adviser on Fine Arts and Monuments" as a stopgap measure. The first candidate, Metropolitan Museum of Art Director Francis Henry Taylor, failed the physical for being overweight. John Walker, Chief Curator of the National Gallery of Art and former Professor of Fine Arts at the American Academy in Rome, suggested a friend and colleague already in the military: Captain Mason Hammond.

A Bostonian by birth, Mason Hammond had a youthful appearance and preppy face that belied his forty years. He had had a brilliant academic career, studying at Oxford as a Rhodes Scholar before joining the faculty of his alma mater, Harvard, in 1928. He taught Classical Studies at the American Academy in Rome from 1937 to 1939, during the height of Mussolini's dictatorship. After his stint in Rome, he returned to Harvard and resumed his position as Professor of Classics. In 1942, Ham-

mond joined the Army Air Force, working in the Intelligence Branch at the Pentagon before becoming Adviser on Fine Arts and Monuments. "My qualifications were not in art or art history, but at least I knew some Italian and was somewhat familiar with ancient art and architecture." But this assignment came at a considerable sacrifice; he had to leave behind his wife and two daughters to serve overseas.

Hammond knew some of the men who had developed the idea of creating cultural-preservation officers during war, including George Stout, a colleague at Harvard who had become a pioneer in the conservation of works of art. Stout spent World War I as an army private stationed at a hospital unit in Europe, then returned home to attend the University of Iowa, where he studied drawing. After saving his earnings for five years, Stout returned to Europe and toured the great cultural centers of civilization. By then, he was hooked. His calm, methodical, and studious personality equipped him perfectly for the science of art conservation.

Stout possessed a rare combination of visionary and patient thinking merged with the know-how and discipline to get things done. During the Spanish Civil War, Stout studied and recorded the impact of new innovations in bombing on the preservation of art—none with more far-reaching implications than the development of incendiary bombs and their consequent fires. He also maintained contact with friends in the German museum community, who wrote him about the Nazis' removal of some museum directors and curators—and art they judged "degenerate"—from German institutions during the late 1930s.

After Japan's surprise attack on Pearl Harbor in December 1941, Stout took the initiative to write a field manual on the protection of works of art during armed conflict. This pamphlet incorporated his many insights from years of analysis. Stout believed it was only a matter of time before the course of the war turned and American boys would again be back in Europe fighting their way to Berlin. This time, however, the stakes would be much higher than in World War I; developments in the technology of warfare threatened to destroy much of the

heritage of Western civilization. To prepare America's soldiers, Stout worked closely with Paul Sachs, founder of Harvard's Museum Studies course, to pitch his idea for what would become known as "Monuments officers" to the War Department. By the summer of 1943, Stout's efforts had led to the creation of the Roberts Commission—and, indirectly, the transfer of Mason Hammond, Professor of Classics, to the war zone.* After the call went out, more than two hundred men volunteered, most with exactly the expertise needed, hoping to be transferred to the new "program" being endorsed by the War Department.

The urgency of getting Hammond in theater required the army to fly him to his first destination, Allied Force Headquarters in Algiers, rather than send him by ship. Although initially called an "adviser," Mason Hammond was, in fact, the first Monuments Man. He reported for duty on June 7, only to discover that "the assignment for which I was destined was not concerned with the Monuments of North Africa. It has, therefore, proved impossible as yet to make any inspection of these, chiefly because of the difficulty of securing transport." That single issue—transport, as in "lack thereof"—proved the most consistently vexing challenge the Monuments Men would confront.

In one of his first letters from North Africa to Samuel Reber, a friend working in the army's Civil Affairs Section in Washington, DC, Hammond went as far as he ever would in expressing his frustration: "It is unfortunate that they did not give me more explicit information as to the job [while] in Washington, as they sent me out in a great hurry. . . . I doubt if there is need for any large specialist staff for this work, since it is at best a luxury and the military will not look kindly on a lot of art experts running round trying to tell them what not to hit."

Hammond's letter didn't mention how frustrating it was to work within an organization as slow moving and at times inflexible as the United States Army. While he knew quite a lot about Italian art, Ham-

* Stout would also be in harm's way as the de facto leader of the Monuments Men attached to the Western Allied forces in northern Europe.

mond wasn't an expert on the monuments of Sicily. Knowing that the army expected him to be fully prepared, on just a few weeks' notice, he tried to learn what he could. But the army had placed the public library in Algiers off-limits, fearing that his appearance there would somehow reveal their invasion plans for Sicily. Even after Sicily was in Allied hands, Hammond could only find one volume of the three-volume set, *Italian Touring Club Guide for Italy*, which had been captured in Libya.

The lists of important monuments and churches in Sicily and maps showing their locations weren't available because Paul Sachs and the team working at the Frick Art Reference Library in New York City had yet to finish them. Hammond departed with the hope that the needed reference materials would be provided after he arrived in Sicily. Only then did the true picture begin to emerge: he would be expected to do his job, still largely undefined, without transportation or staff support. For the foreseeable future, Captain Mason Hammond, the first Monuments officer in the United States Army, was on his own.

PERHAPS THE ONLY experience more frustrating than not being *prepared* for his assignment in Sicily was not *being* in Sicily. Not until July 28, almost three weeks after the Allied invasion began, did Hammond finally reach Italy's largest region and island. When he landed in the ancient town of Syracuse, the professor of classics and student of the humanities felt he had, in a sense, returned home. He spent the first few months working with municipal officials in each town he could reach. In some settlements he discovered that local museum employees had walked off the job for lack of income. Hammond worked through the problem with the Civil Affairs Finance Section of Allied Military Government to get funds flowing to municipal officials. Only then would the knowledgeable workers be able to feed their families and return to work to help with temporary repairs and protective efforts.

Hammond had pathetically few tools to do his job: a desk, a chair, and the use—as he put it—of the "ancient" portable typewriter he'd

brought with him from the States. His job, assessing damage to churches and other monuments in the island's smaller towns, depended on transportation, which he had no hope of getting from the army. Thus began a series of independent efforts by Hammond to secure a vehicle, a pattern that would be repeated by virtually all Monuments officers who came after him. His British counterpart, Monuments officer Captain Frederick H. J. Maxse, who arrived in early September, nearly six weeks late, described one of Hammond's early field demonstrations on the art of improvisation. Using "methods too devious to bear the cold light of print," Hammond found a car that would assume legendary status in his reports, a "small and decrepit" Balilla. Not without a sense of humor, they named it "Hammond's Peril."

An amusing story accompanied each subsequent addition to their expanding motor pool. A Lancia, "model about 1927, of stately elegance and abundant room, was requisitioned for Advisers. However, the owner showed such an attachment to this Ancient Monument, and the question of maintenance was so problematical, that the Advisers felt that their official position required its return for conservation before it suffered 'war damage.'" As Hammond and Maxse wryly observed about their fleet of vehicles, "None of these has endured and the Advisers ended their career as they began, on their feet."

Despite these and other frustrating experiences—Hammond had only learned about the creation of the Roberts Commission by reading a clipping from *The New York Times*—his odyssey in Sicily as the first official Adviser on Fine Arts and Monuments affirmed the concept envisioned by George Stout, embraced by Paul Sachs, and endorsed by President Roosevelt. Hammond assessed damage to monuments, effected temporary repairs where possible, got superintendents and other local museum and church officials back to work, and cut down on billeting problems by well-intended troops seeking shelter. His work in the field proved the job could be done.

Serving as the guinea pig for the Monuments officers became Hammond's enduring legacy. Each miscue provided invaluable informa-

tion about what to do differently once Allied forces reached the Italian mainland and began the push northward. Hammond's acute skills as an observer not just of the process but of people—the local population and Italian officials, his fellow officers, and the average GI—and his ability to articulate the improvements that would be required in the months ahead, would ease the burdens of each Monuments officer who followed.

The most significant monuments of Sicily largely survived the Allied invasion and subsequent battles. Considerable bombing and occupational damage occurred in Palermo, but the raids claimed a far greater toll on the Baroque (and, by consequence, more delicate) churches of Palermo than those built hundreds of years earlier. The Cathedral of Messina lost its roof, but at least it wasn't the original, which had already been rebuilt in 1908 after a devastating earthquake. Sicilians naturally lamented damage to even a single church, but Hammond and the other Monuments officers knew it could have been so much worse.

The battle for Sicily paled in comparison to the potential carnage that would accompany an Allied invasion of Western Europe, as Hammond explained in a September letter to his wife:

> One has the ever present spectacle of a ruined city and one multiplies it by so many cities in Europe and it seems as though the task of reconstruction would never be done. And the loss of works of art is irreplaceable—beautiful churches gutted, archives buried under rubble, libraries exposed to weather and theft. . . . this work seems so much more important and so hopelessly immense. And singlehandedly I feel like the seven maids with seven brooms even in my little corner. . . . it would certainly help us if the rest of the country would give in without a battle.

BY AUGUST 17, after thirty-eight days of continuous fighting, the Allies claimed victory in Sicily, bringing the war to the Reich's back door. Most of the German forces had by then evaded capture, having crossed the

Strait of Messina onto the Italian mainland. Even while Marshal Badoglio reiterated Italy's ongoing commitment to Nazi Germany, his emissaries secretly engaged the Allies in surrender discussions being held in Portugal. But Hitler, following his earliest instincts that it was only a matter of time before Italy double-crossed its ally, ignored Badoglio's reassurances and began increasing the German military presence in Italy.

Allied forces commenced Operation Baytown on September 3 and started landing troops in Calabria, their first foothold on the European continent. That same day, while Badoglio's representatives were signing an armistice agreement with General Eisenhower's commanders in Sicily, Hitler's envoy, Rudolf Rahn, was meeting with Badoglio in Rome, listening to the Italian leader's words of assurance. The Allies embargoed news of the surrender for five days to coincide with Operation Avalanche—the landing of the main invasion force at Salerno.

On September 8, Rahn, still in Rome, attended a brief late-morning audience with the king, who promised that Italy would "continue the struggle, to the end, at the side of Germany, with whom Italy is bound in life and death." The pretense ended abruptly at 6:30 p.m. Mindful of the fifty-five thousand Allied troops just hours away from hitting the Salerno beaches, and still fuming over the message he had received from Badoglio earlier in the day attempting to *renounce* the surrender agreement, General Eisenhower made an announcement over Radio Algiers: "The Italian government has surrendered its armed forces unconditionally." Left with no alternative, Badoglio confirmed the news by making his own radio announcement shortly afterward. Many Italian soldiers "threw their weapons away," one German officer wrote in his diary, "and showed their joy that the war was now over for them." In the dark early morning hours, fearing for their lives, the king, Badoglio, and others fled Rome for the remote Adriatic town of Brindisi, leaving Italian troops leaderless and, worse, without orders.

German forces seized control of Rome on September 10, meeting only token Italian resistance. Within twenty-four hours, Generalfeldmarschall Kesselring placed all Italian territory under German military

control. The pope had instructed the commander of his Swiss Guard that under no circumstances were they to resist should German troops violate the neutrality of Vatican City. But would German forces really usurp the pope's authority in the capital of the Catholic world?

The feared moment soon arrived—first the sound of boots marching in unison across the cobblestone streets, growing louder and louder, followed by the appearance of heavily armed Wehrmacht troops. As they approached St. Peter's Square and Bernini's imposing colonnades, however, the marching came to a halt. The Germans posted guards but proceeded no farther.*

On September 12, Hitler received dramatic news. SS paratroopers had executed a daring raid at a ski resort on the Gran Sasso mountain in central Italy to free Mussolini from guards holding him on orders from Badoglio. "Duce, the Führer has sent me to set you free," exclaimed the leader of the mission, SS Captain Otto Skorzeny. Relieved, Mussolini replied, "I knew my friend Adolf Hitler would not abandon me." Forty-eight hours later, a haggard Mussolini arrived at the Rastenburg airfield. Standing by to greet him were his rescuer, Adolf Hitler, and his "keeper," SS General Karl Wolff, newly appointed "Supreme Leader of all SS Troops and Police in Italy." Hitler informed the Duce that he would form a new Nazi-backed Fascist state—the Italian Social Republic—later referred to as the Salò Republic, named for its de facto capital on Lake Garda, near the northern town of Salò.† Mussolini would be the titular head, but in truth Hitler and his designees—SS General Wolff and Rudolf Rahn—would be running the new government.

Wolff had returned to Hitler's headquarters on September 14 to

*Later in 1943, at the urging of Gestapo Chief SS Lieutenant Colonel Herbert Kappler, a white line was painted across St. Peter's Square, indicating for German troops the boundary of neutral Vatican City. However, others believed it served as a reminder to occupants of the Vatican that they were prisoners.

†This is an imprecise reference. Salò was one of several northern Italian towns serving as headquarters for various government offices. Salò did, however, house the Ministry of Foreign Affairs.

receive further orders from the Führer. Hitler wanted Wolff, in addition to his previously assigned responsibilities, to provide round-the-clock protection for Mussolini. "You vouch for the Duce," Hitler told him. Never again should he be placed in such jeopardy. "A command of selected SS officers is never to leave him out of sight." This seemed straightforward; the second part of his assignment was not.

"I now have a special order for you, Wolff, which I needed to present to you personally, because of its international importance. I am making it your duty to not talk to anyone about it, except the Reichsführer SS [Himmler], who I have already informed, until I specifically allow you to do so. Do you understand me?" "Yes, my Führer!" replied Wolff.

"As soon as possible I want you and your troops to occupy the Vatican and Vatican City, as part of the German counter measures against this unspeakable 'Badoglio treachery,' secure the Vatican's archives and art treasures, which have a unique value, and escort the Pope (Pius XII) together with the Curia up North 'for their protection,' so that they cannot fall into the hands of the Allies and under their political influence. Depending on military and political developments I will determine whether to accommodate him in Germany or in neutral Liechtenstein."

"There will be quite an uproar worldwide," admitted the Führer, "but it will calm down. This will be quite a harvest. . . ." "How long might it take you to carry out this mission?" asked the Führer.

Himmler had briefed Wolff on his assignment before the meeting, but hearing Hitler describe his intentions shocked the SS general. He scrambled to think of a response, one that would appear credible while buying time. "I am quite frankly not sure, my Führer. Most of my SS and Police troops have still not arrived. At the moment I am trying to recruit voluntary forces from within the population of South Tyrol and the remaining Italian Fascists to strengthen our troops, but even with greatest attention this takes all my time." Wolff then explained that such an operation would require locating experts fluent in Latin and Greek to assist in the analysis of the Vatican's immense archives. Wolff estimated he would need about six weeks. "This seems too long a time for me!"

exclaimed the Führer. "I would prefer to deal with the Vatican immediately and clear it out." But after a few tense moments, Hitler seemed resigned to waiting and added, "If one wants a first class result, one cannot expect it to take place overnight."

ON OCTOBER 1, 1943, German radio announced: "The U.S. President of the European Monuments and Art Treasures Committee, an organisation consisting of thieves and Jews, said in a statement to the Press that a large number of maps are being distributed to U.S. soldiers to enable them to trace artistic treasures easily. A well-known gangster has been appointed as Director of the Committee."

Nazi propaganda specialists characterized the intent of the Roberts Commission, and the work of the Monuments officers, as a premeditated looting operation. Fourteen days later, Radio Rome provided an update: "The first ships left Sicily for London today with precious works of art, some of which will go to the British Museum and some to private collections." These two radio addresses marked the opening salvo in the battle for public opinion in Italy. The Americans had no immediate response. For months, Europeans would hear only the German and Italian side of the story, breeding fear and suspicion of Anglo-Americans claiming to be interested in protecting their art.

5

GROWING PAINS

On September 25, Deane Keller received orders to report for active duty at Fort Myer, Virginia. From there he hoped to report to the army's School of Military Government in North Africa as part of the unit being formed to protect monuments and works of art. While getting to Italy still seemed a far-flung dream, at least his journey had begun.

Being in the army thrilled Keller. Between the draft and enlistments, the war had claimed most of the students from his classroom, taking much of the joy out of teaching. There would be hardships, of course. He told himself he wouldn't miss having a car, and he made peace being without his drawing studio; these were adjustments he could make. Besides, with pencil and paper, he could draw anywhere. But making arrangements for his army pay to be sent to his wife, Kathy, somehow made the situation all too real. He fought the anxiety by writing letters—lots of letters—to his sisters, to his parents, but mostly to Kathy and their three-year-old son. Letters back and forth became his lifeline, as they did for many new soldiers.

Deane's father sent him intellectual letters that discussed his politi-

Nazi German propaganda aimed at Italians depicted American soldiers as barbarians intent on removing the country's works of art. In this example, an American soldier, portrayed as a black gorilla, is stealing the Venus de Milo. *The Allies also employed propaganda, in this instance suggesting that the Germans would inflict on Rome the destruction they had wrought on other European cities. [Left: Massimo & Sonia Cirulli Archive, New York. Below: The Ohio State University Billy Ireland Cartoon Library & Museum]*

cal views on the war. But those with his mother's soft touch and tender understanding helped sustain him. She wrote to him on October 7, acknowledging that his military service "is a big sacrifice for you, but I am thankful you can see beyond that to realize the great need for good men to help. I believe you will never regret it for your own sake and the sake of Dino. He says proudly now—'My Daddy's a sojer.' I don't know who told him that—but I suppose he saw you in that first uniform."

Keller felt disheartened that Kathy and Dino were now living in Hartford with her family, having decided to lease their home at 133 Armory Street in New Haven for the duration of the war. This was a practical move driven by the nationwide housing shortage, but it underscored how much upheaval the Kellers, like millions of other military families, experienced because of the war.

After a month of waiting, orders finally arrived. On November 2, Keller boarded a Liberty ship bound for North Africa. Like his shipmates, many of whom were young GIs headed into combat, Keller felt proud, excited, and scared. Twenty-two days aboard the ship, with its "prisoner rations & tight quarters," inspired camaraderie among the men, but all sensed the dangers ahead. "The convoy arrived [in Oran, Algeria] with only one incident—a sub. chased one of the ships for two hours." Being off the ship felt like a reward. On Thanksgiving Day, Keller ate his dinner out of a mess kit in an open barracks with a dirt floor, and he informed his wife that "we are in North Africa. . . . am living as a soldier (imagine me) in a tent, shaving in the open . . . and washing in my steel helmet."

Keller spent the first week at a replacement depot near Oran; then he took a train to Algiers for a one-night hotel stay in the capital city—also the site of Allied Force Headquarters. There he presented a card marked SECRET to a lieutenant who ordered him to report to the remotely located Military Government School in the desolate hillside town of Tizi Ouzou. On December 2, after finally reaching his destination, some sixty miles from Algiers, Keller began a two-month course focused on the cultural history of Italy and its modern-day governmental structure.

———

AT TIZI OUZOU, Keller joined an international gathering of art experts. Since May 1943, small groups of officers had been arriving for Civil Affairs Training School. "From the beginning of the conquest of Sicily we had been engaged in a new type of task, that of providing government for a conquered population," General Eisenhower later explained. "Specially trained 'civil affairs officers,' some American, some British, accompanied the assault forces and continuously pushed forward to take over from combat troops the essential task of controlling the civil population." These officers specialized in areas of public health, transportation, agriculture, finance, law, public relations, and, in the case of the Monuments Men, the arts.

Even before he exchanged his bow tie and flowing cape for a military uniform, Tubby Sizer's walrus mustache made it easy to pick him out of a crowd. Prior to his commission in the army, Tubby had lectured at Yale as a professor of Art History. Famous for his enthusiastic presentations, and prone to wandering the stage lost in his delivery, Sizer had survived at least one fall from the podium while addressing his students. More recently, he had served as Director of the Yale University Art Gallery. His background was filled with incongruities, none greater than a five-foot, ten-inch man weighing a slight 150 pounds being called "Tubby." Childhood nicknames die hard. Although a professor at Yale, he had graduated cum laude from Harvard, class of 1915. Tubby ultimately chose a life of public service and academia, but not before spending several years trying to make a buck in the import export business.

The Roberts Commission was putting ever-greater pressure on Paul Sachs to submit names of candidates for Monuments service. Sizer had had military experience as a first lieutenant in the army during World War I and had held a commission since 1942 as a major in Army Air Force Intelligence—despite, as he put it, "misconceptions of my military prowess and oblivious to my age." A new kind of war had begun, one that required precise rather than wholesale destruction. It was Sachs's job to identify the soldiers to fight it. Tubby Sizer had been an obvious choice.

Sachs had another great prospect in Norman Newton, one of the nation's most accomplished landscape architects. Newton's teaching career at Harvard's Graduate School of Design, which began in 1939, brought him into contact with Sachs. Newton had been an aviation cadet in the U.S. Marine Corps Reserve in 1918. While that experience seemed far removed from combat, his familiarity with the ways of the military made him a more valuable candidate than many others being considered. Sachs knew that Newton had spent three years at the American Academy in Rome (from 1923 to 1926) as a Rome Prize recipient. In addition to owning a private landscaping company, Newton had also been the resident landscape architect for the northeastern region of the National Park Service during the 1930s, working on various projects that included a redesign of the Statue of Liberty grounds.

In early September 1943, Sizer and Newton began eight weeks of Civil Affairs training at the Military Government School in Tizi Ouzou, an experience Sizer characterized as "extremely restive." The fifty-one-year-old Sizer enjoyed the humor of the situation. In a letter to Emerson Tuttle, a colleague at the Yale University Art Gallery, he wrote, "You would laugh if you could see a lot of elderly men being put through the paces by young 2nd Lieutenants of foreign extraction."

British Monuments officer Edward "Teddy" Croft-Murray, Assistant Keeper of Prints and Drawings at the British Museum in London, and his good friend Lionel Fielden, the father of radio broadcasting in India and an executive at the BBC, arrived in Algiers in early November. Upon receiving orders to report to Tizi Ouzou, Fielden asked his friend, "What on Earth is Tizi-Ouzou?" Teddy replied, "Awful I think. Some sort of school. Nobody knows how long we stay there. I'm going to get out of it if I can."

Neither man had any way of actually getting to the appointed destination. After stopping by Allied Force Headquarters to plead for the intervention of a duty officer and friend, the two men bumped into Lieutenant Colonel Sir Leonard Woolley, who was himself desperate to get to recently liberated Naples to make an inspection tour. Despite

his rank and title, "Archaeological Adviser to the War Office," Woolley couldn't get to Italy. "Deplorable lack of organization! Here I am with all the necessary papers, and the Home authorities wanting me back, and day after day I come to this office and there's no transport!"

As the reality of the situation sank in—there was no "getting out of" Tizi Ouzou—a few minutes of conversation with the duty officer revealed a new problem: the army's "Priority" system. Fielden explained: "Priority I was reserved for VIP—Very Important People—and got you anywhere. Priority II was for generals and such, and ensured you a moderately quick passage, provided that transport was available. Priority III was for lesser but still urgently needed fry; we might have got it if somebody had urgently needed us, but they seldom did. All other Priorities were scarcely worth having."

After explaining that Woolley was a world-famous archaeologist and head of Great Britain's efforts to protect cultural treasures, the duty officer replied, "Well, well, we know nothing about him here, you know. Perhaps he should have Priority II? I have only given him [Priority] III, which means he'll never get there."

Days later, Fielden and Croft-Murray reached Tizi Ouzou after sitting on the floor of a troop carrier for the long, cold, and very bumpy ride. The school, such as it was, consisted of clusters of half-finished buildings without doors or windows, each of which had been named after an Allied city, including "London," "Manchester," and "Washington." According to Fielden, buildings "were filled to more than overflowing with four hundred elderly officers, of whom three hundred and fifty, at the time of our arrival, were American. . . . a less military-looking lot can hardly ever have been seen."

BY THE TIME Keller arrived at Tizi Ouzou, Fielden and Croft-Murray had completed their training and departed. So, too, had Sizer and Newton. On December 12, he wrote his parents to report he was in good health, giving the same type of lectures to both American and British officers

that he had delivered at Yale. He also kept up his drawing, sending sketches of the locals to his friends. "I have fired a carbine, .45 revolver, and a Tommy gun, doing best with the latter. Got 9 out of 10 shots on in bursts and all three single shots inside the inside ring. Talk about a new experience." He told them that the presence of a small group of men he had taught at Yale had made him "feel a little less like a lost sheep" in his new surroundings.

The first Christmas without his family hit Keller hard. "Dearest Kathy. . . . As I write, you will be through breakfast and will have opened the stockings. I can imagine Deane worrying the string and paper on his parcels and the look of anticipation on his face. What did you get for him?" As hard as he tried to create a sense of normalcy, Keller couldn't ignore reality. "Still, I talked to a British GI this morning, who was spending his fifth Christmas away from home. And when you think of the boys up on the front you withdraw all kicks and private feelings. . . . Theirs can't be a happy Christmas."

As it had for Croft-Murray, Woolley, and many others at Tizi Ouzou, disillusionment set in for Keller after just five weeks. Keller wanted to put his knowledge and experience to work, not sit around at a place he took to calling "Toozy Woozy." "I hear there is a lot to do in Italy and I hope the day comes soon for that," he wrote Kathy. "I have great faith in this work, others to the contrary, and I want my chance."

6

A NEW ORDER

DECEMBER 1943

The Allied Army's process of delivering Monuments officers to the war zone *after* combat operations commenced made "protection" work impossible. Mason Hammond and the handful of officers who finally disembarked in Sicily weeks after the invasion spent their time largely on salvage operations. Sicily had hundreds of buildings needing attention. There were too many monuments and too few Monuments Men. Events on the ground prevented them from solving the problems of transportation, staff, and supplies. They wrote reports—lots of reports—explaining the situation and their needs, but no one in authority in Washington initially paid any attention. As Hammond humorously observed, "Military channels are like a tunnel (I won't say sewer)—you put stuff in one end but most of the time you never know where or when it comes out."

In late November, just a few weeks into his assignment in Palermo, Tubby Sizer gleaned a sampling of what Mason Hammond had dealt with for months:

It's a curious city of poverty & plenty, breadlines & marvelous pastry cakes, telephone wires strung by the Signal Corps on the heads & outstretched arms

of marble saints, mounds of uncleared rubble in alleys, bombed Baroque churches, hot roasted chestnuts, walnuts, almonds & oranges, salvage dumps & hospitals, blackouts & bomb shelters. The things which effect [sic] life most are the lack of glass—most windows were shattered, shortage of water (I have to fill my helmet & wash in it morning & night), constant G.I. food (all restaurants are off bounds) & the cold (one is never quite warm).

Experiencing the situation firsthand left Sizer in awe of Hammond's accomplishments in Sicily. Within a few days of landing, he observed, "Everything worthwhile has been already magnificently accomplished by Mason Hammond." (Still hoping to cross paths with Deane Keller, he added, "No Keller as yet.") By early December, however, Hammond's ordeal had taken its toll. After ignoring his health all summer long, Hammond grew so ill he finally had to admit himself to a hospital in Palermo. Sizer wrote their mutual friend, Paul Sachs, to share the distressing news: "M.H. [Hammond] literally worked himself to death & has been in the hospital the past 10 days—out soon." Besides exhaustion, Hammond also suffered from severe dysentery.

Hammond attributed his health problem to "the mess at Syracuse [Siracusa], where the flies had feasted equally with the humans on the food that was served." Two very miserable weeks later, the hospital discharged him. Nevertheless, Hammond remained in good spirits. "He ran into a WAC [Women's Army Corps] officer who studied archaeology," Sizer wrote Sachs, "found she was a mess officer, took her & all the cooks sight seeing & has had a deep dish apple pie every other day in consequence." Sizer added one other comment: "Mason Hammond has done the longest—& best job."

MUCH TO THE surprise of the earliest-arriving Monuments Men, changes in the late fall of 1943 bolstered their authority and improved their effectiveness. A new organization, known as the Allied Control Commission (ACC), divided Italy into regions (Region I, Sicily; Region II, Southern

Italy; Region III, Naples; and so on), then ordered Civil Affairs staffs, including Monuments officers, to each region. While some Monuments officers would be working out of MFAA Headquarters, others would be directly attached to the Military Governments of U.S. Fifth and British Eighth Armies in the field. This change in structure broke the logjam at Tizi Ouzou and resulted in a sudden influx of Monuments Men in the combat areas.

By early December, the number of Monuments officers in Sicily increased from the initial army of one—Mason Hammond—to include Fred Maxse, Tubby Sizer, Norman Newton, Lieutenant Perry Cott, Major Bancel LaFarge, as well as British officers Major Paul Baillie Reynolds and Captain Teddy Croft-Murray. Their request for staff support had also been heard. Three enlisted men received orders to report to work as clerks: Sergeant Nicholas Defino, Corporal D. Pascale, and Sergeant Bernard Peebles. Additional officers completing their training at Tizi Ouzou would soon arrive.

During these structural changes, the Monuments operation received a new name, which surprised Mason Hammond more than anyone. "I was told in Sicily that my Boston accent made [Fine Arts and Monuments] sound to our British Colleagues like 'Finance and Monuments,' so the name was changed to 'Monuments, Fine Arts, and Archives,'" or MFAA.

Other changes were afoot. British Professor Solomon "Solly" Zuckerman, head of the RAF Special Air Mission, under orders from the Commander-in-Chief of the North African Air Force, British Air Chief Marshal Sir Arthur Tedder, requested preliminary lists of cities of exceptional cultural significance that should be balanced against military objectives in future operational planning. This signaled a sea change in the existing procedure. Now the Monuments officers enjoyed direct communication with Army Air Command. No one wanted another embarrassing incident, such as the recent bombing of Pompeii. The Allies had flown at least eleven missions, dropping 156 bombs on suspected German command posts around the ancient archaeological site. This accomplished little beyond killing Pompeii's dead, again and again.

The southern portion of the site lay in rubble; the Pompeii Antiquarium was "half demolished" with "serious losses to the collection." Adding irony to insult, the date of the first Allied raid—August 24—marked the 1,864th anniversary of the devastating eruption of Mount Vesuvius.

Monuments officer Fred Maxse learned that Zuckerman requested revised lists because the original submission didn't plainly indicate the priority of importance of each site. This was exactly the kind of engagement and feedback the Monuments Men had been seeking. It marked the first time someone within Army Command had expressed interest in their expertise. Zuckerman was anything but subtle in his parsing of targets: "If the whole of Italy had to be destroyed except one city, which city would you choose? If two cities were allowed to remain, which would they be? etc."

On December 8, Maxse, Sizer, and Baillie Reynolds submitted the revised list, containing the names of forty-six Italian cities plus three on the Dalmatian coast, to Zuckerman. Beyond satisfied, Zuckerman expressed his hope that future operations would be coordinated through the Monuments officers. By this time, the Monuments Men had submitted more than five months of reports to Washington and sent numerous letters to associates back in the States, all pleading for someone in authority to consider their proposed changes. Their effort had finally paid off—and not a moment too soon, given the reports coming out of Naples.

Major Paul Gardner was the first Monuments officer to arrive in Naples. Gardner withdrew from Massachusetts Institute of Technology to serve in the U.S. Army during World War I. Upon his return, he spent nine years as a ballet dancer and co-owner of a dance school. Only then did he resume his studies. A man of varied interests, Gardner later enrolled at Harvard Graduate School, where he attended Paul Sachs's Museum Studies program. In 1932, while still a graduate student, he accepted a position as assistant at the new William Rockhill Nelson Gallery and Mary Atkins Museum of Fine Arts in Kansas City, Missouri, to help oversee incoming shipments to the collection. His Harvard pedi-

gree made him quite a catch; the following year, he became the museum's first director.

To his surprise, Gardner received orders to report to Ischia, a mountainous volcanic island in the Gulf of Naples with a relatively small population and even fewer monuments. While Allied forces battled to liberate Naples, Italy's third most populous city, Gardner had little more to do than count the island's thermal spas. From his perspective, the Monuments, Fine Art, and Archives operation seemed to be getting worse, not better.

Gardner didn't reach Naples, one of the most-bombed cities in Italy during the war, until October 19. The city lay in ruins, part of the cost of gaining a foothold on the mainland and access to Naples's excellent port facilities. In an effort to deny the Allies use of the port, German forces sank every vessel in the harbor. What the enemy hadn't willfully gutted, Allied bombing had smashed. Every essential utility had been damaged or destroyed, including oil refineries, steelworks, sewer lines, the telephone exchange, the city's electrical generators, and, of most immediate concern, the main aqueduct. An absence of running water and shortage of food placed an additional burden on Allied troops, now responsible for feeding the city's hundreds of thousands of citizens.

Italy's change in allegiance had been a bitter blow to German soldiers, especially those who later fought and survived the battle for Naples. They had lost comrades during the fight. Scathing remarks from Berlin about the "Badoglio treachery" fueled their sense of betrayal. The resulting anger claimed a prominent and innocent victim: the University of Naples. Founded in the year 1224, the institution boasted Thomas Aquinas and many other legendary scholars among its former faculty. The school's rector, Dr. Adolfo Omodeo, described the events of September 12:

> Some German patrolmen [came] upon two poor Italian sailors just outside
> our gate; they stripped them of their uniforms and beat them up. One of

them showed fright; and it was decided to shoot him on the spot so as to have a pretext to rage against the university buildings. The Germans ran through the neighboring houses, hounded their dwellers down and compelled them to look on, kneeling, while the cruel execution was performed. By gun fire from their armoured cars, they burst our gates open, and on entering they started by wrecking the inscriptions on which the university had recorded the names of its dead in the first world war; they then poured torrents of petrol everywhere . . . and, when the lecture rooms burned as pyres, they went off dragging away the unhappy hostages with them to a neighbouring borough where on the next day, the fourteen carabinieri were shot whose crime had been to resist the destruction of the central telephone station. . . . No haphazard incident; no irresistible outbreak of war fury, but rather a careful plan, drawn up with icy perversity, scarcely camouflaged by a crime entailing the shooting of a guiltless sailor.

Gardner could do very little to help the university, but the experience served as added incentive for the Monuments Men to protect the surviving buildings—not only from the Germans but also from well-intentioned Allied troops. Most of these young men, especially the Americans, had never traveled outside their home countries; many hadn't ventured far from their homes or farms. Achieving "personal immortality" by inscribing their names on an ancient building or picking up artifacts as souvenirs was a constant temptation. As Tubby Sizer noted, "a locked door is an irresistible challenge to an American GI."

Upon learning that the Museo Nazionale had been requisitioned for use as a medical depot, Gardner wrote a sobering report. After explaining the importance of the museum's collection, Gardner noted: "The continued requisitioning and pillage of historical monuments in Naples is furnishing just the type of propaganda that the Germans and Fascists use with telling effect."

Despite the successful launch of Monuments work in Sicily and Naples, the Monuments officers still had no command authority other than to observe and report. They didn't even have a patch to identify

them or their assignment. They could post OFF-LIMITS signs on historic and cultural structures, but since no one other than a few Civil Affairs officers knew who or what a Monuments officer was, most troops ignored them. After all, it is very hard to order a dirty, dog-tired, frustrated field commander, much less a GI, lucky enough to have found a building with an intact roof and some form of running water, to vacate the premises and bunk elsewhere just because some old structure might be important to an art historian. Five hundred miles and countless towns and villages separated Naples from Italy's northern border; this was only the beginning of the struggle.

THE BILLETING PROBLEMS in Naples highlighted another recurring issue. Without higher rank, or endorsement of their mission by senior Allied military leaders, the Monuments officers did not have authority to give orders. Members of the Roberts Commission issued appeals to the staff of General Eisenhower. Army Chief of Staff General George C. Marshall had already cabled Ike on October 14, stating: "Protection of artistic and historic monuments in Italy is a subject of great concern to many institutions and societies." Accounts of Allied soldiers living in some of Naples's most famous cultural monuments, treating them like saloons, were not what the Chief of Staff had in mind. That General Marshall would make a point of stating something so obvious underscored its importance and served as a reminder for Ike to proceed very carefully. A great many people on all sides were watching; mistakes would be very costly.

 In late November, British Monuments Adviser Lieutenant Colonel Sir Leonard Woolley, who finally secured Priority transport from Tizi Ouzou to Italy, made an inspection of Palermo and Naples amid horrific reports of damage and, of more immediate concern, looting and inadvertent destruction by Allied soldiers. At sixty-three, Woolley had long since established himself as one of the world's leading archaeologists, but since 1941 he also had become a respected staff member at the British War Office. On three separate occasions in 1943, Woolley met with

Prime Minister Churchill concerning his work on cultural property. He returned to Allied Force Headquarters in Algiers in early December to inform General Eisenhower's staff about the damage being done to monuments by Allied troops in Naples. "I suggest . . . a General Order to the effect that no buildings registered as a historic monument in the short lists printed in the Zone Handbook may be used for military purposes without the special permission of a C in C."

Just a week later, Assistant Secretary of War John McCloy weighed in with a memorandum to Eisenhower summarizing observations from a recent inspection tour he had made of Sicily and Naples. His memo addressed the very issues raised by Woolley, noting the "unnecessary use" of historic monuments by troops.

> *Crimes are being committed in the name of military necessity that I think could be avoided by some pronouncement from you. . . . We have been running many articles in the States as to the good work the Armies in Italy are doing toward respecting the great monuments of Italy, but I was a bit shocked at the way the thing was operating in Naples itself. . . . Could not some expeditious method be setup whereby the military government people [Monuments officers] could have authority to veto the use of the great monuments for billeting unless overruled by the Commanding General? Now they have to yield in practically every instance.*

The cumulative weight and momentum of General Marshall's mid-October admonition about the importance of protecting Italy's cultural treasures, followed by successive warnings from McCloy and Woolley and the reports of Monuments officers themselves, finally produced a change. On December 29, General Eisenhower issued a directive that placed the responsibility of protecting cultural property squarely upon the shoulders of *every* commander and, in turn, *every* officer and *every* soldier. It also, for the first time, introduced the Monuments officers (referenced as "A.M.G. officers"—Allied Military Government) to everyone in uniform.

To: *All Commanders*

Today we are fighting in a country which has contributed a great deal to our cultural inheritance, a country rich in monuments which by their creation helped and now in their old age illustrate the growth of the civilization which is ours. We are bound to respect those monuments so far as war allows.

If we have to choose between destroying a famous building and sacrificing our own men, then our men's lives count infinitely more and the building must go. But the choice is not always so clear-cut as that. In many cases the monuments can be spared without any detriment to operational needs. Nothing can stand against the argument of military necessity. That is an accepted principle. But the phrase "military necessity" is sometimes used where it would be more truthful to speak of military convenience or even of personal convenience. I do not want it to cloak slackness or indifference.

It is a responsibility of higher commanders to determine through A.M.G. Officers the locations of historical monuments whether they be immediately ahead of our front lines or in areas occupied by us. This information passed to lower echelons through normal channels places the responsibility of all Commanders of complying with the spirit of this letter.

<div align="right">

DWIGHT D. EISENHOWER

</div>

Ike's directive was bold; it was concise; and it was now official policy. His Chief of Staff, Major General Walter Bedell Smith, issued an accompanying order that provided more specific details on how this new policy should be implemented. Woolley remarked that Ike's words "made it clear that the responsibility for the protection of monuments lay with the army as a whole and not with the [Monuments officer] specialist." Even Churchill weighed in on the matter: "The weakness of the Monuments and Fine Arts organization in the past was . . . due to the fact that it had . . . depended on an external civilian body not in touch with the Army. . . . The new arrangements which have been worked out in the light of experience are well calculated to promote, as far as military exi-

gencies allow, a more effective effort to protect historical monuments of first importance in the future."

Many problems lay ahead for implementing this new order. Mistakes would continue. The order would be put to the test in a major way within just six weeks. But it marked the turning point for the Monuments officers and their work. For the first time since Mason Hammond had landed in Sicily, the Monuments Men had the backing of the Commander-in-Chief. Their work contributed greatly to the experience Eisenhower would take with him to England to plan the invasion of Western Europe as the newly appointed Supreme Commander of the Allied Expeditionary Force.

7

A TROUBLED BUNCH

Despite General Eisenhower's historic order, the Western Allies were not the only army to conceive of protecting cultural treasures during war. Ironically, so too did Germany, the same nation that since 1939 had systematically looted the countries it had conquered and occupied.

On August 25, 1914, less than a month after Germany's invasion of neutral Belgium and the outbreak of World War I, German soldiers patrolling the "open" and undefended university town of Louvain, near Brussels, were shot and killed. Believing their deaths to be the act of partisan snipers, German military authorities first rounded up and executed 248 citizens and then ordered other residents to stand in the streets while German troops burned their homes, one by one. The soldiers then torched the University of Louvain's library, one of Europe's oldest and most distinguished collections. The blaze destroyed 250,000 books—some eight hundred of which had been printed before the year 1500—and five hundred illuminated manuscripts. The destruction of the Louvain library became a notorious example of wanton wartime destruction.

The world reacted with swift and united indignation. So, too, did alarmed German cultural officials. Within three weeks, Wilhelm von Bode, Chief Superintendent of the Prussian Museums, proposed that Otto von Falke coordinate efforts with Belgian officials to protect that nation's movable works of art. The following month, Dr. Paul Clemen, a distinguished professor of Art History at the Friedrich Wilhelm University in Bonn, was appointed to formally develop a system to protect the monuments of Belgium and later France.*

Clemen's role as Provincial Conservator of the Rhineland, and his pioneering work in art conservation, uniquely qualified him to become the first leader of the *Kunstschutz*, Germany's "art protection" unit. On January 1, 1915, he received a commission from German military officials that coordinated his art protection responsibilities with front-line commanders. Although hardly well known, the name of Paul Clemen became favorably associated with the protection of cultural property during World War I. So, too, was the name of Bode, best known for his leadership of the Kaiser-Friedrich Museum in Berlin. "Cultural goods and art have to be saved for every cultivated country," Bode once stated, "and . . . the protection of arts and monuments has to be executed the same way on enemy territory as it is in our own country." But his vision would prove short-lived.

ON MAY 10, 1940, Nazi Germany invaded Western Europe and, for a second time, occupied Belgium. Incredibly, seven days later, the University of Louvain Library—having reopened in 1928 after ten years of rebuilding—was again reduced to ashes. Of the nine hundred thousand books destroyed that day, some two hundred thousand had been donated to the library by Germany per the terms of the Treaty of Versailles. The painful irony was that many of those books contained bookplates with a Latin motto, *Sedes Sapientiae non Evertetur* (The Seat of Wisdom Shall

*Clemen had been an exchange professor at Harvard University in 1908.

Not be Overturned). German forces claimed that British troops fleeing the town of Louvain had started the fire; a subsequent investigation attributed the source to German artillery. The appointment, less than a week earlier, of Professor Dr. Franz Graf von Wolff-Metternich as the leader of the Kunstschutz, with a mandate to advise German High Command on the preservation and protection of works of art and monuments in occupied territories, had begun badly.

The challenges Clemen faced in establishing the Kunstschutz in 1914 seemed meager by comparison with those confronting Wolff-Metternich in 1940. By the time of his involvement, Hitler and Nazi Reichsmarschall Hermann Göring had set in motion the greatest looting operation of the twentieth century. Much of Eastern Europe's cultural wealth had already been stolen or destroyed. Soon Wehrmacht troops would march into the artistically rich cities of Brussels, Amsterdam, and Paris, where the ERR (*Einsatzstab Reichsleiter Rosenberg*—Special Task Force Rosenberg, named for its leader, Alfred Rosenberg) would begin operations, all outside Wolff-Metternich's authority.

As an aspiring student of painting and architecture, Hitler had been rejected by the Vienna Academy of Fine Arts, but his interest in art endured. If anything, the rejection motivated him to prove his "underestimated" gifts to the world. Working with young but established architects, including Albert Speer and Hermann Giesler, Hitler developed plans to rebuild entire cities, including his hometown of Linz, Austria. Beginning in May 1938, inspired by a tour of the Uffizi Gallery in Florence during a state visit to Italy, Hitler approved plans that led to an extraordinary museum—the Gemäldegalerie Linz, commonly referred to as the Führermuseum—that would contain what he considered to be the world's most important objects.

Under Hitler's leadership, art became a weapon of propaganda. Art was used to promote Nazi racial policies. During a 1937 visit to "The First Great German Art Exhibition," Hitler was infuriated by works of art he considered "degenerate" and removed them from the walls himself. He used the occasion to explain:

Certain people's eyes show things differently than they are . . . men who see, or as they may say, "experience," the present-day body shapes of the people of our Nation only as degenerated retards, who generally perceive meadows as blue, skies as green, clouds as sulfurous yellow, and so on. . . . I just want to prohibit in the name of the German people that these poor unfortunate individuals who clearly suffer from bad vision, try to forcefully sell the results of their misconceptions to their contemporaries, or even declare it as being "art."

Out the doors of German museums went paintings by German and Austrian Expressionist painters Ernst Ludwig Kirchner, August Macke, and Oskar Kokoschka. Works by Van Gogh, Picasso, Monet, and Renoir, among many others, soon followed, all part of the sixteen thousand objects declared "degenerate" and later sold, traded, or burned.

Hitler's taste ran toward German-speaking nineteenth-century painters, including Makart, Spitzweg, Böcklin, and Grützner, who in his view had been misjudged by those without his artistic talent. He also admired and sought works by such Old Master artists as Leonardo da Vinci, Jan Vermeer, and the great German Renaissance painters Albrecht Dürer and Lucas Cranach. Hitler intended that some of these masterpieces reside in the Führermuseum; others would be distributed to a network of regional museums throughout the Reich.

Each year Hitler added to his collection. Agents acquired works for him through legitimate purchases, forced sales, and confiscations. The Nazis issued decrees to maintain legal cover, in particular for items looted from Jews. But the enterprise grew larger; hiding the nature of the crime became an exercise in paperwork. Upon establishing operations in Paris, the ERR and other Nazi agencies began targeting works of art owned by preeminent dealers and collectors in France, including David-Weill, Rothschild, Bernheim-Jeune, Seligmann, and Kann. Often they characterized the confiscations as "safeguarding." ERR staff then created elaborate, brown leather-bound albums containing photographs of the works of art, each caption identifying the family from whom the

object was taken and noting the inventory number assigned to that particular object. For paintings, the number would be stamped on the back of the stretcher. (For example, "R-4888" referred to the 4,888th item stolen from the French branch of the Rothschild family.)

Presentation of these albums, which included sculpture, furniture, jewelry, paintings, and other art objects, allowed Hitler to select those items he wanted for the Führermuseum, or another museum he designated. These albums regularly accompanied him—from the Reichschancellery in Berlin to the Wolfsschanze on the Eastern Front to his home in Berchtesgaden.

Over time, the Nazi looting agencies built their operation to industrial scale. The Führer, like Napoleon and other conquerors before them, believed that the possession of art projected power and a sense of superior knowledge, thereby placing him among the great men of history. But power alone didn't explain Hermann Göring's motivation; he was also driven to possess beauty. "Perhaps one of my weaknesses has been that I love to be surrounded by luxury and that I am so artistic in my temperament that masterpieces make me feel alive and glowing inside," he once said.

Seldom had greed found a more compatible host than Göring, whose very existence became defined by abundance. The expansion of his residence couldn't keep pace with that of his collection. Like Hitler, Göring also coveted works by the Old Masters, but his taste ran much broader than the Führer's. His collection included fifty-eight works attributed to the Flemish painters Peter Paul Rubens and Jan Brueghel the Elder (thirty-two and twenty-six, respectively), thirty paintings by the French Rococo master François Boucher, and sixteen works by the Venetian colorists Titian and Tintoretto. Göring cornered the market for works by the German painter Lucas Cranach the Elder, some sixty paintings in all.* But his collecting became indiscriminate, too often focused on quantity over quality.

* Some were later determined to be "School of Cranach."

In contrast to Hitler, who relied on advisers and purchasing agents, Göring took an active, personal role in his acquisitions. The thrill of the hunt became inseparable from the pleasure of each purchase. From November 1940 through 1942, Göring had made twenty separate visits to the primary ERR depot of works stolen in Paris, the Jeu de Paume Museum, to make selections for his own collection. He then had them loaded onto his private train and shipped to Germany. In August 1942, Göring plainly stated his intentions: "It used to be called plundering. . . . But today things have become more humane. In spite of that, I intend to plunder and to do it thoroughly." Metropolitan Museum Director Francis Henry Taylor characterized it differently, noting that "not since the time of Napoleon Bonaparte has there been the wholesale looting and destruction of art property that is going on today in the occupied countries of Europe."

NAZI LOOTING IN Italy unfolded very differently from that in the occupied countries of northern Europe. Hitler made his first official state visit to Italy in May 1938. Residents of Naples welcomed Hitler with hundred-foot-long banners bearing Nazi swastikas hanging from the balconies of buildings overlooking the path of his motorcade. In Rome, he and many of the senior Nazi leaders walked through the ancient Colosseum retracing the steps of the gladiators. He reveled in the splendor of the Villa Borghese and its important collection of paintings and sculpture. But it was Florence, a city German General Alfred Jodl later referred to as "the jewel of Europe," that held Hitler's fascination.

After arriving at the Santa Maria Novella train station on a resplendent late spring day, Hitler joined Mussolini in the back of an open-top Lancia Astura Cabriolet limousine for a tour of the city. The motorcade carried the two leaders past tens of thousands of Tuscans who lined the parade route, chanting Hitler's name. Never had the city appeared more stately. Oversize red flags and banners emblazoned with the black Nazi swastika alternated with those bearing the city's emblem—a red

fleur-de-lis on a white background—from every building and window-sill, some 4,340 in all. No detail of the visit had been overlooked.

The motorcade route had been designed to condense what would normally be a day-long tourist experience into thirty minutes—passing the Duomo, driving south on the city's legendary shopping avenue, Via Tornabuoni, then across the Arno River over the Ponte Santa Trinita, one of the city's key bridges. After a short rest at the Pitti Palace, the two leaders headed north once again through the Piazza della Signoria and then passed by the church of Santa Croce on their way to the Piazzale Michelangelo for a quick panoramic view of the city.

In great contrast to the breakneck pace of the city tour, almost two hours had been set aside for the main attraction, Hitler's visit to the extraordinary collections—which included jewels of Renaissance painting—of the Pitti Palace and the Uffizi Gallery. Professor Friedrich Kriegbaum, Director of Florence's *Kunsthistorisches Institut* (Art History Institute), and the world authority on the Ponte Santa Trinita, accompanied Dr. Marino Lazzari, Director General of Fine Arts, the official guide.

After a brief walk through the Pitti collection, past such masterpieces as Raphael's *Madonna of the Chair* and *La Donna Velata*, Caravaggio's *Sleeping Cupid*, and Andrea del Sarto's *The Holy Family,* the group entered the Vasari Corridor, a passageway built atop the Ponte Vecchio and named for its architect, the noted sixteenth-century biographer and artist Giorgio Vasari. Kriegbaum paused at one of the west-facing windows to point out to the Führer the beauty and importance of the nearly four-hundred-year-old Ponte Santa Trinita, with the weight of its three catenary arches—the shape of a hanging chain, inverted—gracefully resting on a pair of prow-shaped stone piers. This marvel of functional elegance had always been attributed solely to Bartolomeo Ammannati, a sixteenth-century Florentine architect and sculptor. Kriegbaum, however, had recently concluded that Michelangelo contributed to the final design, perhaps as a "last gift to his . . . native city." The adjacent Ponte Vecchio, while substantially older, had been rebuilt on two previous

occasions after being swept away by floods; it could only stand in the shadow of such greatness. But the Führer didn't want a history lesson; his favorite bridge was the Ponte Vecchio. He also admired the Vasari Corridor, its hallways lined with self-portraits of the great artists whose works fill the Florentine museums.

The large group finally reached the Uffizi, then made a tour of its collection in reverse order to that of a tourist. After passing Titian's *Venus of Urbino* and Michelangelo's *Doni Madonna*, they paused at a section of hallway overlooking the Arno, this time to get a better view of the Ponte Vecchio and admire the hills of San Miniato and Bellosguardo. Then came the rooms containing paintings of *Adam* and *Eve* by one of Germany's most talented painters—and Göring's favorite—Lucas Cranach the Elder; Leonardo da Vinci's *Adoration of the Magi*; and Botticelli's *Birth of Venus*.

Each painting had its own story and legend; the Führer wanted to hear them, one by one. But Mussolini, who once proclaimed, "Italy has too much art and too few babies," considered the tour mind-numbing. Art historian Ranuccio Bianchi Bandinelli later commented that "Mussolini was bored because the tour. . . . was lasting too long. He walked by me and, with a gesture as an invitation to walk faster, whispered, 'Here, we would need a week.'"

Mussolini had never been a protector of his nation's patrimony. During the early years of their relationship, the Führer and his art advisers had made special requests to purchase famous works from Italian collectors. Such pieces, designated *notificati* because of their historic importance, had been restricted from ever leaving the country.* Italian authorities vigorously objected to these sales, invoking the nation's patrimony laws, which protected such works. But Mussolini considered the

*The *notifica* is a procedure of the Superintendence of Cultural Heritage that bars from export outside Italy cultural goods of any type that are recognized as having significant historic and artistic value.

laws a bureaucratic formality. As Duce, he disregarded them; the sales went through.

First to go was the *Lancellotti Discobolus*, a Roman sculpture of a discus thrower dating from 140 AD, a copy of the original that the Athenian Myron sculpted in the fifth century BC. Italian cultural authorities described the piece as "an irreplaceable monument for our knowledge of the *Discobolus of Myron* and of the art of this great master, in any case among the most distinguished works of ancient art." Naturally, they rejected the initial export request. But Count Galeazzo Ciano, the Foreign Minister—and Mussolini's son-in-law—overrode their objections. Soon the sculpture departed for Germany. Other works quickly followed, including paintings by Hans Memling and Peter Paul Rubens.

Reichsmarschall Göring then got in on the act, shipping thirty-four cases of art to Germany in 1941 and another sixty-seven the following year. Regardless of the legality of his purchases, the Italian government should have exacted an export tax based on the market value of the works, but in both instances the fee was based on ridiculously low valuations. The crates arrived sealed; customs officials did not open them to verify the value of the contents. No matter—the Italian Ministry of Foreign Affairs paid the tax on Göring's behalf.

With the fall of Mussolini's Fascist government in Rome and Italy's subsequent change of allegiance, the contents of the German libraries in Italy departed for the Fatherland on Hitler's explicit orders, despite an international agreement stipulating they would never be removed. The haul included the Hertziana Library and its rich material on Michelangelo and Bernini, and the holdings of the German Archaeological Institute, the oldest archaeological research institute in Europe. They also evacuated Florence's Kunsthistorisches Institut, founded by German scholars dedicated to the study of Italian art and architecture.

Wolff-Metternich and other Kunstschutz officers did liaise with their Italian counterparts to discuss general protective measures, but since Mussolini and his reconstituted government were considered an ally of Nazi Germany, not an occupied country per se, the Italians were respon-

sible for protecting works of art located within their borders. The wanton destruction of the University of Naples by German troops was an early indication—but not the only one—of the difficulties they would confront.

On September 30, a band of German soldiers near the town of Nola, acting on orders of their commander, set fire to a villa that served as a temporary storage facility for the contents of the Filangieri Museum and the State Archives of Naples. The fire burned the museum's priceless collection of ceramics, glassware, and enamels, as well as forty-four paintings by such artists as Van Eyck, Botticelli, del Sarto, Pontormo, and Chardin. Destruction of the State Archives—perhaps the richest collection in Italy other than that of the Vatican—saw the obliteration of eighty-five thousand archival documents, some dating from the year 1239, including manuscripts, codices, and treaties of the Kingdom of Naples; much of the archives of the ruling Bourbon and Farnese families; and the archives of the Order of Malta. These criminal acts resulted in a loss not just to Italy but to all of Western civilization.

As the Allies pushed German forces northward, up the Italian peninsula, Generalfeldmarschall Kesselring ordered his Intelligence Branch to implement procedures to protect historic buildings and movable works of art. He deployed personnel from the German Embassy in Rome, and German historians affiliated with the German Historical Institute, to aid in this effort. Without a formal Kunstschutz operation, however, the safety of Italy's cultural treasures depended on the discretionary judgment and benevolence of each German commander. The spiteful burning of the Filangieri Museum and the State Archives contents at Nola, and the University of Naples, demonstrated the risks of this approach.

The destructive events in Nola and Naples generated considerable alarm. In late October 1943, Dr. Bernhard von Tieschowitz, head of the Kunstschutz based in Paris, received orders to report to Italy to establish an operation there. Protecting buildings and works of art became his first concern. In an effort to begin operations quickly, Tieschowitz pressed into service well-respected German art scholars in Rome and Florence. Because of their knowledge of Italy, much good work followed.

But the Kunstschutz operational structure had an inherent flaw. As events in Paris and other European cities had demonstrated, the best efforts of its most dedicated officials to protect movable works of art could be subverted by Nazi Germany's leaders at any moment, jeopardizing if not destroying its credibility. In contrast, the mandate of the Monuments officers had been approved by President Roosevelt and endorsed by General Eisenhower. Unlike the intentions of the leaders of Nazi Germany, their efforts were single-mindedly devoted to winning the war, not stealing art.

8

GIFTS

With the liberation and consolidation of Naples complete, Allied forces set their sights on Rome. The distance, just 140 road miles, seemed tantalizingly short, but the topography and wet weather favored the defenders fighting under Generalfeldmarschall Kesselring.* The German commander used the terrain to his advantage, establishing a series of heavily fortified defensive lines that ran perpendicular, like ribs across the mountainous "spine" stretching the length of Italy. This slowed Allied progress to a crawl, creating costly stalemates. German troops would fight a ferocious battle, then retreat to the next line.

Three defensive lines had been built between Naples and Rome, the last of which, the Gustav Line, passed near a town named Cassino, still eighty miles southeast of Rome. Of the two paths leading to the Holy City, one—Route 7, the ancient Appian Way—hugged the coastline and passed through the flooded, malarial Pontine Marshes. The other—

*In November 1943, allegedly at the urging of SS General Karl Wolff, Hitler removed Generalfeldmarschall Erwin Rommel as commander of forces in northern Italy and appointed Kesselring Commander-in-Chief OB South-West and Commander-in-Chief Army Group C. "Overnight, [Kesselring] had become the most powerful man in the Mediterranean region."

Route 6—provided a straight shot for the Allies from Naples to Rome, through the Liri Valley. But it first required passage through a gauntlet of rising hills, mountain ridges, and entrenched German defensive positions. As British General Sir Harold Alexander observed, "All roads lead to Rome, but all the roads are mined." A momentous battle loomed.

German Captain Dr. Maximilian Becker understood well that no matter the victor, many men would die. As a doctor assigned to the elite, independent, and battle-hardened Hermann Göring Division, a paratroop panzer division attached to the Luftwaffe, he had seen enough battles to envision what lay ahead. But this engagement would be different, because it also threatened the Benedictine Abbey of Monte Cassino.

Becker's enthusiasm for medicine coexisted with his passion for art and archaeology. With a sketchbook constantly at his side, he marveled at the sight of the colossal abbey, perched regally on a rocky outcrop some 1,500 feet above the Liri Valley. The fourteenth-century white stone rectangular building, rising four stories above the summit, was admired more for its sheer size than for its beauty. But the abbey's location and history played a notable role in the development of Western civilization. Saint Benedict, who founded the abbey in 529 AD, declared the sacred site an intellectual center, one he hoped would be protected by its location from the profane world below. Such splendid isolation served the abbey well, but it also offered an irresistible strategic position. Its walls provided a panoramic view of all troop movements in the adjacent valleys. The location—and its unique collection of ancient books, illuminated manuscripts, papal documents, and works of art— had attracted conquerors past, including Napoleon's forces in 1799.

Without fortifying the mountain ridge surrounding the abbey, German forces would have little chance of halting the Allied drive northward. It was, simply, the preeminent defensive position south of Rome. German troops had specific orders prohibiting use of the abbey itself, but many were positioned so close to its heavily fortified walls that, to Allied forces below, it would appear they were in the building. Becker believed the abbey was doomed.

In mid-October, acting without authorization, Becker developed a plan to relocate the abbey's treasures. It depended on logistical help from the Hermann Göring Division's supply officer, Lieutenant Colonel Siegfried Jacobi. Without trucks, the plan couldn't succeed. Jacobi, a policeman in Berlin before the war, offered to cooperate but then commented to Becker: "If we're supposed to do all that, there'll have to be something in it for us, too. . . . keep just a couple of paintings. . . . Just cut them out of the frames and roll them up."

The following day, pondering Jacobi's unsettling comment, Becker drove up the steep, winding road to the abbey for his first meeting with the monastery's leader, seventy-eight-year-old Abbot Gregorio Diamare. He entered through the building's massive wooden doors, beneath the single Latin word PAX (Peace), and was escorted down a long, barrel-vaulted hallway, past rows of bookshelves, glass cases, and oversize globes, before entering the abbot's workroom. There, to his great surprise, he discovered another officer from the Hermann Göring Division named Julius Schlegel. The lieutenant colonel explained curtly that there was no need for Becker to meet with the abbot about evacuation plans because, at the directive of Jacobi, he had already handled the arrangements.

Undeterred, Becker greeted Diamare and his fellow monks, resolved to present his plan rather than rely on whatever Schlegel may have told the abbot. Speaking through an interpreter, Becker explained exactly how and why he wanted to relocate to safety as much of the abbey's treasures and to do it as soon as possible. Diamare's frumpish appearance, with his slumping shoulders and weighty, black-rimmed glasses, masked the cleverness and experience of someone who had survived thirty-four years of leadership of the abbey, including one world war, and the unstable politics between Italy and the Holy See. Although the meeting ended without conclusion, Becker remained hopeful, but another meeting would be required.

That evening, Becker's suspicion of Schlegel diminished when he learned that he had owned a transport firm in his hometown of Vienna before the war. That seemed to explain why Jacobi had sent Schlegel to

meet with the abbot. The following day, Becker and Schlegel drove back up the mountain for a second meeting. As they entered the abbey, a man dressed in the uniform of an Italian museum guard called out, *"Dottore, dottore!"* It took a few moments, but Becker vaguely remembered dressing a minor wound for one of the guards at Pompeii during a visit several weeks earlier. Incredibly, this man had been his patient.

Speaking in a hushed tone, the guard dropped a bombshell: he and another museum employee were secretly guarding 187 crates of artworks that Naples authorities had delivered to Monte Cassino for safekeeping on September 9, the day after the announcement of the Italian surrender. The shipment included paintings and bronzes from the Museo Nazionale, some from the ancient sites of Pompeii and Herculaneum, and other works of art from the Museo San Martino, the Reggia di Capodimonte, and the Mostra d'Oltremare.

Many of the most priceless works of art from Naples now resided at the abbey, including *Danaë*, by the prolific Venetian colorist Titian; Flemish master Pieter Bruegel the Elder's *The Blind Leading the Blind*; and Italian pioneer Caravaggio's *Flagellation of Christ*, one of the canvases created by the volatile master between his flight from Rome in 1606 and his dramatic death in 1610. They were in good company, alongside paintings by Masaccio, Botticelli, Bellini, El Greco, Correggio, and the Carraccis. The Abbey of Monte Cassino had always been a repository of knowledge, but with the astonishing news about the Naples collections, Becker realized it had also become a fortress for art.

While waiting for their second meeting with Abbot Diamare to begin, Schlegel casually pointed to a nearby medieval sculpture and mentioned to Becker what a perfect addition it would be to the collection of their division's patron, Reichsmarschall Hermann Göring. Schlegel's offhand comment set the tone for the days ahead.

The abbot had many questions about Becker's plan. Who could blame him? It had all been strung together so quickly that even Becker wasn't sure where the abbey treasures would be taken. He could only assure Diamare that they would be headed north. "Do you mean to Ger-

many?" asked the abbot—a reasonable question, given reports of German looting. But after listening to Becker's and Schlegel's professions of goodwill and personal assurances, and no doubt realizing a major battle of the war would soon be fought outside the abbey walls, Diamare reluctantly agreed.

With the abbot's permission, the Hermann Göring Division's plan to relocate the abbey's extensive holdings could proceed. Monks would accompany the trucks containing property of the abbey to two Benedictine monasteries in Rome, St. Paul Outside the Walls and St. Anselmo. The Naples treasures, and other property belonging to the Italian State, would be held in trust at a location to be determined, awaiting transfer arrangements with Italy's new government officials. Under no circumstances, however, would Diamare and his inner circle leave their home.

The crating operation alone was a Herculean task. The abbey's holdings included the state-owned Library of Monuments and the Archive of the Abbey, as well as the church-owned Pauline Library, Private Library of the Monks, and Diocesan Library—including some forty thousand parchments dating from the ninth century onward; thousands of paper documents; 1,200 illuminated manuscripts from the ninth, tenth, and eleventh centuries; and 100,000 printed works. The abbey also contained tapestries, paintings, and jewel-encrusted religious objects. Packing these treasures would have been a daunting task during a time of peace. Given the wartime shortage of materials, it seemed impossible.

Becker and Schlegel began by relieving a nearby bottling factory of its wood, nails, and tools. German carpenters worked alongside refugees living within the abbey walls to build the crates and then load them onto trucks. Each evening, shipments departed for Rome or the undisclosed storage facility. By November 3, in just three weeks, Becker and Schlegel had overseen the transport of one hundred fully loaded trucks. It was a remarkable accomplishment.

While Schlegel completed the last of the shipments, Becker grew increasingly fearful about the disposition of the state-owned Naples treasures and decided to confront Jacobi. Without explanation, Jacobi

handed Becker the file copy of a letter he had sent to Lieutenant Colonel Bernd von Brauchitsch, chief adjutant—and an adviser—to Reichsmarschall Göring.

Becker read the letter in shock. The division intended to make a gift of works of art from the Naples museums to its patron. They wanted Brauchitsch to send an art expert to Italy to make the selections. The Reichsmarschall's birthday was in January; these unique and priceless works of art would be wonderful additions to the grand gift-giving festivities. Becker's worst fears had been realized.

On November 10, *The New York Times* reported: "Unique Collection of Art Treasures Taken Away by Germans in Italy." Professor Amedeo Maiuri, Curator of the Museo Nazionale in Naples, who had been injured in one of the Allied attacks on Pompeii, said, "The responsibility of the Germans before the whole civilized world will be multiplied beyond all their previous responsibility for devastations, sacking and lootings." As Maiuri spoke, he wept, "not for himself or for Italy, but for the things that are the heritage of the world of culture." After the deliberate destruction by German troops of the State Archives and paintings from the Filangieri Museum, Maiuri feared the treasures of Naples might be next.

In late November, Becker received word that an art expert from Berlin had indeed finally arrived at the secret storage facility, a villa near Spoleto, about seventy miles north of Rome, which the division had commandeered as its supply depot. Becker drove for more than ten hours, over roads recurrently subjected to Allied air attacks, to reach the villa. He pulled up to the door, exhausted by the harrowing journey and fearful of what he would find inside. His suspense was short-lived. The original crates from Naples had been stacked in the center of the reception area. Many had already been pried open, their seals broken. Packing material littered the floor. The scene looked like an art gallery, with paintings leaning against the wall as if a dealer had just unpacked his latest acquisitions. Becker had walked in on a looting operation initiated by the Hermann Göring Division.

Boiling with anger, Becker blurted out, "There's some unbelievably shitty business going on here!" That drew the attention of soldiers in

the room as well as the art expert. Becker also informed him that members of the newly formed German Kunstschutz in Italy had recently visited the supply depot, inspected the paintings, and departed, satisfied that all the contents were intact. Becker then threatened to report the activities of the art expert to his superiors if any painting or object left the Spoleto depot without authorization from Generalfeldmarschall Kesselring.

Upon returning from Spoleto, Becker found Jacobi and angrily explained what he'd witnessed. Far from being defensive, Jacobi justified the right of the Hermann Göring Division to exact a legitimate reward—a good deeds commission—for transporting and saving art treasures from a war zone on behalf of Italy.

Italian art officials besieged Tieschowitz, the Kunstschutz representative, shortly after his arrival in Italy, desperate to know the status of the collections taken from Monte Cassino. Tieschowitz subsequently questioned both Schlegel and another officer, probably Jacobi. The answers they received summed up the arrogance of the Hermann Göring Division. "We didn't get [the collection] away from the priests just so we could give it back to the church. This stuff belongs to Germany!" After Tieschowitz informed both officers that his orders provided for the Hermann Göring Division to turn over to the Vatican those treasures formerly stored at the abbey, they exclaimed, "You're upsetting our whole applecart!"

Tieschowitz then arranged a meeting with Kesselring to seek his help in forcing the Hermann Göring Division to produce the missing artwork, but to little avail. Having dealt previously with the independently minded division, who "had not complied with my issued orders at all," Kesselring knew that expending valuable political currency doing battle with the Reichsmarschall was futile.

THROUGHOUT THE FALL of 1943, SS General Karl Wolff managed to delay his report to Hitler regarding seizing control of the Vatican. He used that time to brush up on the medieval power structure within Italy.

The independent city-states and kingdoms had only united as the nation of Italy in 1871, just seventy-two years earlier. Most of the country's political parties were even newer. But the authority of the Catholic Church dated back centuries. From Wolff's perspective, it made sense to develop good relationships with high-ranking church dignitaries, not incarcerate them, and then use his power as head of the SS to grant favors to church officials and others as their inevitable special requests arose. Wolff later referred to it as his "easy hand policy."

In early December, Wolff returned to Hitler's headquarters to submit his recommendation to the Führer. During his time as the SS liaison officer, Wolff had studied the many approaches taken by others in their meetings with Hitler. He knew from experience that a successful meeting with the Führer depended on seeing him privately, and that anything said had to be supported by facts presented in an uncomplaining manner. Shifting blame to others would only enrage him. "The Führer and I spoke the same language," Wolff once commented. "We were both front[line] soldiers of World War I."

Wolff began the meeting by explaining the war weariness of the Italian people. "The mood of the Italian population towards the Germans is not directly hostile yet, but they consider us, due to the continuous destructions on Italian soil and the losses among the civilian population, to be unpopular prolongers of the war." He then discussed the "undisputed authority" of the Catholic Church, noting its far superior influence on Italians than Mussolini's reconstituted Social Republic:

> *After I recognized this, I immediately and at any given opportunity—mostly petitions for mercy from the high Clergy for condemned and arrested Italians—tried to reestablish a good contact to high ranking dignitaries of the Church and the Vatican, which eventually led to my proposal [to church authorities]: "I protect your ecclesiastical institutions, your authority among the Italians and the German occupying forces, your property and your life; and you in your areas keep the population quiet and discourage them from actions against the German authority."*

With Wolff's SS forces already stretched thin supplying Kesselring's front-line troops, and Himmler unable to send reinforcements to Italy, Wolff urged the Führer to "give up your Vatican Plan and allow me to act with determination when necessary and continue my policy of the 'easy hand' with Italy. . . . As I see the situation, the occupation of the Vatican and the kidnapping of the Pope would have so many negative repercussions for us as well among the German Catholics at home and at the front."

Hitler seemed resigned to accept Wolff's recommendation, thanking him for his presentation and the details of his research, but not before admonishing him to remember: "I have to hold you responsible in case you cannot uphold your optimistic 'guarantee.'"

BY EARLY DECEMBER, some combination of efforts by Becker, Tieschowitz, Italian art officials, appeals to the Vatican by the congregation of Monte Cassino and others, and a steady stream of newspaper stories from abroad, compelled the Hermann Göring Division to relinquish the works of art and other objects under its control. With the full support of Italian authorities, an arrangement had been reached for the Vatican to receive the state-owned items and archives in two parts. On December 8, with German cameras rolling, fourteen large trucks bearing the division's insignia arrived in Rome, slowly crossed the Tiber River, and pulled up to the entrance of Castel Sant'Angelo, formerly the mausoleum of the Roman emperor Hadrian. This first delivery was a staged production designed to portray the division, and the German Army, as defenders—not destroyers—of Europe's heritage.

Officials watched as each truck backed through the entrance doors and down the loading ramp, where local workers and uniformed soldiers waited to offload the contents, 387 cases in all. Out of the trucks came drawers (removed from their cabinets) filled with scrolls and archival documents bound by silk ribbons, the abbey's ancient globe, and crates containing works of art that had once adorned the walls of the

monastery. Schlegel and others spoke at the short ceremony, although Kesselring had ordered the Kunstschutz representative to "say no more than three sentences. . . . the less said about this matter the better." Handshakes followed. The Hermann Göring Division, the German Army, and Kunstschutz officials had their propaganda coup.

Several weeks passed before the Hermann Göring Division returned the remaining—and most magnificent—objects from Monte Cassino to Italian officials. On January 4, the German propaganda machine prepared for the second and final delivery, this time to officials at the Palazzo Venezia in Rome. Cameras began recording the arrival of thirty-one trucks containing six hundred crates of books from the National Library evacuated from another storage facility by Becker and, finally, the Naples collections. With the safe arrival of the remaining Monte Cassino treasures, the long-drawn-out affair appeared over.

After the ceremony, Italian officials, including Emilio Lavagnino, Central Inspector of the General Direction of the Arts, and former Superintendent of Galleries in Rome and Naples, supervised the unloading. Of the 772 crates delivered that day, 172 contained the Naples treasures. Everything proceeded smoothly until the German officer in charge of transport mentioned that enemy machine-gun fire en route had delayed the arrival of two trucks.

The two trucks containing fifteen additional crates did indeed reach their destination, much to the relief of the leaders of the Hermann Göring Division and Göring's adviser, Brauchitsch. But their destination had been Berlin, not Rome. Their timing was perfect. Birthday festivities for Göring were just around the corner. There were many new gifts to wrap.

SECTION II

STRUGGLE

What happens when this dense fabric of human achievement, so infinitely precious, so incalculably old, so carefully guarded, is struck by the full force of modern warfare?

—MONUMENTS OFFICER FRED HARTT

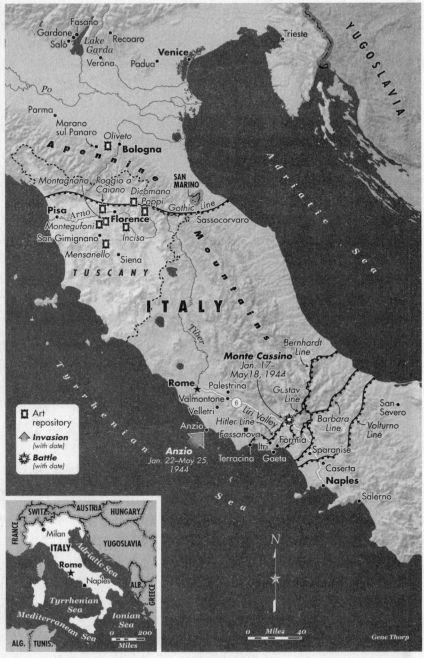

Central Italy

9

THE FIRST TEST

Major Ernest DeWald considered the December 29, 1943, directive from General Eisenhower "the first official ground under our feet on which we can build." But there was still much to do. The Western Allies had no tradition of working with a formalized group of Monuments officers. Even with Ike's new order, they numbered just fifteen men in an army of hundreds of thousands.

The transfer of MFAA headquarters from Sicily to Naples in February 1944 created an immediate need for additional officers. Deane Keller, still stuck in North Africa, finally received orders to report for his new assignment. No one bothered to tell him what that new assignment was, but his Priority status enabled him to escape the doldrums of Tizi Ouzou and board a ship for the mainland. He arrived on the evening of February 6 and reported for duty the following morning to the original Monuments Man, Mason Hammond. Keller "brought with him no copies of his travel orders or of any orders assigning him to the Subcommission [as] his assignment . . . was made verbally." After eight months in his new assignment, very little about the ways of the United States Army surprised Hammond.

The very evening of his arrival, Keller wrote Kathy a letter to let her know he had arrived in Italy: "I could write you fifty pages of what has happened to me. . . . I am quartered in a hotel, expecting blankets tonight; my bedding roll was dropped off the boat in unloading into the water. . . . I carried my 100 pound bedding roll seven flights to my billet and then my barracks bag, soaked in water and very heavy." Despite the initial hardships, Keller remained undaunted in his sense of purpose, telling Kathy, "I feel I am on a personal crusade, and if I can save a bit no matter how little, for America and for Italy, I'll be satisfied."

As a security precaution, censorship rules prohibited soldiers from disclosing key information in letters, especially references to their unit or location. Letting Kathy know that he'd reached Italy was the limit to what he could say. "I have been here before and am in the 7th Heaven as far as that goes." She would have to guess the location of "here." These rules created considerable frustration for loved ones and often required writerly acrobatics. One of Keller's letters sent a day later included the absurd line: "We had a trip without incident to here where I have been before."

"Here" turned out to be the former Greek colony of Naples, among Europe's oldest settlements, dating back almost three thousand years. But the Naples that greeted Keller in February 1944 appeared unfamiliar. The "light-hearted" Neapolitans that Keller had described to his classes at Yale seven months earlier were now hungry, homeless, and out of work. By September 1943, twenty thousand civilians already had been killed during the 105 Allied bombing raids on their city. Many survivors had been living in underground air-raid shelters (*ricoveri*),* "great cavernous excavations with cathedral-like chambers accommodating thousands of people"—places dominated by "terror, dirt, [and a] sense of impotence." Monuments Man and fellow artist Salvatore Scarpitta observed that the city's "churches are the war's innocent victims whose

* *Ricoveri* and *rifugi* are interchangeable. Visitors to Italy today may occasionally find a painted R or *Rifugi* with arrows on prewar buildings. These signs identified for civilians the nearest public air-raid shelter. The Monuments Men and other Allied soldiers often referred to these as *ricoveros*.

price is paid bitterly by all in this unprecedented conflagration." On the bright side, a typhus epidemic finally seemed to be under control after special "dusting" squads began disinfecting more than eighty *ricoveri* per week in late December.

Keller's first weeks saw him working out of the damaged but functional Post Office building, where a room large enough for one senior executive had been jammed full of small desks and typewriters. Frequent air-raid sirens interrupted the tedium of preparing reports and sent Keller and the others to the nearby bomb shelter, often overnight. His daily exercise came from walking up and down the seven flights of stairs to reach his room at the Hotel Volturno, on Via Roma.

He derived satisfaction from being out of the office on inspection trips. Keller and his colleagues traveled around southern Italy, meeting officials and inspecting monuments, but these trips also thrust them close to the agony and hardships being endured by the Italian people. Each wounded child, destroyed home, and damaged town made Keller realize how sheltered and privileged his life had been. One letter to Kathy conveyed scenes he would see again and again during the months to follow:

> *At the hospital today a tall man, one leg shriveled, a man without any nose—two holes in his face and great sores on his cheeks asked me for a cigarette and bread. . . . Another man, a custodian, lost his house and holdings, in the American raid. . . . Then the flood came and ruined what little he had left. . . . He says, "Thank God the Americans came, killed and destroyed, for then the Fascists and Germans left for good, and I can stretch and [breathe] and speak again."*

Keller could barely contain his fury when soldiers turned cold shoulders to the sufferings of the local people. "I'll do what I can and try to make some of them feel that we all don't consider them all the scourge of the earth," he wrote Kathy. "I wonder sometimes how much heart there is in the world." He understood why some thought the Italians'

plight was earned punishment for their alliance with Nazi Germany. But during his three years as a student in Rome, Keller had developed a fondness and admiration for them. It became one of his motivations for entering military service. "You must understand that the Italians are good people by and large. . . . As they say themselves, 'Buona gente, buonissima gente, ma bisogna saperla prendere.' Good people, very good people, but you have to know how to take them."

Keller's paternal feelings also extended to "the boys," the young American soldiers, many the age of the students he once instructed. At forty-two, Keller was old enough to be their father. He admired them greatly, always taking time to study them as they passed. "There is a quiet seriousness about the foot soldier. He is proud, he knows what he's done & what it means to the individual. He does not complain. . . . it is near the top experience of my life to know some of our men who are risking everything."

Kathy responded to these letters with letters and packages. She and other family members sent boxes filled with chocolate, notebooks, soap, toilet paper, shaving soap, pencils, toothpaste, and stationery—staples her husband had requested but that nevertheless provided cause for celebration upon arrival. She also included pictures of her holding little Dino that offered a glimpse of home, which meant everything to him.

Making friends with the other Monuments officers came slowly to Keller. His taciturn demeanor hid a shyness known only to his closest friends. Few of his colleagues were married or had children; several were gay. He avoided after-work get-togethers and socializing, instead preferring to visit a church, stop by the Red Cross, or return to his room and write letters. Tubby Sizer, the man responsible for encouraging Keller to pursue becoming a Monuments officer, had departed Italy by the time of Keller's arrival. He had been transferred to the Civil Affairs Training School in Shrivenham, England, to begin work with newly arriving Monuments officers. Mason Hammond would soon follow. The Supreme Allied Commander, General Eisenhower, intended to capitalize on their experience in Sicily and southern Italy as he assem-

bled his invasion forces for Western Europe. Many churches, museums, and other monuments lay in the path to Berlin. Their knowledge would prove invaluable to incoming art scholars and museum men.

Hammond's successor, Major Ernest DeWald, formerly a professor in the Department of Art and Archaeology at Princeton, had been designated the Director of the Monuments, Fine Arts, and Archives Subcommission in Italy. A change in directors brought new leadership and ideas, a development Keller hoped would free him and the others from their cramped Naples office. But without a breakthrough at Cassino, there would be few new towns or villages to inspect. For the time being, they were stuck. Keller wrote, "The big work lies ahead and I'm getting myself in the proper frame of mind. . . . We are truly in the hands of Destiny, and I wouldn't have it different."

THE BATTLE FOR Cassino began on January 17, 1944. It would prove to be one of the most gruesome campaigns of the war. U.S. Fifth Army spent six weeks—and suffered sixteen thousand casualties—advancing the last seven miles to Monte Trocchio. The town of Cassino, on the edge of the Germans' Gustav Line, was still three miles away. Kesselring's commanders capitalized on what Allied General Harold Alexander called "one of the strongest natural defensive positions in the whole of Europe" to entrench their troops. By February 11, after three weeks of demoralizing struggle—against the Germans, the high ground, and poor weather—Allied Forces had incurred some ten thousand additional casualties. Memories of World War I stalemates such as Verdun began to creep into the minds of some commanders old enough to have witnessed the vast, muddy trench fields of eastern France and Belgium.

Casualty numbers alone do not convey the brutality of the fight. Colonel Young Oak Kim, a second-generation Korean American in the U.S. 100th Infantry Battalion—later known as the "Purple Heart Battalion"—condensed the misery and gallantry of the battle at Monte Cassino into a single story about a young infantry soldier:

All the way up this mountain ridge we had Germans at different levels all dug in and all shooting at us. They could put machine guns up there and fire at us and be totally immune to anything we could shoot at them. . . . I had one person next to me just two days before we withdrew. He was from Mississippi and had joined us a few months before. And he was sitting next to me, and we were both pinned down on this rocky ledge by a German sniper, and every time we tried to move our heads even a couple of inches he would fire. And so we were pinned there for something like three and a half hours. . . . it's raining miserably and we're stuck there, flat against this sort of rock. Some of our people are trying to shoot this sniper . . . trying to get us out of this predicament. All of a sudden he quits firing for almost twenty minutes . . . before, a rifle round was coming every two or three minutes. So we feel it's relatively safe. We figure, "well maybe one of our guys hit him." So we both sit up, and we no sooner sit up than Claudy—that was his nickname— was pulling out a cigarette and says, "You got a light?" I said, "Yeah." So I have to lean back to try to get in my trouser pocket to get the lighter out. The moment my head gets out of the way the sniper fires and put a bullet right through his head. And if he hadn't asked me for that light I would have been dead too. I was pinned there again for another two hours with Claudy dying on my side.

Day after day, through the injury and death of their buddies, soldiers fixed their attention on the imposing five-story structure of the abbey atop the hill. Without controlling the mountaintop, there could be no breaking through the Gustav Line. Incoming reports repeated the refrain, "The centre of resistance is Monte Cassino." At a certain point the distinction vanished. "The fortified mountain and the building at its summit were in military terms a single piece of ground." Allied generals now grappled with the question of how to approach that "single piece of ground" when the building was one of considerable historical and religious importance.

In accordance with Eisenhower's directive "to respect those monuments so far as war allows," Fifth Army commander Lieutenant General

Mark Clark had received a request from his superior General Alexander, commander of Fifteenth Army Group, that the Abbey of Monte Cassino be spared. However, Lieutenant General Bernard Freyberg, commander of the New Zealand Corps, whose men were fixated on the abbey while fighting to break through the Gustav Line, was convinced the abbey had to be destroyed. In a memo to Clark and Alexander, Freyberg insisted that "no practicable means available within the capacity of field engineers can possibly cope with this place. It can be directly dealt with by applying blockbuster bombs from the air."

But Eisenhower's order also stated that "if we have to choose between destroying a famous building and sacrificing our own men, then our men's lives count infinitely more and the building must go." Which part of the order applied to the abbey? With Ike now in England preparing for the invasion of Western Europe, Clark and Alexander sought the right answer. It would be the first significant test of Eisenhower's directive.

In an effort to evaluate Freyberg's request, many became convinced—and some convinced themselves—that German artillery spotters were actually in the abbey. Lieutenant General Ira Eaker, who had been reassigned from Eighth Air Force in northern Europe to command the Mediterranean Allied Air Forces, which included Italy, flew over the abbey on February 14 and reported seeing "Germans in the courtyard and also their antennas." That same day, Major General Geoffrey Keyes flew a similar mission and reported seeing "no signs of activity." He claimed that those who believed there were Germans in the abbey had "been looking so long they're seeing things." But to the battle-weary soldiers like Colonel Kim, dug into the hills and taking fire, the abbey had become a symbol of mocking invincibility.

The interpretation of Eisenhower's order, like the decision on whether or not to bomb the abbey, involved the entire chain of command. In the end, the order was given: dislodge the Germans by bombing the abbey. On the morning of February 15, waves of Allied bombers—229 in all—dropped 493.5 tons of high explosives and incendiaries. Portions

of the monastery walls collapsed into rubble even as more bombs fell. Hundreds of displaced persons had taken refuge inside; 230 were dead, including some who had assisted Dr. Becker of the Hermann Göring Division with crating and removing the abbey's cultural treasures just four months earlier. No Germans died because none were inside the abbey. Abbot Diamare and six fellow monks who sought shelter in the deepest vaults of the abbey survived. They and some thirty refugees— many severely wounded—emerged to discover a rubble pile where their medieval building had once stood.

Allied leaders took criticism for the decision to bomb Monte Cassino. President Roosevelt defended the action at a press conference by disclosing General Eisenhower's December 29 order for the first time, emphasizing the senior commander's concern for the lives of each Allied soldier. The former Archbishop of Canterbury, Lord Lang of Lambeth, took an opposing position, stating, "The loss of some temporary military advantage . . . could not be compared with a loss of civilization and religion which would be for all time, and irreparable." Others, such as Reverend L. F. Harvey, countered, "Does the Archbishop wish to convey that he regards human life as of less value than a monument?" A reader sent a letter to the editor of *Time* magazine slicing the question a different way: "May I inquire if any of the gentlemen so deeply concerned over the ancient monuments of Rome have an only son whom they are prepared to sacrifice on the altar of St. Peter's? If not, may I ask them to moderate the enthusiasm with which they propose to substitute mine?"

The "Allied lives or a monument" argument missed the point of Eisenhower's order, which rested on whether or not "destruction of the Abbey would in fact achieve a useful military purpose." General Alexander provided his perspective:

> *It was necessary more for the effect it would have on the morale of the attackers than for purely material reasons. . . . when soldiers are fighting for a just cause and are prepared to suffer death and mutilation in the process, bricks and mortar, no matter how venerable, cannot be allowed to weigh against*

human lives. Every good commander must consider the morale and feelings of the fighting men; and, what is equally important, the fighting men must know that their whole existence is in the hands of a man in whom they have complete confidence.

The morale of the fighting men, momentarily elevated by the punishing air attacks, did not stay elevated for long. German forces capitalized on the destruction of the monastery, using the remains as enhanced fortifications, just as some Allied commanders had argued they would. The rain and cold continued. So, too, did the dying.

10

CLOSE CALL

On January 22, 1944, the Allies launched Operation Shingle, an amphibious landing of British and American troops of the U.S. Fifth Army's VI Corps on the beaches of Anzio and Nettuno, some sixty miles west of the stalemate at Cassino and just thirty-five miles south of Rome. Allied military planners hoped to outflank German forces in the Liri Valley and, by threatening Rome and the German rear, draw off sufficient forces from the Cassino front to permit an Allied breakthrough. Neither objective succeeded. Kesselring had a contingency plan for just such an outcome and responded at once by holding at Cassino while also sending a rapid-reaction force to Anzio.

By early February, the Germans had amassed an army of more than ninety-five thousand men, preparing to launch a counterattack that would come close to driving the much smaller Allied force back into the sea. Only the magnificent stand of British and American troops saved the Anzio beachhead. Allied soldiers hunkered down in their foxholes, trying to survive the punishing shelling. One American soldier wrote, "Anzio was a fishbowl. We were the fish." That month, a record nineteen

hundred American soldiers died in the Mediterranean; March promised even worse casualties.

In an effort to change the dynamics on the ground, General Eaker and his Director of Operations, Brigadier General Lauris Norstad, expanded the use of Allied airpower, targeting German supplies and transportation in central Italy. The name of the operation—STRANGLE—defined its objective. Following a reorganization of United States Army Air Forces in the Mediterranean Theater, the heavy bombers of the Fifteenth Air Force oversaw "Strategic Operations"—longer-range missions targeting industrial sites in Germany and northern Italy. The Twelfth Air Force and the British Desert Air Force had responsibility for "Tactical Operations," which supported Allied ground operations and disrupted enemy railroad marshaling yards, repair facilities, and supply and communication lines.

The lists designating towns of cultural importance and related maps, which Monuments officers Sizer, Maxse, and Baillie Reynolds had submitted to Professor Zuckerman in early December, were now provided to aircrews. But the maps bore no resemblance to the terrain observed by pilots and bombardiers flying overhead. To rectify this, the Air Force flew a series of photograph reconnaissance missions over seventy-nine towns and cities in Italy. They then worked with Monuments officers to overlay the data on protected targets. These "Shinnie maps" (named for their creator, archaeologist Peter Shinnie) were published in February 1944. Later that month, Norstad also issued a two-page directive updating the list of Italian cities and segregating each into one of three categories.

Group A included just four cities: Rome, Venice, Florence, and Torcello (an island near Venice likely chosen for its archaeological importance). Those cities were off-limits to any bombing without special authorization from Norstad. Group B included such cities as Ravenna, Assisi, Como, and San Gimignano; Group C cities included Pisa, Siena, Verona, Bologna, Lucca, and Padua. Pilots had authorization to perform day and night bombing over Groups B and C cities. The accompanying rules were designed to minimize damage to nearby monuments with

the proviso that "it should be made quite clear to air-crews that the responsibility for such damage is accepted by this Headquarters."

On March 2, as the battles in Cassino and Anzio entered their third months, Norstad approved an attack on a previously protected target: the marshaling yards of Florence, one of the four Group A cities.* Norstad's instructions authorized his pilots to proceed if they deemed such a mission "necessary to meet critical military requirements. All possible precautions will be taken to avoid damaging the city, particularly within 1000 yards of Ponte Vecchio." Aware that any such mission would be difficult, and eager to minimize the burden on his pilots, Norstad added: "It is appreciated that the main marshalling yard in Florence can not be attacked without some damage to the city resulting."

Nine days later,[†] at Decimomannu Airdrome in Sardinia, drivers made their usual morning run to pick up aircrews from the 319th and 320th Bomb Groups—men in their late teens and early twenties—and ferry them to the main building. Pilots, navigators, and bombardiers filed into their respective briefing rooms, dressed in heavy high-altitude jackets, the occasional flying helmets, parachute harnesses, and "Mae Wests" (flotation devices that, when inflated, protruded like the vaudeville actress's buxom figure). The presence of a U.S. Army Signal Corps film crew, their cameras rolling, interrupted the otherwise-familiar routine. When the briefing commander entered the room, with its wall-size map of Italy and the Mediterranean area behind him, the chatter of the crews tailed off into silence.

* Florence had been bombed on September 25, 1943, as a secondary "target of opportunity" selected on short notice after the original mission on Bologna was abandoned due to cloud cover. Eleven of the thirty-nine B-17 Flying Fortresses changed course and headed for Florence to bomb the Campo di Marte marshaling yards. The bombs largely missed their target but killed 218 people, including Friedrich Kriegbaum. The Allies later bombed the outskirts of Florence on January 18 and February 8, 1944.

[†] Many sources cite March 23, 1944, as the first bombing of Florence. This is a popular misconception, probably due to an article published in National Geographic in March 1945. The author, 1st Lt. Benjamin C. McCartney, participated in the March 23 raid and stated his belief, although in error, that it was the first raid on Florence.

"Gentlemen . . . The target for today is the marshaling yards at Florence." As a round of low whistles filled the room, he continued:

We've been hitting targets around Florence for a long time, but we haven't actually hit in the city itself because approximately ten percent of the world's art treasures are located right here in Florence. And so we've got to be very careful. . . . It really is a hub of all of the rail supplies which come down into the Cassino Front and the Anzio beachhead. And so we've got to go in there today and we've got to smash the rail yards in Florence in order to relieve this pressure for these boys in the fox holes over at Anzio.

After distributing aerial photographs to each bombardier, the briefing commander directed their attention to the target pictures—photographs of the city's northwest marshaling yards with superimposed white boxes around churches and cultural sites that had to be avoided. One bombardier spoke up: "Sure got a lot of things we can't hit." The wisecrack explained the presence of the film crew; the higher-ups wanted proof that precautions had been taken for the precarious bombing mission on Florence.

The "northwest marshaling yard," or "main marshaling yard," referred to the main city railroad station, Santa Maria Novella, named after the historic church located just 426 feet away. Begun in 1246, Santa Maria Novella was the city's first great basilica. Its façade features unique S-shaped volutes and a broad, triangular pediment inlaid with geometric patterns of green and white marble. The upper portion is one of the few Renaissance façades on any of the churches in Florence. The interior, containing a wooden crucifix carved by Brunelleschi and fresco cycles painted by Domenico Ghirlandaio and Filippino Lippi, remains a critically important example of the late Gothic period in Europe.

In 1427, Santa Maria Novella received one of the divine gifts in the history of art—and its most treasured possession—the *Trinity* fresco by Masaccio. In this seminal piece, which represented an inflection point in the development of Western European art, Masaccio had intro-

duced the concept of one-point linear perspective, a groundbreaking technique that created the illusion of three-dimensional depth on a flat wall. As early as 1550, Giorgio Vasari gazed upon Masaccio's stunning achievement and explained how the artist "gave a beginning to beautiful attitudes, movements, liveliness, and vivacity, rendering relief in a way that was characteristic and natural and that no painter had ever before attempted." Through the centuries, artists and architects have studied

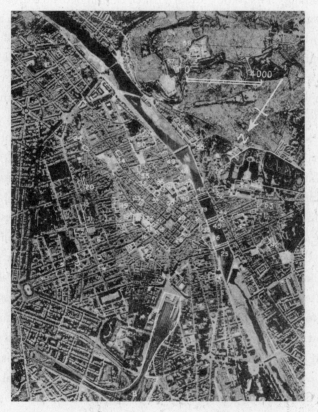

Allied bombers used this "Shinnie" map of Florence for their March 11, 1944, bombing of Santa Maria Novella train station (inside boxed area at bottom center). The Arno River runs vertically through the center of the photograph. Each monument received a number identifying it by name. The Ponte Vecchio is in the center (number 46); the Ponte Santa Trinita is below it (number 45). [National Archives and Records Administration, College Park, MD]

and admired the young master's creation, which proved to be one of his final works. Masaccio died just one year after completing the *Trinity* fresco at the age of twenty-six.

The men of the 17th, 319th, and 320th Bomb Groups did their work astonishingly well. First Lieutenant Roy Seymour, a twenty-four-year-old pilot from the 319th, son of a logger from the state of Washington, saved a bomb pin removed just before the drop and noted on the attached tag, "First time Florence has been bombed—did a good job."* The attack on Santa Maria Novella station may well have been the most precise bombing mission of the war. Seventy-eight B-26 Marauders dropped 145 tons of high explosives. All of the bombs stayed within the target area. The railroad tracks north and south of the city through the station were severed, and warehouses and repair shops were damaged or destroyed. There were at least twenty direct hits on the north end, and twelve toward the southern end nearest the church. "No flak or [enemy aircraft]. 1 B-26 crashed on take off, crew safe, and 1 is missing." The Air Force had proven that it was possible to achieve necessary military goals without destroying monuments.

That same day, March 11, more than one hundred B-17 Flying Fortress heavy bombers of the Fifteenth Air Force hit the marshaling yards of the Group C northern city of Padua, about twenty-five miles west of Venice. This was a strategic mission, not a tactical one. Taking the opposite approach from the Santa Maria Novella station mission, aircrews focused on what to hit rather than what *not* to hit. According to the postmission report, "The main concentrations of bombs fell on and around the R.R. station." From the view of the planners, this mission was also a success, but through the eyes of Lieutenant Fred Hartt, it had been a disaster.

Hartt had arrived in Italy on January 14, 1944. He spent his first three

*Just twenty-three days had passed since Lieutenant Seymour's first bombing mission. The target that day had been the Abbey of Monte Cassino. On the tag from that mission he wrote, "Excellent job—Demos."

months as a photographic interpreter for the 90th Photo Wing Reconnaissance, evaluating bomb assessment photos. The army provided him with images of cities after the smoke had cleared from bombing runs. Hartt then used the photos to assess collateral damage to nearby monuments.

In the aftermath of the Allied bombing of Monte Cassino, German radio aired propaganda accusing the Allies of damaging Italian patrimony. This made Hartt's mission all the more vital. Nevertheless, he found it agonizing. Hartt had signed up to save Italy's great masterpieces, but he couldn't save what had already been destroyed. He wanted to be a surgeon, not a pathologist. Restless and impatient, he looked for ways to wangle a transfer into the Monuments section.

The assessment photos from the Padua raid showed that bombs falling "around" the station had destroyed a number of key buildings. Even worse, two wayward projectiles had hit the Church of the Eremitani and its Ovetari Chapel. Hartt's dispassionate report belied the personal wound he felt: "Chapel of Mantegna obliterated by a direct hit, together with the apse and the whole right transept. Façade half-destroyed by direct hit. E. side of monastic buildings demolished." Moments later, the full impact of what he had just seen overwhelmed him. "I just couldn't continue working. I wandered into the streets of San Severo and realized 'the Mantegna frescoes are gone, they're gone, and I'm the only one on this side who knows.'"

Like many artists of his period, Andrea Mantegna had moved to a thriving city seeking the support of a wealthy patron or atelier. Since the early 1300s, the prosperous university town of Padua had drawn such talent. After being adopted by his teacher, Francesco Squarcione, an older Paduan painter, Mantegna enrolled in the local painters guild in 1441 at just ten years of age. Eight years later, he began painting the walls of the Ovetari family chapel, located in the Church of the Eremitani. The frescoes depicted the lives of St. James and St. Christopher. Mantegna's use of perspective—furthering the innovations of young Masaccio—and painstaking attention to detail resulted in lifelike scenes

so beautiful that his name would be mentioned by the fifteenth-century Italian poet Ludovico Ariosto in the company of just two other artists: Giovanni Bellini, and Leonardo da Vinci.

Still filled with rage four weeks later, Hartt wrote a letter to the new director of the MFAA, Major Ernest DeWald, pleading for a transfer. He informed DeWald that, "The Eremitani has been very badly hit, & the Ovetari Chapel, with all the Mantegnas, utterly wiped out. As a matter of fact, you can hardly tell there was a building there. The last of the stick of bombs missed the Arena Chapel by a mere hundred yards." Although not as well known as the Sistine Chapel, its destruction would have been no less great a loss.

Enrico Scrovegni, a wealthy Paduan banker, built the Arena Chapel in 1303 atop an ancient Roman arena. Dante had immortalized Scrovegni's father as the wicked usurer in his *Inferno*. Seeking to expiate his family's sins while demonstrating his own sense of good taste and piety, Scrovegni commissioned Giotto, who almost singlehandedly resurrected painting from the Dark Ages, to decorate the small and narrow devotional chapel. His creation was breathtaking: a series of individual stories or scenes, each part of a narrative, with common themes of the drama of human relationships. Giotto depicted the tenderness and affection of Joachim and Anna's kiss at the Golden Gate of Jerusalem in one scene as a contrast to the treachery and betrayal of Judas's kiss in another. These frescoes blended seamlessly from the walls to the barrel-vaulted ceiling, which Giotto had painted in lapis blue with gold stars, symbolizing heaven.

The fact that the Arena Chapel had avoided damage was, in Hartt's opinion, pure luck. Hartt closed his letter to DeWald on a cautionary note: "With Florence, Rome & Venice great care is being taken, but not with the other centers, and if you do not wish to see the great works of architects & fresco painting ground off one by one, prompt action will be necessary. . . . Right now I should characterize the situation as desperate." Two weeks later, his orders came through.

On April 15, Hartt filed a summary report of bomb damage in sixteen

Italian cities. It was an extraordinary piece of work. An academic career scrutinizing images of works of art, seeking clues to identify an artist or understand his working methods, had prepared him well to parse post-damage photos. One entry on Milan stood out from all others. Working with an aerial photograph dated September 5, 1943, Hartt evaluated the damage to Santa Maria delle Grazie and its adjoining Refectory and commented: "Neighboring Dominican convent [the Refectory] almost demolished by HE [high explosive], save for small section at NW corner, containing Last Supper of Leonardo da Vinci."

11

REFUGE

In May 1944, the last of the shipments of art from museums and churches across Italy arrived at the Vatican for storage. This marked the end of an effort that had begun almost four years earlier, largely at the direction of Professor Pasquale Rotondi, Superintendent of Fine Art for the Marche region, and Emilio Lavagnino, Central Inspector for the General Direction of the Arts.

The commencement of Allied bombing of Italy resulted in orders being issued by the General Director of Fine Arts to all Italian cultural officials: "The provisions arranged for the protection of cultural heritage shall be implemented immediately." Museums in Italy followed the lead of other great institutions in Europe, including the Louvre Museum in Paris, the National Gallery in London, and the Rijksmuseum in Amsterdam, and transported their contents to remote storage facilities. Officials began removing works of art from Italian cities, transferring them to various countryside villas and castles. Custom-made shelters protected those objects that couldn't be moved.

One place offered unparalleled protection: the 468-year-old stone Fortress of Sassocorvaro, about sixteen miles northwest of Urbino,

more than two hundred miles southeast of Milan, near the Adriatic Sea. Within its thick walls, massive rooms provided secure space for storing works of art. First to arrive were the collections of the Marche region—Bellini's altarpiece from the Pesaro Museum; paintings by Titian, Rubens, and Signorelli; ceramics and tapestries, nearly 350 pieces in all. In October 1940, seventy crates from Venice followed, including Giorgione's *The Tempest*. Shipments would continue to arrive over the next two years.

By early 1943, Sassocorvaro had reached capacity, forcing Rotondi to identify a second storage facility to stay ahead of the huge volume of paintings still arriving from museums and churches throughout Italy. In April, works of art from the Lombardy region arrived at the Marche region's new repository, Palazzo Carpegna. Included were archaeological items from the Castello Sforzesco in Milan. A second shipment brought the sumptuous high altar and retable—the *Pala d'Oro* (Golden Pall)—from St. Mark's Basilica in Venice. Even precious objects in Rome, some 190 miles to the south, were no longer considered safe from war. Masterpieces from the Borghese Gallery, along with the Cara-vaggio paintings from the Contarelli Chapel in the Church of San Luigi dei Francesi, soon departed the Eternal City to join thousands of oth-ers under Rotondi's watchful eye. Paintings belonging to the Brera and Poldi Pezzoli Galleries in Milan followed. By summer's end, Rotondi found himself safeguarding some thirty-eight hundred works of art and four thousand priceless archival documents. Conspicuously absent were any objects from the art-rich cities of Tuscany.

The sudden influx of German troops into Italy following the Sep-tember 1943 armistice spurred Rotondi to take additional precautionary measures. He concealed the most important paintings behind fake walls and removed labels from crates to dissuade curious German troops from inspecting their contents. The inventory list remained with him at all times. At one point, the increasing presence of German troops in Sas-socorvaro compelled Rotondi to hide paintings by Mantegna and Bellini in his bedroom at Villa Tortorina in the Urbino countryside. He placed

Giorgione's *The Tempest* under his bed. "That was a moment when I was really scared," he later said. "I feared these works of art would be stolen from me, or even worse, destroyed."

For all the precautions taken by Rotondi and other Italian art officials, too little consideration had been given to the possibility of a ground war. The Allied invasion of Sicily, followed by the landings at Salerno, changed that. Hundreds of thousands of troops would soon be fighting for every inch of Italian soil. No existing repository seemed safe.

With the Allied beachheads established, many of these same officials now wanted to relocate the great collections. But to where? In late 1943, Pope Pius XII had offered sanctuary by allowing the refugee artwork to temporarily join the massive collection of the Vatican. With German troops in control of Cassino, Rome, and areas north, and continued Allied air attacks, the neutral Vatican City emerged as the only place in Italy that offered any lasting hope of safety.

In December 1943, Rotondi and Lavagnino set their plan in motion. After scrounging for trucks, tires, and the increasingly rare commodity of gasoline, Lavagnino and a handful of dedicated men made a series of harrowing trips on bomb-cratered roads, pelted by rain and snow, usually during the dead of night, ferrying treasures to the Vatican. Kunstschutz officials, including its director in Rome, provided important assistance. At one point, Rotondi's wife tried to distract a local SS officer by getting him drunk, while her husband and others loaded paintings onto arriving trucks. The following day, the SS officer took both of them aside and said, "For what you did to me yesterday, I could have you shot right away, but I will not do it, I'll pretend nothing happened."

Lavagnino and other art officials were forced into retirement on January 1, 1944, for refusing to join Mussolini's Nazi-supported puppet government, but they continued their work anyway, without pay. By January 17, 1944, the works from Sassocorvaro had found safety in the Vatican. The effort to relocate items from museums and churches around Rome continued. On eighteen occasions, between January and May 1944, Lavagnino traveled back and forth from Rome, "by car, truck,

and pickup truck, carrying sculptures, paintings, sacred vestments. . . .
Of course I had moments of great fear and sometimes I even had to run
through the fields when we saw Allied aircrafts but, all in all, nothing
serious ever happened."

ITALIAN ART OFFICIALS were not the only ones worried about protecting
their collections. Six hundred miles away, a caravan of trucks continued
arriving at the working salt mines of Altaussee, Austria, about fifty miles
southeast of Salzburg—and less than a two-hundred-mile drive north-
east of the Brenner Pass on the Italian border. The trucks wound their
way through the mountains along a narrow road. Heavy snow accumu-
lations, in some places measuring sixteen feet, required the use of trac-
tors to complete the journey. Workers had been converting the mines
for a new use since August 1943. Elaborate shelving, in some places
more than two stories high, had been built into areas hollowed out by
hundreds of years of excavation. Workers from neighboring mines had
been reassigned to the task of handling the fragile cargo that was now
arriving—thousands of works of art, including masterpieces by Rem-
brandt, Vermeer, and Rubens, many selected by Adolf Hitler for the
Führermuseum in Linz.

Hitler's concern for the safety of his own art collection bordered on
paranoia. Some of these objects initially had been stored above ground
at monasteries in Austria; others had been hidden in underground air-
raid shelters. In December 1942, the German leader had directed his
private secretary, Martin Bormann, to write to an assistant, asking
"whether everything humanly possible has been done to protect our art
against fire." Bormann then added that a worried Führer "had asked
again whether the monasteries were really air raid safe and whether
camouflaging the buildings was not an idea as well."

By the fall of 1943, Allied bombings of German cities had become
increasingly frequent and punitive. The violence Hitler had rained upon
Europe had produced the greatest upheaval of art in history. Now it

threatened to claim his own collection. On Christmas Day in 1943, Hitler authorized the consolidation and transfer of his collection to the impregnable salt mines in Altaussee.

Those mines, as well as the city of Linz, fell within the territory of the Upper Danube, ruled by *Gauleiter* (district leader) August Eigruber, a founding member of the Upper Austrian Hitler Youth. Eigruber had declared his belief in fellow Austrian Adolf Hitler years earlier. During the early rise of the Nazi Party in Germany, while it was outlawed in Austria, Eigruber spent eighteen months in jail for spreading Nazi propaganda. Known for his fiery temper and ruthlessness, Eigruber quickly became "one of the most powerful Gauleiters of the Reich." In his eyes, everything was expendable in service to the Führer.

SS COLONEL DR. Alexander Langsdorff, recently appointed head of the Kunstschutz operation in Italy, arrived in Florence around May 9, 1944, with orders to oversee a very important operation. Langsdorff had served as a lieutenant in the Imperial German Army during World War I. He spent his eighteenth birthday, and the two that followed, in France as a prisoner of war. After his release, he studied German prehistory, ancient history, and archaeology in Berlin and at the Universities of Marburg and Munich. An ongoing interest in archaeology took him to Egypt, Iran, and Iraq from 1929 to 1933, where he became acquainted with Sir Leonard Woolley—now the senior British Monuments Adviser—during his historic excavations in Ur (in modern-day Iraq).

A supporter of Hitler as early as 1923, Langsdorff was present that November at the Beer Hall Putsch, Hitler's first attempt to seize power. He joined the Nazi Party and the SS in 1933, a "Septemberling" like General Wolff. The following year, he became the "personal artistic and cultural consultant" to SS leader Heinrich Himmler, serving as a member of his staff through 1944. During that time, he worked extensively with Himmler's cultural-heritage project, the Ahnenerbe, while continuing his affiliation as a curator with the Berlin State History Museum. In Feb-

ruary 1944, at Himmler's instigation and without consulting OKW, the Armed Forces High Command, Langsdorff became responsible for the Kunstschutz in Italy.

Langsdorff had fallen in love with Italy during his travels there as a student. Now, with so many of Germany's cities in ruins, he felt fortunate to return to his apartment in Florence, not far from Piazzale Michelangelo, with its enchanting view of San Miniato. "I experience Italy as never before, I breathe in the still existing, though everywhere so much threatened beauty, and am grateful and devout," he noted in his diary.

Kesselring's headquarters had ordered Langsdorff to assist Giovanni Poggi, the Superintendent of Galleries for Florence, Arezzo, and Pistoia, in moving three sets of bronze doors and some fifty sculptures out of an old rail tunnel near the town of Incisa. German troops had previously assisted Poggi's team in placing the doors in the tunnel as a protective measure. Now Kesselring needed the tracks for his supply trains. The art would have to go.

Andrea Pisano, and later Lorenzo Ghiberti, had created these remarkable doors for the Baptistery of San Giovanni in Florence, with their relief sculptures depicting scenes from the Bible, in the early fourteenth and fifteenth centuries, respectively. The last set of doors created by Ghiberti consumed twenty-seven years of work. Vasari described them as "undeniably perfect in every way," adding that they "must rank as the finest masterpiece ever created." Michelangelo paid homage to the work of Ghiberti with such lofty praise that it led to the name by which the doors became known: *Porta del Paradiso* (*The Gates of Paradise*).

As head of the Kunstschutz, Langsdorff's responsibilities included working with Florentine officials to relocate their works of art. Moving such historic and beautiful pieces conferred honor not only on the Kunstschutz operation but also on the German Army. Langsdorff considered the assignment a privilege. Transporting the doors back into the city, however, proved harrowing. The move, which required the use of cranes, fifteen train cars, and several trucks, occurred overnight, "in very

scary conditions due to continuous bombing." After delivering the last of them to the Pitti Palace, he celebrated at a beer garden in Fiesole with the others who had assisted him.

FOLLOWING EIGHT MONTHS of occupation, Kesselring and his troops prepared to evacuate Rome, and not a moment too soon. In the preceding months, partisan resistance fighters had conducted increasingly bold raids against the German occupiers. Communists, monarchists, socialists, Catholics, liberals, and anarchists throughout occupied Italy had joined forces in the fall of 1943 to create the Committee of National Liberation. This group of "clandestine origin" took up the fight against Nazi-Fascism as armed combatants. One attack in late March resulted in the deaths of thirty-three German policemen from the Alto Adige region assigned to Rome. German forces retaliated with swiftness and brutality. Acting on Hitler's orders, SS troops implemented a ten-for-one disincentive ratio for those considering such future attacks and rounded up and murdered 335 Italian citizens, seventy-five of whom were Jews.* The victims were led into the Ardeatine Caves, about three miles outside Rome, then executed in groups of five by a gunshot to the neck. The bodies, piled upon each other, filled the cave, which SS troops attempted to seal using explosives.

The brazen attack in the heart of Rome indicated that Germany was losing control of southern Italy. Sicily and Naples had fallen to the Allies. The Wehrmacht's grip on Monte Cassino and Anzio was tenuous at best. Soon the Allies would be driving on Rome. While General Wolff's "easy hand" approach to quelling unrest had failed as a policy, maintaining good relations with the Catholic Church had earned him favors with several influential members of the clergy. Now was the time to use them.

*The original list had 330 names. However, the Germans miscounted, and five extra men were also executed.

Upon returning to Rome on May 9, Wolff learned from his assistant, SS Colonel Eugen Dollmann, that he had been granted a special audience with the pope. It would be the only meeting between the Holy Father and a senior SS official during the war, and Wolff's only chance to win the favor of the still-influential leader for the uncertain days ahead. The meeting would also provide Wolff with an opportunity to capitalize on his assurance to the Holy Father, made the previous December, that as long as Wolff held his position in Italy the Vatican and its occupants were safe from abduction. Scheduling, however, presented a problem for the tall general, who arrived carrying a suitcase containing nothing but uniforms. The image of Wolff, the second-highest-ranking SS leader in the Nazi Party, wearing his black Nazi livery with its SS-bolts badge, and cap with its death's-head insignia, being greeted by Pope Pius XII, in his white robe, jewel-encrusted silver cross, and Piscatory Ring—the Ring of the Fisherman—would draw attention to a meeting neither party had any interest in advertising. Wolff scrambled to find more appropriate attire.

The following morning, wearing a suit and tie that belonged to his much shorter assistant, Wolff arrived for the audience with the pope. Dollmann accompanied him. The interlocutor, Father Pankratius Pfeiffer, explained that although the Holy Father wouldn't himself ask, he did hope for the release of a leftist youth leader, son of a well-known lawyer and a personal friend to the pope, who had been arrested and sentenced to death. As head of the German police in Italy, Wolff surely would be prepared to demonstrate his good faith by interceding. (Indeed, Wolff made the arrangements; almost four weeks later, the man was released to the custody of Father Pfeiffer.)

When Wolff entered the papal antechamber, Father Pfeiffer made the formal introduction and then withdrew; the audience commenced. During the course of their conversation, Wolff and the pope discussed the idea of a negotiated peace between the Germans and the Allies. Wolff "expressed my firm belief to see in him—the Pope—the indicated person to begin a relationship with the Western powers with the objec-

tive of anticipating the end of this war, which had now become point-less." Wolff knew this was dangerous. He noted that, "for the objective just expressed . . . I would be ready to put my own life and that of my relatives at stake."

It had long been the ambition of the Holy Father to act as a mag-nanimous peace negotiator to the warring parties. During their Janu-ary 1943 conference in Casablanca, however, President Roosevelt and Prime Minister Churchill had announced that the only basis for ending the war would be "unconditional surrender." This stance left no room for potential intermediaries. Roosevelt later explained the importance of this policy during a radio address drawing attention to "the Axis propagandist[s] [who] are trying all of their old tricks in order to divide the United Nations. . . . In our uncompromising policy we mean no harm to the common people of the Axis nations. But we do mean to impose punishment and retribution in full upon their guilty, barbaric leaders."

Both Wolff and the Holy Father agreed that "unconditional surren-der" was a mistake, albeit for differing reasons. Pope Pius XII called the policy "an obstacle on the path to peace." From Wolff's perspective, the whole notion of "punishment and retribution" offered nothing but a lengthy prison sentence—or a hangman's noose—for senior SS officials like himself.

This extraordinary meeting lasted about an hour. At its conclusion, Wolff faced the pope and, as he later recalled, "instinctively raised my arm" in a Nazi salute. "For years I had lost the habit of wearing civilian clothes, and that happened so spontaneously, as a gesture of respect. At that point, Father Pfeiffer took my arm and said that the Pope would have understood it in the right way."

12

LIFE ON THE ROAD

LATE MAY–JUNE 1944

The entrenched conflict at Monte Cassino and Anzio tethered the Monuments Men to their desks in Naples. The group—including Deane Keller, Fred Hartt, Ernest DeWald, and Perry Cott—grew increasingly anxious despite the transformation of Naples into a rest and recreation center. For soldiers on leave, and those stationed there, Naples had become "a fairyland of silver and gold and great happiness. . . . You could buy things in the shops; you could get drunk; you could have a woman; you could hear music." In a city where those lucky enough to find work often earned just 60 lire a day (about 60 cents), many women resorted to selling themselves, charging up to 2,000 lire a night ($20). And quite successful they were: at one point, more than ten percent of Allied soldiers in Italy had a venereal disease, which some treated with black-market penicillin.

Keller spent most nights in Naples alone. While he knew a lot about art history, he preferred the process of creating art rather than endlessly analyzing and discussing it. But many of his fellow Monuments officers enjoyed such conversation. "My patience has been sorely tried today," he wrote his parents. "Often I have to think of Michelangelo and how

bad he strove to keep on an even keel. Why God made me a painter I don't know." His letter to Kathy added the missing detail: "Two of my British Capt. companions discussed some God Damn draperies like a couple of fairies in my office today." "If I have to pass the days with a couple of jonquils* I'll be glad to go anywhere—just to get away from them."

On May 18, Allied Forces finally captured the Abbey of Monte Cassino and its remaining defenders, sixteen severely wounded German troops and two orderlies left behind by their fellow soldiers. When the cost of "victory" was calculated, the numbers did resemble the ghastly battles of World War I: fifty-five thousand Allied casualties, and some twenty thousand dead and wounded Germans.

Monuments officer Norman Newton reached the heavily mined and booby-trapped abbey, still under fire from German mortars, just hours after the remaining Germans had been driven out. While the west end of the abbey had suffered some damage, the sides facing the town of Cassino had been "mostly leveled to ground floor. . . . Statue of St. Benedict is headless but otherwise intact." The basilica was almost gone, but he noted: "Reconstruction of entire Abbey is possible although much is now only heap of pulverized rubble and dust."

While Monuments officers read Newton's report with dismay, most had agreed with the decision to bomb the abbey. Deputy Director John Bryan Ward-Perkins, who originally fought to save the building, felt differently upon arriving at the battlefield, observing that "the situation of the Allied troops in the ruins of Cassino was a brutal one. . . . For morale alone I believe the Abby had to go."[†] If the battles for Rome, Siena, Florence, and Pisa proved even a fraction as destructive as the fight for Monte Cassino, the Monuments officers faced a harrowing and tragic mission ahead.

* A slang term for a homosexual.

[†] His wife's uncle, fighting with the British Eighth Army, died at Monte Cassino.

Successes at Monte Cassino and Anzio enabled Allied forces to begin their drive toward Rome. Plans called for most Monuments officers to be transferred to the newly liberated regions of Italy as each came under Allied control. Several received new assignments. Keller's exceeded all expectation: he would be the lone Monuments officer attached to U.S. Fifth Army Allied Military Government.

Fifth Army included soldiers from more than a dozen nations, including Brazil, France, India, New Zealand, North Africa, and Poland. Only one-third were American. British troops accounted for another third. After frontline troops advanced from conquered territory, Fifth Army Civil Affairs officers established Military Government operations in newly occupied areas to stabilize day-to-day life and assist locals in rebuilding their towns. Keller would be Fifth Army's first responder, evaluating and reporting on the conditions of the monuments of every conquered town on the way to Rome and beyond. Norman Newton received the same assignment, representing the British Eighth Army.

On May 19, the night before departing Naples to join Fifth Army, Keller held up the sleeve of his uniform to the small light near his bunk. In one of his March letters he had written: "I haven't worn my ribbon or shoulder patch yet. Don't know when I will. I feel the boys at [the] front are the ones to wear the stuff. Maybe some day I'll feel I earned it." Now, two months later, on the eve of his march toward Rome, Keller thought it was time.

As he pulled the needle through, Keller couldn't help but be impressed with his sewing skill. The shoulder patch had a large white *A* standing like stilts over a white *5* on a field of blue, overlaid on a red patch. The field of blue was actually a silhouette of a mosque—a reminder that Fifth Army had been activated in the French Moroccan town of Oujda. The shoulder patch wasn't regulation issue—he had bought it on the streets of Naples—but it would do.

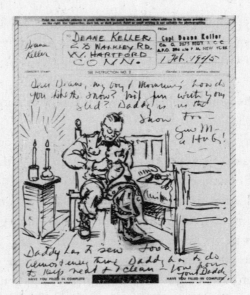

This drawing by Deane Keller shows him sewing a Fifth Army patch on his uniform. This, and dozens of others he drew for his son, Dino, created a lasting bond between father and son. [Deane Keller Papers, Manuscripts & Archives, Yale University]

NINE DAYS INTO his new assignment, Keller drew an army jeep on a piece of V-Mail stationery alongside a message to his three-year-old son.* "Kiss Mommie for me. You are a good boy and Daddy loves you—good bye now—love from Daddy."

Since his deployment, he had continuously tried to parent Dino from afar. In April, he began sending him personalized cartoons. The boy could not write yet, but drawing became their way of communicating, a jointly understood language. This shared love of drawing would come to define their relationship.

Keller slept in a different place almost every night. That's how it was

* "V-Mail" stood for "Victory Mail." According to the National Postal Museum, the creation of V-Mail involved microfilming the original letter sheets and then transporting the microfilm overseas, where it was printed for the recipient. V-Mail saved valuable cargo space and was usually transmitted more quickly than regular mail.

with Fifth Army, and, as he explained to Kathy, it suited him just fine. "I have been as happy in my work in this outfit as I can be on this side. . . . I feel that my job is a great honor." Keller rarely used the word *happy* in his letters. Sense of purpose alone seemed to buoy his spirits. On the long rides, he prepared for each new assignment: inspect all monuments in a given region, make an initial assessment of damage, take neces- sary measures to protect monuments and cultural treasures from fur- ther harm, and then move on to the next town. Usually he would arrive within hours of its liberation.

While most outfits proved helpful, a few officers and GIs sometimes referred to the Monuments Men as "mousy Venus Fixers." Even General John Hilldring, who as Chief of Civil Affairs would later become a strong supporter of the mission of the Monuments Men, once referred to them as the "'scholarly mouse' type . . . rambling noiselessly around the Medi- terranean Theater. . . . they didn't do a damn bit of good, because the word didn't get down to the troops what General Eisenhower wanted." Keller knew that only consistent, hard work would debunk the notion that Monuments officers were in Italy for something more than some kind of surreal art tour.

Keller had departed Naples for his new assignment on May 20 and was driven thirty-five miles north to Fifth Army AMG Headquarters, in Sparanise, "a tent city in olive groves." When he arrived, the army issued him the most critical part of his gear: a "general purpose" vehicle, whose first two initials—GP—had evolved into the nickname "jeep," or so some said. One person commented that *jeep* "sounded more like a noise than a name" for a vehicle. "Good Lord, I don't think we could continue the war without the jeep," wrote Ernie Pyle, America's most popular war correspondent. "It does everything. It goes everywhere. It's as faithful as a dog, strong as a mule, and as agile as a goat. It constantly carries twice what it was designed for, and keeps on going."

Keller received in a day what Mason Hammond had sought for seven months: reliable transportation. There would be no jury-rigged civilian vehicles—no "Hammond's Peril." Eleven feet long, five feet wide, and three

feet high, the jeep, with its sixty-horsepower manual transmission, was anything but a vehicle of luxury. But to Deane Keller it was empowering.

Eighth Army's liberation of Cassino had freed up most of Fifth Army to advance northwest into the high country. The mountainous region, with its sharply curved roads and steep valleys, encouraged the same ambush-and-retreat strategy so effectively employed by German forces south of Cassino. As a student at the American Academy in Rome some eighteen years earlier, Keller had traveled these roads. He knew that the 130-odd-mile stretch to Rome linked dozens of small towns, each with its own rich history, monuments, and cultural treasures. If the shattered remains he had already passed were any indication, his path to Rome— the first Italian city to captivate him—was going to be a dissonant mixture of "beauty and desolation."

Keller's first official assignment with Fifth Army began the following day at the seaside town of Gaeta, thirty-four miles from camp.

The road was bumpy and dusty. . . . The roads were hardly cleared of rubble— just enough to let a 6 x 6 by. All other vehicles except 10 ton wreckers with carriers (tanks) could make it. Wires were down; mine sweeping squads were working over the ditches on either side of the road. "Mines swept + 4 feet" signs, black on yellow, were spaced at intervals. MPs and all sorts of military were parked on the route. The jeep was open and at the Light Line the windshield had to go down as the glare would make it a fair target.

After passing a bend in the coastline road, Keller observed a distressing scene. Many of the buildings in Gaeta had been damaged by shelling and bombing, rendering numerous streets impassable. Beaches resembled a maze of barbed wire. The town's main water supply had been destroyed. Allied troops had turned inland, and in their wake, several hundred Italian civilians had stumbled out into the streets, filthy and starving. Deane Keller, portrait painter, was trained in the art of expression, but he had never witnessed anything like Gaeta. These people were lost.

At the side of the main road, a Civil Affairs officer was waiting with

salt for the local baker, but there was no vehicle to deliver it. Keller and his driver, an officer of the Carabinieri, Giuseppe de Gregorio, arrived on the scene. Keller understood that bread in Italy wasn't just peasant food: it was a symbol, a sacrament. "A middle-class Italian told me he could not bear to see a child drop a piece on the floor and spoil it for eating. To throw away bread is worse than swearing." Keller didn't hesitate; they loaded the jeep and drove the baking supplies into town.

He lugged pipe so the town's engineers could repair the main water works, then he delivered the freshly baked bread to a distribution point in the town square. Keller watched the Italians eat. These were defeated people, stunned and fearful. Many were refugees from the south, cut off for weeks from their families and friends. Some were children. Some were badly wounded. "When I see a little boy Deane's age with one leg, the other blown off by a bomb. . . . It makes me feel terrible. I got sick to my stomach and sick at heart." Quite a few, he would learn, had been living in caves, scavenging insects and berries from the hills. The farms had been so thickly mined by the Germans that the fields were unworkable. There was nothing else to eat.

The instructions from Brigadier General Edgar Hume, commander of Allied Military Government in Italy, had been clear: provide direction, but make the local population do the work. In Gaeta, Keller realized the wisdom of that advice. The Italians needed something to do, some way to participate not only in rebuilding their lives but also in rebuilding their pride. Seeing the broken faces, among the crowd quietly eating their bread, reinforced the wisdom of Hume's advice.

Finding someone who knew what had happened to the town was essential. While Keller listened to the local priest, Giuseppe carefully maneuvered through the town's rutted and mine-strewn streets. Local knowledge not only proved essential to Keller's preservation mission, it also kept him alive.

Keller heard a story that would become all too familiar in his inspections of other small towns. It began in September 1943 with the German occupation. In early May 1944, shortly before Allied forces had captured

Cassino, German troops began to dig trenches. After chopping down trees to create roadblocks, they positioned artillery and heavy guns. Looting of shops, churches, museums, and homes often followed. Civilians scattered to the hills, or huddled in cramped basements, knowing the battle neared. A tense silence followed until the first of the Allied bombs, then artillery, and finally the German retreat, fighting backward from building to building, cutting electrical lines and blowing up bridges as they fled.

Shelling from the big guns of the Allies crumbled the buildings. The fighting intensified, with bodies from both sides lying facedown along the road, or hanging lifeless out of windows. Small arms and machine-gun fire would crackle through the narrow streets. And then it would be over. It might take a couple of days or only a couple of hours, but the battle would rise from nothing and disappear just as completely, leaving behind wounded and dead soldiers, blistered buildings, and terrified civilians. The people would crawl out of their churches or their caves, wherever they had been hiding, and wander aimlessly among the ruins, dazed and silent.

At first, Keller's fellow officers and some troops wondered why, with wounded men to care for and the dead to be buried, he would show so much concern for buildings and works of art. Yet Italians never questioned his presence or his mission. They cheered as he plucked the local superintendent from a crowd, or sought help from a prominent citizen if the superintendent had been a Fascist. There was always someone knowledgeable and passionate about the town's history and artistic heritage. As he examined the remains of each building on his list, Keller would listen as the local man recounted the familiar sequence of destruction. When he reached into the back of his jeep and grabbed an OFF-LIMITS sign, a group of townspeople always gathered round nodding and smiling as he nailed it on the wall of a building.

Citizens of the liberated cities and towns appreciated his effort. The Italian government had bombarded its citizens with misinformation, saying that the Allies "have but one aim, to destroy everything, with no discrimination. . . . the enemy—proving it for the 1000th time—wants

to hit our people, wants to humiliate and destroy our history and our civilization." Keller's presence and interest in their villages resoundingly undermined such propaganda.

Most villagers were helpful. A few—the holdovers from the Mussolini era, the *impiegatucci* (little bureaucrats), focused more on making a good impression—*fare una bella figura*—and exercising their *autorità* than doing any meaningful work. As Keller explained to Kathy, "Maybe I am getting a little pooped, for the Italians irritate me a lot. Too much talk and too little accomplished . . . at least with the little bureaucrats. I know their sufferings, but it's exasperating."

Gaeta was just the first town on Keller's list, not the worst hit. Each day he visited others. The town of Itri, an ancient jewel perched on a mountainside seven miles north of Gaeta, had tumbled down the cliff and splintered into a slag heap. He couldn't even identify the remains of its most famous monument, the Monastery of San Martino. It had simply disappeared.

In the ancient town of Terracina, Keller discovered a message left by German troops on a blackboard in front of the Civic Museum. *"Chi entra dopo di noi non troverà nulla"* ("Whoever comes after us will find nothing"). The Roman sculptures, the pride of the museum, had been left in the unlocked building for anyone to steal. But something quite different had been left behind near the Temple of Jove Uxor: telephones, guns, beds, food, and two hundred dead bodies stretched out in rows. Keller remembered the thick, sweetish smell of death. The fact that the dead were German soldiers didn't really matter; every man had a face.

AFTER SEVERAL DAYS on the road living out of his jeep, Keller would circle back to his new "home," the Allied Military Government (AMG) advance camp at Formia, a coastal town about halfway between Naples and Rome, to restock supplies and have access to a typewriter to prepare his official reports. On such evenings, letters to Kathy and drawings for Dino had to wait, as would a stop for a beer or a shot of whiskey at the

small bar run by the nice Italian boy. He preferred to write his report while the details were fresh. After arranging his field notepads and the list of monuments he had examined, Keller began typing, "doing it by the numbers," as he always had.

In the two weeks since joining Fifth Army AMG, so much had happened, so quickly, that Keller had a difficult time recording it all in his reports. He thought about Valmontone, a mountain city just thirty miles southeast of Rome that had been shelled without mercy. The dome of its cathedral had been cracked, the doors smashed, the walls pitted and flaking like the skin of a man in the dying stages of leprosy. Behind the church, Keller found hundreds of civilians huddled in a cave, their meager belongings at their feet.

The memory of the first dead American infantryman Keller saw, lying in the street of the nearby town of Palestrina, haunted him. As he looked down at the body, he noticed the lining half pulled away from the steel plate of the soldier's helmet. Inside Keller found a letter addressed to the boy's mother. For a man who believed that "the life of one American boy is worth infinitely more to me than any monument I know," it was a sorrowful experience.

But the experiences hadn't all been tragic. One happy memory that lingered occurred at the great Abbey of Fossanova, "an admirable example of French Gothic architecture and among the most beautiful churches in all of Italy"—and the place where Thomas Aquinas had died in 1274. Reports that the Germans had occupied the abbey for the duration of their stay in that area, even holding an elaborate party in the refectory on Christmas Eve in 1943, left him worried about its condition.

As he drove to Fossanova, along the edge of the Pontine Marshes, the beauty of the afternoon was marred by thoughts of the victors at Anzio, whose reward was to slog through the low-lying malarial plain. From a distance he caught his first sight of the abbey, its white walls gleaming. Ten-ton trucks rumbled by on the main road, artillery boomed in the distance, but the old stone walls stood apart, seeming to rise to meet him as he approached.

Keller entered the undamaged sanctuary and saw the priest of the abbey, Don Pietro—"a very capable fellow"—who had been providing accommodations for Allied servicemen and refugees. Noticing an organ behind the High Altar, Keller asked him to play Schubert's *Ave Maria*. Some fifty or so Allied soldiers listened raptly. As the last note resonated, the servicemen stomped and cheered for more. War had introduced many new sounds to a soldier. After months of artillery fire, gunshots, trucks, planes, engines, and radios, music offered otherworldly grace. That sublime moment would sustain Keller in the months ahead.

13

TREASURE HUNT

The advance of Allied troops forced Generalfeldmarschall Kesselring to finalize his plans for the withdrawal of Rome. He first submitted recommendations to OKW on February 4, 1944. Although Kesselring had no desire to damage monuments or other important structures, slowing down the enemy advance took priority. For that reason he advocated demolition of the city's bridges crossing the Tiber River. That plan had received approval but for one glitch: owing to the Führer's view that Rome's bridges had "considerable historical and artistic merit," they were to be spared. On June 3, OKW directed Kesselring: "Führer decision. There must not be a battle of Rome."

Hitler had relished the experience of visiting Rome in 1938 and again in 1940. After viewing the paintings and sculpture in the Borghese Gallery during his first trip, he "continued imagining the possibility of returning to Italy, perhaps one day, 'when everything would be in order in Germany' and to move into a small house in the outskirts of Rome and visit the museums incognito." Hitler understood that the destruction of Rome's historic and artistic monuments would be disastrous propaganda, but, more than that, he loved the city itself.

On Sunday, June 4, two days before Allied forces stormed the beaches at Normandy, U.S. Fifth Army became "the first army in fifteen centuries to seize Rome from the south." In the weeks that followed, a steady stream of dignitaries—diplomats, intelligence officials, and military officers—headed to the Vatican for audiences with the Holy Father. Among them was the tall, silver-haired Major Ernest DeWald, Director of the MFAA in Italy. At fifty-two, the World War I veteran and Princeton professor was one of the world's leading authorities on medieval illuminated manuscripts and early Italian paintings. Fluent in German, Italian, and French, he had a great love of opera and even briefly pursued a career as a singer. One Monuments officer noted that, on occasion, he could be seen, "walking stick in hand, singing Mozart arias."

DeWald's Deputy Director, Major John Bryan Ward-Perkins, a British archaeologist, had stayed in Naples to make arrangements for the transfer of MFAA operations to Rome. DeWald had no prior experience in Monuments work, but Ward-Perkins had served with distinction in the North Africa campaign, where his efforts to protect ancient ruins from curious troops made him, in the words of Mason Hammond, "the first officer, British or American, actually to undertake Monuments work."

Ward-Perkins had previously worked at the London Museum, and the University of Malta, before joining the British Army in 1939. Colleagues found him charming and enjoyed working with him. During the North African campaign, he crashed his motorcycle and landed in an Egyptian hospital. While recuperating, he fell in love with Margaret Long, a British nurse serving in the Voluntary Aid Detachment. They married shortly afterward and honeymooned in Luxor. After returning to duty in January 1943, Ward-Perkins and Lieutenant Colonel Sir Mortimer Wheeler, acting on their own initiative, saved the ancient Roman sites of Leptis Magna and Sabratha (in Libya) from damage by convincing commanding officers that the ruins should be placed off-limits to troops. They also posted guards and set about educating soldiers about the importance of the sites as a way of winning over their cooperation. In time, Monuments officers in Italy and Western Europe would repeat the strategies Ward-Perkins pioneered.

Seeking to avoid the billeting problems and looting that had plagued their efforts in Naples, DeWald arranged for three Monuments officers—Lieutenant Perry Cott, British Captain Humphrey Brooke, and Lieutenant Fred Hartt—to enter Rome with the troops. Within days, Hartt had completed a damage assessment of the city and its most prominent monuments. The Basilica of San Lorenzo, which received one direct hit in the July 19, 1943, Allied bombing raid, was severely damaged—but repairable. In fact, Hartt reported that local art officials had already erected scaffolding to repair the roof. "Despite widespread damage to civilian buildings in the Ostiense, Tiburtina, and S. Lorenzo suburbs," the areas surrounding the marshaling yards and airfields bombed by the Allies during their July and August 1943 raids, "no further damage to cultural monuments in Rome could be ascertained from inspection or from reports."

Credit for the extensive protective measures taken in Rome, like those in other Italian cities, belonged to the nation's cultural officials. After evacuating movable works of art, authorities went to work protecting permanent works. Officials wrapped Michelangelo's eight-foot-tall sculpture of *Moses*, located in the vestibule of Rome's Church of San Pietro in Vincoli, in protective cloth, then entombed it in brick. The Arch of Constantine—a triple arch measuring almost seventy feet in height and eighty-four feet in width—was encased using sandbags and scaffolding. Roman authorities even wrapped Trajan's Column in brick, a project so beautifully conceived and executed by local craftsmen that the protective measures weren't noticeable at first glance.

Beyond the mammoth labors of the Italians, undertaken and executed with foresight and dedication to their culture, the most difficult assignment fell to Perry Cott, a man well known to DeWald. After receiving his undergraduate and doctoral degrees from Princeton, he became Associate Director and Curator of the small but important Worcester Art Museum in Massachusetts before beginning his career as a Naval Reserve officer. His knowledge of art and gift for languages made him an easy choice for Monuments service.

Cott had orders to verify that the city's museums were secure and

then to post OFF-LIMITS signs on all buildings on the MFAA's "protected" list to prevent troops from entering. He hitched a ride up the Janiculum Hill to the American Academy, alma mater to four of the Monuments Men on duty in Italy.* There he met with Professor Albert van Buren, who had insisted on remaining in Rome to oversee the academy after it suspended regular operations in 1941. Van Buren briefed Cott on the general situation in the city and the German occupation. He spent his first night in Rome bivouacked in the gardens of the Villa Borghese. The following day, Cott met with Professor Aldo de Rinaldis, Superintendent of Galleries in Rome, to discuss the security of the city's museums, all but one of which had long since been closed. De Rinaldis informed Cott that most of the works of art in Rome had been safely stored in the Vatican, but only after the incredible adventure orchestrated by Rotondi and Lavagnino, in which the art went out to the countryside and back again under harrowing conditions.

Even before the arrival of Rotondi and Lavagnino's shipments, the Vatican possessed one of the greatest collections of art in the world. With the temporary addition of works from the Brera Picture Gallery in Milan, Accademia in Venice, Borghese Gallery in Rome, Museo Nazionale in Naples, the holdings of dozens of less prominent museums, and many priceless riches from the nation's churches, it now had few, if any, rivals anywhere on earth. Joining its remarkable collection were—to name just a few—the Caravaggios from Santa Maria del Popolo and San Luigi dei Francesi, and oversize canvases by Titian, Veronese, Tintoretto, and Tiepolo from Venice. Never before or again would the results of such creative genius be gathered in one place.

After presenting his credentials to the Holy Father, DeWald explained the purpose of the Monuments operation, offering his services to the

* Monuments Men Deane Keller, Norman Newton, Sidney Waugh, and Bernard Peebles each received the Rome Prize. So, too, did Keller's friend Walker Hancock, a Monuments officer serving in northern Europe. Monuments Men Patrick Kelleher, Mason Hammond, and Craig Hugh Smyth became postwar fellows, bringing to eight the number of Monuments Men affiliated with the American Academy in Rome.

papal collections and the Vatican. This marked the beginning of a close relationship between the Monuments operation and the Vatican, as evidenced by DeWald's subsequent audiences with the Holy Father. DeWald and his team then set to work inventorying the crates that the Hermann Göring Division had delivered to Rome the previous winter.

On June 26, DeWald, Cott, and Lavagnino began the first of six separate inspections. The team relied upon an inventory list DeWald had received from the Naples Superintendent. During the course of their work, Lavagnino recounted for the others the events of that cold January day six months earlier, when trucks of the Hermann Göring Division pulled up to the Palazzo Venezia and began unloading the 172 Naples crates. Lavagnino then let it slip that he suspected the Germans had taken paintings out of the crates before delivering them to Rome. He told DeWald that although a German officer initially told him the convoy was "delayed," the missing crates never arrived. In late January, eager to identify the contents himself, Lavagnino began inspecting crates and noticed that "almost all the boxes have been opened previously, because the paper that wrapped the pictures has been torn apart, probably to identify the paintings." The sudden news of the Allied landings at Anzio, thirty-five miles south of Rome, forced Lavagnino to suspend his investigation into the mystery of what appeared to be tampering of the shipment by the Hermann Göring Division.

Within a few minutes of DeWald and Cott's examination, the group came to the same conclusion as German officer Dr. Becker had eight months earlier when he interrupted the looters engaged in their "unbelievably shitty business" in Spoleto. Crate no. 1, which, according to the Naples superintendent's list, should have contained the world-famous painting of *The Blind Leading the Blind* by Pieter Bruegel the Elder, and two paintings by Anthony van Dyck and Thomas de Keyser, was missing. When DeWald later opened crate no. 29, he discovered that someone had shoved into it the de Keyser painting from crate no. 1. He then found the Van Dyck belonging to crate no. 1 inside crate no. 58. But the Bruegel, by far the most important painting of the three, could not be

found in any of the crates. Obviously someone had taken it. The thieves not only knew its importance, they also knew enough to leave behind the lesser paintings by Van Dyck and de Keyser, placing them in crates with extra space.

And so it went. Case no. 3: "completely missing." Gone were paintings by Pannini, Battistello, and Titian's *Danaë,* one of the world's best-known and priceless works of art. "Case No. 8: Two of three pictures are missing. They are: Filippino Lippi, 'Annunciation.' Joos van Cleeve, a Triptych. The third picture, 'Cain' by B. Cavallino, was found packed in with the pictures of case No. 29." DeWald summarized their work in his report: "The evidence therefore of the foregoing is fairly complete that the cases were tampered with prior to their reaching Rome. The particular evidence of cases No. 1, 8, and 38 show that these pictures were intentionally taken."

DeWald and his team, including Lavagnino, had no doubt that the missing Naples pictures had been taken by the Hermann Göring Division. The brazenness of their theft appalled the Americans. To steal some obscure work of art was one thing. But the works taken from the Abbey of Monte Cassino were among the most recognizable works of art in the world. For all practical purposes, the Hermann Göring Division might as well have driven to Naples, backed up to the doors of the Museo Nazionale, and lifted the masterworks off their hooks.

Reports of Nazi looting throughout Eastern and Western Europe proliferated. By now, the missing artworks were likely in Germany, perhaps even hanging on the walls of one of Reichsmarschall Göring's homes. Naples had introduced the Monuments Men to wanton destruction caused by German forces, but the inventorying of crates at the Vatican provided them with the first evidence of theft by the Nazis in Italy. With the Germans now retreating northward, through art-rich Siena, Florence, and Pisa, it seemed certain there would be more.

14

SURPRISES

Strangely enough, of the hundreds of works of art DeWald and his team catalogued at the Vatican, none had been sent from Tuscany or its capital, Florence. Somewhere in the path of the retreating German Army lay famous paintings and sculpture by Leonardo da Vinci, Michelangelo, Raphael, Botticelli, and others. Although officials in Rome had lists indicating the locations of the Florentine repositories, they considered them outdated. But they did not appear unduly worried. The Florentine Superintendent, Giovanni Poggi, was one of the world's most knowledgeable experts on the protection of cultural property during war. Most likely they had been moved back from the repositories into Florence and safely stored out of harm's way.

While DeWald, Cott, Hartt, and others from the Naples office were busy in Rome, Keller continued his inspections of newly liberated towns and villages farther north. Six weeks on the job as the Monuments officer for U.S. Fifth Army had already provided him with quite an education, as he explained to Kathy: "In smaller towns there is usually one church which people like better than any others, usually the patron saint of the town. . . . now when I enter a new place I always try to discover

the patron saint immediately in order to get on the right side of the people there. It is a sort of Dale Carnegie method for getting along in Italy."

His jeep had taken on the importance of a cowboy's horse. "I am getting more careful all the time, look out for my jeep with the care which you exercise in looking out for our beloved Dino. . . . jeeps are stolen and all sorts of things can happen to them. I need it, for it is my life & my job." The condition of the roads was dismal, usually nothing more than dust ground as fine as talcum powder. "I shook my pants on the window and a cloud arose. I've learned to cherish my wash cloth like a child." Despite being consumed by his work, Keller managed to remember his upcoming sixth wedding anniversary. He made arrangements through letters to his sister-in-law to have flowers delivered to Kathy, making sure that at least one was yellow.

In the early morning hours of July 3, Allied forces liberated the first town in Tuscany—Siena. The city had suffered minimal damage, having been, in Keller's words, "artistically bypassed" by German forces. A more precise explanation involved Kesselring's decision to declare Siena an "open city." This meant that while German defensive efforts were being abandoned, the Allies would not attack the city. The distance between the combatants was almost nil; Allied forces reached Siena just two hours after German troops had evacuated.

Keller arrived the following day to discover protected-monuments signs already posted on most of the fifty buildings and churches on the MFAA list, the work of a conscientious Civil Affairs officer, Captain Edward Valentine. It had the desired effect, as Keller noted in one of his reports: "We were called 'barbarians, assassins,' and evildoers of all sorts in the rich Italian vocabulary. Now the Sienese could read in English and Italian, for some of our 'Off Limits' and protective signs were in both languages, that the 'Anglo-Sassoni assassini' were not really that at all. In the wake of care for their rich artistic heritage they could also believe that we were to bring them food, law and order, medicines and a return to normal peaceful living."

Siena's great moment of artistic flowering had occurred during the

fourteenth century. The stunning *Trecento* works from its churches and museums had been sent, along with those from nearby towns, to countryside villas and palaces. On July 8, Keller reached the most important of the three major Sienese repositories, the Bishop's Palace at nearby Mensanello. Allied forces had just wrenched control from German troops. French artillery batteries hammered at German positions nearby.

Keller entered the palace to discover a makeshift first-aid station, where a French military doctor was treating three wounded French Colonial soldiers. Continual artillery fire drowned out Keller's introduction. After sizing up the scholarly looking, middle-aged Fifth Army officer standing before him, and establishing why he was there, the French doctor pointed at two large crates leaning against the wall. As Keller walked over for a closer look, he noticed that someone had cut helmet-size holes in the side of each crate and then removed the excelsior and flannel wrapping to see what was inside.

As Keller peered inside the first hole, time stopped. For a moment he was oblivious to the sound of the artillery, the blood on the floor, and even the injured soldiers. Imprisoned inside the crates was an old friend, the *Maestà*—the *Enthroned Madonna*—the high altarpiece from the Siena Cathedral, the city's most important work of art. Keller had last seen it as a student almost two decades earlier.

The Sienese artist Duccio di Buoninsegna created the exquisitely refined panel of the Madonna and Child, surrounded by angels and saints, between 1308 and 1311. Duccio used vivid colors to paint his figures with a delicacy and tenderness, a style that influenced two centuries of artists who followed. And now Keller had found it, some 633 years later, in the middle of a war zone. The guns continued their percussion in the distance, but the altarpiece appeared safe and, from what he could see, undamaged. "The French Captain in charge was kind enough to give [me] five minutes in which [I] explained [my] understanding of the medical situation and importance of the deposit in the room—in this order. The French Captain was most cooperative and said that his outfit and the Americans there were leaving at 7:00 that night."

The doctor hurriedly added that because the Germans took the overseer of the estate with them as they fled, the fate of the *Maestà* and forty other smaller masterpieces fell to Don Luciano, the priest in charge of the seminary at the palace. Rattled by the constant pounding of the artillery, Don Luciano had hidden many of the smaller paintings inside the palace chapel—some in a crate, others in the drawers of a bureau. After examining the unprotected paintings with Don Luciano, Keller carefully removed and wrapped each one in blankets and rags to prevent damage from artillery vibrations.

Although the works were scattered and poorly packed, German troops had largely respected a protected-monuments sign posted by order of Kesselring. The situation could have been far worse—and might yet be. Unable to post guards, Keller notified the Siena Superintendent of his discovery and hoped that, until help arrived, Don Luciano's presence would keep the works safe.

In the month of July alone, Keller had inspected fifty-five cities, approximately two per day. Weariness hadn't diminished his gratitude for such an important assignment. As he explained to Kathy,

> *I am really very fortunate and very much honored by my assignment. . . . It has given me an opportunity to see our great Army in action . . . to see what fearful things occur and to see how men face death and destruction. This sounds a little dramatic, but when a tank looms up out of a dense cloud of dust with a serious American face—young and intelligent, reaching out of the turret, earphones on, part of a team of a few men, guns, fore and aft—deafening clatter & grinding of the caterpillar tread—there is nothing much more dramatic. And it is the truth, the fact, not the act of a Hollywood show.*

ON JULY 4, the same day Keller arrived in Siena, Superintendent of Florentine Galleries Giovanni Poggi received a summons to report to the German Military Commander of Tuscany, Colonel Metzner. With barely a

greeting, Metzner asked "if Villa Bossi-Pucci in Montagnana contained works of art of such importance to require their transportation across the Apennines" to northern Italy? Poggi, fluent in both German and French, was surprised by Metzner's sudden mention of Montagnana, site of the Villa Bossi-Pucci, which served as one of Tuscany's thirty-eight art repositories.

The constant shifting of the battlefield had prevented Poggi and his team from reaching many of the Tuscan repositories, but the Germans had no such impediment. Metzner's sudden curiosity about the Villa Bossi-Pucci—which housed close to three hundred masterpieces from the Uffizi Gallery and the Palatine Gallery at the Pitti Palace, including Botticelli's *Minerva and the Centaur,* Giovanni Bellini's *Pietà,* and Caravaggio's *Sleeping Amor*—was cause for great concern.

By July 1944, few men in the world had more hands-on experience protecting works of art than Poggi, a native Florentine described by Hartt as "a character who walked out from one of Ghirlandaio's frescoes." Poggi oversaw a domain that included the provinces of Florence, Arezzo, and Pistoia. At age sixty-four, he had lived long enough to witness war engulf his homeland twice.

Fate selected Poggi to be a defender of the arts. An illustrious connoisseur and curator, he had been appointed Director of the esteemed Uffizi Gallery in 1912, at the age of thirty-two. The following year, he helped recover the world's most famous painting, Leonardo da Vinci's *Mona Lisa,* stolen from the Louvre in 1911. The painting had been missing for more than two years before surfacing in a Florence hotel. After a brief showing at the Uffizi, and a tour through Italy, Poggi accompanied the painting back to Paris in December 1913.

Just six months later, the outbreak of the Great War consumed Europe. The burning of the library in Louvain galvanized art officials across the continent. Few if any nations had more at risk than Italy, no single city more than Florence. Poggi's quick work protecting the Uffizi's treasures drew the attention of officials in Rome. Soon they enlisted his aid in safeguarding prominent masterpieces in other Italian cities. Now,

for the second time in twenty-six years, Poggi found himself responsible for protecting the treasures of Tuscany from a world at war.

Poggi calmly answered Metzner's question, telling him that there were indeed highly important works from the galleries and museums of the State in Montagnana. But, "due to agreements taken with the General Direction of the Arts and with the Office directed by Colonel Langsdorff, it had been decided, as with the other repositories, not to remove anything unless there were some urgent peril, and in that case paintings would have been moved to Florence and not across the Apennines." Unfazed, Metzner pressed Poggi further, asking in an ominous tone, "So you are rejecting our offer?" Ten months of dealing with German officers had taught Poggi to appeal to their authority—and ego. He explained: "We are not rejecting it, on the contrary, we are grateful. We accept it in the event that it becomes necessary to move these things to Florence." The meeting concluded soon thereafter; Poggi assumed his replies had settled the matter.

THE OUTBREAK OF war in 1940 had caused Italian superintendents to transfer collections to areas outside the city centers. Acting with "frenzied lucidity," Poggi and his team had moved almost six hundred major works to privately owned villas and palaces in the Tuscan countryside in less than two weeks. That number had increased more than eighteenfold—to 11,139 various art objects—within six weeks. Those that couldn't be moved, usually due to their size and weight, had to be protected in situ, often by employing the most ingenious of methods. Local artisans built a brick tomb around Michelangelo's towering sculpture of *David*, and smaller ones for each of his adjacent works, referred to as the *Slaves*. Poggi hoped that these brick silos would provide protection against bomb fragments or even the collapse of the roof in the event of a direct hit on the building.

With the dramatic increase in Allied bombing of Italian cities in the fall of 1942, Poggi and other superintendents received orders to make

additional evacuations from the cities. This required him to secure more villas for storage. The groupings of art were historic. Villa di Torre a Cona contained not only Michelangelo's statues from the Medici tombs in the Church of San Lorenzo but all of the contents of the master's family home, Casa Buonarroti. This collection contained two of his earliest works and many of his letters and drawings. Never before had so many of Michelangelo's works been gathered in one place. Sitting alongside were masterpieces by Verrocchio, Donatello, Della Robbia, Lorenzo Monaco, and the most important surviving work by the Flemish painter Hugo van der Goes, the *Portinari Altarpiece*. The quality and rarity of the art was simply staggering.

The Castle of Montegufoni housed 246 masterpieces from the Uffizi and the Pitti by great masters such as Cimabue, Giotto, Botticelli, Raphael, Andrea del Sarto, Pontormo, and Rubens. The repository at Poppiano sheltered Pontormo's emotive masterpiece, *Deposition from the Cross*, from the Capponi Chapel in the Church of Santa Felicita, and Rosso Fiorentino's crowning achievement, *Descent from the Cross*, from the town of Volterra. The Palazzo Pretorio at Poppi held Hans Memling's *Portrait of a Young Man* and Michelangelo's *Mask of a Faun*; the Oratory of Sant'Onofrio at Dicomano contained Roman sculptures and sarcophagi; the villa at Poggio a Caiano housed Donatello's *Saint George* and Michelangelo's *Bacchus*. The quality and importance of each villa's contents surpassed the last, each filled with the accomplishments of civilization's most creative minds.

The fall of the Badoglio-led government and the occupation of Italy by German forces in September 1943 prompted most Italian art officials, including Lavagnino and Rotondi, to relocate their collections to the Vatican. But Poggi made the decision to keep the Tuscan artworks within his reach at their existing countryside repositories. These villas, he believed, afforded more protection from aerial attack than any fortress in an urban setting. By the time he realized that the Tuscan repositories lay in the path of the coming ground battle, it was too late to return all of the works of art to Florence. And that gave rise to another

concern, one he could do nothing about: perhaps overconfident at the time, Poggi had allowed many of the masterpieces to be transported from Florence uncrated.

Poggi certainly knew that the safest place for a painting was hanging on the wall of a museum. Once it began a journey, the risks of damage increased dramatically. Moving uncrated paintings in trucks exposed them to dust. Canvases were vulnerable to tears, punctures, and scratches. Vibration alone could cause the wood of a panel painting to split. Poggi also knew well that paintings on panel are reactive to sudden changes in humidity. Low humidity during winter weather diminishes the moisture in the wood, increasing the risk it might crack. Sculpture, whether marble (more durable) or terra-cotta (more fragile), was always at risk of being chipped, much less ruined if dropped. Subsequent moves would compound these risks even further, especially if the men handling the works of art were soldiers, untrained in dealing with such fragile and precious objects and acting in haste.

On June 18, 1944, Poggi had attended a meeting with Carlo Anti, General Director of Fine Arts under Mussolini's Social Republic, and SS Colonel Alexander Langsdorff, head of the Kunstschutz, to discuss how best to protect the Florence repositories from the looming battle. Anti insisted that the treasures be evacuated again and moved north, but his argument ignored the shortage of transportation and the speed with which enemy troops were approaching Tuscany. After a heated discussion, Poggi prevailed. The art would remain in the existing repositories. "It is too late," Anti noted ominously in his diary.

In early July, Social Republic officials once again pressed for the works of art to be transported northward. Certain that he knew what was best for "his" works of art, Poggi shrewdly parried the request with the Medici Family Pact of 1737, which required that their collection (the core of the Uffizi and Pitti collections) "never be removed or taken outside its capital and the Grand Duchy." At this stage of the war, Poggi had no real power to keep Fascist officials or the Germans from removing works of art. Clever excuses and tricks were his only tools.

Several days later, Poggi received a shocking telephone call from the German Consul, Dr. Gerhard Wolf, informing him that Wehrmacht troops had loaded 291 paintings from the Villa Bossi-Pucci repository at Montagnana onto trucks and taken them to the small town of Marano sul Panaro near Modena, some ninety miles north of Florence. This was the same villa Colonel Metzner had questioned Poggi about just days earlier. "At one blow at least an eighth of the most prized contents of the Uffizi and Pitti had vanished." Further queries by Consul Wolf later revealed the treachery: the paintings had been taken—and were already en route north—*before* Metzner's portentous meeting with Poggi on July 4.

Gerhard Wolf requested that Langsdorff report to Florence to resolve the matter. Without transportation, Poggi could do nothing. On Sunday evening, July 16, Poggi received a call from Consul Wolf's assistant, advising him that a different German unit had removed works of art from a second, as-yet-unidentified repository. Poggi should expect to take custody of them at German Military Headquarters, in Florence's Piazza San Marco, the next day at 8 a.m. With no sign of Langsdorff, and no further word about the disposition of the artworks from Villa Bossi-Pucci, this latest news horrified and infuriated Poggi.

The following morning, Poggi and other officials watched three German trucks pull into Piazza San Marco, right on time. The officer in charge of the operation, Colonel Hoffmann, informed them "that since the castle of Oliveto was under the fire of the Allied artillery, the military command of the area had decided on the immediate transport to Florence of the works of art." The unloading of paintings commenced, notably those from the Horne Foundation museum and altarpieces from the city's churches—eighty-four paintings, twenty-three crates, and five frames. For reasons Hoffmann didn't explain, more than one hundred paintings had been left behind. While Poggi tried to make sense of it all, the custodian of the repository at the Castello Guicciardini in Oliveto, Augusto Conti, who had accompanied the trucks into Florence, discreetly informed him that Hoffmann's explanation was a lie. The area around the castello had been quiet, void of any combat activity.

Conti then shared even more distressing news. Two panel paintings by German Renaissance painter Lucas Cranach the Elder—*Adam* and *Eve*—had been loaded into an ambulance. He had no idea what had happened to them after that. Poggi knew both paintings well—and he knew that Hitler did too. During the Führer's 1938 tour of the Uffizi, Poggi remembered watching how much Hitler had admired the German painter's works. The disappearance of such masterpieces, which had entered the collection of the Medici in the late eighteenth century, caused great alarm among Florentine officials.

Langsdorff finally arrived in Florence on July 17. Poggi assumed he could rely on the senior representative of the Kunstschutz, just as he had in May, when Langsdorff had provided cranes, trucks, and personnel to return Ghiberti's Baptistery doors to the Pitti Palace. Poggi began by informing Langsdorff of the removals from the Castello Guicciardini in Oliveto that Colonel Hoffmann had delivered just hours earlier. That a portion of the contents from the Oliveto repository never made it to Florence, in particular the two Cranach paintings of *Adam* and *Eve*, worried him. These removals violated the agreement made among Poggi, Carlo Anti, and Langsdorff at their June 18 meeting: in the event of any emergency evacuations of repositories, works of art were to be brought to Florence. Under no circumstances could this occur again.

Langsdorff assured Poggi that not only would he investigate what had happened to the missing items, he would accept full responsibility for locating and returning the Cranach paintings to Florence. As part of his investigation, Langsdorff asked Poggi to prepare a memorandum summarizing what he knew about the removal of art from the Villa Bossi-Pucci. When the report was completed, he wanted it delivered to the Hotel Excelsior, where he had a room overlooking the Ponte Santa Trinita and the Ponte Vecchio. This response hardly satisfied Poggi, but, under the circumstances, he could do little else.

News of continued Allied advances forced Langsdorff to reassess orders he had received from Army High Command (OKH) three days earlier, stating, "The rescue of art objects by the troops has to gener-

ally be stopped." The order also included a directive stating that any art objects that had already been removed should be turned over to the "bishops of Bologna or Modena." German troops had in fact attempted a delivery of the Montagnana items, but the bishops had turned them away, stating they didn't have sufficient space to store the items nor did they have authority to accept such responsibility.

From Langsdorff's point of view, these orders presented a conundrum: following them meant the Florentine treasures would be left in their repositories, unguarded, in what would soon be battle zones. But removing them from the countryside villas not only would violate his orders, it also would expose the works of art to possible Allied air attacks. Confident that he would have the support of SS General Karl Wolff, Langsdorff decided to ignore the previous arrangements with Poggi and Anti and to proceed with evacuations of the repositories.

In an effort to keep German Military Government informed of his decision, he sent a message: "Some art deposits in villas in countryside are now in range of artillery fire. A fortnight ago when I had acquired a lorry to bring the contents back to Florence, the Italian Superintendents asked me to refrain from doing so because of the danger from aerial attacks. Am taking in hand immediately supervision and direction of evacuation measures by our own troops." The time had come to move the art north for safekeeping.

Langsdorff drove to Oliveto later that evening to determine what had happened at the Castello Guicciardini, in particular to the Cranachs, before checking on the hundred or so works of art that hadn't been removed. Before midnight, he phoned Poggi to report that he had inspected the castello and relocated those paintings left behind to the cellar for additional safety; everything there was now fine. He insisted that he was also hot on the trail of the missing Cranach paintings, and he repeated his promise to find and return them to Florence.

What Langsdorff didn't tell Poggi was that the Cranachs were already safe. In fact, they were in his possession, "handed over by the troops . . . asking me to take them north, so that they would not fall into the

hands of the British or the Americans." In the course of his debriefing of Infantry Regiment 71's Oberleutnant Feldhusen in Oliveto, Langsdorff learned that the Cranachs had been "separated from the rest because they were 'Germanic art' and could not be exposed to the danger of being returned to Florence." Never mind the fact that Infantry Regiment 71 had traveled those same unsafe, bomb-cratered roads into Florence two nights earlier. He then wrote out a receipt for "two undamaged pictures, *Adam* and *Eve*, by Lukas Cranach which are to be taken to Germany by the undersigned, MV Abt. Chef Langsdorff," and handed it to the Oberleutnant. Using the safe passage afforded by an ambulance, Langsdorff and his "passengers"—*Adam* and *Eve*—set out for Florence, just as he had assured Poggi he would do.

Wednesday evening, July 19, Poggi stopped by the Hotel Excelsior to visit with Langsdorff and deliver the memorandum he'd been asked to prepare concerning the Montagnana removals. Much to Poggi's surprise, Langsdorff had already checked out and departed Florence. Had Poggi thought to ask the concierge, he might have learned that Langsdorff left the hotel with two life-size parcels that, oddly enough, had arrived two nights before in an ambulance.

In just two weeks, Poggi had been duped by the German Military Commander of Florence, Colonel Metzner, and lied to by the officer who delivered the works of art from Oliveto, Colonel Hoffmann. But those two betrayals paled in comparison to the disappointment he felt toward Langsdorff. Unlike the other two officers, Langsdorff was the senior German Kunstschutz official in Italy. He had an obligation to protect art, not to steal it.

15

GUARDIAN ANGELS

Florence claims a centuries-long heritage of creative genius. The city evolved from early Roman settlements in the first century BC as the well-developed Etruscan society began to move down from the hills of nearby Fiesole to settle along the Arno River. It became an autonomous city-state in 1115. By the early fourteenth century, the city had emerged as a center of international commerce. Its currency, the gold florin, and the banking dynasty it produced, the Medici family, became known throughout Europe. Through their support of the arts, the Medici anchored the Italian Renaissance, Western civilization's most prolific period of artistic achievement since the days of Greek democracy in Athens. Such a group of polymaths as those who arose in Florence—artists, architects, writers, philosophers, and inventors—has rarely been equaled in recorded history.

Michelangelo spent most of his life in Florence. Giotto, Masaccio, Botticelli, Donatello, Leonardo da Vinci, and Raphael all found patronage there. Filippo Brunelleschi applied mathematics to ancient architecture to conceive the dome of the city's magnificent cathedral, the Church of Santa Maria del Fiore, often referred to simply as the Duomo.

Lorenzo Ghiberti wrought from bronze perfect expressions of human anatomy to produce the world's most exquisite doors for the cathedral's Baptistery. Guido di Pietro, better known as Fra Angelico, created frescoes and panel paintings that helped define the early art of the Renaissance. Writers and philosophers, including Dante, Petrarch, Boccaccio, and Machiavelli, crafted definitive works on the heavens and the underworld, European cultures, and human nature itself. Galileo, the father of modern science, peered at the stars from his various homes, including Villa dell'Ombrellino, atop the hill of Bellosguardo.

The twentieth-century city, a place of "the past contending with the present," still boasts twisting cobbled streets, many barely wide enough for vehicles, upon which walked these immortal scholars and artists. Their sculpture decorates the city's piazzas; their paintings adorn its churches; and their creative thought fills its archives and libraries. One of the city's two most important bridges, the Ponte Santa Trinita, "represented the pledge of love and faith between one bank and the other." To cross the Ponte Vecchio, the famous double-tiered bridge from which Dante dreamed of Beatrice, his muse for *The Divine Comedy,* is to pass into another time.

Once a navigable river of transportation and commerce, the Arno became the lifeblood of the city's early development. Prime real estate of the day could be found on the *Lungarno* (along the Arno), in particular near the Ponte Vecchio, and the streets emanating from each end— Via de' Guicciardini to the south, and Via Por Santa Maria to the north. There, the dynastic families constructed their *palazzi* and medieval towers, braiding the city's future growth with its glorious past.

No other family matched the power and prestige of the Medici. The patronage of its members funded and supported the arts and each of its disciplines, including painting, sculpture, architecture, and gardening. They also expanded their personal residence, the Pitti Palace, and its magnificent Boboli Gardens. In 1560, Duke Cosimo I commissioned the construction of the city's administration offices along the north side of the Arno. But twenty-one years later, his son, Francesco I, began con-

verting the facility—the *Uffizi* (offices)—into a gallery to house the family's burgeoning art collection.

Atop the Ponte Vecchio and its numerous jewelry stalls is the less-visited Vasari Corridor. This private passageway, constructed in 1565, connected the Uffizi and the Pitti and provided the Medici with an escape route in the event of political unrest. Its narrow hallways are decorated with more than a thousand paintings, mostly self-portraits, by many of the artists whose works adorn the walls of the city's museums and churches. Farther north is the Palazzo Vecchio (the town hall), the Duomo, and the Accademia, home to the world's most famous piece of marble, Michelangelo's *David*. In the summer of 1944, war placed this legendary city, and centuries of creative achievements, in danger of utter destruction.

ON NOVEMBER 10, 1943, Adolf Hitler remarked to Ambassador Rudolf Rahn, "Florence is too beautiful a city to destroy. Do what you can to protect it: you have my permission and assistance." Hitler's affection for the city initially gave Florentine Superintendent Giovanni Poggi and other city officials hope that Florence would be spared the fate of Naples. The fact that Rome and Siena had escaped major damage also encouraged them. But, as Allied soldiers inched closer each day, a small group of dedicated souls—now seen as guardian angels of Florence—became increasingly concerned that the coming battle would overtake their city. They had few resources and dwindling options.

These benefactors' best hope was to push Germany and the Allies to jointly declare Florence an "open city," first suggested by the Director of the Kunsthistorisches Institut, Friedrich Kriegbaum. But for a city to be declared "open," it had to be undefended; there could be no military targets; and both sides had to have freedom of entry. In Florence, German forces had positioned two artillery batteries in the della Gherardesca and dei Semplici Gardens. They had stationed soldiers at numerous mortar positions in the city. Additionally, Florence, like Rome before it fell to

the Allies, served as a major rail transport hub for the German Army. Even after the Allies' air attacks on the Santa Maria Novella and Campo di Marte marshaling yards, men and materiel moved through the city.

Undaunted by these facts, German leaders referred to Florence as an "open city," accusing the Allies of refusing to publicly affirm that designation. For their part, the Allies wouldn't declare Florence an open city until the Germans removed their guns and soldiers. The standoff held through the spring and early summer of 1944, while Allied forces were engaged in combat operations hundreds of miles to the south. Things grew much more urgent following the liberation of Rome in June and of Siena in July.

City officials believed that their portable art treasures, tucked away by Poggi in Tuscan villas, were safe. But protecting the city's architectural treasures still depended upon securing an official, unequivocal declaration of Florence as an open city. Members of the principal group working toward this designation were the German Consul, Gerhard Wolf; the Archbishop of Florence, Cardinal Elia Dalla Costa; the Extraordinary Envoy and Minister Plenipotentiary of San Marino to the Holy See, Marchese Filippo Serlupi Crescenzi; and the Swiss Consul in Florence, Carlo Alessandro Steinhäuslin. These four men did more to save Florence than anyone else.

After four years of service in the German Army, Gerhard Wolf attended Heidelberg University, where he met Rudolf Rahn, who would become a lifelong friend. In the years following graduation, both would enter Germany's Foreign Service. Seeking to distance himself from the Nazi Party, Wolf accepted a position as the German Consul to Florence.

Cardinal Dalla Costa, a seventy-two-year-old prelate, was another of the city's guardians. Soft-spoken yet forceful, he assumed an increasingly visible role in defense of the city. During Hitler's 1938 visit, he ordered that the windows of his palace be shut in symbolic protest. He declined to participate in the official celebrations, explaining that he did not worship "any other cross, if not that of Christ." As the situation became more desperate, the cardinal agreed to issue notices that stated, "His

Eminence Cardinal Elia Dalla Costa, Archbishop of Florence, declares that this building and the artworks inside, are under the protection of the Holy See." While he pleaded with the German commanders to respect Florence as an open city, he did so knowing that, "in order to truly protect Florentine works of art, it would be necessary to place a huge pavilion made of impenetrable steel and unbreakable bronze, to cover the entire city."

Cardinal Dalla Costa was not the only representative of the Catholic Church fighting to save Florence. Marchese Filippo Serlupi Crescenzi enjoyed the favor of Pope Pius XII and Dalla Costa. This entrée proved helpful to Giovanni Poggi. "I had to ask Serlupi to avail of his relationships with the high personalities of Vatican City," Poggi later said, "to turn the interest of the Holy Father towards the monuments and works of art of Tuscany and put them under the protection of the Holy See."

Behind the scenes, Serlupi, a lawyer by profession, risked his life taking action to help friends in need. Using his diplomatic status as cover, Serlupi offered assistance to individuals being hunted by the Nazis and Fascists, including the famous art scholar and collector Bernard Berenson, an American Jew. The seventy-nine-year-old Berenson owned a home, Villa I Tatti, filled with early Italian paintings and an extensive art library that had become a gathering place for collectors, dealers, and students of art worldwide. According to Berenson, "Marchese Serlupi did not miss one chance to come in aid."

Carlo Steinhäuslin, a native Florentine and heir to the eponymous private banking firm, brought a patrician's concern to the effort. As Consul for Switzerland, his diplomatic privileges—like those of Serlupi and his close friend Consul Wolf—created opportunities to help others, albeit at considerable risk. Steinhäuslin was particularly concerned with protecting the city's water pipes, which ran under the bridges. His position as a diplomat of the most prominent neutral nation earned him the ear of German Colonel Fuchs, recently appointed the Commandant of the city.

In spite of the Führer's November 1943 assurance to Ambassador Rahn about protecting Florence, the city was becoming more milita-

rized, not less. In late January 1944, British officials inquired through the Vatican whether or not there would be an official German declaration of open-city status. Germany's Ambassador to the Holy See, Ernst von Weizsäcker, could only provide "an official declaration of the unofficial declaration and then only verbally and not in writing." Consul Wolf then made four separate visits to Generalfeldmarschall Kesselring, seeking his support for proposals to limit military access to the city center. Kesselring agreed and then commented that he had "never realised what it was like to fight in a museum, until [I] came to Italy."

On June 3, Gerhard Wolf received a copy of a very disturbing letter from General Alfred Jodl, the OKW Chief of Operations Staff: "I therefore have to say with my greatest regret—that hope for Florence to come out of this war unharmed, can only be very slight." The reply devastated Wolf, Germany's chief nonmilitary representative in Florence, along with Cardinal Dalla Costa and Swiss Consul Steinhäuslin.

Consul Wolf's sustained diplomatic efforts won him the trust of prominent Florentines. On numerous occasions he used the power of his position to rescue important citizens and partisans from Captain Mario Carità, a sadistic Italian who headed the *Ufficio Politico Investigativo* (Political Office of Investigations). Working out of a home—*Villa Triste* (House of Sorrow)—on via Bolognese, Carità, who at one time had expressed a desire to become "the Himmler of Italy," had constructed a basement torture chamber so gruesome that even some Nazi SS officers found it disturbing. Carità and his henchmen used grisly methods to extract confessions from victims before their execution. Colonel Dollmann described "tables laden with thick whips, rods of steel, pincers, manacles, the whole paraphernalia of mid-twentieth-century persuasion."

By late July, stress took a severe toll on Wolf's health. With the impending withdrawal of German forces from Florence, Rahn gently ordered his friend to leave the city and report to the German Embassy at Fasano, near Kesselring's headquarters. Some in Florence, fearing for Wolf's safety, pleaded with him to stay, in particular his close friend

Carlo Steinhäuslin, but on July 28 Gerhard Wolf left the city in the hands of his countrymen, "ashamed of what the German soldiers had the courage to do."

ON SATURDAY, JULY 29, German commanders contacted city officials and asked for a map that detailed the central bridges, including the Ponte Santa Trinita, the Ponte Vecchio, and adjacent buildings. By the time Poggi found out about this ominous inquiry and informed Dalla Costa, German forces had posted a proclamation on buildings, issued on orders of Colonel Fuchs, that all inhabitants within 330 to 660 feet of the Arno—more than fifty thousand people—had to vacate their homes by noon the following day.* In a hollow effort of reassurance, Fuchs stated that the order was purely a cautionary measure meant to spare the population from attack by the enemy. Instructions specified that all personal belongings were to be left behind.

By Sunday, the British Eighth Army, just south of the city center, prepared to advance on Florence. Stuck on the German side of the line, Poggi, Dalla Costa, and Steinhäuslin composed a letter to Colonel Fuchs that recited Germany's many previous assurances about open-city status and pleaded for permission to contact the Allies to continue open-city negotiations. Upon receipt of the hand-delivered letter, Fuchs, who had once said, "For me a bridge is just a bridge," said he didn't have authorization for any member of their group to cross the line. In his view, there was no evidence that the Allies intended on recognizing Florence as an open city.

The last realistic chance for Florence to avoid becoming a battleground had in fact ended ten days earlier with German Colonel Claus Schenk Graf von Stauffenberg's failed effort to assassinate Adolf Hitler at his Wolfsschanze headquarters near Rastenburg. As Consul Wolf later observed, it would have been "quite impossible for any one to ask

* Steinhäuslin subsequently convinced Fuchs to extend the deadline to 6 p.m.

[the Führer], let alone receive permission to make direct contact with the enemy. Hitler would have considered it as an act of treachery on Kesselring's or Rahn's part if such contacts were made."

On July 30, Ambassador Rahn finally reached Kesselring's headquarters in Recoaro to make what seemed a final plea on behalf of the city. Rahn stood before an angry and unsympathetic Kesselring, who gripped one of the thousands of leaflets dropped from the sky by the Allies the day before. The leaflets contained a "Special Message" to all Tuscans from Allied General Harold Alexander. One sentence in particular stood out: "It is vital for Allied troops to cross Florence without delay in order to complete the destruction of German forces on their retreat northwards."

Kesselring felt great "psychological pressure" from Hitler concerning the fate of the bridges of Florence. He believed that any decision he made would be criticized. On the one hand, he had already incurred the Führer's wrath for ordering his troops to retreat from Rome without having first destroyed its bridges—despite orders from OKW to *avoid* their destruction. Muddled, even contradictory, orders were not uncommon, especially those from Germany's mercurial leader. Still, Kesselring had no intention of making the same mistake twice.

At a meeting with Hitler on July 19—the day before Hitler's own officers tried to kill him, Kesselring had been ordered "to pursue his retreat, fighting to hold on south of Florence as long as possible and to stem the enemy advance to the best of his ability. Florence itself would not be defended, so as to spare its art treasures." Hitler made it clear that under no circumstances was Kesselring to destroy the city's bridges, adding: "Their artistic and historical value should be respected, the military disadvantages, which should not be overestimated, [are] to be accepted."

Kesselring, interpreting the Allied leaflets as a sort of call to arms, contacted Hitler's headquarters seeking clarification of his orders. Informed that the Führer wanted to ensure "it was only the enemy who ignored the irreplaceable cultural values of this city," he was told there would be no destruction of the bridges except on Hitler's specific order.

Based on Kesselring's assessment of the situation, there would be no declaration of Florence as an open city. He could only assure Ambassador Rahn that the Ponte Vecchio would be spared.

As the Allies drew ever closer, tensions mounted. On Monday, July 31, Fourteenth German Army Command sent written orders to the 1st Para Corps in Florence instructing them to "prepare *Feuerzauber*." Operation Feuerzauber called for the destruction of all bridges "in and near Florence," except for the Ponte Vecchio. Everyone understood that the operation could only proceed with Kesselring's express authorization. Nevertheless, travel anywhere near the bridges was forbidden. Rahn, Poggi, and the others remained nervous. Florence had become a city divided.

The only civilian in Florence who had permission to cross the bridges using his own car was the Swiss Consul, Steinhäuslin, who later recounted that experience: "While we argue[d] with the guards to let us cross Ponte alla Carraia, a car arrives. Colonel Seubert tells me that the 'soldiers' are moved more by the romanticism of Ponte Vecchio than by the incomparable artistic beauty of Ponte Santa Trinita." Steinhäuslin was sickened when a municipal guard informed him that the Germans had mined the bridges. After making another plea to one of the German commanders to at least spare the central bridges, he crossed the Ponte Santa Trinita and observed that "5 separate rows of boxes, measuring between 70 by 50 by 30 centimetres [28 by 20 by 12 inches], had been placed under the great arches of the bridge, joined together with electrical fuses." Military officials aside, Steinhäuslin was in all likelihood the last person to traverse the 374-year-old masterpiece.

That evening, the southern sky flickered with light from the Allied bombardment of nearby German positions. Florentines experienced their third successive night of blackness due to German sabotage of the central power plant. The explosions backlit the hills of Poggio Imperiale, San Miniato, Belvedere, and Arcetri. German forces had evacuated the southern defensive position and were now in the city preparing to execute their retreat.

On August 3, German Fourteenth Army Command reported: "The enemy artillery fire was now aimed at the south and the bridges of the city. . . . it was clear that the enemy saw the Arno bridges as a military target." After weeks of internal debate, and relying on the Fourteenth Army report,* Kesselring made his decision, stating, "I could not accede to [the] request to renounce the defence of the city as I could not obtain a similar concession from the enemy so the road through it was blocked by various demolitions, which unfortunately involved the destruction of the wonderful bridges across the Arno."

At 2 p.m., Thursday, August 3, German officials declared a state of emergency. Notice was given, under threat of death, for all citizens to remain inside, away from windows, preferably in basement areas. No one was permitted outdoors, pending further edicts. Shortly before 10 p.m., the first of two explosions shook the ground beneath the Pitti Palace and its Boboli Gardens. Among the thousands of citizens—now refugees—living in the Pitti Palace was an art official of the Florence Superintendence, Dr. Ugo Procacci, who described the experience: "It seemed that the earth was trembling and that the great palace would be conquered from one moment to the next; at the same time from every side glass and pieces of window rained on the crowd, and the air became unbreathable. Terror seized the crowd; a few began to cry 'The bridges, the bridges.'"

Another round of explosions began around midnight, this time less violent but continuous. From a villa just north of the city, Bernard Berenson observed "the Neronian spectacle of a huge fire which flared up like an immense column of thick, glowing flame, thinner in the middle than at the ends. At the same time a great explosion seemed to burst from the heart of Florence."

Around 2 a.m. on August 4, the genius of the design of the Ponte

* The report on which Kesselring relied was wrong. Allied artillery aimed at the south side of the Arno in an effort to dislodge German troops. Unintentionally, some shelling of the city did occur, nicking one of the bridges, the Ponte alla Vittoria. Even then, that bridge, the most westerly of the city's six main bridges, was located more than a mile from the city center.

Santa Trinita was revealed in the saddest of ways. Great engineering had masked with delicate and genteel lines a bridge built to stand for centuries. It had endured both the fury of a raging Arno and the grinding weight of modern-day vehicles. For a short while, it seemed the formidable bridge might even survive the work of German demolition experts. The first blast caused the bridge to "heave its shoulders"—but it stood, intact. A second blast followed; the bridge survived. Just before dawn, however, the third blast left nothing but the prow-shaped piers. The sun would rise moments later, but it would never again cast the same shadow on the Arno.

Giovanni Poggi was one of the first Florentines to witness the aftermath of the demolitions. "At dawn, from my house in Piazza San Felice, I was able to go near the Arno on Via Maggio, and through debris covered with corpses, the fog and dust which were still weighing down on the river, tears like a veil to my eyes, I was able to verify with unforgettable horror, that the beautiful arches of the bridge of S. Trinita did not exist anymore."

Sometime before 7 a.m., Consul Gerhard Wolf, suffering from exhaustion and a nervous breakdown, awoke to the news that German forces had destroyed the Ponte Santa Trinita. As he stood in "stunned silence," his thoughts must have been not of the bridge but of the man who first introduced him to it when he arrived in Florence, his good friend Professor Friedrich Kriegbaum, who had been killed during the bombing of Florence in 1943. Kriegbaum had once remarked to Wolf, "I'd rather be dead than see all I love destroyed!" Sadly, he had gotten his wish.

16

"LITTLE SAINTS, HELP US"

On July 31, while at British Eighth Army AMG Headquarters, Regional Monuments Officer for Tuscany Fred Hartt and others heard a stunning announcement broadcast by BBC Radio. Wynford Vaughan Thomas, a veteran correspondent, accompanied by Major Eric Linklater of the Royal Engineers, had, in the course of visiting the Castle of Montegufoni, a villa located in the center of a major battle zone, stumbled upon a repository containing masterpieces from Florence's Uffizi Gallery and Pitti Palace. This discovery greatly alarmed the Monuments Men. In June, Rome officials had led them to believe that the Florence repositories had been emptied and their contents returned to the city. But this sudden announcement cast doubt on that assumption and called to mind jarring images of unprotected, art-filled villas dotting the Tuscan countryside.

With orders to drive to Montegufoni as quickly as possible, Hartt, "armed and helmeted," jumped into a "battered" jeep that had survived the North Africa and Sicily campaigns. "Its windshield was shattered, it had only four, much worn tires, its radiator leaked, its springs were weak, its shock absorbers defective. It possessed neither mirrors nor canvas

top, and its rattling body threatened momentarily to disintegrate." But unlike Keller's vehicle, Hartt's jeep had come with a name. Someone had painted on the metal riser that once contained a windshield: *13 Lucky 13.*

Heavy artillery fire blocked Hartt's route, forcing him to navigate roads so small they didn't appear on his maps. Hours later, he reached Eighth Army press camp at San Donato in Poggio. Night was falling. "The hills beyond, sloping down toward Florence, shook continuously with gunfire in the darkness while their ridges stood out fitfully against the constant flashes of the artillery."

Linklater and Vaughan Thomas, just returning to camp after a day spent checking on three other nearby repositories, were greeted by "a tall, eager, bespectacled, wildly excited American lieutenant, an expert in the fine arts, who had been sent forward by the Allied Military Government to take charge of the pictures. He had brought no camp-kit with him, but as he was too agitated to sleep much he did not suffer unduly from the lack of it." Linklater and Vaughan Thomas then proceeded to tell Lieutenant Fred Hartt the most astonishing story he had ever heard.

LINKLATER, WHO HAD been commissioned to write the official history of the Eighth Army campaign, was eager to visit the 8th Indian Division, just one of the many multinational components of British Eighth Army. He and Vaughan Thomas arrived at the Castle of Montegufoni, property of Sir Osbert Sitwell, on the afternoon of July 30. The castle had been designated field headquarters of the First Battalion, Indian Maratha Light Infantry, a distinguished group of fighters with a history dating back more than a century. Enemy forward positions were now just a little more than a mile away from the castle. While waiting to interview the senior commander, Linklater and Vaughan Thomas wandered through the capacious building, which reminded them of Florence's Palazzo Vecchio, and noticed various groups of panel paintings leaning against the wall, painted surfaces exposed to view.

These spliced photos, taken from the rooftop of Santa Maria delle Grazie Church in Milan, are the earliest known images taken after the August 15/16, 1943, raid that nearly destroyed Leonardo da Vinci's The Last Supper. The bomb landed in the Cloister courtyard (indicated by the rectangle), destroying the covered arcade and causing massive damage to the surrounding buildings. The obliteration of the east wall of the Refectory (denoted with a straight line) caused the roof to collapse. [Civico Archivio Fotografico, Milano]

This photograph of the Refectory interior, taken sometime between 1875 and 1910, shows what the Allied bomb destroyed. Gone is the frescoed vault above the three lunettes on the north wall, lost when the roof collapsed. All of the ornamental scrollwork along the east wall disintegrated. The windows above do not exist today. [Alinari]

While Padre Acerbi's Dominican workers helped clear debris, engineers constructed a platform (atop the X brace) to build a small terra-cotta protective roof that would shield the painting from rain. A canvas tarp (barely visible at upper left) provided an interim solution. [Olycom]

ale Associate Professor of Drawing and ainting Deane Keller and his son "Dino," in 942. [William Keller Collection]

Monuments officer Captain Mason Hammond conducted classes on Italy while still in North Africa, prior to the Sicily landings. [Elizabeth Hammond Llewellyn Collection]

his open-air cafe in Tizi Ouzou, Algeria, catered to the tribesmen of Kabyle, in the country's north. The Monu- ents officers, and others serving in Allied Military Government, began their training in buildings such as these 1943 before their transfer to the Italian front. [Pennoyer Papers, Department of Art and Archaeology, Princeton niversity]

SS leader Heinrich Himmler presents a painting to Adolf Hitler on his fiftieth birthday, April 20, 1939. In attendance was Himmler's Chief of Staff, Karl Wolff (far right). [The Granger Collection, New York/ullstein bild]

Deane Keller found this undated photograph of Wolff and his second wife, Inge, among the general's papers at his office in Bolzano sometime around May 14, 1945. [Deane Keller Papers, Manuscripts & Archives, Yale University]

A very young Giovanni Poggi (right), at the time Director of the Uffizi Gallery, takes a last glance at the Mona Lisa in December 1913, shortly before returning it to Paris. Poggi played a key role in recovering the painting from the man who stole it from the Louvre in 1911. [Roger-Viollet, Paris]

Hitler visited Florence on May 9, 1938, and spent almost two hours studying works of art in the Pitti Palace, Vasari Corridor, and Uffizi Gallery. Others shown are Dr. Joseph Goebbels (short man behind Hitler); Professor Friedrich Kriegbaum; Benito Mussolini and Superintendent Giovanni Poggi (hat in hand). [Arianna and Elisa Magrini and Edizioni Polistampa Firenze]

The saw-toothed ruins of the Abbey of Monte Cassino. Monuments officer Captain Roger Ellis (in the lead) and Major Ernest DeWald are accompanied by Captain Turner, of the British File Unit, for the two-mile ascent up the narrow path cleared of mines by Polish engineers. This photograph was taken on May 27, 1944, just nine days after the battle ended. [National Archives and Records Administration, College Park, MD]

Monuments officer Lieutenant Fred Hartt, standing next to his jeep, Lucky 13. [Frederick Hartt Papers, National Gallery of Art, Washington, DC, Gallery Archives]

Fred Hartt digs through the remains of the Church of Santa Maria of Monte Oliveto in Naples in May 1944. [Pennoyer Papers, Department of Art and Archaeology, Princeton University]

Deane Keller found a lifelong friend in Charley Bernholz. [Eric Bernholz Collection]

A high point of Keller's military service was his chance meeting with fellow artist (and cartoonist) Bill Mauldin in Bologna in April 1945. [Deane Keller Papers, Manuscripts & Archives, Yale University]

German Generalfeldmarschall Albert Kesselring (upper photo, on right) personally supervised the work of engineers as they mined the bridges and adjacent streets of Florence, including the Ponte Vecchio (lower photo). Kesselring is standing in front of one of the many jewelry shops that line the famous bridge. In the foreground is a crate containing six five-kilogram bombs. Note the stacked empty bomb crates in the upper photo (far left). [Top: Bundesarchiv, Koblenz. Bottom: Bundesarchiv, Bild 101I-480-2227-10A, Bayer photo]

An American B-26 Marauder passed over the severely damaged Ponte Vecchio even while the Germans still held the northern part of Florence. The Duomo and Giotto's Bell Tower emerged relatively unscathed, but the buildings on both ends of the Ponte Vecchio were demolished. [Pennoyer Papers, Department of Art and Archaeology, Princeton University]

"But they're very good!" one of the men remarked. "They must be copies!" As they entered another room, Linklater saw many more paintings—a few crated, most not—and then heard Vaughan Thomas give a yelp. "The whole house is full of pictures. . . . They've come from the Uffizi and Pitti Palace!" Hearing the excitement, a group of villagers who had taken refuge in the castle gathered round the two men as they moved from one painting to the next.

The group then wandered into the spacious, high-ceilinged living room, which had been divided by a large cluster of paintings in the center. To their amazement, Paolo Uccello's *Battle of San Romano* sat before them. The panel, depicting the 1432 battle between Florence and Siena, was more than ten feet long. Nearby, they found Giotto's *Ognissanti Madonna,* a gold-ground panel painted around 1310. It measured almost eleven feet high and seven feet wide.

Moments later, Vaughan Thomas, who had walked to the other side of the cluster of paintings, shouted, "Botticelli!" More refugees had wandered into the room; they rushed around to see him gazing at *Primavera*, an instantly recognizable work of art. Suddenly, a short middle-aged man appeared in the room, wearing a gray tweed knickerbockers suit. The man was beside himself with excitement—not because of the works of art but because the liberators had finally arrived.

Cesare Fasola, Librarian of the Uffizi, had reached Montegufoni on July 20. He had left Florence on foot, walking the seventeen-mile distance, through battlefields, to guard the Uffizi collection. He first stopped at the Villa Bossi-Pucci in Montagnana. By the time of his arrival, German troops had already taken 291 masterpieces—everything except those too large to fit in their trucks. The doors of the villa had been pried off their hinges, windows were wide open, and books from the library had been tossed on the ground and trampled by the soldiers' boots.

With nothing more to do at Villa Bossi-Pucci, Fasola walked to the Castle of Montegufoni, fearful he would discover a similar scene. While the paintings were still inside the castle, so, too, were enemy soldiers. It was a scene of filth: "The packing-cases had all been opened, the pic-

tures taken out and flung about. Some had been piled up in a dark corridor where a fetid smell left no doubt as to the use that had been made of this passage."

Fasola had arrived too late to prevent the removal of paintings from Montagnana, but he hoped to prevent German and SS troops from harming the works at Montegufoni. As the days passed, he befriended the soldiers in an effort to keep them away from the paintings. Sometimes he succeeded, other times he did not. German soldiers' use of fifteenth-century Florentine Domenico Ghirlandaio's round panel painting, *Adoration of the Magi*, as a tabletop was a low moment. When Fasola asked the soldiers to remove their wine and glasses, one of the soldiers pulled out his knife and flung it at the wood, gouging the surface.

Lacking any authority, Fasola could do little more than accompany the castle's custodian on his nightly rounds. It was a helpless feeling, but not hopeless. One evening, Fasola watched as the custodian stared at a group of religious paintings and whispered to himself, "Little Saints, help us!"

THE FOLLOWING DAY, August 1, Hartt, accompanied by Linklater and Vaughan Thomas, made the short journey from the San Donato press camp to Montegufoni, where "the thunder of the British guns placed all around us, and an occasional German shell screamed overhead to explode nearby among the vineyards and cypresses." Hartt knew every work of art: the *Rucellai Madonna* painted for Santa Maria Novella; Andrea del Sarto's *Annunciation* from the Pitti Palace; Rubens's *Nymphs and Satyrs*; Raphael's *Madonna del Baldacchino* and *Descent from the Cross*, from the Pitti and the Uffizi; and of course Botticelli's *Primavera*, which had so startled Vaughan Thomas. As he would later observe, "A description of these pictures would constitute a history of Italian painting." The halls contained 246 works in all.

From Montegufoni, the group made the short trip to the repository in Poppiano, where Hartt viewed the damage to several works of art.

He was elated to discover that Pontormo's masterpiece—the *Deposition from the Cross*, from Santa Felicita in Florence—was intact and looking as beautiful as it had the last time he had seen it. But further inspections revealing the quantity and importance of the works still at Montegufoni confirmed that the Tuscan repositories had not been evacuated back into Florence.

Hartt sounded the alarm. His cable to Ernest DeWald was blunt and to the point: "Five deposits located. Reference BBC broadcast. Situation in hand. All safe save for damage to Pontormo *Visitation* and Bronzino *Portrait*." He then prepared a memo to Lieutenant General Oliver Leese, Commander of Eighth Army, marked "SECRET," which contained map references, a list of twelve deposits, and a terse summation of the situation: "The fate of these priceless treasures lies in the hands of the Eighth Army."

That night, Hartt drove ninety miles back to Eighth Army Headquarters. Hours later, after finding Norman Newton, Monuments officer for AMG Eighth Army, Hartt pleaded to "be assigned the job of the deposits, and be the first to reach each one before there was time for much damage by troops." Realizing the dangers at hand, Newton promptly approved Hartt's plan. Within hours, Hartt was on his way back to Montegufoni and the other repositories, posting guards and rearranging many of the paintings to provide more safety until the situation on the battlefield stabilized. Days later, General Alexander arrived to inspect the collection and urge that "everything possible [to safeguard the works of art] be done." Five Monuments officers now rushed to the Montegufoni area. Deane Keller, who found himself amid horrific destruction in the seaside city of Livorno, was not among them.

AT 5 A.M. on August 4, eight trucks carrying more Florentine treasures from the repository at Dicomano reached the northern city of Verona via back roads. The final leg of the five-day trip had been harrowing. While crossing the Po River, the German convoy came under attack by Allied

planes. Bomb fragments hit the cab of one truck, injuring the driver, but the works of art arrived safely. Almost three weeks had passed since SS Colonel Alexander Langsdorff had notified German Military Government that he intended to coordinate "rescue operations of art objects at the front by our troops." While Langsdorff initially had neither the trucks nor the fuel to mount such an operation, he knew someone who did.

On the afternoon of July 21, Langsdorff, in possession of both of the Cranach paintings, had arrived at the headquarters of SS General Karl Wolff—Villa Besana in Gardone on Lake Garda—to enlist his help. Wolff's pending appointment as General of the Wehrmacht "behind the battlefront" would place the Kunstschutz, a department of the Military Government, firmly under his command.* Eager to assist Langsdorff and his rescue operation, the general provided the Kunstschutz chief with the trucks he needed, along with formal orders to "go and remove whatever could be saved of the endangered works of art belonging to the Uffizi and the Palazzo Pitti in Florence." Langsdorff now had operational authority in the field, reporting to Wolff as SS Commander in Italy, who then cleared decisions through Himmler in Berlin.

Having taken control of the two Cranach paintings from Infantry Regiment 71, Langsdorff was eager to see them reach what he assumed would be their final destination in Germany. On July 25, Wolff sent a telegram to Himmler, informing him that Langsdorff had just rescued and brought to Wolff's headquarters the two paintings by Lucas Cranach, "which the Führer greatly admired upon his visit to Florence." Wolff also sought guidance as to "whether these art treasures should be brought to the Führer's headquarters so that the Führer can decide next steps with regards to these world-famous pictures saved by us." Himmler's reply came the following day, advising that the Cranach paintings, and any others from Florence, should remain in South Tyrol, "which guarantees a good safekeeping of the pictures, without initially undermining the authority of the Italian State. It must however be cer-

*Wolff requested this designation, which took effect on July 26, 1944.

tain that the area in which the pictures are then kept is in all events protected by Germany."

On July 28, Langsdorff returned to Florence to oversee more evacuations of the Florentine repositories. He arrived at a deserted hotel, now emptied as German troops prepared their exit from the city. "Everyone awaited numb and in suspense of the things to come." At 11 a.m., Langsdorff met with Giovanni Poggi. Upset at Langsdorff's betrayal, Poggi expressed surprise at seeing him. Langsdorff explained that he had located the two Cranachs and that they were safe at an undisclosed location. In what would prove to be their last conversation, Poggi recalled that Langsdorff "was worried about the fate of certain recoveries located in dangerous areas." Once again Poggi demanded the return of the Cranachs to Florence. And once again Langsdorff promised to do what he could "to provide for their safety."

Langsdorff did put his team of soldiers and their trucks to good use removing endangered works of art from the repository at Dicomano—but not back into Florence, as he had promised Poggi. The art traveled northward, temporarily landing in the northern city of Verona. On August 5, meeting again at Wolff's headquarters in Gardone, Wolff and Langsdorff ironically had to address the same dilemma that had confounded Poggi and Italian museum directors years earlier: finding a safe place to hide the art. Each option carried a different risk.

On June 18, Langsdorff had written Poggi, reminding him that he "created a repository for the works of art of northern Italy in Lago Maggiore, on the Isola Bella [one of three islands making up the Borromean Islands]." This remote island, accessible only by boat, provided a secure storage facility away from any bombing targets. The Wehrmacht must have concurred, because on August 3, it issued an order stating, "The Borromean Islands are to be kept clear of any occupation and [are] to be offered as art-depots." But now, Wolff refused to transfer the works of art to Italian custody. Acting on Himmler's instruction, he pursued another, more elegant solution, finalizing it during a phone call with Franz Hofer, the Austrian Gauleiter of Tyrol-Vorarlberg.

Italy's most northern province, known as South Tyrol in English and Alto Adige in Italian, forms an autonomous region that, from the time of Charlemagne until 1919, was part of the Holy Roman and Austrian Empires. The majority of its inhabitants speak German; names of the province's cities, towns, and streets are displayed in German and Italian. Following the September 1943 armistice between Italy and the Allies, German forces occupied the province and declared the region part of Operational Zone Alpenvorland. The area was subsequently added to Gauleiter Hofer's territory. One partisan commented, "The laws of the Social Republic did not apply there." By hiding the works of art in repositories in the Alto Adige, Wolff could keep the Florentine treasures on Italian soil, thus avoiding a transfer across the border but still under the de facto control of the German Reich.

Wolff knew that Hofer was the "uncrowned king in his own Gau." Carlo Anti, General Director of Fine Arts under Mussolini's reconstituted government, observed, "In Alto Adige one has the impression to be in an autonomous territory, that is neither Italy nor Germany. In addition, Hofer is of absolutist temperament, fanatic Tyrolese and expressly anti-Italian, who decides exclusively according to what he wants and on everything, be it on small or on big problems, without listening to opinions or explanations. . . ." Wolff believed he could work with Hofer, but the Gauleiter's alignment with other hard-core Austrian Nazis, including Gauleiter August Eigruber and General of the Police and Waffen-SS Ernst Kaltenbrunner—Wolff's "deadly enemy"—meant he had to be watched.

LINKLATER AND VAUGHAN THOMAS entered Florence on the morning of August 4, alongside the South African Armoured Division, the New Zealanders, the 24th Guards Brigade, and the 4th Infantry Division. Linklater observed:

> The Florentines of the South Bank, poor people for the most part, gave us a warmer welcome than the Romans. Tears streaked their faces while they

cheered. . . . Vaughan Thomas . . . was mercilessly embraced by a bristle-bearded labourer while I, with my left arm clutched to an unseen but young and palpitating bosom, was being heartily kissed by a pair of the plainest old trots in Tuscany; but then the crowd broke and scattered as snipers opened fire from a window or a roof. . . . the smoke of ruined buildings was still rising beyond the Ponte Vecchio, and bursts of machine-gun fire echoed along the river bank. . . . In the late afternoon rain drove the people indoors, and all the flowers they had thrown lay wetly trampled on empty streets.

Captain Roger Ellis, the first Monuments officer to enter Florence, arrived one full week after Linklater and Vaughan Thomas had entered the city. Ellis immediately began inspecting monuments and churches on the south side of the Arno, but he determined that "the tactical situation prevented any inspection north of the river." Hartt, who had spent the previous eleven days bringing order and security to the repositories, was filled with anxiety over his inability to get into Florence and be the first to make contact with the city's art officials. He later noted: "By August 12 the suspense of waiting for an order to go to Florence had become unbearable, and I drove down to Eighth Army headquarters to try to cut the waiting short."

Hartt entered the southern portion of Florence the following morning, "in a state of feverish excitement. . . . The destruction of Florence seemed the end of all civilization. . . . We passed below the Certosa di Galuzzo [sic], still undamaged on its hilltop, which I had last seen as a young student years before. At the road fork below Poggio Imperiale the direct road into Porta Romana, the great southern gate of the city, was closed by a simple sign with the words 'Under Enemy Observation.' . . . The valley around reverberated with shellfire."

At Villa Torrigiani, temporary headquarters of the Allied Military government, Hartt found Professor Filippo Rossi, Director of the Galleries of Florence, and Dr. Ugo Procacci. An impromptu meeting followed, during which Hartt explained the purpose of the MFAA and described the expertise of his fellow Monuments officers. When the

meeting ended, Hartt had a complete list of the locations of the Florentine repositories and their contents.

Hartt had to see the damage to the medieval part of the city for himself. He and Procacci attempted to reach the Ponte Vecchio, but "a mass of rubble thirty feet high" prevented access, so they had to climb a makeshift ladder from one side of the Boboli Gardens to reach the portion of the Vasari Corridor that hadn't been damaged. In an instant, centuries of beauty and history had disintegrated.

> *On the south bank the wonderful old buildings that overhung the river, those anonymous accretions of ages, floor on floor, balconies, arches, crowding roof tops all supported on consoles over the water—how often had we seen them, how often walked them at night to gaze through Vasari's arches at the picturesque wall of houses reflected in the quiet stream. It was these houses that had given the Ponte Vecchio its beauty, a city vaulting the river. Now it stood stripped, the houses all one gigantic trash pile together, spilling into the Arno. . . . Form to formlessness, beauty to horror, history to mindlessness, all in one blinding crash.*

A week passed before Hartt had time to compose his first official report. Hardly a notable structure escaped mention, including the churches of Santa Croce, Santo Spirito, and San Lorenzo, as well as the Uffizi, the Duomo, and the Baptistery. But one part of his report focused on something besides buildings and monuments: "Santo Stefano, in Por Santa Maria is gravely damaged. The 13th-century façade is split from top to portal, the roof tiles are gone, and the interior full of rubble. The 93-year-old *parroco*, Padre Veneziani, refused to leave his church, and died from the concussion of the mines. His body was removed only 18 August, from the sacristy where it had lain since 3 August." The death of this parish priest attached a face to the mission for Fred Hartt, something Deane Keller had understood from the beginning.

On August 31, AMG headquarters received a telegram sent by the Swiss Government. They had transmitted it four days earlier, but circumstances prevented its receipt. The telegram contained a strange message:

German authorities have stored in Villa Reale Poggio a Caiano . . . valuable artistic collections and archives concerning Tuscan Renaissance works. Stated by German Government that there are in neighborhood Villa Reale no repeat no German troops and Villa Reale itself not used for military purposes. German Government desires to inform British and American Governments of its desire to avoid bombardment or destruction Villa Reale. Grateful you inform Army AMG of contents of this message.

Hartt viewed this message with great skepticism, especially after having heard about Poggi's unsavory experiences with Langsdorff and other German officers during the last days of occupation. While the message might have been a sincere effort by German Kunstschutz officials to protect the Tuscan monuments, Hartt worried about what he would find once he reached the villa at Poggio a Caiano. For now, he could only wait.

17

"THE MOST BEAUTIFUL CEMETERY IN THE WORLD"

SEPTEMBER 1944

While Fred Hartt and the British Eighth Army were in liberated Florence battling the consequences of German occupation, Deane Keller and the U.S. Fifth Army were fifty miles to the west, about to enter Pisa after a brutal struggle to dislodge German forces.

Following the liberation of Rome, Allied forces had attempted to sprint north, hoping to split and destroy the two main German fighting units before they could cross the Arno and reestablish superior defensive positions. By late summer, however, Allied generals made the decision to halt offensive operations and allow weary troops to rest after their furious push up the peninsula from Cassino. They also needed to regroup, now that seven divisions of troops had been withdrawn from Italy to aid in Operation Dragoon, the Allied landings in southern France on August 15.

Kesselring's troops made excellent use of this delay by accelerating completion of the Gothic Line, the Nazis' last major fixed defensive position in Italy. The Gothic Line ran the width of Italy—from the

west coast about twenty miles north of Pisa, across the ridges of the Apennine Mountains, and down to the east-coast city of Pesaro, just north of Ancona. This ten-mile-deep perimeter had been fortified with 2,376 machine-gun posts; 479 mortar, antitank, and assault guns; and seventy-five miles of barbed wire—all taking advantage of the mountainous terrain. Allied penetration of the Gothic Line would facilitate passage over the Apennines and provide a clear shot to Germany's southern door. The longer the Germans could delay the Allies in Pisa, the more time they had to complete the Gothic Line defenses. The city paid dearly.

Pisa, a city with ancient, yet still debated, origins, sits astride the Arno River some eight miles inland from the Tyrrhenian Sea. The city owes its early development to the Romans, who understood the strategic position of its ports. Pisa reached the height of its political power as a Maritime Republic by the second half of the twelfth century. That growth and consequent prosperity funded construction of its *Duomo* (cathedral) in 1063, *Battistero* (Baptistery) in 1152, *Campanile di Santa Maria* (bell tower, better known as the Leaning Tower) in 1174, and *Camposanto* (cemetery) in 1278.

The city's political and economic decline began in 1284 with a naval defeat at the hands of the Genoese and culminated in 1406 when a cruel siege by their fierce rivals, the Florentines, ended the autonomy of the city and significantly reduced the population. The matter was settled in a rather expensive way: the Florentines accepted the secret offer of Giovanni Gambacorta, *signore* [leader] of Pisa and now betrayer of the citizens' trust, and bought the city of Pisa for 50,000 gold florins and the trade of a few castles and fortresses. Over the next hundred years, momentary glimpses of its heyday appeared, such as the creation of a botanical garden—Europe's oldest—in 1544. But the once-dominant Maritime Republic of Pisa no longer held sway on the Mediterranean. Such defenseless beauty made the cruelties of August 1944 all the more tragic.

As late as July 28, Vatican Deputy Secretary of State Monsignor

Giovanni Montini had appealed for the city to be spared. In a letter to Myron Taylor, President Roosevelt's personal representative to the pope, Montini stated: "The Holy See . . . cannot do other than entertain the liveliest fears for the fate of such a city as Pisa, where generations of believers and artists have erected irreplaceable religious, historical and artistic monuments, whose destruction would constitute an irreparable loss not only for Catholics but for the whole civilized world."

But despite its world-famous monuments, and numerous appeals by the Holy Father, Pisa had—inexplicably—only received a Group C status from Allied Military leaders. Thus, while Allied pilots received instructions to avoid hitting monuments, they were also told in advance that any consequent damage was accepted. The contrast in the treatment of Florence, a Group A city, and that of Pisa, a Group C city, was stark. In both cities, Allied forces succeeded in driving German troops north of the Arno River. But whereas Florence suffered minor damage at the hands of the Allies, repeated bombing runs flattened its once-more-powerful rival. Fifth Army artillery further devastated the buildings the bombers had missed during the six-week battle.

In four months, Keller had already driven more than eight thousand miles, over dusty, potholed, bomb-scarred roads, inspecting hundreds of damaged towns. Although he had seen plenty of misery and hardship, the situation in Pisa exceeded anything he could have imagined. Upon entering the city on September 2, Keller noted, "The south side was so badly destroyed in part that a new City Plan has been worked out." The city was a skeleton of its former self. "The south side of the city was booby trapped and the whole area was thickly sewn with mines." The danger drove away the citizens; Keller saw but two civilians in a city with a prewar population of seventy-two thousand.

Keller's AMG advance team, seven officers with different specialties, carefully maneuvered their jeeps around the mounds of debris. They climbed over ruins, jumping at the occasional rat in the rubble, all the while looking for mines. Because of the number of booby-trapped buildings, it took most of the first day just to reach the old city hall near

the banks of the Arno. There, as the sky burned orange and the sun dipped to the horizon, Keller and Captain McCallum, the engineer on Keller's reconnaissance team, hung the Stars and Stripes and the Union Jack from the building's balcony so that they faced the river. Their sense of pride was short-lived. "There was little sleep that night, for the American Batteries within a block of the billets fired every few minutes and the Germans flew over and dropped bombs and their shells continued to fall."

Early the next morning, Keller crossed the Arno over the remains of a narrow streetcar track that was once attached to the Ponte Solferino near the city center. Just as they had in Florence, German forces had detonated demolition charges as they moved northward out of the city, destroying the Ponte Solferino and the city's other three bridges. The historical importance of the bridges was of secondary concern to Keller. He wanted to reach his primary objective, the Piazza dei Miracoli (Square of Miracles), where the Duomo, Baptistery, Leaning Tower, and Camposanto were located.

Keller was initially encouraged when he entered the piazza. The Baptistery had sustained hits; he observed several holes in the roof of the Duomo and one on a façade column, but none looked serious. A glance to his right confirmed that the Leaning Tower had maintained its flawed verticality. However, after walking farther north and emerging from between the Baptistery and the Duomo, he stopped in his tracks: the roof of the Camposanto was gone. Only a few stubs of charred timber were visible. In this war, even the cemeteries were dying.

The architectural curiosity of the Leaning Tower, and the adjacent Baptistery, with an intricately carved thirteenth-century marble pulpit by Nicola Pisano, had always drawn steady crowds. But the jewel of the Piazza dei Miracoli was the Camposanto, a building constructed atop the site of the ancient cemetery on the north side of the piazza. Its exterior walls measured 40 feet high by 415 feet long by 171 feet wide (slightly larger than an American football field). A rectangular grass courtyard in the center opened to the sky, much in the style of a cloister. It was

said that soil had been brought from Golgotha, the hill on which Jesus was crucified. Opposite the exterior walls were Gothic marble arcades open to the grass courtyard from each side and crowned by enormous wooden A-frame beams that supported a roof made of lead.

For almost seven centuries, the Camposanto, not the Leaning Tower, had been the "must-see" destination for visitors to Pisa. Hordes had come to gaze upon its extensive frescoes. A much younger Deane Keller had made the pilgrimage during his student days at the American Academy. Paintings and frescoes are usually measured in inches or centimeters, occasionally in feet or meters. But the inner walls of the Camposanto displayed some twenty thousand square feet of vibrantly colored frescoes painted by some of the most talented artists of the fourteenth and fifteenth centuries. The frescoed walls extended horizontally for more than a fifth of a mile. The volume of painted space boggles the mind. (For comparison, the area of frescoes in the Camposanto was about three thousand square feet larger than the area of frescoes in the entire Sistine Chapel.)

Keller knew that the Camposanto glorified local memory stretching back to the medieval era. Richly colored Early Renaissance frescoes depicting *The Last Judgment*, *Hell*, and *The Triumph of Death* surrounded the cemetery's "permanent residents" and filled the walls along the corridors, floor to ceiling. The marble pavement was interspersed with sepulchres, each marking the burial spot of a luminary of the city or a member of the Medici family.* Throughout the building, statuary sat atop stone pedestals in front of the frescoed walls. The Gothic marble arcades providing the building's interior structural support diffused the sunlight that emerged from the grass courtyard, creating beautiful shadows. The famous golden light filtered through this kaleidoscope, changing throughout the day and the seasons. Facing the frescoed walls, at the

*The influence of the Medici extended well beyond Florence. After the acquisition of Pisa, Cosimo I de' Medici brought new life to the city in the sixteenth century with the construction of noble residences and the redesign of the Piazza dei Cavalieri by Giorgio Vasari.

base of the arcades, were 125 Roman sarcophagi, some distinctly and elaborately carved, which had been opened and reused in the Middle Ages.

But Keller's overriding memory wasn't of the building's beauty—its frescoes, tombs, or history. It was of the serenity of the space, a welcoming respite for the living, a solemn resting place for the dead. The bombs had destroyed that peace as much as the fire had mangled its contents.

Keller's report of the destruction read like an autopsy:

> *On the floor next to the walls were thousands of pieces of fresco which had fallen to the ground either from the heat [or] the concussion from the jarring of the great beams as they fell to the floor. These were mingled with myriads of pieces of broken roof tiles, carved chunks of all sizes from the tombs, blackened embers and nails. All the sculptures were covered on the upper sides thoroughly with the molten lead and the perpendicular surfaces were streaked with it. Stains from heat and the running lead were to be found on tombs and paintings alike.*

Extreme temperatures cause expansion or contraction of moisture within the frescoed plaster, which then leads to disintegration. For this reason, frescoed surfaces are mostly found inside covered dry spaces. While the Camposanto frescoes were susceptible to general humidity, the roof precluded exposure to sun or rain. With the roof gone, what frescoes remained affixed to the wall had been baked for thirty-eight days by the intense Tuscan sun, reducing many of them to a chalky dust. "Thousands of pieces" wildly understated the volume of fragments; it had to be into the millions. The floor of the Camposanto contained an immense jigsaw puzzle.

Keller suspended his inspection to speak with Bruno Farnesi, the *capo tecnico* of the piazza complex, who had witnessed the fire. Farnesi approached Keller, speaking Italian so hurriedly that Keller had to calm him down and ask him to begin again. After catching his breath, Farnesi told Keller that on July 27, five weeks earlier, a violent artillery barrage

had shaken the Piazza dei Miracoli. The Americans seemed to be aiming at a German observation post in the Leaning Tower. Although the use of church steeples and the heights of historic buildings as observation posts violated the rules of war, it had happened often in Italy and quickly became a common occurrence in the battles of northern Europe.

Farnesi watched as a few shells hit the massive structure, but he doubted the Allies were trying to destroy the Leaning Tower. German soldiers had established a position there to call in target coordinates to artillery batteries located far away from the Square of Miracles. Several other rounds struck the Duomo where the archbishop said Mass. Farnesi knew the cathedral was strong. It could take a dozen blows. But when the shelling stopped and the sky cleared, he saw a thin column of smoke rising from the Camposanto.

Even from the ground, flames were clearly visible on the northern side of the roof. Farnesi said he would have doused the flames, but the city had been without water for days. The only "weapon" to fight the fire was a tall ladder, which Farnesi had placed inside the Camposanto two months earlier.

Farnesi and a small group of volunteers, armed with nothing more than shovels, clubs, and poles, climbed the ladder, but the wind off the Tyrrhenian Sea was pushing the fire across the roof faster than the men could fight it. The day was dying, but the fire was gathering strength. Farnesi watched as it ran along the great wooden support beams and wrapped its fingers around the lead roof. The beams snapped and crashed to the ground, causing the lead to run in rivulets down the walls. Farnesi urged the men forward, despite the blistering heat.

A shell whistled in, hitting the Duomo. But the great building held. Soon a volley of shells was raining down on the complex. The crowd scattered. The men struggled down the ladder and huddled behind the walls of the Camposanto. The shellfire seemed to be coming from the south, where the Americans were encamped. While the wall offered no protection from artillery, it was the only spot sheltered from the heat of

the flames. Another explosion less than a hundred feet away knocked one of the men off his feet. This time, the small group ran for the safety of the cathedral.

Some time later, maybe ten minutes or an hour—it was impossible for Farnesi to determine—the artillery fire stopped. When he stepped outside, night had fallen.

Farnesi continued the sorry tale, his hands trembling:

I went back to the monument, and it was even clearer to me now how we were absolutely powerless to prevent its complete destruction. I had to witness the tragic sight, impotent, with a lump in my throat and an oppressed and bleeding heart. We stared at the destroying flames, and I had a fleeting, yet clear vision of the long time I had spent there; and my thoughts went to the works carried out with care and love, to the complete restoration of the roof and to the entire rearrangement of the Sarcophagi and of all other monuments, to the Commission, to the Polemics on the conservation of the famous frescoes and on their restoration, to the concerns for even one drop of water on the walls, to the care of the roses and the lawn; in short, to everything that happened every day, for twenty years.

Farnesi paused to look up at the American officer in his dusty uniform. Keller couldn't decide whether his look was sad or accusatory, or whether he was just thankful someone was listening. "In the night, the Piazza dei Miracoli seemed to bleed in the vermilion color of the flames; the Duomo, the Baptistery, and the Campanile . . . were there, solemn, almost tinted with blood, to witness the tragic destiny of their brother, minor in age but not in beauty, who was perishing and was irredeemably consumed."

Anyone who loved culture or history would have had a difficult time being unmoved by the sight of the ruins of the Camposanto: the fire-blackened walls, the charred timbers, the cracked tombs. How hard must it have been for this man who had dedicated his life to its care?

Farnesi started again, "I saw again the visitors and the numerous

caravans of Italians and foreigners who, dazzled by so much harmony, by so much splendor, remained rapt and astonished by such luminous beauty in the admiration of what was the most beautiful cemetery in the World."

KELLER, TOO, LOOKED at the shattered pieces of frescoed plaster that covered the floor of the Camposanto and reflected on past events. He thought of the women in Naples, carrying buckets of rubble while their babies sat in the ruins. He thought of the town of Itri, shattered on the side of a steep hill, and the Italian refugees he had found living in caves and eating grasshoppers to survive. He thought of the Monastery of San Martino, not one lintel of which he could find, and the town of San Miniato, on the hills outside of Florence, where twenty-seven civilians were killed when a mine detonated inside the cathedral into which they had been herded by the Germans. He thought about how Florence must look without its bridges and medieval towers, whole portions of the old city reduced to dust. He thought of the reports of missing art. Michelangelo. Leonardo. Donatello. Botticelli.

What had he done in that time? He had advised. "My assignment is MFAA officer, AMG Fifth Army," he had written his parents just weeks earlier. "I am not supposed to step out of my role. I would have no authority at all. The way I help is to talk with people, serve as interpreter—give help to any of the others who need it, and once in a while interject something in a meeting."

He thought of that first dead American soldier he had seen south of Rome, a letter for his mother tucked in the lining of his helmet. That American boy had become every soldier. That village had become every terrible place he'd visited. Naples. Gaeta.

But the scenes of death that had gripped him gave way to positive images: of Sezze Romano, where fifty townspeople had followed him to his jeep, offering prayers and thanks; of Monte Oliveto Maggiore, where the monks had hidden Allied personnel amid the artwork of Siena. He

remembered his joy upon hearing that Rome was virtually unharmed; the Farnese Palace in Caprarola, where seventeen cases belonging to the king were untouched; Siena's most prized painting, Duccio's *Maestà*, protected inside its wooden crates; Michelangelo's *David* and the *Slaves* entombed in their beautiful, secure silos of brick.

He thought of the Cistercian Abbey at Fossanova, where Thomas Aquinas had died in 1274. He remembered again the long drive along the desolate Pontine Marshes, and his first glimpse of the abbey's famous white walls; the arched walkway; and Don Pietro, the priest, dressed in his robes and sitting at the organ behind the High Altar playing *Ave Maria*.

Keller turned to the forlorn Farnesi and instructed him to bar entry to anyone without first obtaining his permission. He then started looking for the nearest field radio; he had to make an emergency call.

18

WHEREABOUTS UNKNOWN

MID-AUGUST–OCTOBER 1944

New York Times reporter Herbert Matthews observed that "Florence is no longer the Florence that the world has known for 400 years. . . . the heart of Florence is gone." Of its six bridges—San Niccolò, alle Grazie, Vecchio, Santa Trinita, alla Carraia, and alla Vittoria, only the Ponte Vecchio survived. In fact, the Germans had rigged it with demolition charges as well. Some among the Allies theorized that the Germans had changed their plans at the last minute, perhaps concerned that the debris caused by the destruction of the two-story bridge would actually have facilitated an Allied crossing by providing enough rubble to form a new foundation in the low water of late summer.

The destruction of the bridges was a double tragedy. The one that should have been spared based on artistic merit was the Ponte Santa Trinita, not the Ponte Vecchio. Professor Friedrich Kriegbaum had argued as much to Hitler when they walked through the Vasari Corridor in 1938. Instead, German forces had spared the Ponte Vecchio by destroying the adjacent medieval *palazzi* and buildings at both ends of the bridge. Moreover, the demolition of the bridge hardly delayed the Allies at all. Hartt and others quickly found "loopholes . . . through

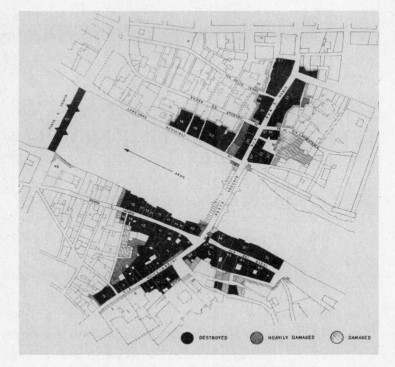

After the war, Fred Hartt created this map of central Florence that depicts the consequences of the German demolitions on August 4, 1944. Areas in black were obliterated, including the Ponte Santa Trinita (upper left) and large areas north and south of the Ponte Vecchio (center) [Eugene Markowski Collection]

which Allied vehicles could cross." At 6 p.m. on August 17, a "Bailey bridge"—consisting of portable prefabricated parts—assembled atop the surviving piers of the Ponte Santa Trinita allowed Allied military vehicles and Florentines to reach the north side of the Arno. The temporary crossing was christened the "Trinity Bridge."

Hartt, and thousands of people who had become refugees in their own city, witnessed horrifying scenes during the initial days of liberation.

In the city there was no water, no light. . . . the mosquitoes came in clouds from the stagnant Arno, the heat was intense and the air suffocating with the odors from the broken sewers and gas mains, the unflushable closets

[toilets], and the corpses still buried under the ruins along the Arno. Fascist snipers from windows all over the town picked off civilians at random. During this period nearly four hundred persons, mostly civilians, were killed by the German batteries which continued to shell the town sporadically from Fiesole.

Even after Allied forces gained control of the north side of the Arno, life remained miserable for Florentines. People accessed the north and south sides of the city by walking across the broken remains of the other shattered bridges. Few buildings had intact windowpanes. Stretches of what had once been one of the world's most cultivated city centers had been replaced with piles of rubble thirty to forty feet high along sections of both sides of the Arno. Women picked through the pieces searching for heirlooms. Men, armed with picks and shovels, hacked away at the remnants of their beaten city to clear paths for workers and begin the process of rebuilding.

Gaunt faces conveyed the hardship endured by the Florentines. Barefoot women, standing shoulder to shoulder, prepared spartan meals on outdoor stoves in the Boboli Gardens. Others hunched over on their knees along the banks of the Arno, using its dirty water to scrub even dirtier clothes on pieces of stone debris created by the blasts. Despite the filth, thousands of people sought relief from the heat and dust by swimming in the muck.

No one indulged in vanity. Young, dark-haired women looked thirty years older, with their once-well-coifed hair standing on end, caked with grayish dust. Men patched and repatched their ragged clothes. A cluster of people usually indicated the location of one of the city's temporary clean-water supplies. Such oases were fairly easy to find; just follow someone carrying straw-covered wine jugs or gasoline cans in each hand. The children of Florence sat in circles on the ground, devouring meager suppers. It was a desperate moment in the city's storied history.

In liberated Florence, war correspondent Martha Gellhorn—Mrs. Ernest Hemingway—filed a heartbreaking report.

The botanical gardens are now a graveyard and they are the most frighten-ing place in Florence. The Germans had taken all the hearses; the cemeteries of Florence lie to the north of the city and are in German hands, and there is no wood for coffins. Add to these basic facts the daily normal deaths in a city of three hundred thousand and the daily deaths resulting from mines, mortars, shells and snipers and you have the ghastly problem of Florence. Dead had been left unburied by the Germans, and it was not always pos-sible to retrieve bodies. For instance, one body lay for days on the stumps of Alle Grazie Bridge. No one could reach it, first because of snipers and then because of mines. So trenches are dug in the botanical gardens and the uncasketed bodies are laid in them.

With British Eighth Army now east of the Apennines and advancing on the Gothic Line, Florence and the region of Tuscany fell within the jurisdiction of U.S. Fifth Army. The size of Tuscany and the multitude of its cultural treasures forced the MFAA temporarily to divide responsibili-ties between Deane Keller (stationed in the western provinces of Pisa, Livorno, and Grosseto) and Fred Hartt (who assumed primary respon-sibility for the three eastern provinces of Florence, Siena, and Arezzo). Hartt pointed out to Keller that such an arrangement would keep them from "getting constantly in each other's hair."

Monuments officers had standing orders to effect temporary repairs, but the moonscape of Florence strained this directive. With the bridges gone and many of the streets impassable, much of the initial work had to be done by hand. There were few workers and even fewer supplies. When army engineers did arrive, they showed little discrimination in what they tore down. Hartt would struggle to explain to them the sturdy structural dynamics of a medieval tower, only to watch wrecking crews ignore the tutorial offered by the second lieutenant art historian.

These confrontations came to a head when Hartt began work to recover the rich library of the Colombaria Society, buried under the rubble of towers and buildings. Hartt believed the library's manuscripts and documents, which dated from the early Middle Ages, could be

located and saved. But his good intentions clashed with the "devouring bulldozer[s]", and their operators, whose orders were to remove rubble as expeditiously as possible and, if need be, shove it into the Arno. The city and its citizens urgently needed water, and the principal water main passed beneath what was once the Colombaria Society.

From Hartt's perspective, working with the British Royal Engineers was a game of cat and mouse. "[I] made between three and five trips each day, losing about an hour for each trip, to the site of the excavations, and each time whatever British authorities on the spot agreed to stop the bulldozer short of the river in order to allow examination of the rubble heap. Each time [I] left the scene, however, the rubble was pushed in directly without examination." The Royal Engineers thought quite differently: "Mechanical excavation and carrying away in trucks was tried and found too slow." In their view, the main problem wasn't the situation on the ground but the "A.M.G. rep.," Fred Hartt.

The British lieutenant colonel went on to state: "After many complaints from the A.M.G. rep. none of which were found on investigation to be justified. The Library was then skirted and it was found possible to clear the line of the pipe. . . . This was done. In this work I received the reverse of cooperation from Lieut. Hartt . . . but very good cooperation from some of the Italians." Despite the procedural difficulties, however, the combined efforts brought water to the Florentines and uncovered "in surprising numbers" the most important archives of the library—its manuscripts and incunabula.* The majority of the modern holdings, however, never emerged from the rubble.

In time the engineers and Monuments officers overcame these early mistakes and made real progress. Then a new problem arose. Every damaged building, church, and museum in the center of the city needed roofing tiles. Poggi proposed a resourceful solution: use the terra-cotta tiles from the Medici-era Forte di Belvedere, whose architectural integrity had long since been compromised. Despite the fort's

* *Incunabula* are books and other documents printed in Europe before 1501.

size, however, the quantity of tiles proved woefully short of the city's needs. In late September, it began raining, day after day—for thirty-five consecutive days. Hartt lamented that anyone walking through the galleries of the Uffizi would have to "wade up to the ankles during the autumn rains."

One of the mysteries circulating in Florence after liberation was the whereabouts of American Bernard Berenson, widely considered to be the world's leading art scholar and connoisseur of early Italian paintings. "B.B.," as his friends knew him, had lived in Florence since 1900 at his home, Villa I Tatti. With the signing of the armistice in September 1943, and the subsequent occupation of Italy by German troops, Berenson had been urged by his many friends to seek safety and leave the country. Although he initially refused, the Jewish scholar disappeared soon thereafter.

Many of the Monuments officers knew Berenson, some quite well. Monuments Man Captain Cecil Pinsent had been the architect and landscape designer who, "from 1907 to 1951 . . . was the architect of choice for the Anglo-American expatriate community in Florence," including Berenson. One writer later described his creation at I Tatti as "a princely estate—the villa crowning gracious terraces echoes the splendour of the Villa d'Este—and answered perfectly Bernard Berenson's imperious character."

In early 1942, Hermann Göring's agents made inquiries to Professor Friedrich Kriegbaum and Consul Gerhard Wolf about Berenson's paintings but later—and incorrectly—dismissed them as being unworthy of the Reichsmarschall's esteemed collection. Not satisfied that Göring's agents would stay away, and acting on the advice of Kriegbaum and Giovanni Poggi, Marchesa Serlupi and her staff inventoried Berenson's paintings and sculpture and, at some personal risk, then hid them. The more valuable pieces were taken to the Serlupi home; lesser works had been walled up in an apartment near the Ponte Santa Trinita and Ponte Vecchio belonging to the sister of Berenson's secretary, Elisabetta "Nicky" Mariano. When the Gestapo later attempted to locate Berenson, Consul Wolf lied to them and then spread the rumor that the great

scholar "had gone to Portugal, via the Vatican." The guardians of Florence had protected one of their own.

Hartt met Berenson before the war while in Florence doing research. The aspiring art scholar had admired the grand lifestyle enjoyed by Berenson. Hartt considered the aesthetic life in Florence, amid a great art collection and an extraordinary research library, the pinnacle of achievement. And besides, someday, when the war ended, Hartt, like millions of other servicemen, would return home and need to find a job. A person of Berenson's stature could be very helpful.

On a mid-August day, Hartt and Monuments officer Captain Sheldon Pennoyer had a chance encounter with Professor Giovanni Colacicchi, director of the Accademia delle Belle Arti and a close friend of Berenson's. Colacicchi wanted to know whether it would be possible to exchange two Nazis "still living in his own house" for the return of Berenson, who was safe but in hiding at the home of Serlupi. Not only had Serlupi and his wife provided shelter and false identification papers for Berenson and Nicky Mariano, they had saved most of his collection. But the area around the Serlupis' home—Villa delle Fontanelle, located in the neighborhood of Careggi, about three miles north of Florence—was still within German lines; a visit or inspection would have to wait.

On September 1, the first Allied soldier to go in search of Berenson was Captain Alessandro Cagiati, an Italian American intelligence officer of the OSS (Office of Strategic Services, precursor to the Central Intelligence Agency) and a close friend of Serlupi's. Hartt arrived the following day and observed with relief that the "Villa [delle Fontanelle] was perforated with at least thirty shell holes of small calibre. . . . Berenson was found in weak and somewhat shocked condition, but quite safe and well." In fact, Nicky Mariano described just how close Berenson had come to becoming a war casualty. On *Ferragosto,* August 15, during their meager celebration of the Feast of the Assumption, "A shell burst near the convent enclosure and a goodish sized splinter crashed through the dining room window and passed between the heads of B.B. and our hostess and hit the wall behind them."

Later in the month, the rest of the Monuments officers, including Deane Keller, visited Berenson at his home. Hartt sought refuge there every week he was in Florence. Pennoyer summed it up best: "After all the humanity that one rubs up against in the army to say nothing of the surroundings that go with its day after day grind, the refreshment of stepping into a completely civilized and tastefully furnished home of an American was like a cool beverage after a seemingly unending thirst."

AS GERMAN SOLDIERS gathered more and more artworks from Tuscan repositories, officials began the search for a new repository where they could be hidden. The initial site approved by General Wolff and Gauleiter Franz Hofer proved unsuitable. As Major Leopold Reidemeister, another of the German art historians serving in the Kunstschutz, explained to Hofer during their August 8 meeting, the dampness of the building wasn't half as disturbing as the ammunition stored inside. Sensing an opportunity, the Gauleiter suggested taking the works of art out of Italy to Innsbruck, Austria, or into the Bavarian region of Germany. Prepared for a diplomatic chess game, Reidemeister reminded Hofer that General Wolff would have to be consulted for any such move. The two men agreed that a new location in the Alto Adige region would have to be found. Hofer instructed Reidemeister to contact Dr. Josef Ringler, Superintendent of Monuments and Galleries of Trento (thus also responsible for Alto Adige) who would assist with the search.

Within several days, Major Reidemeister and Dr. Ringler identified two ideal storage facilities in remote villages near the Brenner Pass, the principal Alpine link between Italy and Austria. The first delivery of works of art arrived without difficulty on August 11; more continued to arrive throughout the following weeks. But on August 29, five trucks, each filled with recently plucked masterpieces, ran out of gas in the town of Bolzano, capital of Alto Adige. That convoy also included the ambulance carrying the two Cranachs belonging to the Uffizi Gal-

lery. The fuel shortage proved so severe that OKW temporarily pulled Wehrmacht divisions from the front out of concern they might become stranded.

In the interim Dr. Ringler agreed to store the Cranachs at his office in Bolzano. Even that came with complications. The sounding of sirens on August 31 and September 1 forced him to hand-carry the two life-size paintings of *Adam* and *Eve* into the air-raid shelter on three separate occasions. Then came the astonishing suggestion that Ringler load the paintings onto furniture vans and haul them to the two repositories by horse or oxen. Fortunately, Ringler soon received a call from Hofer, who had heard from Wolff's headquarters that "700 liters [185 gallons] could be obtained from the police's off-limits petrol."

The Cranachs finally reached one of the two newly selected repositories on September 6. The following day, Colonel Langsdorff's assistant, Captain Zobel, stopped in Bolzano to visit with Dr. Ringler. Zobel was accompanying two trucks carrying the Gordon Craig Theatrical Archives—property of an English actor, director, and stage designer, which the Führer purportedly had purchased. After discovering that Ringler had already departed, Zobel resumed his trip north—past the two new repositories containing the Florentine treasures, across the Brenner Pass into Austria, to the salt mines of Altaussee, less than 250 miles away.

WITH THE MISSING Cranachs and the paintings from Montagnana on their minds, Fred Hartt and the Monuments officers pondered the meaning of the suspect radio message they received in late August concerning the villa at Poggio a Caiano. The Germans appeared to be asking the Allies not to bomb in the area because of the art treasures stored in the villa. But Hartt remained skeptical that it was an act of benevolence. Now that the line of fighting had shifted, Hartt and his driver, Franco Ruggenini, departed Florence on September 5 to investigate. Although the area surrounding the villa had been liberated, the drive posed other

hardships. A key bridge had been destroyed, forcing Hartt and Rugge-nini to wade across a canal. When they reached the other side, to their great surprise they found themselves "greeted as liberators by a village which had never before seen an Allied officer."

Upon arriving at the villa, the custodian informed Hartt that Ger-man soldiers had made off with fifty-eight cases of sculpture. As Hartt pointed out in several of his reports, "The withdrawal of these works of art corresponds narrowly with the dates of the German radio appeals from Berlin to the Allies not to bombard Poggio a Caiano." The Ger-mans had used the radio transmission as a feint so they could empty the villa. At the caretaker's insistence, the Kunstschutz representative, Major Reidemeister, had signed a handwritten receipt for what was taken. He also acknowledged that the works of art were protected by order of Generalfeldmarschall Kesselring and by virtue of Cardinal Dalla Costa's letter placing the villa and its contents under the protec-tion of the Holy See.

Missing were some of the most important pieces of Renaissance sculpture in existence. Discovering that German troops had taken works by Michelangelo and Donatello belonging to the Bargello Museum in Florence left Hartt in a state of despair. "Donatello's *Saint George*! What loss could Florence have felt more keenly? The ideal hero, the saintly warrior, represented for the Florentines the very incarna-tion of the martial vigor of their lost republic." Although crated, these fragile works had been loaded onto a truck and driven to destinations unknown over some of the worst roads Hartt ever had the misery to traverse.

Overwhelmed with anger, Hartt immediately contacted DeWald:

Dear Ernest:

 This is what they stole. I retain the original hand written document which the custode [sic] made out. Was going to write a thing for the papers, but no time. Dig out your files on Poggio [a Caiano] & you will notice that they started stealing the stuff two days before they broadcast to us not to

bomb it. God knows where it is now. If I were you I would call in the cor-
respondents & make a big story out of this. Maybe that will save other stuff
from being stolen.

On September 7, and again on September 18, Hartt attempted to reach the Palazzo Pretorio in Poppi, which contained additional master-pieces from the Uffizi and the Pitti; both efforts failed. For all his enthu-siasm, Hartt knew that when he confronted a sign on the road that read, THIS IS THE FRONT, he had to turn back and try another day. After the front moved north, Hartt made a third attempt to reach Poppi; this time he was successful. On September 27, he made a follow-up inspection. Unlike other removals by German troops, this one had occurred at gun-point over the course of almost five days.

On August 18, a German officer had arrived under the pretext of checking for concealed weapons and ammunition. Four days later, three German officers offered the weak excuse that "the village was a nest of spies and rebels." After forcibly inspecting all the rooms of the palazzo, and breaking down doors when keys weren't produced quickly enough, these officers, revolvers drawn, forced the municipal police to carry one crate of paintings to their waiting truck. The Germans fired shots in the air to scare away the townspeople, then drove off. Only an hour passed before German soldiers returned, informing the locals that they were about to detonate mines placed under the town gate. Everyone was ordered to remain in their cellars, where they would be safe. Of course, this also kept idle witnesses indoors during the removal of additional paintings from the palazzo.

The following morning, two German second lieutenants arrived to report that the night's work had been "official and had been ordered by the High Command, that it had been executed only in order to save the works of art from the damage of war and especially from theft by Anglo-American troops, that the German authorities were extremely sorry they had not been able to remove all of the works of art, and that the remainder would have to be protected by the population." True to

their word, at 2 p.m. the Germans detonated the mines, destroying the town's medieval gate, some of the surrounding houses, and the only road into the village of Poppi.

GERMAN FORCES HADN'T limited their removals to the Florentine public collections; private collections had also been taken north during the summer. At the Villa Landau-Finaly, property of an heir to a former director and representative of the Jewish-owned Rothschild Bank in Turin, a German parachute division ignored three separate OFF-LIMITS signs posted by Kesselring, the Holy See, and Consul Wolf. They then emptied the cellars of the neighboring Villa La Pietra, where most of the Finaly collection had been hidden together with that of its owners, the prominent Acton family. Florentine art dealer and collector Conte Contini Bonacossi, who had sold paintings to Göring, hid his collection in a villa at Podere di Trefiano. Once German Regiment 1060 began using the villa as its headquarters, Kunstschutz officials ordered its commander to evacuate the works of art. The 16th SS Panzer Division also removed the Bourbon-Parma collection from the castle of the Duke of Bourbon-Parma.

By early October, Hartt, working out of the Florence Superintendence, finally completed his inspections of all but one of the thirty-eight Tuscan repositories. According to his October 8 report, German soldiers had removed works of art on specific orders from senior Nazi leaders. Most of the removals involved subterfuge or threat, and at least one took place at gunpoint. In Hartt's opinion, "Only the fearless conduct of Superintendent Poggi prevented the departure of even more treasures." "On three separate occasions Poggi was visited in his office by SS officers who had an order on Himmler's authority to take away all the important works of art in and around Florence, and that these officers enforced this demand with the utmost rudeness and threats, which had little effect on the 64 year old Superintendent." Hartt had no way of knowing that Himmler had merely granted his approval to decisions made by General Wolff.

Once again the art historian in Hartt found its way into his official report:

> *The pictures taken were of such importance that it is difficult to know which ones to choose as the principal losses. Suffice it to mention Rembrandt* Portrait of an Old Man, *Ingres* Self Portrait, *Botticelli* Madonna and Child, *Filippo Lippi* Madonna and Child, *Raphael* Self Portrait, *Dürer* Calvary, *Caravaggio* Head of Medusa, *Raphael* Donna Velata, *Rubens* Holy Family, *Titian* Concert, *Velasquez* Portrait of Philip IV. *It should be further emphasized that a very large number of the missing pictures are German, Flemish and Dutch artists.*

The list of what had been taken clearly indicated a bias toward northern artists. Cranach's two paintings of *Adam* and *Eve* would find worthy companions. Remarkably, masterpieces such as Leonardo da Vinci's unfinished *Adoration of the Magi*, Andrea Mantegna's completed version of the same subject, Botticelli's *Birth of Venus*, and Michelangelo's panel painting known as the *Doni Madonna*—one of only four known paintings by the great master and certainly his most important—had been left behind.

As he tallied the number of objects missing from the Florence repositories, Hartt felt overwhelmed. "A grand total of 529 paintings, 162 works of sculpture and minor arts, 6 large cartoon drawings, and 38 pieces of medieval and Renaissance textiles had been taken from the public collections of Florence, all in all 735 objects."* He concluded that Florence "had suffered robbery . . . on a scale to dwarf the depredations of Napoleon."

* Hartt's calculations did not include objects removed from private collections.

19

RESURRECTION

The disappearance of its priceless artworks aside, Florence had been far more fortunate than Pisa. The Tuscan capital had lost a great number of medieval structures, but Florence and its citizens were alive. In contrast, the city of Pisa—or what was left of it—was ghastly and quiet. War had emptied the streets and piazzas. While Deane Keller focused on saving Pisa's Camposanto, his overarching concern was restoring life to the city itself.

U.S. Fifth Army troops battled the Germans for six weeks before liberating the city on September 2. Allied bombers had done their work well; the devastation had rendered the city largely uninhabitable. Even then, German long-range artillery pounded the city for an additional three weeks. As Keller noted in his report, little remained undamaged: "Thirty-eight of her monumental churches exhibited major war damage; eight of her secular buildings of monumental importance suffered severely; numerous houses dating back to the Renaissance times were hurt . . . this in addition to the loss of her bridges, railroad station and other public utilities."

Keller understood that saving the Camposanto presented the army

with a considerable challenge. Damage to the frescoes was extensive. John Bryan Ward-Perkins noted: "The whole fresco was painted against a wicker ground which has partly burned, partly come away from the wall, and only immediate action will save it from disaster." The Allies didn't have the resources for such an exhaustive and time-consuming project, but ignoring the problem would draw the scorn of the press and alienate Italians. One rainstorm would wash away the remains of centuries of history. Something had to be done.

From Keller's perspective, if the Monuments, Fine Arts, and Archives Section ever stood for anything, it was this. On September 3, he made a call to a senior Civil Affairs Officer, Major Hamilton T. Walker, and explained the risks—and opportunity—of taking immediate action. Brigadier General Edgar Hume arrived the following morning. After a second tour of the Camposanto with Keller (who served as translator) and the Archbishop of Pisa, Hume contacted Fifth Army Commander Lieutenant General Mark Clark and briefed him on the situation. Clark had learned the cost of adverse publicity following the destruction of the Abbey of Monte Cassino. The attention of the army commander made a big difference; within nine days of Keller's initial call, a group of army engineers, eighty-four Italian military personnel, and fresco specialists from Florence and Rome were in Pisa and at work on the Camposanto.

Things began badly. On September 10, Keller wrote Kathy: "On my way home we ran over a dog. . . . Stopped the car and went to see. In a minute some 40 people gathered around. When I left, the owner came up to me and said, 'Americans good. Germans no stop, hurt dog.'"

As soon as he reached Pisa, Keller had to arrange lodging for all the incoming workers and provide food for some one hundred extra people. Then followed a rash of sickness. Initially it was feared to be lead poisoning. The workers had been peeling away the lead rivulets from the tombs and frescoes. As Keller noted, "the dust was terrific." If this activity was harming them, the operation would become even more complicated. Closer examination, however, found a more benign cause: food poisoning.

The Superintendent of Monuments and Galleries of Pisa, a key figure in the cleanup, had been accused of being a Fascist, "a man with a very doubtful political past," and removed from his post. Keller believed his involvement was essential, so he arranged to have him temporarily reinstated, much to the benefit of the project. German shells continued to fall; one killed a woman in a nearby building. The encampment was soon moved. Needing additional lumber for the framing and beams, Keller led a surreptitious "midnight requisition" aboard a ship in the nearby harbor of Livorno.

Despite these hardships, Keller, the engineers, and the workers performed heroically. After thirty-four days of work, a twelve-foot-wide tarpaulin with tarpaper covering, designed to protect the existing frescoed walls from rain, was attached at a downward angle to the walls of the Camposanto, supported by wooden beams in the interior space. Keller proudly observed that "the Camposanto of Pisa is now one of the greatest laboratories in Italy for the study of fresco painting." Every speck of painted plaster had been picked up—most by hand, some gingerly with shovels—and removed from the site, preserved for the day when the tedious work of reassembling the pieces could begin. In an October 12 letter, Keller wrote, "The job is done, works perfectly. The frescoes were dry as a 15th century tibia in the last downpour." With a sense of relief, Keller wrote Kathy, telling her, "This is the biggest job I have had of its kind and it has been interesting all through, though fraught with unforeseen troubles. I wonder if this whole story will ever come out for people to know about and to realize—I doubt it."

Keller had other responsibilities in Pisa besides the Camposanto. The nearby Leaning Tower had been closed due to an accumulation of water that some thought might threaten the foundation. The water proved more of a nuisance because of the horrid smell than any structural problem. After arranging for the water to be pumped out, and rerouting traffic away from the building, he reopened the Leaning Tower to the public. It became an instant attraction for soldiers.

Well aware of Pisa's reputation as a center of learning, Keller put his

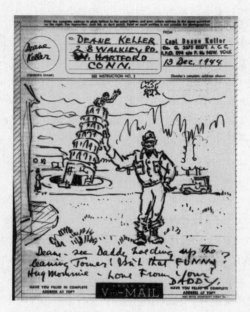

With the reopening of the Leaning Tower and other
attractions in the Piazza dei Miracoli in Pisa, Allied
soldiers had a chance to visit these famous attractions.
[Deane Keller Papers, Manuscripts & Archives, Yale
University]

knowledge of academic life to good use by jump-starting the university.
"Without the University the town has no economic future at all let alone
its importance as an intellectual center. All its factories and industries
are destroyed." It took two months to locate the faculty, remove mines
that the Germans had placed throughout the university's buildings, and
return to its library books that had been stored off-site for safekeeping.
On November 25, General Hume returned to Pisa and hosted a cer-
emony celebrating the reopening and the enrollment of some six hun-
dred students. The city's key institution was operational. The dead city
Keller had encountered when he first arrived started to resuscitate.

After turning over the ongoing responsibilities in Pisa to Fred Hartt,
Keller resumed his inspections of other towns farther north. Until this
point, he had been so far in advance of the other Monuments Men that

his interaction with them had been very limited. But the sharing of Tuscany's provinces with Hartt, transitions in both Florence and Pisa from the emergency phase to long-term recovery, and the halt to offensive operations changed that arrangement. Hartt now worked directly with Keller. The physical distance between them shrank to nothing. Not surprisingly, friction ensued, initially the result of two well-intended but overzealous comments by Hartt.

The first, included in his monthly report to the Senior Civil Affairs Officer to whom both Keller and Hartt reported insinuated that certain uninspected towns in Keller's territory had been neglected. The other comment surfaced in a letter from Hartt to Keller, telling him that the temporary roof Keller had designed at the Camposanto should be extended in several areas: "It is really necessary, as these frescoes, while not as well known as the Traini and Gozzoli ones, are of great importance. . . . Personally I consider this urgent, far more so than much of the other stuff we are now doing."

Keller found Hartt's message patronizing. How could Hartt say that towns had gone uninspected while at the same time suggesting further work on the Camposanto was a priority? On October 18, his frustration boiled over in a letter to his wife: "[Hartt] bores me to death—lectures to me all the time if I happen to walk down a street with him. . . . Frankly, I don't take the interest the historians do." Keller figured that Hartt, twelve years his junior, at times had "the young intellectual's habit of underrating experience and overrating knowledge." Still, he never let his personal feelings affect his assessment of Hartt's performance. A day later, he wrote a letter to DeWald telling him what an outstanding job Hartt had done in Florence, especially dealing with a complex situation. However, the sting of Hartt's comments lingered.

AS THE RECOVERY of Florence progressed through the fall, Hartt allocated more time to hunting down the missing Florentine treasures. Two months had passed since he and Poggi had met with Cardinal Dalla

Costa to seek the Vatican's assistance in finding the works taken from the repositories. Hartt had been consumed with work in Florence and the neighboring provinces, but after hearing from Poggi that the archbishop had finally received a reply from Rome, he immediately shifted all focus to the investigation.

According to Poggi, the November 15 letter from Vatican Secretariat of State Montini stated: "The works of art were stored in the [Alto] Adige, in a place called 'Neumelans in Sand.'" Hartt was confused, Poggi likewise. "I could find no such place in any Italian guide, nor did even Poggi know where it might be." There wasn't much Hartt or the Monuments Men could do about it anyway. The Allied armies were digging in for winter, hundreds of miles from northern Italy, where the works of art were most likely located—if they hadn't already been taken across the border into Austria or Germany. Much to Hartt's frustration, the hunt would have to wait until spring, when offensive operations resumed.

20

CHRISTMAS WISHES

LATE NOVEMBER–CHRISTMAS 1944

The Vatican that greeted OSS Captain Alessandro Cagiati and his travel companions, Marchese Serlupi Crescenzi and a priest named Guido Anelli, was alive with activity. Christmas would be celebrated in a liberated Rome, free of Fascist rule and the presence of German troops. Many meetings were taking place; committees were being organized. Construction and cleanup proceeded with manic intensity. Behind closed doors, political plans were afoot.

Cagiati and Anelli were in town to meet with Monsignor Montini, favored adviser to Pope Pius XII. The Vatican hoped an Allied victory would bring an early end to the war. The Holy See had a keen interest in who would govern postwar Italy and under what form of government. Many inside the Vatican, especially Montini, had grave concerns about the threat of a postwar Communist Italy.

Within a month of the liberation of Rome, General William "Wild Bill" Donovan, founder and Director of the OSS, trusted confidant of President Roosevelt, and a devout Catholic, met with the pope seeking his assistance in three vital areas of interest to the United States: booting the German Army from northern Italy; preventing Communists from

securing power in the future government of Italy; and gathering and relaying intelligence on war developments in Berlin and Tokyo.

Donovan found a kindred spirit in Montini, whose progressive political views, especially his disdain of Communism, mirrored official policy of the United States and Great Britain. In the judgment of Vincent Scamporino, a key OSS operative in Italy, Montini was a "trustworthy man . . . the son of a parliament member of the Popular Party, today known as 'Christian Democrats,' which has always been anti-fascist and anti-communist. He must be our favored man."

At five feet nine inches tall, with brown hair, blue eyes, and a fair complexion, Cagiati did not look much different from thousands of other men walking around the Eternal City. Born in Rome, where his father was a prefect of the Pontifical Library at the Vatican, Cagiati immigrated to the United States in 1934, after great difficulty due to the record high unemployment caused by the Great Depression. His Italian immigration lawyer, one of the guardians of Florence, Marchese Filippo Serlupi Crescenzi—"Pippo" as Cagiati referred to him— had become fond of the young man. Even after Cagiati left Italy, the two men exchanged many letters.

Donovan also liked Cagiati. In December 1942, he wrote to Assistant Secretary of War John McCloy:

> *We should like very much to have the services of Lieutenant Alessandro Cagiati in connection with a secret mission to North Africa. . . . Lieutenant Cagiati is of Italian descent, has spent half his life in Italy, and was educated in Italy and in England. . . . If he could be assigned to duty with the Office of Strategic Services, we would like to have him here for two or three weeks to receive special instruction, and we would then ask that he be ordered to report to our representative in General Eisenhower's theatre.*

During a brief posting to Algiers early in the summer of 1943, Cagiati's first assignment involved the training of other OSS operatives. His knowledge of Italian had earned him a position with General Clark and

U.S. Fifth Army. He landed at Salerno on D-day, attached to Colonel William O. Darby's Rangers. Three weeks later, Cagiati was the first American to enter Naples.

Using a Counter Intelligence Section pass—Special Pass No. 2—that entitled him to travel freely within Allied-controlled territory, Cagiati continued to recruit new OSS operatives from those who had crossed the German lines. Cagiati made his way into Florence with British Eighth Army, serving as a liaison between partisan fighters on the north side of the Arno and Allied forces on the south. On September 1, he journeyed up the hill of Careggi to Villa delle Fontanelle, relieved to see that Serlupi, his wife Gilberta, and Bernard Berenson and his secretary were all alive and in good health.

The meeting among Cagiati, Anelli, and Montini took place on Saturday, November 25. Don Guido Anelli was the parish priest of Ostia Parmense, a small village near the northern town of Parma. But Anelli's flock consisted of more than just parishioners; he was also the founder and active leader—nom de guerre: Don Tito—of a brigade of partisan fighters known as the Seconda Julia. Parma was German-controlled territory; the thirty-two-year-old Anelli had secretly crossed enemy lines to reach Florence, where he met Cagiati, who then accompanied him to Rome for the meeting with Montini. Anelli's mission was to "inform the Vatican of the activities of the Church in the clandestine movement in North Italy" and, most important, to obtain money and supplies for the local partisans before winter descended on them.

By the fall of 1944, partisan forces in Italy had succeeded in creating a war within a war. In addition to the battle raging between Kesselring's Wehrmacht troops and the Allied armies, partisan fighters were successfully disrupting German operations in the mountainous area behind the Gothic Line. These isolated actions became such a threat that the German commander of 14th Panzer Corps, Lieutenant General Fridolin von Senger und Etterlin, began traveling in a small Volkswagen with no identifying marks. Partisans had already killed another German general after they identified his command car.

As head of the police activities in Italy, SS General Karl Wolff held responsibility for controlling partisan activity behind the front lines. But increasingly their attacks were aimed at German officers and soldiers on the front line. This forced Kesselring to order his troops "to adopt the severest measures. . . . Should troops etc. be fired at from any village the village will be burnt down. Perpetrators or ringleaders will be hanged in public." In his view, the partisans were insurgents who were murdering his men and demoralizing military operations. The partisans proved so difficult to fight that, according to Kesselring, "Only the best troops . . . are barely good enough." As such, he believed they fell outside any rights accorded a uniformed enemy soldier. The subsequent burning of villages and shooting of innocent men, women, and children, some as young as three years old, by German Wehrmacht troops only escalated partisan anger and their attacks. Don Anelli and his parishioners needed urgent help.

Cagiati's report summarized the course of discussion and the events that followed: "During the interview lasting one hour [Montini] questioned Don Anelli very closely concerning the resistance movement in N. Italy, with particular reference to the work of the Church, and the position of the Christian Democrat party." Serlupi's wife recorded an even more detailed account in her diary: "Cagiati and the other partisan liaison officers discovered, through [Anelli's] words, that the mass of Partisans were Christian Democratic and not communist, as they had thought, and therefore decided to give them more support."

Subsequent meetings took place with Monsignor Domenico Tardini—Deputy Secretary of State for Extraordinary Affairs—the following day, and then representatives of the Christian Democratic Party on Monday. During those meetings, Anelli pleaded for the Vatican to assist the resistance fighters, either directly or through the party. Cagiati reported that Don Anelli had done an excellent job establishing his credibility and explaining why the Vatican needed to take immediate action. He wrote: "The news that large numbers of partisans are fighting under the aegis of the C.D. Party, and that there is much that

the Church can do in the movement seemed to come as a complete surprise to [Montini], and the Pope himself has expressed intense interest."

The last portion of Cagiati's report confirmed for General Donovan and the OSS that developing connections with the Vatican had other significant upsides: "From an OSS point of view. . . . there may be some valuable contacts and the present inestimably valuable cover and protection and information service afforded by the Church in Italy and elsewhere." Simply put, the OSS envisioned using the Vatican's extensive network of churches, especially those behind enemy lines, to aid in the gathering of information about Nazi Germany.

Vatican officials and representatives of the Christian Democratic Party quickly granted Don Anelli's wish. Weapons and supplies were dropped by parachute to the partisans; a large cash contribution of 13 million lire followed.* One fellow partisan later explained: "That money saved our squads when two weeks later, during a blast of harsh winter weather, the most extensive and violent search [by German troops] of the entire war was raging. Thousands of soldiers were saved from starvation and freezing thanks to those blessed millions which the Fatherland had given us, and that a humble priest from the countryside had brought us from the sky."

After almost a month in Rome, Anelli was eager to return home to celebrate Christmas. But he and Cagiati both knew the terrain; crossing enemy lines on foot in winter weather was out of the question. The safest and quickest solution, one embraced by Anelli, was to drop him by parachute. Ironically, the man who would become known as "the flying priest" had, in fact, never been in an airplane. Before boarding, Don Anelli, wearing his helmet and parachute, posed for a photograph with the crew in front of the C-47. Legend has it that after the successful drop, one of the crew members noticed a prayer book in Anelli's abandoned seat, so the pilot circled back while the crew member wrapped the

* About $1,700,000 in 2012.

prayer book in a cloth. As the plane reached the drop point, it banked, and the prayer book followed Anelli's path to earth.

Several months passed before Cagiati and Anelli would meet again, but the relationship they forged during that last week of November would play a vital role in the Allied effort to locate and save the missing artwork of Florence.

ON DECEMBER 9, Fascist Radio broadcast a report stating that Carlo Anti, General Director of Fine Arts under Mussolini's Social Republic, had inspected the Florentine works of art and judged the storage facilities and conditions perfectly adequate. Anti penned a more personal reflection in his diary: "I am choking as to all this beauty in exile." Although the report didn't identify the locations of the works, the announcement was clearly designed to quell increasing public concern, in particular among the foreign press, about the safety of the works of art and criticism of German intentions.

The following day, Dr. Josef Ringler, who had selected the hiding places for the art, received a telephone call informing him that two men acting on specific orders from Martin Bormann, Adolf Hitler's private secretary, would be arriving in Bolzano to inspect the Florentine artworks. One of the men, Dr. Helmut von Hummel, was Bormann's special assistant; the other was Dr. Leopold Rupprecht, head of the Arms Collection of Vienna's Kunsthistorisches Museum.

While Ringler didn't know the purpose of their mission, he, like everyone else, knew of Martin Bormann. The name alone was terrifying. Ringler knew that these two men had to be on a mission of highest importance if they carried an order from the person closest to the Führer. So, too, did SS General Wolff. Determined to monitor all activity concerning the works of art, Wolff made arrangements for his own representative—Reidemeister—to accompany Bormann's men on their inspection. When Ringler realized that Reidemeister wouldn't

arrive in time, he drove Hummel and Rupprecht to one of the two repositories.

Their trip took them along a mountain road, past hills and scenic cottages blanketed with the first winter snow. After a little less than an hour, they entered a small town thirteen miles from the border of the Reich and pulled to a stop alongside a three-story building that served as the municipal courthouse and local jail. As the men entered the building, the jailer produced a massive ring containing at least fifty keys to open a series of jail cell doors where the "prisoners"—the great Florentine paintings—were stored. Ringler's choice of hiding place had been unorthodox, but there had been no other safe option for storing such important artworks.

The inspection was brief; examining hundreds of paintings crammed into very tight spaces wasn't feasible. Later that evening, an art dealer from Munich arrived, apparently part of Hummel's inspection team. No one told Ringler why the art dealer was there, or the purpose of the inspections. But he knew that Rupprecht was building an arms collection for the Führermuseum in Linz, which caused Ringler great consternation. He had yet to learn that Hummel was in fact responsible for the formulation of "the directives governing confiscation and purchase" for the Führermuseum.

AS CHRISTMAS APPROACHED, the temperature in Italy, as throughout Europe, sank below freezing. Midmonth, news arrived of a major German offensive in the densely forested area of the Ardennes in Belgium—what would become known as the Battle of the Bulge. Hitler, hoping to split two of the Allied armies, had mounted a charge toward the Belgian port city of Antwerp. The attack caught the Allies by surprise, forcing a quick retreat. General Eisenhower admonished his senior commanders during a December 19 conference: "The present situation is to be regarded as one of opportunity for us and not of disaster. There will be only cheerful faces at this conference table."

Four days later, clear skies allowed Allied air superiority to turn the tide, punishing the enemy's tank and supply-line columns and dooming the German offensive.

News of the Battle of the Bulge filled American newspapers, heightening the concern of those who had loved ones overseas. In letters to his family, Keller, like other married men in service, regularly downplayed the risks of his particular assignment. But he didn't hesitate to share them with his mentor and friend, Tubby Sizer, who by that time had been discharged due to illness and had returned home from England.

One letter described the random dangers of Keller's work:

On entering the city hall, we all had our revolvers drawn. . . . We learn where to walk and how to put the foot down on a staircase or a step. There may be a trip wire running under the tread. No doors that are locked are broken open until carefully inspected with flashlight—No one with any sense enters a shop, door blown in with enticing souvenirs on the shelves, one boy and his companions were blown to bits in a music shop—saxophone lying innocently atop the piano and one picked it up.

With Christmas approaching, millions of soldiers began preparing for another holiday apart from loved ones. On his second Christmas abroad, Keller tried to explain to Kathy the perspective the war had brought him:

Dearest:
Today is Christmas and my first thoughts are with you and Deane. . . . As I write the roar of tanks and heavy vehicles is in the air. . . . Some boys will eat a turkey leg in a pup tent or in a foxhole. Some will die this day. . . . I have seen so much human misery that anything better will seem pretty wonderful. Also I believe that I have a better idea of what counts in this world and what does not. What counts is very briefly told and all the rest is so much froth to be blown away in the lightest puff of wind.

At that moment, Keller noticed an Allied P-38 fighter passing over-head. The war was not over, perhaps far from it. But the sound of sol-diers singing brought forth a final thought.

Downstairs the radio has just come on and someone is singing a Carol. Shades of Michelangelo and Giotto and Ghirlandaio, and Michelozzo and Arnolfo di Cambio. This is my Christmas—a big one filled with the highest ideals man is capable of, experienced by you and me and Deane.

All my love, Deane.

SECTION III

VICTORY

Absolute secrecy is essential to a successful surrender.

—OSS CHIEF MAJOR GENERAL WILLIAM J. DONOVAN,
MEMORANDUM TO THE PRESIDENT
OF THE UNITED STATES

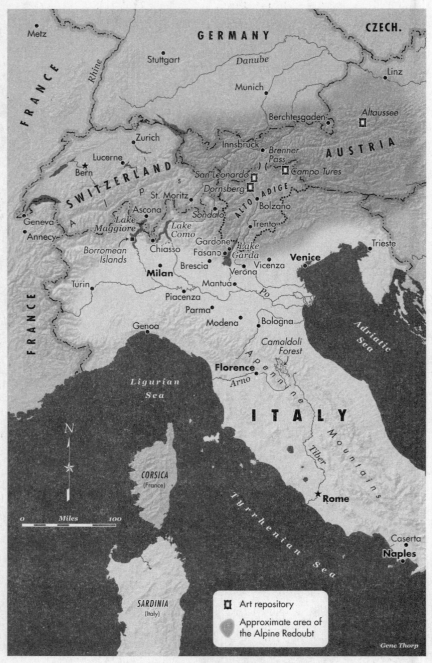

Northern Italy and the Alpine Redoubt

21

TROUBLE IN THE RANKS

JANUARY–FEBRUARY 1945

By late January, the Allied armies had Nazi Germany trapped in a vise. As one senior U.S. official observed, "Now it is not a war for [German] supremacy but a war of survival." General Eisenhower's forces had penetrated Germany's western border, from Switzerland north to the Netherlands. The Soviet offensive launched on January 12 had propelled the Eastern Front nearly three hundred miles westward— from the Vistula River in central Poland to the shores of the Oder River marking the German border. To the south, Kesselring's frontline divisions and Wolff's rearguard soldiers formed the last lines of defense against the U.S. Fifth and British Eighth Armies. The question of who would win the war seemed decided. The question now was how much longer the fighting would continue.

The momentum of Germany's December 16 surprise attack in the Ardennes Forest had long since dissipated. Eisenhower had been right in his assessment. The Battle of the Bulge had presented a moment of great opportunity, and the Allies seized it, crushing Hitler's troops. By the end of January, between eighty and a hundred thousand German soldiers lay dead, wounded, captured, or missing. German Gen-

eral Friedrich Wilhelm von Mellenthin later commented: "Our precious reserves had been expended, and nothing was available to ward off the impending catastrophe in the East." Hitler's armies would never again gain ground.

The Battle of the Bulge also cost the victors dearly. Official reports listed 19,246 American deaths. More than four times that number had been wounded or were missing. Altogether, Americans suffered 108,000 casualties. In stark contrast, the British, whose forces were positioned away from the battle, suffered fourteen hundred casualties; two hundred British soldiers were killed. Prime Minister Churchill noted that it "is undoubtedly the greatest American battle of the war and will, I believe, be regarded as an ever-famous American victory."

In October 1944, Deane Keller had received news that he was being considered for the Bronze Star. General Edgar Hume requested that he submit a written summary of his work with Allied Military Government. The prospect of the medal lifted his spirits considerably. But eleven days later, Keller wrote Kathy to inform her that it would not be his. "Do not be too disappointed, for I am not. . . . If I were any less sure of why I am over here I would be upset and discouraged."

Once again, Keller hedged his true feelings in an effort to spare his wife. He was, in fact, very disappointed. He remained convinced that his failure to receive the medal would diminish his standing in the eyes of Yale University's leaders: "If I had gotten the award I'd probably be a full-professor by June 1945. Without it I am nothing to them. . . . I'll be told, 'Well, after all, you were away two years', or whatever it will be, 'and others carried on for you.' . . . Many men profited at Yale in the last war by staying home and there is no reason to believe they won't in this."

After more than a year away from home, what Keller needed most of all was a friend. While standing in line for mail in Florence one very cold December day, he found one. Charley Bernholz was about to lose his job. He had been the driver for Colonel Edward B. Mayne, Chief of Staff for AMG Fifth Army, who, relieved of duty, would soon depart for England. Keller arranged for Bernholz to become his driver and assistant. Charley's experience with operations at AMG headquarters proved as

helpful as his knowledge of the Italian roads, and his easygoing manner contrasted with Keller's intensity. The Yale professor quickly realized he had gained a trusted companion. "I don't care much about a lot of things," he wrote Kathy, "but a few friends are needed."

Keller considered Charley, a Bronze Star recipient and veteran of the Sicily and Volturno campaigns, a true hero. His citation from Lieutenant General Mark Clark described how Bernholz had risked his life in Nettuno after a German plane attacked an ammunition convoy and set it ablaze. "Private First Class Bernholz rushed to the scene of the bombing and removed a severely wounded driver from the danger of exploding ammunition." Only after Charley had returned to the burning wreckage to check for other wounded personnel did he seek safety.

Having a close friend improved Keller's outlook. He and Charley decided to paint a Fascist slogan—"*Me ne frego*"—on their jeep. It meant, "I don't give a damn." This was the first time in sixteen months that Keller had held a paintbrush. The addition of Bernholz—as driver and professional photographer—also enabled Keller to pursue in earnest an idea he had been mulling for several months: the creation of a pictorial history of AMG Fifth Army. The idea received quick approval, and on January 10 Keller added this new responsibility to his regular duties as Monuments officer for Fifth Army.

An early assignment involved Keller and Bernholz observing and photographing the execution of an Italian spy. Early in the morning of January 11, 1945, the two men waited outside Florence police headquarters, in the darkness of the empty Piazza della Signoria. Moments later, they accompanied British officers and a priest to the old Le Murate prison for the identification of the prisoner. The small motorcade, led by a hearse, then proceeded to a quarry northeast of the city. Upon arriving, the men climbed out of the vehicles and unloaded the prisoner. Keller counted about twenty British military police present.

Some were digging holes with picks for the gun rest which was shoulder high with a rest for the kneeling position. Ground was frozen. Lights of a jeep were used and flashlights. At 15 paces the chair was set up. The legs were

reinforced on all four sides . . . making it impossible for the chair to topple over. . . . Behind one pile of rubble the firing squad of 6 . . . stood banging feet and hands to keep warm. The officer in charge had them march up to the firing line for a rehearsal. . . . The officer said the only command would be "FIRE" which he shouted at the top of his voice. . . . The prisoner wore a pale blue sweater and gray trousers. His head and the tip of his nose was covered with a heavy white bandage. Over his heart, about 8" square, was a white cloth. He was accompanied by the priest to the chair. Hands tied behind his back. He was seated and secured by the M.P.s and Major Langford and other officers, one of whom slipped and fell. The priest stood on his left talking to him. . . . The firing squad had already taken their positions at the gun rest. The priest remained by the side of the prisoner until someone ordered him away. The firing squad took their rifles and made ready. All officers, onlookers, grouped in back and the sides of the firing squad. After the priest had stepped aside, perhaps 4 seconds [later] the prisoner said: "Posso dire qualcosa?" ["Can I say something?"] No audible reply was heard, but time was given for the following statement from the prisoner: "Evviva l'Italia, Evviva gli Alleati, spero che gli Alleati vincano" ["Hurray Italy, Hurray the Allies, I hope the Allies will win"]. No command was heard but the volley was fired, one blast. The prisoner had been sitting straight, facing the squad. His broad chin and jaws shown [sic] pale but distinct. The white bandage, and square patch over his heart was bright. The light was not too bright, but these targets were clear. He slumped back immediately, his knees sagged apart and his head fell back, completely inanimate. He must have died instantly. . . . The M.P.s untied the knots and a coffin was brought from the hearse. . . . The chair, blood stained, was put in the truck and all left the place.

Bernholz took photographs of the execution, some twenty in all. Keller later made a rough sketch showing the kneeling soldiers shouldering their weapons moments before firing. His drawing captured the solemnity of the scene; standing alone, perhaps uttering the prayers of the last rites, was the figure of the priest. It was a gruesome beginning for the pictorial history project, one that Keller wished to forget, but it foretold the chaos and settling of scores that lay ahead in Italy.

On February 1, Keller received official notification that he and six other AMG officers would receive a citation—not the one he hoped for, perhaps, but one of considerable distinction: Knight of the Order of the Crown of Italy. Keller's commanding officer, General Hume, made a point of emphasizing that "without exception they have all rendered service under fire. It is understood that this is a combat award."

Two weeks later, Keller supervised the return to Florence of a bronze statue of Cosimo I de'Medici and his horse, completed in 1594 by the Flemish master sculptor Giambologna. In August 1943, local art officials had disassembled the eight-ton statue and moved it on an ox-drawn cart to the villa at Poggio a Caiano for safekeeping. Getting it back into the city had become a matter of urgency. With reconstruction of the railroad bridge nearing completion, there soon wouldn't be enough clearance for Cosimo and his steed to pass.

After several days of planning and preparation, a crane hoisted Cosimo onto the back of a truck. Moving the horse, far larger and heavier than the rider, proved considerably more difficult. The horse was standing in a prancing position atop a wooden skid, front and rear legs astride a crisscrossed stack of logs for stability. It took three and a half hours to pull the skid into position on the tank trailer, using a moving technique Keller described as primitive, "in the manner of a Maine back countryman moving a house with pulleys and tackle and a horse for the power."

An American soldier named Smokey mounted the horse to lift the telephone and telegraph wires along the route into the city. As Smokey tried to straddle the hole where Cosimo and his saddle would normally be joined, Keller heard someone shout, "Captain, that horse is full of shit; them Dagos' been crappin' in it!"

Although the journey into Florence covered just fourteen miles, rainy weather and numerous stops stretched the travel time to an hour and a half. With Bernholz serving as traffic director, the procession arrived in the city at 3 p.m. Giovanni Poggi, Fred Hartt and *Lucky 13*, and a few hundred Florentines awaited them in the Piazza della Signoria. Keller noted that the climax of the trip occurred when "a driver of a *carrozza*

[carriage] pulled by a horse at a trot, [raised] his hat and, beaming from ear to ear, [said]: '*Cosimo, ben tornato!*' ('Cosimo, welcome back!')." Keller later recorded in his report the lasting impact of the return of Cosimo: "The implications of such a transport as manifested in the faces of Italians along the route and in Florence City proper make it on the contrary, a large and important undertaking in terms of giving pleasure to a people who have suffered."

Within a week, however, sad news overshadowed the triumph of Cosimo's return; Smokey had been killed in action at the front.

By mid-February, strain in the work relationship between Keller and Hartt became pronounced. A January 2, 1945, *New York Times* article by Herbert Matthews triggered a major disagreement. "The story of what has happened to the incalculably rich art of Tuscany [*sic*] cities during this campaign is one of the saddest of the war," Matthews wrote, "but it is possible to report now, after four or five months have passed, that repair and protection work has made great strides under the supervision of a young American, First Lieut. Frederick T. Hartt, who is in charge of the work for the Allied Military Government."

Several Monuments officers, including Keller, took offense, thinking Hartt had gone out of his way to garner press coverage without giving credit to his colleagues. Keller wrote to Kathy, telling her, "I am not alone in thinking that Hartt has gone too far in publicity for himself. All the rest are of the same opinion. He has made an ass of himself." The unfortunate wording of Matthews's article implied that Hartt was the lone Monuments officer on the case. Although Hartt later told Keller that he was sorry, that "he had forgotten to mention the names of others to this war correspondent," the damage was done.

Keller also wrote Lieutenant Colonel DeWald, noting, "I know the Army feeling about publicity and I have avoided it. It tends to cheapen our efforts. The ones who fight and win the war are the ones to get it now. In the future, around the hearth at home there will be time to recount the brave deeds in liberating world masterpieces." Harry Butcher, Naval Aide to General Eisenhower, once commented about how much his

boss and General George Marshall "don't like cheap publicity." Even *Stars and Stripes* cartoonist Bill Mauldin noted: "Very few [soldiers] shoot off their mouths about their own heroism when the inevitable reporter from the home-town paper comes around to see them." Hartt said he had merely wanted to get attention for the imperiled monuments, but Keller and the others hardly had the patience to see it that way.

Nor was this their only conflict. Keller and Hartt had another run-in over what Keller saw as a breach of protocol when Hartt appealed to Hume to overturn a judgment call made by Keller concerning OFF-LIMITS signs. Neither Keller nor any other Monuments officer doubted Hartt's sincerity and passion for the job. And they didn't disagree that some publicity about the role of Monuments officers might benefit their work. But they considered Hartt's personal behavior reckless, and his disregard for army protocol an affront. Hartt, however, was taken aback by Keller's criticism: "We always got along fine up till now, and I really feel a little hurt and let down by this incident, the first of its kind."

Six days later, Keller contacted another of his superior officers to summarize his position on the publicity issue and explain his view about the OFF-LIMITS violation. Noting that "Lt. Hartt has done an excellent piece of work," he then addressed both issues head-on: "Sunday morning last, I advised [Hartt] on two points in particular: That I will do nothing to jeopardize what good relations MFAA Section has with the combat soldiers (he wanted a protest from Gen. Hume over a violation of Off Limits signs, which seemed to me comparatively trivial) and the fact that an Army Officer should keep personal publicity at a minimum."

Sometime during late winter, Keller drew a cartoon and sent it to his friend and fellow Monuments officer, Sheldon Pennoyer. Above a sarcastic caption that read "A.M.G.–5th Army and Regional Cooperation," Keller drew a caricature of himself standing, one foot balanced on a stack of books, with a large wooden paddle in midair and a grin on his face, preparing to rump-swat Lieutenant Fred Hartt, whom he had begun referring to as the "Tuscany kid." In the background, hanging on the wall, was a smiling Madonna, a spectator seemingly poised to watch

and applaud the event with glee. That aspect of Keller's drawing was playful, but his effeminate depiction of Hartt, with his fleece jacket, gold ring, and elongated fingernails, reflected an uncharacteristic pettiness on Keller's part.

Keller felt ambivalent about Hartt, but he needed him. Hartt's knowledge was invaluable. No one knew how many more months of fighting remained, or what kind of destruction they might find on the advance northward. The Florentine treasures were still missing, their location unknown to the Monuments officers. The passing of winter would bring a spring offensive. The search for the treasures, or what was left of them, would resume. And the two Monuments officers in the best position to find them were barely speaking.

FOR THREE AND a half years, Nazi Germany had terrorized the Soviet Union, causing the brutal deaths of tens of millions of Red Army soldiers and innocent civilians. On Hitler's orders, Wehrmacht troops had razed entire cities and towns. Now the tide had turned. Six million Red Army soldiers filled with thoughts of revenge amassed along the front, which by February 2, 1945, was less than thirty miles from Carinhall, the palatial country estate of Nazi Reichsmarschall Hermann Göring. Aware the end was near, Göring and his art adviser sorted through his collection, deciding which items should be evacuated immediately. The first train left in early February, bound for hiding places in southern Germany. The masterpieces from Naples were not among them.

More than a year earlier, shortly before his fifty-first birthday, Göring's private secretary had informed him that the army division bearing his name wanted to present a generous gift. Discovering that they intended to deliver the Naples treasures from Monte Cassino, Göring declared that he would, "Under no circumstances allow such things to be presented to [him] as birthday presents." Despite the dubious manner in which he had assembled much of his collection, such a prolific collector of art could not be seen accepting stolen masterpieces from the Naples

museums. The Reichsmarschall and his agents had worked too hard to create the appearance of legitimacy.

Instead, Göring instructed his art adviser to accept the objects taken from the Abbey of Monte Cassino, but only for a temporary display at Carinhall. Several months later, he had the Naples paintings transferred to Kurfürst, an antiaircraft bunker near Potsdam. Sculpture and other objects from the abbey remained at his estate until early February 1945, when he began shipping his collection south. Göring then arranged for all of the masterpieces from Naples to be delivered to the Reichschancellery in Berlin, with instructions for Hitler's private secretary, Martin Bormann, to send them on to Munich.

22

SWITCHING SIDES

EARLY MARCH 1945

On March 8, 1945, seven men dressed in civilian clothes, including four senior officers of the SS, boarded a train in the Swiss border town of Chiasso, bound for Zurich. They occupied two travel compartments, hidden from view. SS General Karl Wolff had reason to stay out of sight on the journey into neutral Switzerland. Acting on his own initiative, without the knowledge of Generalfeldmarschall Kesselring, much less the Führer, Wolff had decided to take a calculated gamble. Being spotted by border officials, spies, or informants would put his life at risk.

From the moment of his transfer to Italy in the fall of 1943, Karl Wolff had been at the center of intrigue. In May 1944, Wolff had found himself inside the Vatican, engaged in conversation with Pope Pius XII and discussing an end to the hostilities. He had promised the pope he would do anything he could to facilitate an early end to the war. But the fall of Rome on June 4, 1944, prevented a follow-up meeting with the Vatican leader. Wolff now had a plan that would fulfill his promise.

———

AS A WELL-EDUCATED and cultivated man, Wolff understood that he would be held responsible—by the Führer and history—should the works of art from Florence, worth billions, be damaged or destroyed. But the situation also presented opportunity. Controlling the artistic patrimony of an entire nation might provide a bargaining chip.

Throughout the late summer and fall of 1944, Carlo Anti and other Italian art officials pleaded for their works of art to be transferred to Stra (near Venice), the Borromean Islands in Lago Maggiore, or Sondalo (in Lombardy). Any of these locations would have placed the works under the control of Italian authorities. Wolff remained unmoved, however, stating that the artworks "were safer in a German Gau [district] than upon an Italian Island." German stubbornness convinced Anti "that the transportation of works of art to Alto Adige is part of pre-meditated plan."

In late October, a partially recovered Consul Gerhard Wolf and Professor Ludwig Heinrich Heydenreich, a member of the Kunstschutz, tried to make headway. Heydenreich wrote Colonel Langsdorff, asking him to urge General Karl Wolff to allow Italian art officials to inspect the two repositories near the Brenner Pass and receive lists of their contents. After two weeks without a response, Heydenreich wrote Langsdorff a second time. A curt reply followed: "Gauleiter Hofer would not allow Italian visitors, that the Führer and General Wolff alone would decide the fate of the works of art." Langsdorff closed by inquiring, ominously, why Heydenreich "was showing so much interest in the Italians."

On November 27, 1944, Wolff personally reassured Carlo Anti of "the Führer's promise that the artworks are, and stay, the undisputed property of Italy." Over the following two days, he finally allowed Anti, accompanied by Langsdorff, to conduct an inspection of both repositories. Langsdorff attempted to show Anti only the works belonging to the Italian state and to conceal the private collections. Anti's limited inspection was the only occasion when any Italian official had access to the repositories.

Anti also received an inventory list, but it contained only those items taken from the Villa Bossi-Pucci repository in Montagnana. Wolff explained that he had supplied partial lists because he wanted Mussolini to be the first Italian to receive the documents. By March 1945, however, neither Mussolini nor any other Italian official had seen the complete lists. Anti lost his patience, writing one of the Kunstschutz representatives to say, "Without these my inspection was reduced to an interesting and very nice trip thanks to the friendliness of our German colleagues, but nothing more." Despite Wolff's assurances, some Italians remained convinced that "without a doubt the Germans will take the art with themselves once they withdraw." Even Mussolini proved powerless; a message expressing his "wish that the confiscated articles be transported to the Borromean Islands" was simply ignored.

Ironically, the greatest threat to Wolff's control over the Florentine treasures came from within his own circle. Austrian Gauleiter Franz Hofer, one of the "radical Nazi fanatics" who had originally suggested the treasures be taken to "Innsbruck or Bavaria," was determined to maintain control over all activities in what he considered *his* territory. He had already upbraided Wolff by reminding him that anyone contemplating activities in the Alto Adige region "should address me personally with possible proposals." At one point, Hofer even demanded that several paintings from the Florence collections be given to him as compensation for allowing them to be stored, as if they were his "guests." Wolff flatly rejected the Gauleiter's preposterous suggestion.

Sometime after January 26, 1945, Wolff had received a written order, characterized as a "Policy Instruction," which had been issued by Martin Bormann, on behalf of the Führer: "Based on the Führer's orders, the existence of all confiscated works of art, especially paintings, objects of artistic interest and weapons of artistic importance, in Greater Germany and the Occupied Territories, is to be reported to the Führer's advisors in such matters; who, on consideration of the individual cases, will send a report to the Führer through me, so that the Führer can himself decide what use he will make of the acquired articles."

Coming at any other moment, Bormann's order would have seemed routine and innocuous. But just weeks earlier, Wolff had received instructions from Himmler to relocate the Florentine artworks to the Führer's main art repository at Altaussee, Austria. Both orders revealed the growing sense of desperation among German leaders in Berlin. Stalling, Wolff informed Himmler that he was "unable to do this owing to lack of MT [motor transport] and petrol."

While transport and gasoline were indeed in short supply, Wolff had the rank and resources to effect their transfer, just as he had granted Langsdorff the means to continue his "rescue" operation in Tuscany in July 1944. This new tactic, however, represented more than just a clever blocking maneuver. Wolff had crossed the divide by lying to the head of the SS.

Presumably as an insurance policy, Wolff ordered his staff to prepare an album of photographs of the Florentine artworks. He informed Langsdorff and others that the album would be presented to the Führer on his fifty-sixth birthday, April 20, 1945. Wolff chose not to provide the more precise explanation: he might need the album as protection in case trouble arose. The Führer's love of art was hardly a secret; Nazi Party leaders and German industrialists had for years given him paintings and other objects. Alfred Rosenberg and his ERR looting organization had taken things a step further by delivering leather bound albums—catalogues, essentially—containing photographs of stolen items.

But Rosenberg, a political weakling, had prepared the ERR albums in a bid to save his position. Wolff ordered preparation of the Florentine album as part of his plan to save his life. Showing Hitler the good work he had been doing, protecting the artistic wealth of Florence, might just act as a shield if Himmler or Kaltenbrunner attacked him for not relocating the works to Altaussee.

THE CRUSHING DEFEAT of German forces in the Ardennes Forest at the hands of the Western Allies paled in comparison with the losses they

were incurring in the fight to prevent Soviet soldiers from seizing Berlin. In January and February alone, German losses on the Eastern Front totaled more than six hundred thousand men, five times worse than in the Ardennes. As the Vistula-Oder campaign advanced Soviet soldiers to within forty-five miles of Berlin, the day of reckoning for German atrocities in the eastern lands neared. Germans—soldiers and civilians alike—knowing there would be no mercy, were terrified. Langsdorff noted in his diary that "millions were unable to be evacuated before the Russians' arrival" onto east German soil. "It is a situation of madness from which common sense can see no way out." Wolff knew the Allied bombings that had temporarily closed the Brenner Pass between Austria and Italy had "prevented the German soldier [from] receiving news from home, just at the time when he was feeling the greatest anxiety about his relatives owing to the Russian advance." This caused an increasing "collapse of morale" among German soldiers and officers stationed in Italy.

By the end of January 1945, Wolff had become convinced the war was "irretrievably lost." As he later noted, German officers who "had taken part in the spearhead of the Ardennes Offensive . . . had been promised eight days' air superiority to be effected by 3000 Luftwaffe sorties a day; but Allied [antiaircraft] fire and defenses had proved too strong, and they themselves had seen scarcely a German plane." While the average German soldier still placed faith in Hitler's assurances that new secret weapons would turn the tide in Germany's favor, Wolff knew that if such armaments had existed, they would have been used during the critical Ardennes battle or against the Soviet advance. Any remaining doubt vanished on February 6, during one of his regular trips to Berlin. Wolff asked his sources whether such "wonder weapons" existed. The absence of "a straight answer" confirmed his suspicions that they did not.

Certain the Anglo-American-Soviet alliance would eventually collapse, Hitler believed he only needed to hold out long enough for nature to take its course. At a military briefing on August 31, 1944, the Führer stated his firm conviction: "The moment will come when the tension

between the Allies will become so great that the break will occur never-theless. All coalitions in history have disintegrated sooner or later. One only has to wait for the right moment, no matter how hard it is."

By early February 1945, however, Hitler's two senior SS officers in Germany decided to wait no longer. Realizing that the Nazi regime was faltering, and motivated by self-preservation, Himmler and Ernst Kaltenbrunner made secret overtures to the OSS. One report stated that the two men were "contemplating the liquidation of 'war-mongers' within the Nazi Party," such as Bormann, with the goal of negotiating an end to the war. OSS leaders viewed this as "a sign of the increasing disintegration within the Nazi Party." A later report from the chief of the OSS mission in Switzerland, Allen Dulles, added, "Although persons of the Himmler, Kaltenbrunner type could naturally gain no immunity from us, as long as they believed this were possible, it might give us an opportunity to drive a wedge in the SD [*Sicherheitsdienst*—the intelligence agency of the SS and the Nazi Party]."

Wolff used his February 6 Berlin visit to petition the Führer to approve making contact with the Western powers to explore a political solution. While Hitler didn't authorize him to proceed, neither did he order him to abandon the idea. During that trip, the SS general attended a briefing on Hitler's scorched-earth plans for northern Italy. According to the plan, Wolff's troops would be responsible for destroying industrial capacity, power plants, port installations, and basic services as they relinquished areas of control. Kesselring's frontline forces would then demolish bridges and tunnels as they retreated. There was no end game, no objective to the destruction other than to slow down the enemy advance and buy time, hoping the Western Allies would split with the Soviets.

Nazi Germany had reached the abyss—no future, and no way out. Many of those in Hitler's immediate circle were preparing for the worst. Unwilling to link his survival to the Führer's fate, Karl Wolff had developed a secret plan to surrender an entire German army—some one million men in Italy—to the Western Allies.

That Wolff even had an opportunity to attempt such a plan owed much to a strange mixture of geography, weather, and luck. While Hitler and his commanders battled Western Allied forces and the Soviet Red Army, German and Fascist Italian soldiers in northern Italy waited idly for the snow to melt before the anticipated Allied spring offensive. The comparative calm in Italy lowered Wolff's profile and placed him under far less scrutiny than his peers in Berlin. At that stage of the war, Kesselring and Wolff commanded Germany's most intact fighting force. Wolff's troops also controlled the Brenner Pass, "the most important route for the supply and reinforcement of the Southern Front." It served as the gateway to a mountainous area bounded by southern Bavaria, western Austria, and the Alto Adige region of Italy that came to be known as the Alpine Redoubt.

In August 1944, Dulles sent a telegram to Washington describing the perceived threat posed by the Alpine Redoubt: "The Nazi theory is that by stationing 1,000,000 troops on the Vorarlberg, Austrian and Bavarian Alps, together with sufficient material [sic], they could resist for a period extending from 6 to 12 months." This was but one of many reports on German plans sent to decision makers in Washington and London arguing that the Nazis intended this to be their last stand. It proved one of the great intelligence misreads of World War II.*

The following month, Gauleiter Hofer received a transcript of one of these reports from an SS officer reporting to the Reich Security Main Office (RSHA), which was run by his fellow Austrian Ernst Kalten-brunner. Sensing opportunity, Gauleiter Hofer submitted a report to the Führer recommending the immediate construction of an Alpine defensive fortification—not the Alpine Redoubt holdout that increasingly concerned the Allies. Hofer noted that his objective of "exploiting skillfully and rapidly the 'redoubt psychosis' might help us to open diplomatic negotiations which could bring the war to a satisfactory

* After the war, one German officer even credited an unknown American diplomat working in Switzerland as being the "Father" of the Alpine Redoubt legend.

end." Like SS General Karl Wolff, Gauleiter Hofer also had a plan for surviving the war.

Bormann received Hofer's report in November 1944 and ignored it. Undeterred, Hofer resubmitted his proposal week after week. Eventually Hitler summoned him for a meeting, and on April 20, 1945, approved construction of an Alpine fortress. By that stage of the war, however, the Nazis had insufficient resources to construct and stock anything approaching the strength of the mythical Alpine Redoubt. But that reality didn't deter Reichsminister of Propaganda Dr. Joseph Goebbels from aggressively promoting the Redoubt myth, in which a phantom army of guerrilla fighters is capable of holding out indefinitely.

Believing the Redoubt to be a credible threat, and hoping to avoid a protracted series of battles with Germans entrenched in a mountain hideout, General Eisenhower shifted focus away from Berlin and diverted his armies south toward Berchtesgaden, Germany, the site of Hitler's beloved mountain-ridge home. Wolff considered the idea of building a defensive holdout in the Alpine Redoubt "madness," but, given the Allies' conviction that it existed, he calculated that they would welcome the surrender of his troops.

Wolff's plan offered other benefits to the Western Allies. In addition to ending the fighting, the first German surrender would pave the way for the surrender of other German armies. The morale of Allied troops would in turn be boosted. A German surrender would minimize if not altogether subvert Hitler's scorched-earth policy for northern Italy, something Wolff had already taken steps to prevent. The astute Wolff also played to Anglo-American geopolitical concerns. He realized that a surrender of German forces would enable the U.S. Fifth and British Eighth Armies to swiftly liberate and occupy all of northern Italy. This would preclude Red Army troops from crossing Yugoslavia into the north of Italy; capitalism would arrive ahead of Communism. Finally, Wolff alone could deliver the artwork currently stowed in the Alto Adige region. No plan being pursued by Himmler, Kaltenbrunner, or any other Nazi official could offer the Allies so much.

But the window for action was closing rapidly. Winter would soon turn into spring and bring with it a relentless and victorious drive northward by Fifth Army and Eighth Army forces. The fury of Italian partisans would be loosed and no one wearing a German uniform would be safe. That explained why one of the most senior SS officers, a general of the Wehrmacht, was on a passenger train to Zurich in March 1945. At this stage, almost any plan, no matter the risk, offered more hope than sitting in underground bunkers waiting for the end to come.

WOLFF'S TRIP TO Zurich was a consequence of a February 25 meeting among three intelligence officers: Allen Dulles, Chief of the OSS mission in Switzerland; his closest associate, Gero von Gaevernitz; and their counterpart with Swiss Military Intelligence, Captain Max Waibel. Through a series of intermediaries, Waibel had learned that General Wolff had an interest in developing a connection with Allied leaders. Although Gaevernitz indicated a willingness to meet with Wolff, Kesselring, or one of their representatives, he had little expectation such a meeting would ever materialize.

Dulles received an urgent phone call from Waibel just five days later. One of the intermediaries, Baron Luigi Parrilli, an Italian industrialist, had already returned to Switzerland accompanied by two SS officers, one of whom was Colonel Eugen Dollmann, the much-shorter assistant who had lent Wolff a suit for his audience with the pope in May. According to Parrilli, the SS men wanted to meet the Allied representatives. Gaevernitz had been so sure there would not be a meeting that he had gone skiing.

In his absence, Dulles sent an OSS staff member, Paul Blum, with instructions to find out what the SS officers wanted. After a brief and awkward beginning, Blum told them that the Allies had an interest in making contact with people of goodwill. He reminded them that "unconditional surrender" was official Allied policy and made it clear that there wasn't "a Chinaman's chance" the Allies would ever deal

with Himmler. If they had some proposal in mind, now was the time to present it. While Dollmann didn't put forth a specific plan, he hoped to persuade General Wolff to make the trip to Switzerland for further discussions.

On Dulles's behalf, Blum then handed Dollmann a piece of paper bearing the names of two men—Ferruccio Parri, a senior leader of the Italian partisans and prominent public figure, and Antonio Usmiani, one of Dulles's spies in northern Italy. Both men had been caught and jailed by the SS. Blum informed Dollmann that the release of each man was a precondition of any meeting between Wolff and Dulles. Dollmann appeared "startled" at the thought of releasing such important prisoners, but he assured Blum he would do what he could and hoped to be back in contact within a few days.

By asking for the release of two men, each jailed in a different city (Parri was in Verona, Usmiani was in Turin), Dulles could quickly discover the level of Wolff's commitment and the extent of his power. The demand also provided cover for Dulles's actions. Should news of a meeting with Wolff leak, he could claim it was to negotiate a prisoner exchange, an entirely legitimate component of his job. However, by making such a demand, Dulles accepted the risk that they might never hear from Wolff or his associates again.

Dulles also had to be careful to avoid any actions that might threaten the Western Allies' alliance with the Soviets. In December 1944, OSS leader General Donovan received word that his request to offer immunity to certain Nazi leaders in an effort to induce them to forge a separate peace agreement with the Western Allies had been rejected by President Roosevelt. On January 31, 1945, both Donovan and Dulles received instructions specifically prohibiting such negotiations, much less any form of agreement with German government officials. When the possibility of a meeting with Dollmann emerged, Dulles subsequently sought and received permission to proceed, with the proviso that he do so "without entering [into] any negotiations or without promising any further talks."

On March 8, Gaevernitz received a call from Max Waibel. "Gero, are you standing or sitting?" Waibel asked Gaevernitz. "Because if you're standing you might fall over when you hear the news. Parri and Usmiani are here. They were delivered safe and sound a few hours ago to my man at the Swiss-Italian frontier at Chiasso."

Even more stunning news followed. Earlier in the day, Wolff had crossed into Switzerland, hoping to meet Dulles. Six men accompanied him, including SS officers Dollmann and Guido Zimmer and intermediaries Baron Luigi Parrilli and Professor Max Husmann.

Dulles decided to meet with Wolff, but only on the condition that it take place in an apartment on Zurich's Genferstrasse used by the OSS. With the meeting set for 10 p.m., just hours away, Husmann handed Dulles a document that Wolff had asked him to deliver. A quick glance revealed what was, in essence, Wolff's curriculum vitae, handwritten in German, complete with references and affirmations of others concerning the accuracy of Wolff's various claims. The first two names alone made a formidable impression: Rudolf Hess* and "The present Pope." The following pages listed the various good deeds performed by Wolff during his assignment in Italy. Prominently featured was his role in issuing orders to protect works of art from the Uffizi and the Pitti Palace.

Wolff, the former advertising man, certainly understood the power of first impressions. He had prepared himself for this moment since making the decision to disobey Himmler and seek a solution on his own. The fate of Italy—and perhaps that of the Florentine treasures—hinged on the outcome of his meeting with Dulles.

*Hess was a Reichsminister and the Deputy Nazi Party leader. In 1941, he piloted a plane to Scotland in a botched attempt to negotiate a peace agreement with Great Britain. His plane crashed and he became a prisoner of war.

23

OPERATION SUNRISE

MARCH 8–APRIL 2, 1945

With a grandfather and an uncle who had served as secretaries of state, Allen Dulles seemed destined for a life in the Foreign Service. After graduating from Princeton, he spent time teaching English in India and traveling throughout the Far East before joining the diplomatic service in 1916. From postings in Vienna and Bern, Dulles gathered intelligence during World War I; he then served as a junior adviser during the 1919 Paris Peace Conference. By 1926, he had earned a law degree and begun a career in private practice at the prestigious New York law firm of Sullivan & Cromwell. But his business activities coexisted with periodic engagements as an adviser to the U.S. State Department. One such assignment involved a series of meetings in 1933 with European leaders, including the new German Chancellor, Adolf Hitler.

In October 1941, Dulles became the head of the New York City office of the Coordinator of Information, precursor to the OSS, working out of an office on the twenty-fifth floor at 30 Rockefeller Center. A year later, at the age of forty-nine, he took up a new post, returning to Bern with the title of Special Assistant to the Minister. This job was in fact cover for his activities as spymaster for the United States.

By early 1945, after more than two remarkable years on the job, Dulles had developed an extensive network of contacts. He was shrewd, daring, and ambitious. Experience had honed his listening and negotiating skills, and he understood the social nuances that encouraged the natural flow of conversation. Dulles liked to take the measure of a person while facing the warm glow from the fireplace, scotch at the ready. He assessed Karl Wolff: "A handsome man and well aware of it—Nordic, with graying, slightly receding blonde hair, well-built and looking no older than his age, which was in the middle forties." But Dulles suffered no illusions: "At [this] stage we were more interested in [Wolff's] power than in his morals. We did not expect to find in this SS General a Sunday School teacher."

Following introductions, made without handshakes, Dulles, Gaevernitz, and Wolff began their meeting in earnest. The discussions took place in German. Wolff wanted the OSS men to know that the decisions to come to Zurich and to release Parri and Usmiani were his alone, done without the knowledge of Hitler, Himmler, or Kaltenbrunner. Wolff accepted that Germany was all but defeated, and the Allies would never be divided. Continued prosecution of a war already lost was, in his view, "a crime against the German people," although he freely admitted "that from the early days of Nazism until the previous year he had had faith in Hitler and had been completely attached to him."

Wolff then revealed the purpose of his trip: "I control the SS forces in Italy and I am willing to place myself and my entire organization at the disposal of the Allies to terminate hostilities." This amounted to some 225,000 troops. Unfortunately, Wolff's control did not extend to Kesselring's Army Group C, comprising twenty-seven divisions from German Fourteenth and Tenth Armies and the Social Republic's Ligurian Army. But he added that if he could somehow arrange for a "joint action with Kesselring, Hitler and Himmler would be powerless to take effective counter measures, thus distinguishing [this] situation from that of July 20," the Stauffenberg assassination attempt on Hitler.

Wolff believed that in the event of a surrender in Italy, many German

generals on the Western Front, too fearful to act alone, would follow his lead and surrender their forces as well. Thus his proposed defection "would have vital repercussions." To demonstrate his commitment, Wolff promised that attacks against Italian partisans would be discontinued and several hundred Jewish detainees would be released when possible. The SS general also assumed personal responsibility for the safety of more than 350 American and British prisoners of war.

Gaining Kesselring's support would require Wolff to convince him to renounce his oath of loyalty—not just to Germany but also to Hitler. That would not be easy. Wolff would have to persuade Kesselring that his overriding duty was to serve Germany and its people, not a madman. He hoped that pledges of support from others, most notably Ambassador Rudolf Rahn, would positively influence Kesselring's decision. Wolff said he expected to meet with Kesselring over the weekend and would petition him then. "Gentlemen, if you will be patient, I will hand you Italy on a silver platter."

The following day, March 9, Wolff and his party crossed back into Italy. They were stunned to see the SS Chief Inspector from Milan at the station with two urgent messages. Kaltenbrunner had tried to reach Wolff at his headquarters the previous two days. Somehow he knew that Wolff had left Italy for Switzerland. Wolff could only wonder what else his enemy knew.

The second message proved even more shocking. On March 8, while Wolff had been meeting with Dulles, Hitler had sent his plane to Italy to pick up Kesselring and fly him to Berlin. Once there, the Führer appointed him Commander-in-Chief in the West, replacing Generalfeldmarschall Gerd von Rundstedt. Kesselring would now control all German forces on the Western Front, but not those in Italy. News from the Western Front was so bleak that Hitler had ordered Kesselring to proceed directly from Berlin to assume his new command. Any meeting between Wolff and Kesselring to discuss a secret surrender would now have to take place in Germany at the Generalfeldmarschall's new headquarters. Wolff could only guess how much time might pass before

he got such a chance. It certainly wouldn't occur as quickly as he had represented to Dulles.

Once Wolff reached his headquarters in Gardone on March 10, he learned that Kaltenbrunner wanted to meet with him as soon as possible in Innsbruck, Austria. Wolff's position in Italy afforded him a degree of safety that he could not count on in Austria or Germany, where Kaltenbrunner and Himmler had the upper hand. Wolff decided to tell Kaltenbrunner, his chief antagonist in the SS, that he was too busy to leave Italy at that moment.

There were other problems. Colonel Langsdorff informed Wolff that the photo-album project had been halted at the insistence of Dr. Ringler. Stressed and sleep-deprived, Wolff made time to address what on the surface appeared to be an insignificant staff problem. However, having also assured Dulles that he would safely deliver the Tuscan masterpieces to the Allies, Wolff could not afford any further setbacks.

Dr. Ringler, a stickler for detail, had been against the photo-album project from the outset. He bristled at the thought of making new images of art that had already been photographed innumerable times before, especially using a small, 35-millimeter Contax camera. What could be the point? Moreover, the carelessness of the photographers made him apoplectic. During one unannounced inspection, he discovered that portraits by Raphael and Rembrandt had been removed from their frames and were being photographed outdoors, in the snow. Seething with rage, he demanded that the work be suspended immediately. "So if we want to take this responsibility in front of the entire world, which we have taken upon ourselves by removing these art works," he wrote Langsdorff on March 6, "then we cannot endanger them to this degree. At the end of the day it is I who will be held responsible if something goes wrong." Ringler showed no less concern about the overall protection of both repositories, noting, "The withdrawal of many German Wehrmacht departments . . . brings many people and a lot of strangers near to these repositories[,] making it difficult to keep them secret; danger becomes more tangible."

Sensing trouble, Langsdorff sent a reply on behalf of Wolff, dated

March 12, that clarified the general's role and responsibility: "Those precious items have been rescued by the Highest SS and Police leader in Italy, the Plenipotentiary General of the German Wehrmacht in Italy, SS Obergruppenführer and General of the Waffen SS Wolff. He utilized the Kunstschutz which is subordinated to him as the Plenipotentiary General and myself as an old colleague in the personal staff of the Reichsführer SS."

Langsdorff also tried to assuage Ringler's concern by telling him that Wolff had reconfirmed with the Führer that "the responsibility for the entire Italian works of art removed on orders from higher authority is entirely that of General Wolff, who considers himself in the position of trustee for the Italian nation of these two deposits. You are locally responsible for their maintenance to Hofer, in whose territory they are situated."

Late on the night of March 12, acting on instructions from Wolff, Parrilli, the go-between, returned to Switzerland to meet with Dulles and inform him of Kesselring's transfer. Wanting to gauge Wolff's commitment to the surrender plan, Dulles instructed Parrilli to return to the general's headquarters and ask whether Wolff was prepared to act alone if he was unable to convince Kesselring to support his plan.

In less than forty-eight hours, Parrilli returned with Wolff's answer. The general was prepared to act alone, but only as a measure of last resort. Parrilli then reached into his pocket and handed Dulles a scorched piece of fabric from Wolff's overcoat. While returning to his headquarters after meeting with Dulles on March 8, an American plane had strafed Wolff's car, injuring the chauffeur and another officer and narrowly missing Wolff. While Dulles may have considered it evidence of Wolff's "good sense of humor," the less-than-subtle message emphasized the SS general's good fortune. The whole operation, which Dulles and his team designated with the codename "Sunrise," appeared to be unraveling before it had even begun.*

The second meeting with Dulles and Gaevernitz occurred on March

*The British had their own code name for the "Sunrise" operation: "Crossword."

19 in a private lake house in the small town of Ascona, Switzerland, on the west bank of Lago Maggiore, about six miles north of the Swiss-Italian border. Wolff was unaware that Dulles had selected the villa because it allowed him to conceal the presence of U.S. Major General Lyman Lemnitzer and British Major General Terence Airey, who had orders from Field Marshal Harold Alexander to participate in discussions if circumstances warranted.* Wolff greeted Dulles with the news that General Baron Heinrich von Vietinghoff-Scheel, commander of German Tenth Army, which had fought at Monte Cassino, had been designated Kesselring's successor and would occupy his new command soon. While Wolff had a good working relationship with Vietinghoff, he expressed little hope that such a weak "by the book" commander would support his plan without Kesselring's endorsement.

Wolff told Dulles: "If you can give me five or possibly seven days to act, I would favor an immediate visit to Kesselring. I would need this time as I would have to go by car. . . . I have laid the groundwork with Kesselring, and, what is more, I have a perfectly legitimate reason to visit him. There are many unfinished matters affecting the Italian theater which I would discuss with him."

A second meeting that afternoon included the two Allied generals, dressed in civilian clothes and introduced as "military advisers," not by name. The somber atmosphere marked the first time during the war that senior officers of opposing forces had met on neutral ground to discuss a German surrender. Wolff, anticipating the awkwardness of such an encounter, walked around the table that had been intended to serve as a buffer, determined to shake each man's hand. After further discussion, including details of how an actual surrender might proceed, the meeting ended. Wolff departed for Italy to make arrangements to see Kesselring; the two generals decided to wait in Ascona, hopeful that Wolff would return as promised around March 26, to confirm the end of the war in Italy.

* Alexander was promoted to Field Marshal and Supreme Commander of Allied Force Headquarters in the Mediterranean in December 1944.

———

FRED HARTT AND Deane Keller, like the other soldiers of U.S. Fifth Army, were restless, waiting for the spring offensive to begin. Hartt had used this time to continue inspections in and around Florence. But his preparations to return the art from all of the repositories into the city were suspended following rumors that "the Germans had a V-weapon site in northern Italy pointing in the vicinity of Florence."* There would be no more art returns until the war ended. While Hartt had lost some battles with overzealous bulldozer operators in his effort to salvage the city's medieval towers, his supervision of the repairs to its great churches and museums had earned kudos from civic and military leaders.

Despite this success, the whereabouts of the missing Florentine art filled Hartt with anxiety:

> All we knew was that the works of art, ostensibly to save them from a few shells that might have hit the roofs above them, were exposed to a far greater danger. A third of them had no cases or boxes of any kind, and all of them were being moved over mountain roads which the Allies were shelling and strafing day and night. The charred remnants of German trucks that lined the road from Rome for a hundred miles brought visions of what a fighter plane might do to a convoy of works of art. And even if these works did arrive safely in North Italy or Germany or wherever, who was to assure us that in a last holocaust of nihilistic fury the Germans would not blow them up or set fire to them?

When Marchese Serlupi Crescenzi, one of the guardians of Florence—and Bernard Berenson's protector—suggested that Hartt enlist the help of the OSS, he leapt at the chance. Serlupi reminded Hartt that when he had arrived at Villa delle Fontanelle in early September 1944 looking for Berenson, he had missed by a day an American captain, now

———

*German scientists developed a series of ground-launched long-range weapons known as *Vergeltungswaffen* (retaliation), which were referred to as "V-Weapons." These bombs, and later rockets, caused considerable loss of life and damage in England, where they were first employed.

major, who might be of some assistance. Alessandro Cagiati had operatives sprinkled throughout northern Italy; perhaps they could locate the works and guard them until Allied forces could reach those areas. Never one to allow protocol to interfere with a good idea, Hartt immediately contacted Cagiati, who proved willing to help. Hartt then cleared the idea directly with Ernest DeWald, who feared that the trove of paintings and sculptures "may be shipped across the Swiss border when the stampede begins."

On March 22, Hartt forwarded a formal memo to Cagiati entitled "Works of Art Removed by Germans to North Italy." He summarized the number of objects missing and the circumstances of their removal from the major Florentine repositories and requested that "agents of OSS endeavor to trace whereabouts and condition of works of art removed from deposits . . . and also if possible to arrange that trusted personnel keep watch on the eventual peregrinations of these works [of art] to prevent if possible their disappearance into Germany, or any material damage to the works."

Three days later, Hartt learned that Cagiati had sent a message to one of his operatives near Venice, instructing him to make contact with Professor Ludwig Heydenreich or Carlo Anti and obtain information concerning "disposition of works of art, and arrangements made to prevent their evacuation to Germany or at least an attempt made to trace the movements of these treasures."

Cagiati gained a new title on March 27: Officer in Charge, N. Italy City Teams. Through the fall and winter months, he had built a reliable network of OSS Special Operations teams, some sixteen in all, operating behind enemy lines. The new title formalized his role. Two of his key men in the field—Don Guido Anelli, "the flying priest," and Pietro Ferraro—had already been pressed into service on unrelated missions. Cagiati limited Anelli's initial assignment to gathering information about the location of the works. Ferraro, an Italian partisan leader who, like Anelli, had been parachuted behind enemy lines in July 1944, received instructions to make contact with the Patriarch of Venice, as

well as like-minded members of the Kunstschutz, and obtain what information he could.

Hartt's entrepreneurial effort created another serious rift with Keller. On March 18, while Wolff was in transit to Switzerland for his second meeting with Dulles, Keller received orders to report to Allied Force Headquarters in Caserta for a weeklong assignment helping to prepare the monuments component of Fifth Army's planned occupation of Austria. By the time he returned to Florence, Hartt had devised a plan that, from Keller's perspective, allowed him "to chase all over the place at will, hunting art treasures." That his subordinate had pursued an idea, without regard to military protocol, left Keller fuming. He wasted no time in writing DeWald: "I hope you won't mind if I write very frankly about a situation that has bothered me for some time, aggravated by another instance of it today. . . . I knew nothing of the OSS business and was somewhat embarrassed to have Fred in on the know, contact made and full of it."

Although Keller's frustration was understandable, in point of fact Fred Hartt had set in motion a series of events that had brought new manpower to the hunt.

AFTER RETURNING TO his headquarters from the second meeting with Dulles and the "military advisers," Wolff once again turned his attention to the artwork. At the time, Wolff and Gauleiter Hofer had reached an understanding that neither would make decisions about the art without the other's consent. But Hofer's alliance with his fellow Austrian—SS General Ernst Kaltenbrunner—meant he couldn't be trusted. Others shared Wolff's opinion. General Director of Fine Arts Carlo Anti had long believed that, "in view of Hofer's anti-Italian feeling there was reason to be very anxious for the fate of our works of art," noting that even Dr. Ringler "confessed to me that he felt unsafe." Hofer apparently distrusted Ringler because he was Catholic and not a Nazi Party member.

Meanwhile, Wolff's secret discussions with the Allies had begun to complicate his working relationship with Langsdorff. Unaware that

Wolff had ulterior plans for the treasures, Langsdorff had urged Ringler to press Hofer to allow an Italian supervisor at the repositories. He expected Hofer to agree readily. Instead, Langsdorff was surprised when he received notice on March 21 from Ringler that "the Gauleiter in agreement with *Obergruppenführer* Wolff had refused to give permission for [Superintendent of Galleries of Genoa] Morassi's journey for the purpose of permanently controlling the treasures. . . ." Wolff's sudden and unexplained shift confounded Langsdorff. Weeks would pass before he would understand the reason.

Gauleiter Hofer wasn't the only perceived threat to the art. The nearby population had little reason to defend Italian patrimony; most considered themselves Tyrolean. Dr. Ringler wrote Langsdorff to inform him that "the farmers are tired of this endless standing guard [at the repositories] and [complained] that nobody was at their farms taking care of the fields. One did not understand this effort of precaution, if at the same time our art in the Reich is going under." Carlo Anti bluntly summarized the risk: "Dangerous are the South Tyroleans, and not so much the Germans."

On March 21, Wolff set out by car for Kesselring's headquarters, known as *Adlerhorst* (Eagle's Nest), a complex of bunkers that had served as Hitler's command post and residence during the five weeks of the Ardennes offensive. Because of Allied strafing, a drive that should have taken him five hours consumed a day and a night. Upon arriving at headquarters, near the spa town of Bad Nauheim, about twenty-five miles north of Frankfurt am Main, Wolff learned to his astonishment that Allied forces were just ten miles away. The deteriorating situation on the battlefront had forced Kesselring to begin evacuating his headquarters less than two weeks into his new assignment.

With field telephones ringing and Kesselring barking orders to his commanders, Wolff found it difficult to conduct sensitive discussions. Battlefield conditions supported Wolff's argument for an early surrender, but Kesselring refused. "The idea is a good one for Italy," Kesselring informed Wolff. "But it cannot be carried out by myself for the Western

front. I am too new in this command." While Kesselring wouldn't surrender his forces, he did agree to instruct his replacement in Italy, General Vietinghoff, to act in support of Wolff's plan.

Satisfied that this was the best possible outcome under the circumstances, Wolff prepared to return to Italy. On March 22, however, he received orders to report to Himmler. Ignoring Kaltenbrunner's request was one thing; ignoring direct orders from Himmler was an entirely different matter. Wolff telephoned one of his intermediaries in Milan and instructed him, using a prearranged code, to deliver a message to Dulles that he would be delayed several more days. After another harrowing drive, during which his driver frequently pulled their car off the autobahn to hide from enemy planes, Wolff finally reached Berlin late that evening.

Wolff had known Himmler since 1932. During most of that time, they had been very close. But in 1943, Wolff sought (and received) the Führer's approval to divorce his first wife. She and their children had brown hair and brown eyes, leaving Wolff "feeling guilty of having wasted his Nordic attributes." German historian Jochen von Lang humorously observed: "If the schoolboy Karl had paid more attention in his biology classes in high school, he could have avoided this misfortune; it is a law of heredity that dark dominates over blond." Wolff's mistress, however, had already given birth to their blond-haired, blue-eyed son, and Wolff wished to marry her. Himmler strongly objected and was furious when Wolff went over his head to Hitler. Wolff's transfer to Italy later that year restored their collegiality. Himmler resumed using his affectionate nickname, *"liebes Wölffchen"* (dear little Wolffie), for the man he considered "one of his closest and oldest associates," and would later refer to Wolff as a man "whom I have come to love as a friend." Wolff remained circumspect. Himmler was his superior, and he could be as coldhearted as the situation warranted.

The relationship between Kaltenbrunner and Wolff was an entirely different matter. As head of internal security and the Gestapo, Kaltenbrunner also reported directly to Himmler. Kaltenbrunner viewed

Wolff as a rival and coveted his long-standing friendship with Himmler. His continual prodding of Himmler to dismiss Wolff made the two men enemies. The struggle among the three highest-ranking leaders of the SS had, since 1942, been defined by competitiveness, pettiness, and vanity. The only thing binding them was their loyalty to the Führer.

Himmler and Kaltenbrunner had been informed by General Wilhelm Harster, head of the SS Police in northern Italy, that Wolff had met with Dulles in Zurich on March 8, but they seemed unaware of his second meeting on March 19 in Ascona involving the Allied "military advisers." While Wolff had ready explanations for the first meeting with Dulles, the second meeting constituted treason because of the presence of enemy military personnel. As the conversation progressed, however, it emerged that Himmler's chief complaint was that Wolff had contacted the Allies without his prior knowledge or consent. He expressed jealousy that his former adjutant had been so successful reaching a person of Dulles's high position. The problem soon became clear: three men each had his own survival plan. Only one would succeed.

Aware that Himmler and Kaltenbrunner were criticizing him for his initiative and success, and confident of his good standing with the Führer, Wolff suggested they all meet with Hitler and inform him of the breakthrough with Dulles. While this appeared to be a risky gambit, Wolff knew that Himmler, always nervous when confronting Hitler, had fallen in his disfavor. The gambit worked. Himmler and Kaltenbrunner quickly made excuses, saying such a meeting with the Führer would be ill-timed. For the moment, Wolff had deflected their inquiries.

During the next several days, the greatest threat to Wolff's life turned out to be Kaltenbrunner's reckless driving. On a foggy afternoon, while in transit to an appointment outside Berlin, Kaltenbrunner's car veered off the autobahn into the soft grass and overturned—twice. Minor bruises aside, neither Kaltenbrunner nor Wolff was seriously injured. Before departing Berlin on March 27, Kaltenbrunner counseled Wolff against pursuing further contact with the Americans. Himmler was more direct, ordering Wolff not to leave Italy again.

Before returning to his headquarters in Italy, Wolff made plans to protect his family by relocating his second wife, their son, and her two other children to Munich from a small town on the Wolfgangsee, about twenty miles east of Salzburg. He intended to get them to a town between Innsbruck and the Brenner Pass, closer to his headquarters in Italy. "Wolffie" had witnessed Himmler's ruthlessness on too many occasions to ignore the danger his surrender plan now posed. He finally arrived in Italy on March 29, exhausted, but with little time to rest before another crucial meeting, this one with Vietinghoff, Kesselring's successor in Italy, set for the evening of April 1, Easter Sunday.

Wolff had originally asked Dulles for "five to seven days" to seek Kesselring's consent, but two weeks had now passed. On March 30, Wolff had arranged for intermediaries to courier a message explaining the additional delays and, more important, to inform Dulles that he had obtained Kesselring's support; he would meet with Vietinghoff in two days. With any luck, he expected to return to Ascona on April 2, perhaps even bringing the new German commander in Italy, Vietinghoff, and Ambassador Rahn, to meet with Dulles and the two military advisers.

This message encouraged Generals Lemnitzer and Airey, who had been sidelined from the war effort for two full weeks while awaiting Wolff's return. They and Dulles marveled at Wolff's perseverance and remarkable good luck. If it held, an early German surrender in Italy might be tantalizingly close. But on Monday, April 2, Wolff's intermediaries appeared; Wolff did not. The meeting with Vietinghoff had taken place the previous evening as planned, but not before Wolff received a distressing phone call from Himmler, upset that Wolff had taken the precaution of moving his family. "This was imprudent of you," Himmler informed him, "and I have taken the liberty of correcting the situation. Your wife and your children are now under my protection." Himmler added that he would be making periodic calls to Wolff's headquarters to ensure that he remained at his post—in Italy.

Far from protecting them, Himmler was holding Wolff's family hostage. He also believed that Himmler intended to have him killed

if he attempted another trip to Switzerland. Under the circumstances, Wolff could only send Dulles a message to explain why he had chosen to remain at his headquarters in Gardone rather than travel to Switzerland, as previously planned. Upon receiving this news, General Lemnitzer remarked, "It's not half as bad as it looks," but he was the lone optimist among the Allied team. Dulles summed up the majority view: "Wolff had not sent a single word . . . about what might happen next. All we could do now was send a message back to Wolff reaffirming our continued interest in a surrender."

24

COMPLICATIONS

While Generalfeldmarschall Kesselring evacuated his troops from his military headquarters at Adlerhorst, Reichsmarschall Göring supervised the final packing of his art collection at Carinhall. Two shipments had already departed for Veldenstein in Bavaria; from there, the trains would travel to Berchtesgaden, where Göring also had a home. Some items had to be left behind, including the body of his beloved first wife, Carin, for whom the estate was named. (Göring arranged for it to be moved from its mausoleum and reinterred in the nearby forest.) Wanting to deprive the Red Army of such glorious spoils, Göring left orders for his home and its remaining contents to be destroyed when the enemy neared.

On March 28, the Naples masterpieces stolen from Monte Cassino arrived at their final destination—the Nazi repository at Altaussee, Austria. Miners placed deep inside the labyrinth of tunnels thousands of paintings, drawings, prints, sculpture, furniture, and tapestries, many destined for Hitler's Führermuseum.

Two weeks later, eight wooden crates belonging to Gauleiter August Eigruber arrived in two shipments, each weighing eleven hundred

pounds and marked ATTENTION!—MARBLE—DO NOT DROP. Once again the miners hauled these new arrivals through the narrow tunnel passages, but on this occasion they had received the odd order to intersperse the crates throughout the mine rather than place them together. Had they known that each crate contained a bomb, not a piece of marble sculpture, these instructions would have made sense. Eigruber—like Wolff, Himmler, and Kaltenbrunner—had his own plan. Rather than allow the works to fall into the hands of "international Jewry," he would destroy the salt mine and every priceless work of art stored inside.

ON APRIL 3, Fred Hartt read the first reply from Cagiati: "We have received the following message from the field: 'Anti stated to the Patriarchate of Venice that the works of art in the Alto Adige are in good state. Has asked that they be brought to the [Doge's] Palace in Venice. . . . If possible give us some indication of the chief works of art missing.'"

Cagiati's man had at least narrowed down the location of the repositories to the Alto Adige region. Hartt knew that the Alto Adige, for all practical purposes, was German Reich territory—more than two hundred miles north of Florence but nestled along the Austrian border. Although Cagiati reported that the works were "in good state," his cable said nothing about whether they were safe. Some news was better than none at all. Hartt promptly provided Cagiati with the list of missing objects.

The message had come from Cagiati's operative, Pietro Ferraro, a partisan leader with extensive contacts in Venice. Ferraro had initially shared the optimism of the Superintendent of Venice, Professor Ferdinando Forlati, who believed that Carlo Anti's efforts to transfer the Florentine collections to the historic Doge's Palace—for more than a thousand years home to the chief magistrate of the Republic of Venice—might actually succeed. But Anti had been pleading with Langsdorff to transfer the artwork for eight months without result.

In late February, Anti had contacted the Superintendent of Milan

about moving the art to St. Moritz, Switzerland, a location close to the repositories that could be reached via roads deemed safe from Allied air attacks. This proposal proved sufficiently encouraging that Langsdorff and other Kunstschutz officials traveled to Milan on March 5 to discuss the matter; all agreed that a transfer to Switzerland was the best option. However, Langsdorff stressed, "A decision in this instance is predominantly of a political nature, and could only be effectuated by the Führer and the Duce together." Sure enough, the following day Anti heard the proposal had been refused.

On April 4, Anti had written Langsdorff in an effort to guilt him into giving custody of the works to the Italians. "All your efforts to take these masterworks away from the dangers of the battle zone . . . are undone by multifaceted opposition against our direct custody of the repositories of the Italian State." Anti then offered to send a vehicle to transport the art. He also informed Dr. Ringler that "the Italian state held him personally responsible for any damage to the deposits in the case of a collapse of the German Army."

By April 15, with U.S. Fifth and British Eighth Armies advancing north, Anti had exhausted all possibilities. Cagiati received this disappointing news from his operative, Ferraro: "It is feared by the Germans themselves (those who are friends of the arts) that these works of art will be at the last minute removed or ruined in the haste of removing them by the SS or the [Alto Adige inhabitants]. The Germans themselves believe that the proposal to send . . . a body of Italian guardians and an Italian superintendent, will not do much in the crucial moment against SS or [Alto Adige] forces, but anyway it would be better than nothing."

With both repositories located less than fifty miles from the Austrian border, SS forces could truck some of the objects northward on a moment's notice or destroy them out of spite. Under the circumstances, Cagiati could only confirm that the art was still there and then post observers, perhaps even armed partisans, to watch over it until Allied forces arrived. He needed someone who could move inconspicuously. Perhaps a priest?

Cagiati sent Don Anelli three urgent telegrams requesting that he get to the Bolzano area as soon as possible and then make his way the remaining distance to the repositories. Anelli wanted to help, but he was already engaged in another OSS mission, code-named "Penance," one of its many "morale operations" designed to engender friction between the Germans and Fascists through customized propaganda material. He would need assistance to reach Bolzano. Just as he had done four months earlier, Cagiati made arrangements for Don Anelli to be air-lifted, this time to the Lake Garda area, then dropped by parachute into the Tyrolean countryside to begin his new mission.

ON APRIL 12, 1945, radios around the world crackled to life. "We inter-rupt this program to bring you a special bulletin from C.B.S. World News. A press association has just announced that President Roose-velt is dead." The president, who had held power for twelve years and thirty-nine days, had died from a massive cerebral hemorrhage while sitting for a portrait at the "Little White House" in Warm Springs, Georgia. The shocking news quickly reached leaders overseas. Writ-ing to the First Lady, Prime Minister Winston Churchill stated, "I have lost a dear and cherished friendship which was forged in the fire of war." General Eisenhower concurred: "We were doubtful that there was any other individual in America as experienced as he in the busi-ness of dealing with other Allied political leaders. . . . We went to bed depressed."

But those in the bunkers beneath the Reichschancellery in Berlin greeted the news with jubilation and renewed hope. Friday the thir-teenth seemed a day of deliverance for the Nazis. "My Führer, I congrat-ulate you! Roosevelt is dead," exclaimed Goebbels. "It is written in the stars that the second half of April will be the turning point for us!" Hit-ler, clutching a newspaper clipping, confronted Albert Speer and said, "Here, read it! Here! You never wanted to believe it. Here it is! Here we have the miracle I always predicted. Who was right? The war isn't lost.

Read it! Roosevelt is dead!" Perhaps the rift might open between the Anglo-Americans and the Soviets after all.

In a letter dated April 15, another high-ranking Nazi leader reacted to the death of the president. The recipient was American spymaster Allen Dulles; the sender was SS General Karl Wolff:

> Honored Mr. D:
>
> On the occasion of the passing of the President with whom you were so close and whose loss must have been painful to you in equal measure as a man and as a member of the government, I would like to express to you my sincere and deeply felt sympathy. . . . I want to assure you in this painful moment that I remain now, as before, convinced that a prompt cessation of hostilities is possible.

Himmler's threats in early April succeeded in delaying, but not stopping, his former adjutant. Over the course of three meetings with Vietinghoff, Wolff had gained the support of the man who had taken over Kesselring's job as commander of the German Army in Italy. But Vietinghoff still had concerns, in particular about points of honor.

Meanwhile, the once-mighty German Reich continued to disintegrate. Elements of U.S. Ninth Army reached the Elbe River on April 11 and now waited less than one hundred miles west of Berlin. Vienna fell to Soviet troops on April 13. RAF bombers continued their nightly pounding of Berlin while more than two and a half million Red Army soldiers massed east of the city. Himmler knew that Nazi Germany couldn't be saved, but he remained confident that he would emerge as the reasonable choice to unite Germany and forge an alliance with the Anglo-Americans against the Soviets. But Wolff's independent efforts with Dulles threatened his plans. On April 13, Himmler ordered Wolff to report to him immediately.

After avoiding the SS leader's phone calls for two days, Wolff decided to face Himmler; he boarded a plane bound for Berlin. Before departing, Wolff relayed a message to Dulles, through one of his intermediaries,

informing him of the trip and stating that there was "a chance to do something for the entire German people." Wolff expected to return to Italy no later than April 20.* Only later did Dulles learn that the intermediary also had a note in his pocket from Wolff, a sort of last will that began, "In case I should lose my command," requesting Dulles to ". . . protect, after my death, if this is possible, my two families, in order that they not be destroyed." Dulles and his associates expected the worst; Wolff had planned for it. "It appears that Himmler may now either eliminate [Wolff]," Dulles cabled Washington, "or attempt to use him to help Himmler himself establish some contact [with the Western Allies]."

On April 17, Wolff endured a series of tense meetings—first with Himmler, then with both Himmler and Kaltenbrunner. Unbeknownst to Wolff, Himmler had been conducting secret negotiations with a Swedish diplomat, Count Folke Bernadotte, yet he unhesitatingly accused Wolff of treason for his efforts with Dulles. Wolff demanded that the three senior SS leaders meet with the Führer to discuss his entrée to the Anglo-Americans. This bold move by Wolff, the second round of such brinkmanship in less than a month, had the desired result—almost. Wolff got the meeting with the Führer, but once again Himmler demurred and ordered Kaltenbrunner and Wolff to go without him.

In the predawn hours of April 18, as the two SS men approached the Führerbunker, Wolff moved to protect himself. He told Kaltenbrunner that if he dared cast his meeting with Dulles in a negative light, Wolff would inform Hitler that he had, three weeks earlier, provided both Himmler and Kaltenbrunner with a full account of his contact with Dulles and that the two men had chosen to hide that information from the Führer. Before entering the building, Wolff turned to Kaltenbrun-

*During their second meeting, Wolff agreed to allow Dulles to place a spy—a twenty-six-year-old radio operator named Vaceslav Hradecky, known as "Little Wally"—inside the SS counterespionage building in Milan, and later in Wolff's headquarters in Bolzano. Hradecky, a Czech citizen who had been arrested in Prague in 1939 and imprisoned by the Germans at Dachau before escaping, provided a vital communication link for Wolff with Dulles, and later with Allied Force Headquarters in Caserta.

ner and said, "If I am going to be hung, my place on the gallows will be between you and Himmler."

Wolff and Kaltenbrunner had to wait while Hitler finished a military briefing. At its conclusion, they entered the map room for their meeting with the Führer and SS General Hermann Fegelein. Wolff found the appearance of the German leader appalling. Hitler was stooped. His eyes were tired and bloodshot and his right hand shook uncontrollably. But the Führer went directly to the point: "Kaltenbrunner has announced to me that you have started negotiations in Switzerland with the representative of Roosevelt, Dulles. What made you think of such an enormously arbitrary act?"

Wolff presented his best defense, reminding the Führer that during their February 6 meeting he had sought permission to pursue leads with the Western powers. Having done so, Wolff informed him that the door was now open. Neither Kaltenbrunner nor Fegelein said a word. Hitler seemed to accept Wolff's explanation, although he criticized Wolff's inability to consider how such actions fit into the much larger picture that only he, the Führer, could understand. Needing rest, Hitler informed the group he would consider the matter further, telling them to report back at 5 p.m.

When the meeting resumed, Hitler seemed a different man, filled with hope that the German Army could defend Berlin from the enemy for at least six to eight weeks, time enough for the Western Allies and the Soviets to split. The Führer ordered Wolff to return to Italy immediately and tell Vietinghoff to defend every inch of ground with the blood of his soldiers. Wolff should do nothing more than maintain his contacts with the Western powers: "They will come with many more offers . . . unconditional surrender . . . ridiculous!" Kaltenbrunner's final words to Wolff reflected no such optimism: "Be sure no important civilian prisoners in your area fall into Allied hands. As the Allies approach, liquidate them." With that, the meeting ended. Hours later, a very weary—and lucky—General Wolff departed a darkened Berlin on one of the last flights out of the German capital during the war.

Anxious to hear some news about Wolff, Dulles instead received a stunning telegram on April 20 from the Joint Chiefs of Staff in Washington, formally ending Operation Sunrise. "By letter today JCS direct that OSS break off all contact with German emissaries at once." After six weeks of delays and excuses, the Joint Chiefs had concluded that the German commander in Italy, Vietinghoff, had no intention of surrendering his forces "at this time on acceptable terms." It also mentioned "complications which have arisen with [the] Russians" and stipulated that Dulles should consider the "whole matter . . . as closed and Russians be informed."

The death of President Roosevelt had deprived the Western Allies of the person most adept at dealing with the wily Soviet leader, Joseph Stalin. In the weeks leading up to the president's death, Soviet diplomats, who had been promptly notified of Dulles's initial meeting with Wolff, made increasingly acrimonious accusations that the Americans and the British were negotiating a secret surrender of German forces in Italy at the expense of the Soviet Union. Despite denials by the West, this was, at least in part, true. While Soviet representatives had formally been invited to participate in actual surrender discussions at General Alexander's headquarters in Caserta, they had been denied the opportunity to send military advisers to the meetings, characterized as purely exploratory, between Dulles and Wolff.

On March 24, the matter escalated when Roosevelt wrote Stalin, seeking to reassure him that while meetings with Wolff would proceed, they were in no way a "violation of our agreed principle of unconditional surrender." After recriminations back and forth, Roosevelt graciously concluded the affair with a note to Stalin, sent the morning of his death, that expressed appreciation "for your frank explanation of the Soviet point of view of the Bern incident [OSS meetings with Wolff], which now appears to have faded into the past without having accomplished any useful purpose." Even so, Dulles's "discussions" with Wolff continued with the tacit approval of Roosevelt. But his successor, Harry Truman, felt differently. More sympathetic to Stalin's

concerns, Truman, with Churchill's consent, pulled the plug on Operation Sunrise.

Unaware of the Western Allies' change in position, Wolff, his adjutant (Major Wenner), and Vietinghoff's designated representative (Lieutenant Colonel Viktor von Schweinitz) arrived in Lucerne, Switzerland, on April 23, ready to proceed with surrender. Their sudden appearance caught Dulles by surprise. Dulles first contacted General Alexander, who in turn cabled the Joint Chiefs, seeking reconsideration of their April 20 cabled instructions. He then explained the situation to Waibel, who had the unenviable task of explaining to Wolff that the German delays had raised suspicions in Washington and London. For the moment at least, further surrender discussions were not possible. Wolff and his party were encouraged to remain in Switzerland and hope, like Dulles, for a change in position by the Joint Chiefs.

By April 25, American soldiers and Soviet Red Army troops had linked up at the Elbe River. Partisans in northern Italy, sensing that the moment of liberation neared, came out of hiding and began roving in armed bands. Once again, Himmler contacted Wolff, sending a telegram that read: "It is more essential than ever that the Italian front holds and remains intact. No negotiations of any kind should be undertaken." Three days later, news leaked that Himmler had been meeting with Count Bernadotte in the northern German town of Lübeck, hoping the Swedish official could arrange an introduction with Eisenhower to enable Himmler to surrender German forces in the West. Waibel later told Dulles that, upon receiving the message, Wolff simply "shrugged his shoulders and said that what Himmler had to say no longer made any difference."

Aware of the threat posed by the partisans, Wolff sent word to Dulles that he needed to return to his headquarters in Italy while he still could. Vietinghoff's designee, Schweinitz, would remain behind, along with Major Wenner. Each officer had authorization to review and execute the surrender documents at Caserta if the opportunity arose.

Wolff also informed Dulles that he had convinced Gauleiter Hofer

to go along with his plan. But the truth was more complicated. Knowing that the Allies would never agree to a conditional surrender, much less one on Hofer's terms, Wolff had deliberately avoided telling Hofer that his plan called for unconditional surrender. Hofer's acceptance had come with conditions designed to maintain his autonomy, including the delusional notion that there should be no "occupation of the Alpine region by Allied troops." This Wolff did not disclose to Dulles.

Before departing, Wolff completed a four-page handwritten letter addressed to the two principal Swiss intermediaries, Professor Max Husmann and Chief of Intelligence Max Waibel, but in fact intended for Dulles. The American spymaster had on numerous occasions assured Washington that no deals or incentives had been extended to Wolff, and that he had "engaged in no negotiations, merely listened to [Wolff's] presentation." Wolff's letter suggested otherwise. "You know the incredible difficulties which opposed me over and over again," Wolff's letter began. "Even if I did not succeed in starting and completing our negotiations at the beginning of this bloody struggle I nevertheless today am confidentially acting along the lines of the discussions I had with you and the representatives of the Allies."

The third and fourth pages featured a list of personal belongings, noting, "Wolff to possibly keep," and the location of his family: "SS families (women and children) on Lake Tegernsee 50km to the south of Munich (divorced wife + 4 children Wolff et al)." Beneath the heading titled "Immediate and Preferred Protection of Following Buildings" were the names and directions to three buildings under Wolff's control. The Palazzo Reale in Bolzano, which served as Wolff's new headquarters, also doubled as a vault for the "untouched coin collection of the King of Italy" taken from the Quirinal Palace during the German retreat, and gold bars and bullion belonging to the Royal Treasury. The other two buildings, both located in the Alto Adige region, housed the Florentine treasures. One "contains approximately 300 world famous oil paintings from Uffizi, Florence, saved from castles which were under heaviest fire near Florence." The other stored "approximately 300 other

oil paintings as well as the . . . world famous sculptures." Leaving nothing to chance, Wolff arranged for Langsdorff to gather a group of men, including two members of the Kunstschutz, and drive to the two repositories to protect them "against partisans and looting."

Wolff reached the SS command post, located in a villa in Cernobbio, on Lake Como, late in the evening on April 25. During the early morning hours of April 26, partisans surrounded the villa, threatening Wolff and the other officers inside. When Max Waibel received this news from one of his agents, he and Gaevernitz headed for Chiasso, hoping to keep both Wolff and Operation Sunrise alive. Gaevernitz's effort to go to Wolff's aid was a clear violation of the order from the Joint Chiefs banning any contact with Wolff, but neither Gaevernitz, Waibel, or Dulles was willing to let Wolff fall prey to partisan fury.

After tense negotiations with the partisans, narrowly avoiding a gun battle, Waibel and Gaevernitz extricated and then drove a very grateful SS general to Lugano; Waibel then accompanied Wolff to the Swiss/ Austrian border, arriving the morning of April 27. There they learned that Dulles had just received a "TRIPLE PRIORITY" message from Washington. The Joint Chiefs of Staff had reversed their previous "stop" instructions on Operation Sunrise. Dulles now had authorization to make immediate arrangements for Wolff's two representatives to be flown to Caserta to sign the document of surrender.

IN MID-APRIL, Don Guido Anelli made contact with trusted friends in the Alto Adige area who confirmed the presence of the works of art at each of the two locations. He then arranged for on-site surveillance by dependable patriots of "the Italian population in order to protect [the works of art] against any possible tampering on the part of those belonging to the ethnic minority." Anelli also recruited a fellow priest with the Italian Red Cross in Bolzano and assigned him the task of organizing guides who, at the first appearance of Allied soldiers, would take them to the repositories.

With the commencement of the Allied spring offensive, Deane Keller headed north to Bologna, accompanied by Monuments officer Teddy Croft-Murray. The men entered the city on the evening of its liberation, April 21. The sixty-seven-mile drive had taken eight hours as traffic crawled along blacked-out roads jammed with vehicles.

The relative calm of the three winter months in Florence had dulled their memories of war's carnage. Entering Bologna, ablaze and in ruins, brought things sharply back into focus. Keller wrote to his parents, describing the scene of ". . . death, misery, ruination—Jesus! Coming into town late at night, houses on fire, mines exploded by engineers, smell of death, dead animals, a couple of German soldiers, one in two pieces, another headless. I'm not morbid, but this is what the bleeding hearts should see."

In Bologna, Keller met a boyish-looking twenty-three-year-old, Sergeant Bill Mauldin. The fellow draftsman and cartoonist was young enough to be his son. "What a break to have met up with him. I truly revere that kid's mind and hand. A great gift. All the Old Masters would have seen it and admired it. It's ALL AMERICAN." Keller and Mauldin had one other thing in common: each had young sons. But Mauldin had never met his; he knew the child only through photographs.

Keller soon departed Bologna to inspect other towns being liberated by Fifth Army. Croft-Murray remained and began debriefing the art superintendents, in particular Dr. Pietro Zampetti, Director of Galleries in Modena. Of particular interest were the events of the previous summer, when trucks loaded with the Florentine treasures had passed through Marano sul Panaro en route to northern Italy. Zampetti had since learned that everything the Germans had removed from the Florence repositories could be found in two small villages in the Alto Adige: Campo Tures and San Leonardo.

The mention of these two names electrified Croft-Murray. He immediately transcribed his notes—as in his earliest days in Sicily, he was still without a typewriter—and dispatched them to MFAA Deputy Director John Bryan Ward-Perkins in Florence on April 27. None of

the Monuments Men knew that Florentine Superintendent Giovanni Poggi had known the locations of both repositories for months but had decided against sharing it with them. In fact, Poggi had deliberately misled Fred Hartt.

Five months earlier, Poggi had seen the November 15, 1944, letter from Vatican Secretariat of State Giovanni Montini to Cardinal Elia Dalla Costa that identified a place called "Neumelans in Sand" as one of the secret art repositories containing the Florence treasures. Poggi relayed only that portion of the letter to Hartt, telling him there was no such place. Indeed, Hartt couldn't find a town by that name on any map. But had Hartt seen the letter himself, he would have known that Montini had mistakenly crossed the correct name of the castle where the works were stored (Castle Neumelans) with a portion of the German name of the Italian town in which the castle was located (Sand in Taufers). As a consequence, "Neumelans in Sand" should have been "the *Castle* of Neumelans in the *town* of Sand in Taufers." However, not wanting to leave anything to chance, Montini had also included the Italian name for the location: "Campo Tures." Had Poggi provided that information to Hartt, the Americans would have had an easy time finding it on a map. But for reasons known only to Poggi, he did not. By deliberately withholding the name of the location, he had prolonged one of the great mysteries of the war in Italy.

25

SURRENDER

APRIL 27–MAY 2, 1945

On April 27, as General Wolff attempted to cross the Austrian border back into Italy, Benito Mussolini was searching for a way to escape. Two days earlier, the once-fiery dictator, fearful of being trapped and captured again, departed Milan and drove the short distance to the lakeside town of Como. After bidding his wife farewell, he and his entourage considered crossing into Switzerland, but the area was already under partisan control; they could proceed no farther. A second attempt failed when partisans recognized the Duce, wearing a German greatcoat and helmet, and pulled him from the vehicle.

Mussolini was initially detained in the town of Dongo. After a brief reunion with his lover, Clara Petacci, both were shot. Fifteen others, mostly prominent figures of the Fascist regime, were also taken prisoner and gunned down. A truck carried the bodies to Milan, where they were dumped in Piazzale Loreto at 3 a.m. on April 29. In a scene of ghastly vengeance, the bullet-riddled bodies of the once-beloved Duce and the others were hung upside down from the girders of an Esso gasoline station.

At noon on April 28, Colonel Schweinitz and Major Wenner, each carrying written authorization to surrender the forces of Vietinghoff

and Wolff, boarded General Alexander's luxuriously equipped C-47 airplane in Annecy, France, and departed for Allied Force Headquarters in Caserta, Italy. The first official meeting began at 6 p.m. with the presentation of the official surrender document. Hours later, they returned for a second meeting, which included a Soviet representative, Major General Kislenko, to raise objections and seek clarifications. While Wenner appeared ready to sign the document as presented, Schweinitz objected to Wehrmacht troops being interned at prisoner-of-war camps rather than demobilized on the spot and allowed to return home. This had been one of Vietinghoff's conditions. Schweinitz felt bound to defend it.

During the morning of April 29, realizing that there wasn't enough time to consult his commander, Schweinitz acquiesced. Discussions then focused on the appropriate method and length of time required to communicate to troops on the front line notice of the surrender. The parties agreed that hostilities in Italy would end at 2 p.m. on May 2 (1200 hours Greenwich Mean Time), seventy-two hours after the signing of the official surrender document. No announcement of the surrender would occur until then. After a ceremony that lasted just seventeen minutes, the Allies had in hand an executed document that began, "The German Commander-in-Chief Southwest hereby surrenders *unconditionally* all the forces under his command or control. . . ." On paper at least, the war in Italy would end in three days.

For the surrender to take effect, Vietinghoff and Wolff had to inform their forces and order them to cease fire on or before the 2 p.m. May 2 deadline. Until the Allies received confirmation that Vietinghoff and Wolff had issued the cease-fire notice to their troops—a process that couldn't begin until Schweinitz and Wenner returned to Bolzano and presented them with the executed surrender document—fighting would continue. Unanticipated delays in their return to Switzerland consumed almost ten of the seventy-two hours. By the time they departed Bern for Bolzano, it was nearly 1 a.m. on April 30. Later that morning, they reached the Swiss-Austrian border, only to discover that it was closed.

But an even larger problem loomed. That same morning, as Allen

Dulles petitioned his contacts within the Swiss government to obtain passage for the German deputies, Kesselring, who two days earlier had seen his power expanded to include command of all German troops in Italy, issued orders relieving Vietinghoff and General Hans Röttiger, Kesselring's former Chief of Staff, of their commands. Both officers were ordered to report immediately to a secret army command post at Lake Karer, in the Alto Adige region, for court-martial. The surrender document now bore the proxy signatures of officers with no authority. That Kesselring had known about the Caserta document and acted so quickly indicated that someone was aggressively trying to sabotage Wolff's surrender efforts, but who?

FOUR DAYS EARLIER, on April 26, on orders from Vietinghoff, SS Colonel Eugen Dollmann, had traveled to Kesselring's headquarters to seek final consent for Wolff's surrender plan. Although Kesselring's command did not yet include Italy, the ever-cautious Vietinghoff hoped to obtain his approval. On the way, Dollmann stopped in Innsbruck to have dinner with Gauleiter Hofer. There he learned that Wolff's enemy, Kaltenbrunner, claimed to be in contact with the Allies with his own plan for a surrender of Austria, something that would benefit his fellow countryman Hofer.

More bad news awaited Dollmann's arrival at Kesselring's headquarters. The Führer was preparing to expand the army groups under Kesselring's command to *include* Italy. Not wanting to disrupt Wolff's plan, and sensing that Kesselring "was very nervous of the whole thing," Dollmann deliberately avoided telling Kesselring that the previous commander in Italy—Vietinghoff—had already empowered his deputy, Schweinitz, to end the war in Italy. Before departing, Dollmann asked Kesselring, "What will you do, sir, what answer will you give the German people, if at the critical moment they should appeal to your sense of responsibility?" "You can be sure," answered Kesselring, "that in such a situation I would not hesitate to place everything I have and am at their

disposal." From Dollmann's perspective, they were already at the "critical moment," so Kesselring's answer could only be interpreted as an indication of support for Wolff's plan. Even then, the answer Dollmann sought had been obtained by a deliberate omission. Kesselring believed he had responded honorably and was being consistent with what he had previously told Wolff at Bad Nauheim.

Perhaps aroused by Dollmann's question, Kesselring arranged to meet with Vietinghoff the following day at Gauleiter Hofer's farmhouse near Innsbruck. Ambassador Rudolf Rahn and Hofer also attended, and Wolff would have gone too had he not been delayed by the close call with the partisans. His absence meant there would be no way for those gathered to know that hours earlier, with the lifting of the Operation Sunrise suspension by the Joint Chiefs of Staff, events had been set irrevocably in motion.

After listening to Vietinghoff's presentation of the military situation in Italy—it was grim—Kesselring reminded everyone of his duty. "As soldiers we [have] to obey orders. These [forbid] capitulation unless we [can] conscientiously say that there [is] no other way out." Kesselring believed that while an early surrender might save the lives of many in Italy, it would come at the expense of tens of thousands of German soldiers locked in battle on the Eastern and Western Fronts. While hope—no matter how slight—remained elsewhere, German forces in Italy had an obligation to continue fighting. For that reason, Kesselring would not support independent action or accept unconditional surrender as long as the Führer was alive.

Kesselring's words unnerved Vietinghoff. After departing Hofer's farmhouse, Vietinghoff and Rahn stopped in the town of Merano for a brief meeting to discuss this new problem with Röttiger and Dollmann. The two generals—Vietinghoff and Röttiger—began shouting at each other. Vietinghoff expressed his belief "that he would no longer be able to carry out the surrender." Weary of listening to Vietinghoff go on about a soldier's duty and loyalty to the Führer, Röttiger let fly, telling Vietinghoff that his words of "honor and loyalty and such talk

[are] not going to convince anybody when it [is] obvious that the cause of the trouble [is] a complete lack of personal courage." The two men had been allies in the surrender effort, but the stress of the surrender negotiations, at once treasonous and patriotic, had turned them against each other.

Wolff didn't reach Bolzano until midnight, April 27, optimistic that his surrender plan was finally on the verge of success. At 2 a.m. on April 28, he held a meeting in Hofer's office with Rahn, Röttiger, Dollmann, Vietinghoff, and the Gauleiter to update them on what had transpired in Switzerland with Dulles. He told the group that they had acted just in time: Schweinitz and Wenner were headed to Caserta. With any luck, the surrender document would be signed by the end of the following day, April 29. Their delay in not acting sooner, and further Allied advances on the battlefield, meant that negotiating terms beyond "unconditional surrender" had not been possible.

Hofer became irate. Still under the assumption that Wolff had presented Dulles with his list of conditions, and claiming this was the first time he had heard about an unconditional surrender, Hofer insisted that Ambassador Rahn immediately depart for Caserta to participate in the negotiations to reach "a constructive solution." Determined to maintain control of his province, Hofer then demanded that he be placed in control of the military forces in Alto Adige, another absurd suggestion. When those present rejected it out of hand, the Gauleiter stormed from the meeting.

The following day, Hofer spoke with General Röttiger by phone to once again voice his strongest disagreement with the concept of "unconditional surrender." Then he yelled, "People are going over my head! I won't have anything more to do with your plans. Why don't you fight instead of negotiating?" Hofer also managed to reach Kesselring to report select details of the 2 a.m. briefing by Wolff, in particular the Allies' refusal to negotiate. Hofer prodded Kesselring to act by informing him that within hours, perhaps, Wolff's plan would result in the "unconditional surrender" of all German forces in Italy. That afternoon,

Kesselring telephoned his former Chief of Staff, admonishing Röttiger: "Fight—don't think about negotiating."

Kesselring's near-exact repetition of Hofer's words confirmed for Röttiger that Gauleiter Hofer was the saboteur. Wolff had refused to believe it until Kesselring fired Vietinghoff and Röttiger. Vying to protect his territory and power, Hofer had played his cards well, perhaps well enough to sabotage the surrender. And why shouldn't he? Wolff's unconditional-surrender plan offered him nothing. Wolff also had another worry: Kesselring had reported his actions to the SS leaders in Berlin, which meant his adversary—and Hofer's ally—Ernst Kaltenbrunner, would be handling the case.

Vietinghoff obeyed Kesselring's orders and, as Wolff noted, "disappeared—his courage had given out completely." Röttiger stayed behind, hoping that he and Wolff could find a solution. In Bern, Dulles had written to Washington to report: "Kaltenbrunner is now attempting to save his skin by playing the Austrian card and wants to work out an Austrian capitulation, allegedly to prevent the establishment of [the Alpine Redoubt]." The seventy-two-hour window to notify German troops of the cease-fire had narrowed to forty-eight hours. It would take bold action to salvage the surrender while there was still time.

LATE IN THE afternoon of April 30, Dulles succeeded in obtaining consent from Swiss officials for Schweinitz and Wenner to resume their trip across the Austrian border and on to Bolzano. While the delay consumed precious hours, it had provided time for Wolff to send them an urgent message. Having just learned about Kesselring's dismissal of Vietinghoff and Röttiger, Wolff anticipated that the Gestapo, acting on orders from Kaltenbrunner, would arrest them when they passed through Innsbruck. Wolff instructed the men to bypass Innsbruck and cross into Italy over the Reschen Pass. This would add hours to their journey, but it was the only safe route.

Schweinitz and Wenner finally reached Wolff's headquarters in Bol-

zano around 12:30 a.m. on May 1. Half of the time allocated for implementation of the cease-fire had been consumed by their travels from Caserta; only thirty-six hours remained. Vietinghoff's and Röttiger's replacements—Generals Schulz and Wentzell—had arrived the previous day, sworn to take no action toward a cease-fire without direct orders from Kesselring. All paths of appeal through the German chain of command were closed.

Wolff and Röttiger decided to enact a desperate plan. Around 7 a.m. on May 1, Röttiger ordered a detachment of military police under control of Wolff's SS forces to block the entrance to German Army Headquarters, located in Bolzano on the edge of town, and arrest everyone inside, including Schulz and Wentzell. Röttiger then appointed himself commander of Army Group C (German forces in Italy) and, hoping to avoid some of the mistakes made by Stauffenberg and his fellow conspirators, immediately severed all communications with Germany. With Röttiger's action, German Army Headquarters in Bolzano became a world unto itself.

The ensuing events made sense only in the climate of exhaustion and extreme stress that attended these final hours. As the self-appointed commander of German forces in Italy, Röttiger called a meeting of the subordinate commanders to explain what he had done. But Röttiger's countrymen were unwilling to support actions they deemed illegal and treasonous. Distraught by his failure, and mindful of the consequences of his actions, Röttiger threatened to shoot himself. Hearing this news, Wolff rushed from his nearby headquarters to "prevent [Röttiger] from blowing out his brains." Wolff then proposed to Röttiger another course of action: why not attempt to persuade Kesselring's replacement generals—Schulz and Wentzell—to support the surrender? Cut off from Kesselring, under armed guard, and well aware the war was lost, surely they would see that surrender was in Germany's best interest.

Wolff the salesman went to work explaining to the replacement generals the background of what had happened and why, all the while pleading with them to support a surrender. After he managed to con-

vince them to reconsider their opposition, tempers began to cool. Röt-
tiger even apologized to the replacement generals for placing them
under arrest, which they accepted. He then restored communications
to the outside world and agreed to relinquish control of Army Group C
back to Schulz to enable him to order the cease-fire, if Schulz could be
convinced.

At 6 p.m., now just twenty hours from the deadline, Generals Wolff
and Röttiger, plus Schulz, Wentzell, and several subordinate command-
ers and staff officers, including Dollmann, gathered for another meeting.
A majority view quickly emerged. Further fighting was futile; prolong-
ing the fight would only lead to more German deaths. Schulz softened
his position and agreed to submit the matter, including the majority
opinion, to Kesselring for a final decision. Unfortunately, however, when
Schulz and Wolff tried to reach Kesselring, they were informed that he
was away from his headquarters.

At 9:30 p.m., Wolff received a secret telegram from Field Marshal
Harold Alexander seeking confirmation that the surrender agreement,
and the agreed-upon hour of cease-fire, would be honored. With Kes-
selring still unavailable, Wolff could only respond that an answer would
be forthcoming within an hour. Even that was a guess. After placing
another call to Kesselring's headquarters, the generals were told that the
Generalfeldmarschall was inspecting what remained of his troops; he
would not return before midnight.

During the intervening hours, everyone took a break to eat. With
the arrival of warm sausages and mustard, the barriers separating
those "for" the surrender and those "against" fell away. Camaraderie
reemerged and, with it, a breakthrough. One of the subordinate com-
manders previously opposed to the surrender yielded and instructed his
adjutant to notify troops of the cease-fire. In successive order, most of
the other generals—but not all—followed suit.

Relieved that the logjam had been broken and a consensus for sur-
render was building, Wolff sent a second message to Alexander around
11:15 p.m., informing him that the surrender was proceeding by way

of accord among individual unit commanders of Army Group C. The absence of Kesselring's overarching consent made this a messy solution, but the end result would be the same; at 2 p.m. the following day, May 2, the war in Italy would end.

Startling news arrived moments later. "It is reported from the Führer's headquarters that our Führer Adolf Hitler, fighting to the last breath against Bolshevism, fell for Germany this afternoon in his operational headquarters in the Reich Chancellery." The radio announcer for Reichssender Hamburg then introduced Hitler's successor, Grand-Admiral Karl Dönitz, who solemnly stated: "At the end of his struggle . . . stands his hero's death in the capital of the German Reich. . . . It is my first task to save Germany from destruction by the advancing Bolshevist enemy. For this aim alone the military struggle continues. As far and for so long as achievement of this aim is impeded by the British and the Americans, we shall be forced to carry on our defensive fight against them as well."

Those gathered in the German Army Headquarters in Bolzano "breathed a sigh of relief," Wolff later said. "There were tears in our eyes, because after all the difficulties we had been through and all the wrestling we had had to do with so many people, fate had been kind to us and . . . had removed the last obstacle." Wolff and the other generals had known the end was near, surrender or not. All that mattered now were the terms. Further delays would only undercut the Allies' motivation to negotiate a surrender. Ironically, Hitler's death had offered the group salvation. Kesselring, freed from his oath to the Führer, would certainly now endorse Wolff's plan.

They were wrong. "A message from Kesselring's headquarters: 'No, it's out of the question . . . the fight goes on.'" Schulz backed Kesselring, telling Wolff, "I'm still the Supreme Commander in this place. If you choose to go your own way, well and good; but then it's on your own responsibility; and for God's sake don't expect me to do the same." Suspecting that he and his fellow generals were once again at risk of being arrested, Wolff urged those still supporting surrender to leave Army

Group Headquarters and return to their own command posts, or wherever they felt safest. Wolff departed for SS headquarters in the Palazzo Reale, a few blocks away. Röttiger, "who had walked up in the rain without hat and coat, eventually arrived too, completely soaked." After days without sleep, the exhaustion of both men was temporarily soothed by a late-night snack and sparkling wine.

Sometime after midnight, new orders arrived, less than fourteen hours before the cease-fire deadline. General Max Pohl, Chief of the Luftwaffe in Italy, one of the earliest supporters of surrender, was to be arrested immediately. At 1:15 a.m., replacement General Schulz received additional arrest orders for Vietinghoff (a precaution in case it hadn't been done), Röttiger, Schweinitz, and others. Fifteen minutes later, "in view of the threatening danger," seven SS tanks and 250 troops from Wolff's special units established a protective perimeter within the SS compound.

At 2 a.m., "as all the excitement was mounting to a fever pitch and our emergency luggage was standing in the hall ready and packed for flight," Kesselring telephoned Wolff and unloaded his anger and frustration for proceeding with his plan, having known all along that the terms would be an unconditional surrender. Responding with his own reasons for consummating the surrender plan, Wolff pleaded with Kesselring to vest it with the authority of his position. The impassioned discussion, over a "frightfully bad connection" with "every single telephone exchange" in the SS headquarters building listening in, went back and forth for two hours.

"It is not only a military capitulation in order to avoid further destruction and shedding of blood," Wolff told Kesselring. "A cease-fire now will give the Anglo-Americans the possibility of stopping the advance of the Russians into the West, of countering the threat of the Tito forces to take Trieste, and of a Communist uprising which will seek to establish a Soviet republic in Northern Italy." Kesselring didn't disagree, but his immediate concern rested with the hundreds of thousands of German soldiers who would "feel themselves deserted and betrayed to their pitiless fate." Each hour that passed bought time for them to escape the

vengeance of Soviet Red Army soldiers by surrendering to British and American troops. Wolff pointed out that the Führer's death released Kesselring from his oath. "It is your duty to refuse to transfer this oath to any other person. No oath of personal loyalty is transferable anyway." But for Kesselring, it was no longer about an oath to the Führer; his concerns centered on his fellow soldiers, which demanded that they "fight it out to the bitter end."

At 4 a.m. Kesselring ended the call, telling Wolff he would consider the matter for half an hour and call back. True to his word, Kesselring called General Schultz, who then telephoned Wolff to inform him that Kesselring had agreed to endorse the surrender and honor the 2 p.m. cease-fire deadline, now a little more than nine hours away. All arrest orders had been withdrawn. At the urging of Ambassador Rahn, and over the objection and disgust of many of his fellow officers, Kesselring also reinstated Vietinghoff to maintain the integrity of the surrender process. In the ensuing hours, field radios crackled with instructions to German forces to lay down their arms; the war in Italy had come to an end.

26

THE RACE

On May 2, at the moment of the German surrender, the Allied armies in Italy extended from the Po Valley north to the Alps, and from the port cities of Genoa on the Ligurian Sea to Venice on the Adriatic. Communication problems prevented an even dissemination of the welcome news. Some U.S. Fifth Army troops learned of the cease-fire when German units approached forward lines under white flags to surrender. Others heard a BBC Radio broadcast from London, which reported that "joy was unconfined among front-line troops in Italy tonight as they celebrated the end of a long and bitter campaign." But the truth was far more muted. One infantry lieutenant said, "You feel sort of let down, as if the bottom had fallen out of everything."

Deane Keller heard the news that evening while driving back to Fifth Army AMG base camp in Modena, after an exhausting eleven days of inspections. Springtime may have come to Florence, but from his view, bundled up in a canvas-top jeep in northern Italy, winter had yet to take its leave. Since April 21, he and Charley Bernholz had driven through bitter cold, rain showers, and mud as thick as pudding to get from one northern city to another. They began in Verona, then went to Vicenza,

Mantua, Parma, Brescia, and Piacenza, with visits to numerous smaller towns along the way. An end to the fighting meant more inspections, more reports, and more time to think about when he would be reunited with his family.

While the myth of the vaunted Alpine Redoubt had been exposed, some Nazi leaders had still sought refuge in that area. Fifth Army troops raced northward to link up with U.S. Seventh Army troops pushing southward through Germany and Austria to seal the Brenner Pass. The front was so diffused that the army equipped airplanes with loudspeakers to broadcast news of the surrender and instruct German troops to turn themselves in at the nearest village. OSS and U.S. Army counterintelligence teams helped eliminate the last pockets of Nazi resistance. Others began hunting for those suspected of war crimes, including Himmler, Göring, and Kaltenbrunner.

On May 4, as Keller prepared to depart for Milan, he received a report from his counterpart in Eighth Army, Norman Newton, that the Florentine works of art could be found at Campo Tures and San Leonardo. The message contained agonizingly few details about the condition of the repositories. Keller immediately notified Lieutenant Colonel Ward-Perkins of the discovery and asked him to head north as soon as possible. With large territories newly liberated, and hundreds of works of art waiting to be removed from the repositories, he would need help. Keller also sent a message to Fred Hartt, instructing him to depart Florence with all haste. Despite their differences, Keller knew that no other Monuments officer possessed more knowledge about the Florentine works.

Much as Keller wanted to drive straight to the repositories, he and Charley had to spend a few days in Milan assisting the newly assigned Regional Monuments Officer for Lombardy, Lieutenant Perry Cott. With any luck, he could finish in Milan and still reach the repositories to greet Ward-Perkins and Hartt. But upon arriving in Milan, Keller was shocked to learn that Cott wasn't there and wouldn't be arriving anytime soon. Due to an army snafu, his orders had not been cut. It would take at least three or four days for Cott to get to Milan and begin work. Keller would have to cover for him.

Milan and its rich culture, too often overshadowed by the sunnier, more visited cities to the south, had been punished by Allied firebombing during 1943, before the Allies made protecting cultural treasures a priority. The April 15, 1944, bomb damage assessment report prepared by Hartt had provided a detailed analysis of the impact on the city's prominent monuments and churches, citing, in particular, the scene of destruction adjacent to Leonardo da Vinci's masterpiece, *The Last Supper*. But his perspective had been limited to aerial photographs; Keller would now have a chance to see the destruction at ground level.

Keller began his work in Milan as he always did, by meeting with local officials. He then started moving about the city to assess damage. His initial report contained three pages of heartbreaking details about the loss of magnificent churches, museums, and other historic structures, mostly due to fires caused by incendiaries. Sant'Ambrogio, one of Milan's ancient sanctuaries, dating to 387 AD, had suffered direct bomb hits. Ceiling frescoes by Giovanni Battista Tiepolo, one of the last great Old Master painters, were destroyed; Bramante's Early Renaissance cloister was "about gone." Keller's casualty list included most of the city's landmarks, including the Castello Sforzesco, the Brera and Ambrosiana Picture Galleries, and La Scala. But the scene of devastation to the Church of Santa Maria delle Grazie, and the miracle that had occurred there, took his breath away.

"Bomb hit of August 1943 in the cloister destroyed the right [east] wall of the refectory facing Leonardo's *Last Supper*," Keller noted in his report of that first visit. "The roof was hit and collapsed when the wall fell. The painting had been sandbagged for protection, plus wood planks and iron scaffolding. . . . The roof is nearing completion and the [east] wall has been reconstructed. Until there is no danger from the elements, or danger from what is left of the vaults, which is little, the painting will not be uncovered. . . . Its fate is not known." It was still on his mind when he wrote Kathy on May 11, telling her, "Leonardo's *Last Supper* is in peril and we won't know for some time what it looks like." In another letter the next day, he added, "Leonardo's *Last Supper* may be in ruins."

After the 1943 raids, the Milanese had made an admirable effort

to clean up their city and begin the rebuilding process. But scarcity of funds, lack of materials, and precarious transportation had impaired local officials from doing much more than making the most urgent repairs. Mussolini's government had proven quicker to hinder than to help. As the Milan Superintendent said, "Some authorities even returned our letters requesting their support. Nevertheless, we did not lose our sense of responsibility, both in the defense of damaged monuments and in the wider spectrum of the historical heritage of our city."

Keller believed that if Leonardo's *Last Supper* did emerge intact from behind the scaffolding, its survival would be a miraculous event. By any measure, the high-explosive detonation that destroyed the east wall and roof of the Refectory could easily have taken the north wall—and the creator's work—with it. The protective bracing installed by local officials had provided additional structural support for the north wall. Without that, Leonardo's masterpiece certainly would have been reduced to fragments of plaster and paint. But another miracle of sorts occurred during the early hours of August 16, 1943. Had incendiaries also landed in the courtyard, the wooden scaffolding and the bags of sand behind it might well have ignited. Leonardo da Vinci's mural would have been baked off the wall—just as occurred with the frescoes at the Camposanto in Pisa.

The night of the bombing in August 1943, Padre Acerbi and his fellow Dominican brothers had emerged from their underground shelter and taken urgent action to safeguard the north wall and Leonardo's painting. Battling panic and confusion, Acerbi sent word of the damage to local art officials. He then borrowed a car and drove 360 miles in one day, gathering young, able-bodied Dominican friars in other towns who volunteered to help with the cleanup and protective work. By the following day, a number of men had discarded their habits for overalls.

The future of *The Last Supper* depended on the stability of the north wall. After removing the debris, Acerbi realized there was another threat: rain. Within days, he obtained a waterproof tarp from civil engineers in Piacenza. By September 8, Acerbi watched as workers completed construction of a temporary roof similar to the one Keller later assembled

to protect the Camposanto. Acerbi's quick thinking, and the action of his fellow Dominicans and a team of military engineers (*Pontieri del Genio*), had protected the masterpiece from immediate danger. Until the east wall of the refectory could be rebuilt, a new roof installed, and the north side of the painted wall stabilized, removing the scaffolding and the sandbags to conduct a thorough inspection of the painting would create unknown risks.

On May 8, Keller halted his inspections in Milan long enough to write Kathy about the biggest news yet: "Dearest: It seems the war in Europe is definitely over." The previous day, Eisenhower had informed the Combined Chiefs of Staff of the German surrender, succinctly and with little fanfare: "The mission of this Allied Force was fulfilled at 0241, local time, May 7th, 1945." In New York City, some two million people filled Times Square to celebrate the news, but Keller told Kathy, "There was no celebration here. Even among the soldiers there was little show of emotion."

PIETRO FERRARO, Alessandro Cagiati's OSS operative, had played a significant role in sparing the fragile city of Venice from last-minute destruction by the German garrison. Ferraro, whose mission code name was "Margot," now scrambled to find a way to get to the Alto Adige region.

Days earlier, working out of a room at the famed Hotel Danieli, Ferraro had manned a telephone switchboard that enabled communication between partisan leaders in most of Italy's northeastern cities, and coordination of their activities with advancing Allied troops. On April 27, the German garrison in Venice had threatened to destroy the city's harbors, utilities, and shipping unless they were allowed safe passage to withdraw. Ferraro, the designated go-between, responded by promising the German commander that forty-five hundred partisans, whom he and the OSS had equipped through twenty-three parachute drops of weapons and supplies, would annihilate the forty-one hundred German

and Fascist troops if they dared act on such a threat. After short consideration, the German garrison surrendered; Venice survived with nary a scratch. Ferraro not only succeeded in staring down the commander of the German garrison, he also obtained their maps, designating the positions of mines placed in the harbors and canals, thus sparing the city unimaginable destruction.

Following Venice's liberation in the closing days of April, Ferraro shifted his attention to the art repositories at Campo Tures and San Leonardo. Long on information but short on transportation, Ferraro sought the help of another OSS officer, Lieutenant Richard Kelly, chief of the agency's Maritime Detachment. Kelly arranged for travel permits to the Alto Adige area for the Venetian Superintendent, Ferdinando Forlati, and his team of art experts, along with a vehicle, a driver, and armed guards. Ferraro then requested Cagiati to coordinate the suspension of aerial activity near the repositories, arrange on-site protection, and do everything possible to send advance units that might be able to get there sooner than Forlati's team. Ferraro's telegram concluded with the sentiments of all: "The whole world of art and culture will be grateful for your efforts."*

Ferraro also sent Cagiati an important tip, which he had gleaned from conversations with the sympathetic members of the Kunstschutz stationed in Venice: the contents of the famous Hertziana Library, the Kunsthistorisches Institut, and other archives could be found in an underground salt mine in Kochendorf, near Heilbronn, Germany.

On Thursday afternoon, May 3, the Forlati team departed Venice for the repository at San Leonardo. They entered the city of Trento alongside Fifth Army troops at the moment of its liberation, but it was too

*It remains unclear whether this telegram, also reported by telephone to Allied troops operating in North Verona, led to the Allies locating the repositories. Another possibility could be the priest in Bolzano enlisted by Don Anelli, who may have relayed information to American soldiers passing through the area. A third possibility is a memorandum, dated May 2 and sent by Wolff through General Lemnitzer to General Mark Clark's headquarters, that contained information on the repositories.

late and too dark to proceed farther. The following day, they drove to San Leonardo. According to Forlati, the Kunstschutz representatives—Professors Leopold Reidemeister and Leo Bruhns—were on-site and "mistook us for American reconnaissance . . . the few Italians living there greeted us with celebration." Relieved that the contents at San Leonardo appeared undisturbed, they proceeded to Campo Tures, arriving on Sunday afternoon, May 6. Captain Michael Mohr and his troops of the 3rd Battalion, 339th Infantry, 85th Division (the "Custer" division), had already secured the Castle Neumelans and its adjacent carriage house at 9 a.m. that morning.* Those contents also appeared intact. With both repositories safe, Forlati and the others returned to Venice, their mission complete. Everyone now awaited the arrival of the Monuments officers and the all-important inventory lists.

ON MAY 9, Gero von Gaevernitz, Allen Dulles's right-hand man, and Ted Ryan, another of Dulles's senior OSS officers, accepted Wolff's invitation and arrived in Bolzano to meet with Wolff at his headquarters. Wolff took the opportunity to honor one of his promises to Dulles by formally transferring control of the Florentine treasures to representatives of the Western Allies, not the Italians to whom they belonged. Gaevernitz and Ryan only had time to visit one of the repositories, so Wolff arranged for his car and driver to take them to San Leonardo.

But Gaevernitz's trip to meet with the SS general was not a social call. As he noted six days later, "Many hours were spent in private conversations." His extensive debriefing of both Wolff and Vietinghoff resulted

*On May 4, troops of the 3rd Battalion also discovered a German prisoner-of-war camp that housed 56 Americans and 350 Allied soldiers, "many of them ill." These were, in all likelihood, the prisoners Wolff promised Dulles he would be responsible for protecting. Another task force of the 339th Infantry found a hostage camp containing prominent political prisoners being held by the SS, including a number of the participants in the failed July 20, 1944, assassination attempt against Hitler. The wife and children of Colonel Stauffenberg, the man who planted the bomb and was later executed, were among them.

in a fifty-six-page report, "The First German Surrender," which Dulles and Gaevernitz finished within two weeks. Gaevernitz had one other urgent piece of business: to personally inform Wolff that he would soon be arrested. Allowing a senior Nazi official of Wolff's stature to remain free was untenable for the Allies. For his part, Wolff understood that this was all part of the arrangement he had reached with Dulles through Max Husmann and Max Waibel. On May 12, having no desire to witness the arrest of a man who had, as promised, handed them "Italy on a silver platter," Gaevernitz and Ryan departed.

WITH ORDERS IN hand, a very excited Fred Hartt, accompanied by his driver, Franco Ruggenini, and Professor Filippo Rossi, Director of the Galleries of Florence, departed Tuscany on May 10 for the drive to Campo Tures and San Leonardo. Hartt still had no idea whether his message to Cagiati months earlier had set in motion a chain of events that led to the discovery of the missing works. The passengers in *Lucky 13* headed north, through territory defaced by the war. "Hundreds of square miles of country pitted everywhere by shell holes, and mountainsides showing more shell holes than grass," Hartt noted. "The trees were shaved into spikes by the passing shells, the farmhouses reduced to sand heaps, the roads torn by artillery and mines, the villages smashed and tottering, reeking sharply of death in the warm air of a spring morning."

On the morning of May 12, the three men reached the mountain hamlet of San Leonardo, "in a flurry of dust amid honking geese and screaming children," and parked *Lucky 13* in front of the old jail. Only the iron bars on the ground-floor windows hinted at its previous use. After identifying themselves to the security detachment from the 349th Infantry, 88th Division (the "Blue Devils"), they waited while "the GI on guard fumbled long with the keys before he was able to let us into the dark hallway of the ground floor. . . . Here, piled against each other in damp and narrow cells, were the pictures from [Villa Bossi-Pucci in] Montagnana."

The first cell alone left Hartt breathless. He immediately recognized Caravaggio's painting of *Bacchus,* and then other paintings by Rubens, Titian, and Dosso Dossi leaning against the wall like prisoners from the pages of his art history books. Moments later, Rossi startled Hartt with a "cry of glee." There before them were the two paintings by Cranach—*Eve* standing in front of *Adam*—that Colonel Langsdorff had stashed in his room at the Hotel Excelsior nine months earlier. The next cell housed Botticelli's *Minerva and the Centaur,* Signorelli's *Crucifixion,* Lorenzo Monaco's *Adoration of the Magi,* and several other masterpieces. Museums often allocated an entire wall for paintings of such seminal importance, but in San Leonardo they were jammed together so tightly that Hartt and Rossi had an impossible time moving one painting to see what others might be behind it.

Cell after cell, floor upon floor, three hundred paintings—some among the world's most important—had survived being transported hundreds of miles over bombed-out roads, stacked side by side on open trucks, many with no more protection than a few blankets and strands of straw. In fact, it had been raining the day the paintings arrived. Miraculously, aside from Frans Floris's painting of *Adam and Eve,* which suffered a split down the entire length of the panel, most of the damage consisted of scratches from handling and transportation. They all marveled at the paintings' good fortune.

The lateness of the day kept them from beginning an inventory, so Hartt and Rossi drove to Bolzano for the evening to meet with Ward-Perkins, who had just arrived. On Sunday morning, May 13, Ward-Perkins departed for San Leonardo to see firsthand what Hartt couldn't stop discussing the previous night. He also intended to interrogate the Kunstschutz officials. *Lucky 13* carried Hartt and Rossi to Campo Tures. Hartt described the Castle Neumelans as a "fantastic situation; the typical Tyrolean sixteenth century, four-turret manor house, shadowed by enormous Alpine peaks, was guarded at the same time by Germans, partisans, and GI's from the 85th Division." Even more surprising was the man sent to greet him: SS Colonel Langsdorff, who had been ordered to report there by Wolff on April 30.

"The executor of the greatest single art-looting operation in recorded history received us with a certain amount of petulance," Hartt later noted, "as if we had not really been fulfilling our duty to Art by arriving so late. He had been expecting us for days, anxious to turn over to us his responsibilities." In contrast to the damp jail cells at San Leonardo, Castle Neumelans had proven to be an ideal storage facility, with dry, airy, high-ceilinged salons. Its rooms contained more of the missing museum paintings in addition to the private collections of Contini Bonacossi, Landau-Finaly, and Acton. Nearby rooms housed small bronzes, ceramics, and tapestries.

But the paintings inside Castle Neumelans paled in comparison with what Hartt and Rossi found in the adjacent carriage house. "When the garage doors were unlocked, we looked into the dark interior piled to the ceiling with the stout, Florentine boxes, knowing that within them were the *St. George* of Donatello, the *Bacchus* of Michelangelo, the *Donna Velata* of Raphael"—one of the two paintings Dr. Ringler had witnessed being photographed in the snow two months earlier. The masterpieces that defined Florence were safe.

THE CEASE-FIRE HAD hardly changed Bolzano; even nine days later, the vanquished appeared to be the victors. German soldiers behaved as though they were in charge, leaving Keller and other Allied soldiers wondering who won the war. Days earlier, Hartt had observed "the colossal arrogance of the still-armed Germans, who outnumbered us on the streets of the city ten to one . . . the AMG provincial commissioner had to plod about the town on foot, hot, red-faced and dusty, while haughty and glittering SS generals sped past in motor cars loaded with blondes. . . ." Other German troops could be seen parading through the streets singing in unison, "Hitler Is My Führer."

On this point Keller agreed with Hartt. It was one thing to eat dinner at a crowded restaurant alongside two German captains, but when one of them—a man who a few weeks earlier was trying to kill you—

After the cessation of hostilities, Keller's duties included
interrogating German Kunstschutz officials and
officers. Many Allied soldiers referred to the Germans
as "Krauts." [Deane Keller Papers, Manuscripts &
Archives, Yale University]

extended his hand across the table in a gesture of friendship, well, that
was an offense greater than Keller knew how to describe. The great-
est shock came when Keller heard that German paratroopers of the 1st
Division wanted to enlist in the United States Army to fight the Japanese.

The swiftness of the German surrender outpaced the speed of the
Allied advance. Fifth Army commanders reluctantly accepted the fact
that an interim period of chaos would have to be tolerated before a hold-
ing force could arrive. Germans still greatly outnumbered U.S. troops
in the northern Italian cities. According to Keller's sources, "there were
250,000 fully armed crack German troops in the area, as well as the head-
quarters of General Wolff [and] General von Vietinghoff. . . . Orders had
been given from Allied Forces Headquarters that . . . German units were
to remain intact where they were at time of surrender. These orders

were interpreted to mean that they should remain in their billets which included all of the hotels, barracks, and suitable places in the city."

May 13 marked General Wolff's forty-fifth birthday. Side by side with his second wife and children, he hosted an elaborate celebration in which some two thousand people gathered in the beautiful park setting of his Bolzano headquarters at the Palazzo Reale. Inside were "hundreds of bags of the finest flour and rice, case after case of the rarest champagnes and liqueurs, sides of beef, bolts of silk and linen, typewriters by the dozen, the best of cameras, shoes, and clothing and blankets in enormous quantities. There were also books, prints, etchings and paintings, together with twenty-two boxes of wood bound with steel straps, and sealed with lead, containing [King Vittorio Emanuele III's] coin collection."

U.S. Colonel James C. Fry, recently appointed town commander, was appalled at the spectacle and ordered a column of troops and vehicles to make certain that Wolff and his SS forces understood that, literally, the party was over. The MPs, armed with machine guns, sprinted across the manicured lawn. Fry's troops rounded up and then arrested Wolff and Vietinghoff, Frau Wolff, Dollmann, and most of the people at Wolff's headquarters and the adjacent SS barracks. A later report of the 88th Division stated: "Frau Wolff was indignant at what she called high-handed procedure and threatened Colonel Fry with disciplinary action over what she called 'the breaking of an agreement with Army higher-ups.'" The Blue Devil troops then packed up part of "the birthday feast, including fresh squab and champagne," and delivered it to the headquarters of their commander, with compliments. Dollmann later claimed that American soldiers had shot Wolff's German shepherd as they departed.

Keller finally connected with Hartt, Rossi, and Ward-Perkins for his first visit to the repositories on May 14. His one-to-two-day stay in Milan had turned into a week; he and Charley had arrived in Bolzano only the night before. They inspected Campo Tures first, then drove to San Leonardo the following day. The exuberance Hartt had experienced two

days earlier turned out to be anticlimactic for Keller. After a month on the road conducting inspections and interrogating German officials, Keller was "impatient and irritable."

The reactions of the two men highlighted major differences in their respective approaches to the job. Hartt saw his military service as a quest to save Italy's works of art, churches, and historic structures that he had dedicated his life to studying. Finding the Tuscan treasures, intact and largely undamaged, was his triumphant moment. Keller found more satisfaction in helping people. Saving a revered monument, like the Camposanto, was part of his job. Getting a university operational was his joy.

The responsibility of returning the works to Florence belonged to Fifth Army, which meant it belonged to Keller. Others could rejoice about finding the masterpieces, but he was already focused on logistics: hundreds of paintings lying about uncrated, persistent shortages of packing materials, roads to Florence that were beaten to hell, and a railway system that didn't function because Allied aircraft had destroyed it. On May 18, Keller composed a letter home using stationery taken from the desk of General Wolff just days after his arrest. "The war is not over for me," he wrote to Kathy. "Yes—the shells and bombs are over, but the work goes on and on. When we have all the stuff they have stolen and transported around the country safe back where it belongs, then I'll be through. I hope."

27

THE BIG MOVE

The defeat of Nazi and Fascist forces opened up vast new areas with damaged cultural sites needing inspection. In the closing weeks of the war, Monuments officers inspected hundreds of newly discovered repositories in German and Austrian salt mines, caves, and castles containing hundreds of thousands of paintings, drawings, library books, and sculpture, along with gold bullion and paper currency. More would be found throughout the summer and fall. The expertise of the Monuments Men was in high demand, but their number remained few.

During his trip to Naples in late March, Keller learned that the U.S. Army planned to transfer the existing Italy-based Monuments officers to Austria to meet this increasing need. Hartt had already received orders to report there, but the discoveries at Campo Tures and San Leonardo provided a temporary reprieve. Lieutenant Colonel Ward-Perkins, who had been in uniform for six years, decided it was time to return to civilian life. He would depart at the end of the summer to take up a teaching position at the British School at Rome. This put even greater pressure on the remaining team to complete inspections and compile reports before

their transfer. Few wanted to leave. They had worked in Italy for almost two years; most wanted to stay and finish the job.

Perry Cott finally received travel orders and arrived in Milan on May 10, five days later than expected. He had worked closely with Rome's museum officials the previous summer while stationed in the capital. Drawing from the extraordinary—albeit temporary—collection of art stored at the Vatican, Cott organized a string of wildly successful exhibitions, allowing soldiers to see world-renowned masterpieces. They had endured the ugliness of war; it seemed fitting to provide them a chance to enjoy the objects of beauty their sacrifices helped preserve.

Unlike Rome, however, where the amount of damage was limited, Milan had been extensively bombed at the hands of the Allies. German troops had occupied the city for twenty months. Now everyone—from city officials to owners of villas, museum directors, and priests—wanted his attention. What Cott wanted was more help.

On his first day in Milan, Cott met with Fernanda Wittgens, who had just been reinstated at Milan's Brera Picture Gallery after nearly a year in jail for her anti-Fascist activities and assistance to Jews. Wittgens asked Cott to arrange transportation to enable her mentor, Professor Ettore Modigliani, director of the Brera and a highly respected cultural figure, to return to the city. Approving the transportation turned out to be a very smart decision, as both Wittgens and Modigliani provided valuable assistance in the months that followed.*

Cott timed his initial visit to the Refectory to coincide with the removal of the protective sandbags from *The Last Supper*. By May 15, construction of the new east wall and Refectory roof was all but complete. The structural integrity of the north wall appeared uncompromised, despite the blasts; the scaffolding and steel braces had worked as planned. Until the sandbags were removed, however, experts could not

*Modigliani's Jewish heritage and refusal to join the Fascist Party forced him to hide in the Italian countryside during the war to avoid being sent to a concentration camp. "After 11 years of political and racial confinement, in the winter of 1946 Ettore Modigliani again held the charge of Superintendent and Director of the Brera Pinacoteca."

examine the condition of the painted surface. Work proceeded slowly as laborers carefully removed each bag. Ten more days would pass before Mario Bezzola, a noted restoration expert, gained limited access to the wall to observe, "generally satisfying results. . . . Only in the area of James the Major's tunic, which was always the sickest area of the whole famous painting, a very thin layer of plaster has lifted, with subsequent crumbling of the matter beneath. . . . It is necessary, and rather urgent, to intervene locally to reattach the areas that risk flaking off. Clearly, the whole plaster underneath has in itself disintegrating elements which don't seem easy to eliminate."

Those in the Milan Superintendent's office weren't the only people eager to see *The Last Supper*. News that workers were removing the sandbags attracted large groups of soldiers hoping to catch a glimpse of Leonardo's mural. Cott valued such interest on the part of the troops, especially after his experience curating the temporary art exhibits for soldiers in Rome. Now, however, at this anxious moment, their visits interfered with the restoration effort. On May 26, he reluctantly posted a notice prohibiting access to all military personnel.

On June 10, with *The Last Supper* liberated of its sandbags, restoration experts including Modigliani, commenced a second, more thorough inspection. Milan's Superintendent of Galleries had a favorable assessment:

> *The static conditions of the wall and of the plaster were not subject to any damage; during the explosions of August 1943, some chalk marks appeared on the few, minor cracks, that were surely caused by the air movement from the ground vibration caused by the explosion. . . . Small and partial detachments of paint concern restored spots or old touch-ups. . . . It is urgent to fix the color where it is lifted [from the surface], even if limited to very few spots and very small fragments.*

The Superintendent also observed a "light veil expanding on the entire painting surface," attributable to the bonding of dust with the

dampness of a wall that had had no ventilation for almost two years. Compared to all the things that could have happened to *The Last Supper*, inspectors deemed this a minor problem. It would require an "expert cleaning operation," but in the opinion of all but one of the specialists, it was "not outstandingly urgent," best done after the "dry and warm air of the summer months" could "desiccate"—dry out—the wall.

Five days later, Hartt and Rossi arrived in Milan, a detour on their return to Florence from the Alto Adige repositories, ostensibly for a short visit with Cott. In truth, Hartt wanted to see *The Last Supper*. The following day, Cott proudly notified Ernest DeWald that "the Refectory of S. Maria delle Grazie is now open to the public. A descriptive label in English has been printed by this Division and posted in the Refectory." Much work remained, but Leonardo's masterpiece had survived the war.

IN PREPARING TO transport the art back to Florence, Keller wrote to General Hume's Executive Officer: "This is the biggest undertaking of all in the campaign with the possible exception of the Army's interest in the protection of the frescoes at the Camposanto in Pisa. It is impossible to estimate the importance of the arrival under Allied Military protection of these things in Florence." Keller then ticked off a list of items he would need to complete the mission: packing materials, workmen skilled in such packing, and trucks—a lot of them, perhaps as many as fifty-two, with drivers, fuel, water, and other supplies sufficient for the three-hundred-mile drive. The army wanted to avoid the negative publicity of some incident during the returns, so Keller also budgeted for additional security personnel and their needs. It would be a big operation.

Keller needed a written agreement with Giovanni Poggi, or some other high-ranking official, stating that the Italians not only approved of his plan for the return of their precious objects but also agreed to waive claims against Fifth Army for any accidents that might occur along the way. He also recommended that the arrival be marked with some sort of

ceremony that would allow the Florentines to bear witness to the return of their art. Keller then ended the letter with a quip to underscore his point: "Remember how crowded Piazza della Signoria was when they put up Michelangelo's *David*? You don't, and neither do I, but that's the idea."

By mid-June, with planning complete pending final word on the availability of trucks, Keller and Bernholz made a several-day visit to Florence, their first trip outside the Alto Adige area in more than a month. As fortune would have it, their arrival coincided with the removal of the brick tomb covering Michelangelo's *David* and his adjacent works, the *Slaves*. "The bright spot yesterday was seeing Michelangelo's *David* at length divested of its air raid protection," he wrote Kathy. "It was dusty and dirty, but it was a great thrill."

The familiarity of being back on the road, and then in a city, with all its amenities, was an elixir for Keller's weariness. The time spent with Charley also buoyed his spirits. Charley's lightheartedness had, on many occasions, saved the more serious Keller from despair. "We get along fine and share all things together," he told Kathy. "When I get whiskey, once a month, I give him half, and when he has beer or anything else, he gives me half or all I want. We are not like Capt. and soldier, but like companions." Keller added, "Those that like the army, like Charley, say, 'Free food, free clothes, a bunk, free education, all the gas you want to ride around, your social life taken care of for you, free medical attention. My only worry will come when I am discharged and I'll be out of a job.' Charley is an optimist and really likes this life."

Keller and Charley returned to the Alto Adige several days later to discover that Keller's primary plan—in truth, the only plan—for getting the treasures back to Florence had been thwarted. There would be no fifty trucks, no three-day journey, and no reception in Florence. With some frustration, he wrote DeWald: "Redeployment and winning the Japanese war have a priority over us. I have stated the case a dozen times to all concerned. Poggi knows that trucks are probably out and is not too happy. Hartt is very unhappy." In truth, the war in Japan was only

partly to blame. The army had a duty to feed the starving populations of Milan, Turin, and other northern cities. The fifty trucks Keller needed had been put to a more urgent use.

The alternative to trucks—transit by rail—had already been considered and rejected as infeasible. Between Allied attacks and German demolitions during their retreat, most of the bridges, including the one spanning the mighty Po River, had been damaged or destroyed. Completion of the replacement bridge across the Po was not expected before early to mid-July, so Keller modified his plan and set July 16 as the commencement date for the return operation. The delay burdened everyone involved, as he told DeWald: "This wait has been worrying and uncomfortable to me. . . . Poor Tuscany kid; he must have a constant GI condition waiting on 'his' pics from the north." But Keller and the "Tuscany kid"—Fred Hartt—did on occasion find humor in the day-to-day frustrations of army life. Keller missed a phone call from Hartt because he was "in the toilet for two minutes. So the fate of nations is decided."

By July 16, men working at Hartt and Rossi's direction had constructed 109 crates at San Leonardo and forty-six crates at Campo Tures. All paintings and sculpture had been inventoried, noting any damage from rain and previous handling. The inventory at San Leonardo revealed that ten paintings from the Florentine deposit at Montagnana were unaccounted for, including masterpieces by Bronzino, Lorenzo di Credi, and Jan van Huysum, and a small pair of panel paintings by Antonio del Pollaiuolo. Someone, almost certainly German soldiers, had stolen them during the loading process at Montagnana or en route to San Leonardo.

Keller supervised the loadings at Campo Tures, which proved the more complicated of the two evacuations. Lifting the heavy sculpture required a special truck-mounted winch. Those objects were then taken by truck to the nearby train station at Brunico. Hartt handled the loadings at San Leonardo. After accompanying the first truckload down the mountain road to the station at Merano, Hartt said he felt "not only an unspeakable personal satisfaction but a deep pride in the Allied cause when I realized how sharply this journey contrasted with the manner in which the pictures had come up the same road."

Emptying both repositories and getting their contents to the train stations at Merano and Brunico took two full days. By July 19, everything was in place to begin the final journey back to Florence. The shipment comprised thirteen fully packed freight cars. Six additional cars carried the security detachment of sixty military police and five officers. Rounding out the convoy were a kitchen car, a passenger and office car, and a flat car to carry Keller's jeep and that of Lieutenant Colonel Holmgreen, who agreed to accompany the shipment as the senior officer and train commander. Keller even had the presence of mind to include fifty fire extinguishers, not easy items to find. Located in Livorno, they had been flown to the site in the private plane of Fifth Army Commander Lieutenant General Lucian Truscott, who had taken a personal interest in seeing the treasures returned to Florence.

The big move would begin the following morning, after the cars from each repository were connected in Bolzano. Hartt and his new driver, Florentine Alessandro Olschki, would depart for Florence to finalize details on the receiving end. They also needed to confirm that the return ceremony arrangements were in place. Keller would accompany the artwork on the train. He had shared with Kathy his anxiety about the shipment but also the pride he felt for the men who had worked so diligently on the preparations, the average soldiers "who do not know a Tiepolo from a croquet mallet." "Things are rolling and I'll hope in a week to write you that the Florentine Art is all back in Florence safe. . . . It's a good omen to start on 16 July, for the most important choice I ever made took place happily on that day." July 16 was Keller's seventh wedding anniversary. Once again he had remembered to send flowers, including a yellow one, accompanied by a note "for my wife, who has born[e] herself like a good soldier through these trying times."

IN MID-MAY 1945, unofficial news stories began circulating that the missing Monte Cassino treasures had been found among the thousands of works of art stashed in the salt mine at Altaussee. Monuments Men Teddy Croft-Murray and Humphrey Brooke arrived at the mine on June

23 to find Monuments officer Lieutenant George Stout, the man who had first conceived of a Monuments and Fine Arts operation, presiding over an extraordinary packing and shipping project. Stout confirmed for them that at least some of the Naples treasures were present, but he hadn't yet had time to conduct an inventory. Stout had orders to empty the mine of its contents and transport them to the Allied Central Collecting Point in Munich as quickly as possible.

In the weeks that followed, a special detachment of the OSS, known as the Art Looting Investigation Unit—made up of art scholars hoping to become Monuments officers when the war ended— began months of interrogations of Nazis and other key figures. In the course of their investigations, they pieced together the odyssey of the Naples treasures: their seventeen-month-long, sixteen-hundred-mile journey that began in Monte Cassino and ended at Altaussee. The most frightening revelation was the discovery of the bombs that Gauleiter Eigruber had placed in the mine. Only quick and heroic action by several mining officials and workers had thwarted Eigruber's plan.

ON FRIDAY MORNING, July 20, an electric engine pulling twenty-two packed railcars departed Bolzano for Florence. Director of Galleries Filippo Rossi estimated the value of the Florentine art treasures found in Campo Tures and San Leonardo at $500,000,000. That figure got everyone's attention, especially that of the man responsible for getting them home. A few days earlier, Keller had filled out a freight waybill for car number 346544, containing "art treasures." Under "Remarks," he wrote, simply, "extreme care necessary."

An unexpected bureaucratic delay in Trento tested everyone's nerves. After taking the Italian train inspector aside, Keller warned him, "If there was going to be palaver at every step we would put an MP with drawn automatic at the back of the engineer and treat him in the true SS manner." The threat worked, as Keller later noted: "There were no more stops of any length for awhile." The train then crossed the Po

River over the newly constructed bridge that replaced the one destroyed by retreating German forces. Ironically, the lumber used to build the new bridge had come from trees felled in the Camaldoli Forest, another of the national treasures that Fred Hartt had tried to preserve.

At 4 p.m. on a scalding Saturday afternoon, some twenty-two hours after departure, the most valuable art cargo ever to be loaded aboard a single train pulled into Campo di Marte, the same station that had weathered the initial assault on Florence by Allied pilots in September 1943. Giovanni Poggi, wearing a white panama hat, and other museum officials looked on with great excitement while Hartt directed the first twelve trucks to back up to the tracks to begin loading their cargo for the short drive to the Pitti Palace.

Late the following morning, a small convoy of military vehicles assembled at the station to complete the journey. A jeep loaded with military police headed the column; Hartt, Poggi, and Rossi followed in *Lucky 13*, driven by Olschki. Bernholz drove the third jeep, carrying Keller and Lieutenant Colonel Holmgreen. Directly behind them were six trucks loaded with crates of art. Florentines cheered as the convoy wound through the center of town, retracing a portion of the flag-lined parade route two dictators had traveled seven years earlier.

The column of vehicles arrived at the Piazza della Signoria unadorned but for two flags—one American and one Italian—fixed on the hood of the first truck. A banner attached to its side bore the Fifth Army insignia and an inscription in Italian: "The Florentine works of art return from the Alto Adige to their home." The city's bridges no longer crossed the Arno. Many of its ancient towers existed only in the drawings of street vendors. But the riches of the Uffizi, the Palatine Gallery of the Pitti Palace, and the Bargello Museum had been returned. Keller wrote Kathy that night to describe the experience:

> [driving] through streets, people clapping and weeping! Bells of Orsanmichele ringing, Florentine trumpeters, a dais with 2 Generals on it, several thousand people in the [Piazza della] Signoria square. Gen. Hume made

a nice speech in Italian. The Mayor replied. That's all, then a banquet at noon. I had three martinis. Good! Hot as blazes. The Gen. took me aside and said: 'I have you in for the Legion of Merit Medal and will write to the top American General on your promotion.' . . . At 8:00 tonight the last piece of sculpture was swung into the Bargello by a U.S. Army 12 ton wrecker crane. The stuff is all in Uffizi, Pitti and Bargello now and the mission is accomplished. ALL DONE after 2 months of slaving by Charley and me.

Two nights later, Keller attended what he thought was a dinner in honor of a British officer preparing to depart service and head home. After having drinks at the bar with several friends, his small group walked into the dining room at the appointed moment to a sudden burst of applause from the twenty officers in attendance. Keller assumed the

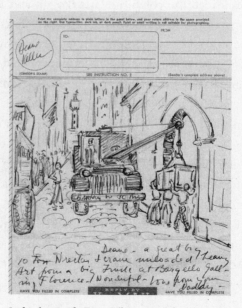

In this drawing for Dino, Keller captured the moment his team unloaded crates containing sculpture by Michelangelo and Donatello into Florence's Bargello Museum in July 1945. [Deane Keller Papers, Manuscripts & Archives, Yale University]

clapping was for the British officer until Fred Hartt leaned over to him and said, "That's for you, Deane." The surprise dinner was as much a celebration of Keller as it was of the successful return of the Florentine artwork. Even General Hume and Lieutenant Colonel Holmgreen showed their respect by attending.

Filled with joy and excitement about what had taken place, Keller shared a few details with Kathy:

> *Gen. Hume got up and described the art stuff to Florence and gave me ALL the credit in no uncertain terms and told how pleased the Chief of Staff and Commanding General of Fifth Army were about the successful conclusion of it all. He said I would not have told it properly and he wanted to and even mentioned that when the convoy of 6 token trucks and 3 jeeps entered the Piazza della Signoria with 3,000 people watching and the special people on the platform erected in front of the Loggia dei Lanzi, that I remained in the jeep with Charley and Col. Holmgreen and did not go to the place of honor—which is true, but for which I take no special credit. . . . Col. Holmgreen is going to have the General write [Yale President] Seymour about me and that will help. That was pretty nice of the Col. and he did it without my asking.*

General Hume did indeed write Yale President Charles Seymour just a week later, pointing out the importance of the return of the Florentine treasures and the role Keller played. "He has been the only member of the Allied Military Government staff to perform this work . . . under shell fire, at times very severe during combat operations. . . . he has twice been recommended for American awards by this headquarters. His comparatively low rank has been a subject of much concern to me and I have done all within my power to have him promoted."

Lieutenant Ralph Major, Hume's Aide-de-Camp, also sent a letter to a member of the Yale faculty, adding, "During the presentation ceremony in Florence, my general was unable to find Deane to have him participate in the official return of the train load to the townspeople of

Florence. After the ceremony was over, we found Deane hidden in a corner of the crowd, too modest to take credit for an achievement that was solely his."

General Hume's speech at dinner provided Keller with an enormous sense of validation. Hume's letter to President Seymour helped assuage Keller's fears that he might not have a job on his return. But another incident, nothing more than a coincidence really, reminded Deane Keller why he had volunteered for military service in the first place.

Some days after the return ceremony in Florence, while walking toward the Pitti Palace, Keller noticed an old man looking at him with great scrutiny. Having made eye contact, the old man approached Keller and asked, "Have you ever been in Sezze Romano, Sig. Capitano?"

In fact, he had. More than a year earlier, Keller had stopped in the small town, about forty miles south of Rome, during one of his daily inspections. The town had been fortunate; war had passed it by. As Keller completed his inspection, curious townspeople gathered around his jeep, some fifty in all, and asked when the Allies would bring food and come to assist them. Keller explained to them, in Italian, that he was part of the advance team of U.S. Fifth Army Allied Military Government; others would follow soon and meet their needs.

Keller looked more closely at the old man, then confirmed to him that he had indeed been in Sezze Romano the previous year. The old man replied, "Yes, I remember you very well. You told us food was coming into our little town and it did, and that the Allied authorities would come to help us and they did. Then we accompanied you to your automobile. Again, let me thank you."

SECTION IV

AFTERMATH

There is something in preserving the world's heritage.
It's a sort of faith that we have. It is tangible and can be
proven—if anything in life is worth proving.

—MONUMENTS OFFICER DEANE KELLER

28

PERSPECTIVE

During the war, acting on the authority of Adolf Hitler, the Einsatzstab Reichsleiter Rosenberg—the ERR—operated in occupied territories and stole millions of objects throughout Europe, including works of art from museums, churches, palaces, and individuals. This organization, and others, methodically and efficiently plundered some of the most prominent works of art in the world, including Leonardo da Vinci's *Lady with an Ermine* (from the Czartoryski Museum in Cracow, Poland), the *Ghent Altarpiece* (from St. Bavo Cathedral in Ghent, Belgium), the Amber Room panels (from Catherine Palace in Tsarskoye Selo, Russia), and Jan Vermeer's *The Astronomer* (from the Edouard de Rothschild family in Paris).

German removals of paintings and sculpture belonging to the great museums in Florence have too often been characterized as theft in the same vein as the Nazis' premeditated looting of the occupied countries in Europe. This has been repeated so many times that it has become accepted fact in many quarters. But the truth is more complicated and nuanced. German looting in Italy was different. The ERR only established operations in occupied territories. Initially an ally, Italy was thus

spared the worst depredations. Nevertheless, thefts of all sorts did occur. Removal of the paintings and sculpture belonging to the Naples museums from the Abbey of Monte Cassino by the Hermann Göring Division was a classic example. Mussolini's role in enabling Hitler and Göring to buy and export priceless works of art in violation of the nation's patrimony laws provides a unique example during World War II of a government actually aiding the Nazis in looting its own nation. Thefts in Italy by individual German soldiers also occurred.

Certainly, when SS Colonel Alexander Langsdorff signed a receipt to take possession of the two Cranach paintings, *Adam* and *Eve*, he fully intended to remove them from Italy and present them to the Führer. On two occasions, he lied to Florentine Superintendent Giovanni Poggi about the search for the paintings. In fact, they were already in his possession. On July 25, 1944, paintings in hand, SS General Karl Wolff sent a telegram to SS leader Heinrich Himmler, inquiring whether they should be brought to Germany. Had Himmler responded affirmatively, the paintings would have left Italy and, in all likelihood, been among the other works of art found in the salt mine at Altaussee. When trying to determine why the head of Germany's art-protection unit would do such a thing, the Monuments Men were told by other members of the Kunstschutz that Langsdorff was "a man with a divided soul, one half SS and the other half genuinely in Kunstschutz." Regardless, there can be no doubt that Langsdorff's actions constituted attempted theft. And Wolff's endorsement of Langsdorff's actions at a minimum made him an accomplice.

How then are we to judge the German removals, initiated by Langsdorff, of the Florentine treasures from their Tuscan countryside repositories to the Alto Adige region? Did Wolff act selflessly, to preserve these objects, or selfishly, placing them at enormous risk? Wolff unquestionably believed he had been their savior. In 1956, he sent a remarkable letter, in Italian, to the mayor of Florence. In it he described in detail his actions to protect the city's works of art during the summer of 1944. "Had I then decided . . . not to do anything and to leave all of the respon-

sibility to the Salò Government [Professor Carlo Anti, and others],"
Wolff wrote, "today I would certainly find myself morally responsible
in front of Italy and the entire civil world for the inevitable loss of the
[treasures of the] Uffi[z]i Gallery."

But Wolff's assertion rings hollow. All things considered, the Flor-
entine works of art were safest exactly where Poggi had placed them.
Further, Langsdorff had already promised Poggi, Carlo Anti, and other
Italian officials that the works of art in the Tuscan repositories would
be left untouched unless they were in immediate danger of destruction.
Then, and only then, would they be moved—and, in that event, only
back to Florence. Army High Command had reached the same conclu-
sion. Its July 14, 1944, order—which Langsdorff and Wolff chose to dis-
regard—made it clear that works of art should remain where they were
found, not removed. The plan had been sound. Keller noted: "In all the
stiff fighting for Florence, the contents of only one deposit were dam-
aged (Poppiano, Villa Guicciardini where a shell hit . . .)." Keller's assess-
ment refutes Wolff's claim that his actions prevented "an inevitable loss"
of the Tuscan treasures.

Wolff's 1956 letter also stated that his decision to provide trucks
and gasoline, without which the removals could not have occurred,
was based on information received from Langsdorff. Wolff wrote
"that with the approaching of the battlefront, these castles would
have found themselves in the fire-zone of the enemy. . . . A great part
of the custodians who had accompanied the treasures had already
run away and the precious collections [had remained] without any
defense." Today we know that Cesare Fasola, Librarian of the Uffizi,
walked *through*—not away from—the battle zone to ensure the safety
of the repositories.

Once Italian officials became aware that German troops had taken
the Florentine treasures to northern Italy, Carlo Anti pleaded with
Langsdorff to turn them over to the Social Republic government. This
began an extensive effort on his part, with the help of others—even Mus-
solini—to regain possession. But the window of time in which Wolff

could have, without consequence, approved their request was limited to a few days. Himmler's July 26 reply about the Cranach paintings, which implied if not outright stated that all works of art should be placed in Alto Adige under German protection, de jure prohibited Wolff from ceding control of the Florentine artworks to Italian officials. The opportunity to capitalize on the August 3, 1944, order making the Borromean Islands available as a repository came a week too late.

As early as August 30, 1944, the Bologna Superintendent of Monuments expressed his frustration, stating that "Germany has no plans for the Italian works of art . . . one doesn't understand why they are taken to the German border, a territory which is no longer under the [Italian] State control, and are handed over to German personnel, instead of being taken to the repositories, created by the State on Italian territory and protected by Italian officers. . . . Such a way of acting cannot but raise some legitimate doubts, especially for the place chosen to gather these works of art."

Anti's efforts to take possession of the Florentine works of art continued until mid-April 1945. He offered numerous alternate locations that could have served as Italian-controlled repositories, including the Doge's Palace in Venice, and St. Moritz, Switzerland. Each suggestion was rebuffed. There can be no question that some officials of the Social Republic, Anti in particular, made significant efforts to free their art from German control.

We must have a more favorable view of Wolff's actions from December 1944 through May 2, 1945, whether they were motivated by survival or altruism. What we know is this: In December 1944, Wolff ignored Himmler's order to transfer the Florentine works to the salt mine at Altaussee. Believing that Nazi Germany was doomed, Wolff began developing a plan to end the war in Italy. The Florentine works of art proved to be an important component.

Following the end of the war in Italy, Ernest DeWald and British Royal Air Force Wing Commander Douglas Cooper, a man with three years of experience conducting interrogations for British Intelligence, investi-

gated the Kunstschutz operation in Italy. On June 30, 1945, DeWald and Cooper circulated their findings in a twenty-four-page report. Of the major suspects, only Himmler and Gauleiter Hofer eluded their interrogation. Himmler had committed suicide on May 23 while in British custody; Hofer had been arrested in Innsbruck.

Their report described "a strange and characteristically German tale of honest intentions mixed with opportunism, which, if not at the outset deliberately dishonest, all too rapidly degenerated in the minds of its prime movers into an unparalleled scheme for the enrichment of the Reich at the expense of Italy." The two officers concluded that most of the Kunstschutz staff had performed their work admirably. DeWald and Cooper did assign blame—on the basis of "culpable negligence"—to Langsdorff's predecessor, Dr. Hans Gerhard Evers, for his failure to determine whether any of the Monte Cassino treasures were missing from the Hermann Göring Division deliveries to Rome in December 1943 and January 1944. They considered the removal of the two Cranach masterpieces "a clear case of attempted looting by Langsdorff and a German unit."

The DeWald/Cooper report provided a remarkably accurate assessment of events, especially considering that they had just seven weeks to locate the key participants and conduct interrogations before submitting their findings. But limited access to General Wolff, and a lack of information about the full extent of his role in negotiating the surrender of German forces in Italy, handicapped their investigation. They cited several instances of what they deemed Wolff's unwillingness to explain certain actions. For example, they couldn't understand why he had ordered the preparation of a photo album for Hitler's birthday, or why the Bourbon-Parma private collection was discovered in the Castle Dornsberg, one of Wolff's residences. DeWald and Cooper weren't informed that Wolff had been instructed to avoid discussion of his secret negotiations with the OSS. Like Keller and Hartt, they were unable to connect the last few dots. One man who did understand the big picture, however, was Allen Dulles.

———

EACH OF THE principal Allied participants in the Operation Sunrise negotiations in their own way echoed the sentiment expressed by British Major General Terence Airey, one of the two "military advisers" introduced to Wolff during his second meeting with Dulles on March 19. "The surrender of the German armies in Italy was due to the initiative of Karl Wolff," Airey noted, "who contacted Allied Forces while the war was still in progress and consequently against the wishes and declared policy of the Nazi government and at great risk to himself. His actions led to the abandonment of a fighting withdrawal . . . into Austria and must necessarily have saved the lives of a large number of German soldiers, Austrian and Italian civilians, and avoided useless destruction."

Wolff risked his life on multiple occasions to effect the surrender agreement. It is impossible to quantify how many lives were saved, and how much destruction of industry and infrastructure was avoided, by the early surrender of German forces in Italy. However, if the acts of vengeance exacted on the city of Naples in the fall of 1943 by embittered German soldiers are any guide, Wolff's actions were significant. Additionally, from December 1944 onward, he made certain the Tuscan treasures were not moved out of Italy to the salt mines of Altaussee. Because of his orders, Kunstschutz representatives were at both repositories to deliver the works of art to American forces—and the Monuments Men—once they arrived.

Yet the good deeds of Karl Wolff, from December 1944 until his arrest in Bolzano on May 13, 1945, must be considered alongside his role in facilitating the Holocaust, and almost fourteen years of devoted service to the SS, including six years as Chief of Staff to its supreme leader, Heinrich Himmler. It was hardly surprising that Allied authorities included Wolff's name on the list of major war-crime suspects (No. 346 on "List 7"). Himmler's death left Wolff as one of the two most senior SS leaders—Kaltenbrunner being the other—to survive the war.

The first public session of the International Military Tribunal in Nuremberg commenced on November 20, 1945. On the second day of

the proceedings, the U.S. Chief Prosecutor, Supreme Court Justice Robert Jackson, delivered the opening statement for the prosecution, certainly one of the most sweeping and macabre indictments in history. The opening statement consumed the entire day. Jackson made a point of mentioning the names of some of the men—including Wolff—who would forever be associated with the most barbaric acts of cruelty in modern time.

Alfred Rosenberg, the man in charge of the principal Nazi looting organization, and Reichsmarschall Hermann Göring, who claimed, "none of my so-called looting was illegal. . . . I always paid for them or they were delivered through the Hermann Göring Division, which, together with the Rosenberg Commission supplied me with my art collection," sat three seats apart in the front row of the prisoner dock. They and the other nineteen defendants present listened impassively as Jackson spoke. Ernst Kaltenbrunner, who had threatened to expose Wolff to Hitler for his dealings with Dulles and the Allies, was seated between them, to the right of Rosenberg. But Wolff wasn't among the defendants in this or any of the twelve subsequent war-crimes trials. Wolff hadn't even been indicted.

The verdicts of the International Military Tribunal at Nuremberg Trial were delivered on October 1, 1946. Göring, Kaltenbrunner, Rosenberg, and nine other defendants were found guilty and sentenced to death by hanging. In light of Justice Jackson's opening statement, how did Karl Wolff elude prosecution?

Allen Dulles maintained to his grave that he had made no "deal" that would have shielded Wolff from prosecution. However, events following Wolff's arrest undercut Dulles's assertion. "One cannot be sure that, at some level, Wolff may not have been given some inducement by agents of OSS," British Military Governor General Sir Brian Robertson later commented. "Although I have no information whatsoever that such inducements were given, my experience of the workings of the occult services led me to conclude that it would be wise to assume that they were."

There are many reasons the OSS would have buried such information. Eager to see the wartime security services unit become perma-

nent, Dulles quickly sought to highlight the OSS's role in achieving the surrender of German forces in Italy. Having Wolff testify in open court would expose Dulles and his intelligence colleagues' dealings with Nazis accused of war crimes—an embarrassing and counterproductive event, especially after Dulles had asserted that no protection had been given. The disclosure of a secret arrangement with Wolff would also have exacerbated the deteriorating relations between the United States and the Soviet Union. Switzerland's appearance of neutrality would have been tarnished for having so proactively assisted Dulles and the Allies. Powerful forces thus had an interest in seeing Wolff and his immediate circle—Wenner, Dollmann, Harster, Zimmer, and Rauff—fade away without public condemnation.* The available evidence indicates that without the steady influence of Dulles and his associates, Wolff would have been tried as a war criminal and convicted of crimes against humanity.

In March 1948, after numerous interrogations at Nuremberg, and half a dozen appearances during the trials as a witness, Wolff was transferred to a detention center while his case was reviewed as part of the German government's de-Nazification process. Later that year, the court found Wolff guilty on the lesser charge of "minor offender." Time served offset the four-year sentence; Wolff was released immediately.

The sensational capture and arrest of Nazi fugitive Adolf Eichmann in Argentina by agents of Israel's intelligence agency, Mossad, and his subsequent trial in Jerusalem in 1961, brought renewed worldwide interest to the so-called desk-murderers—Nazi bureaucrats who claimed to have had no involvement in the actual killings. During the trial, Eichmann characterized Wolff as "one of the salon officers who wishes to

*Each of these men served as officers in the SS. As early as September 1941, Walter Rauff established his role in the Holocaust through the development of mobile extermination vans, known as "Black Raven gas chambers." The fleet of these vehicles, with their modified carbon-monoxide exhaust systems, soon provided an alternative to execution squads for the liquidation of Jews on the Eastern Front.

As German historian Dr. Kerstin von Lingen notes, "Not one of the senior SS figures involved in these cease-fire negotiations was brought before an Allied court."

keep their hands in white gloves and does not want to hear anything about the solution of the Jewish problem." In fact, Wolff later asserted that he knew nothing about the Holocaust—despite his longstanding service to SS leader Himmler and closeness to the Führer—until spring 1945. Eichmann's testimony contributed to Wolff's subsequent arrest and trial by a court in Munich. In 1964, he was found guilty of complicity in genocide and sentenced to fifteen years in prison. He was released in 1969 due to ill health.

Wolff spent his final years arguing for his innocence through lectures, publications, and an occasional television appearance. He died on July 15, 1984, in Prien on Lake Chiemsee, Germany.

Gauleiter Franz Hofer, who tried to sabotage Wolff's efforts and scuttle the Operation Sunrise negotiations, had no such protection. Following his arrest near Innsbruck on May 6, 1945, Hofer was placed in detention at Dachau. Three years later, he escaped and began working in Germany under an assumed name. In 1949, an Austrian court sentenced Hofer to death in absentia for high treason, but authorities eventually stopped pursuing him. Hofer died in 1975 and was buried in Mülheim on the Ruhr River, Germany. To the end, he remained an ardent believer in Adolf Hitler.

After surrendering on May 6, 1945, Generalfeldmarschall Albert Kesselring was arrested and transferred to an Allied detention center. Kesselring believed that "the battle for Italy was not only justified but even imperative." While he later acknowledged that the late-stage events of Operation Sunrise resulted in forty-eight hours that "embarrassed both sides intolerably," he believed he had made the correct decision to hold out to the last minute in a desperate attempt to save the lives of his soldiers.

Kesselring was charged with war crimes for his role in the Ardeatine Caves massacre. A second charge accused him of inciting forces under his command "to kill Italian civilians as reprisals." The trial began in Venice, Italy, on February 10, 1947. In preparing his client's case, Kesselring's attorney wrote to the Archbishop of Florence, Elia Dalla Costa, request-

ing "testimony in favor of the accused." He received a short reply: "Dear Counselor . . . I must declare that there is nothing I can say to benefit the defense of Field Marshall Kesselring. Instead, I could tell of the horrendous massacres in my diocese, if these can be attributed to Kesselring."

The British Military Court hearing the case found Kesselring guilty on both charges and sentenced him to death by firing squad. Believing this outcome too severe, many in the British government, including Winston Churchill and Kesselring's former adversary in battle, Harold Alexander, argued for a lesser sentence. Two months later, the commander of British forces in the Mediterranean commuted Kesselring's death sentence to life imprisonment. In October 1952, after further support from such éminences grises as noted British historian Major General J. F. C. Fuller, Kesselring was released from prison on the grounds of ill health. On July 16, 1960, Albert Kesselring died of a heart attack at the age of seventy-four in Bad Nauheim, Germany. He was buried in his native Bavaria in the village of Bad Wiessee, still admired by the men who served under him.

By September 1945, the remaining major participant in Operation Sunrise, OSS spymaster Allen Dulles, found himself unemployed. After the surrender of Japan and the formal end of World War II, President Truman signed an Executive Order dissolving the OSS. But the administration soon saw the value of a full-time intelligence service. Twenty-two months later, Truman signed into law the National Security Act that formally created the Central Intelligence Agency. In 1953, Dulles, who had resumed a private law practice after the war, returned to government service during the administration of President Dwight Eisenhower, becoming the fifth director of the CIA. Under his aegis, the agency renewed its commitment to covert operations. Dulles, with his extensive contacts from the war, was ideally suited to oversee the task. His leadership lasted until November 1961, when President John Kennedy demanded his resignation over the Bay of Pigs fiasco in Cuba.

Dulles wrote several books after the war, including *The Secret Surrender*, originally published in 1966, in which he asserted that Karl Wolff

received no immunity from prosecution. In the book, he chose to avoid mention of a June 1950 letter he wrote to his former Swiss intelligence counterpart, Max Waibel, by that time the Swiss military attaché in Washington, DC. Incensed that Wolff sought to be reimbursed for his property and financial losses "incurred through the handling of the Italian capitulation as agreed," Dulles wrote Waibel, stating, "Between you and me, [Wolff] doesn't realize what a lucky man he is not to be spending the rest of his days in jail, and his wisest policy would be to keep fairly quiet about the loss of a bit of underwear, etc. He might easily have lost more than his shirt."

29

THE HEROES AND
THEIR LEGACY

Today visitors to the Capodimonte Museum in Naples will find a remarkable collection of paintings, including Titian's *Danaë*, Bruegel's *The Blind Leading the Blind*, and Raphael's *Holy Family* showing no signs of having been hauled more than sixteen hundred miles by the Hermann Göring Division to the salt mines of Altaussee.* The central panel of Duccio's *Maestà*, which Deane Keller found in a villa amid wounded soldiers during an artillery barrage, is once again safely back in Siena's Museo dell'Opera del Duomo. Lucas Cranach's paintings of *Adam* and *Eve*, so admired by Hitler that his subordinates stole them, can be found in Florence's Uffizi Gallery, among its holdings of German School paintings.

But reminders of the war in Italy are, alas, easy to find. The Abbey at Monte Cassino has been rebuilt, but the most visible landmarks from its reconstructed walls are the Polish and British Commonwealth Cemeteries on the hills below, containing thousands of gravestones memorial-

*The painting collection of the Museo Nazionale was transferred to the Capodimonte Museum in 1957.

izing the soldiers who fought the gruesome battle. American soldiers who fell during that battle are buried alongside their brothers at Anzio, seventy miles away.

The bridges of Florence have been reconstructed, the Ponte Santa Trinita appearing largely as it did before its demolition, thanks in part to the extensive archival photographs taken at the direction of German scholar (and member of the Kunstschutz) Professor Heydenreich, as Director of the Kunsthistorisches Institut. However, the bridge's *Four Seasons* statues, with their thousands of hairline fractures and reassembled parts, inform visitors of what took place some seventy years ago. So, too, do the incongruous modern buildings that line the south side of the Arno nearest to the Ponte Vecchio, occupying space where the medieval towers once stood.

Today the Ponte Vecchio appears much the same as it did before the demolitions of August 1944. But a reminder of wartime events does exist. Opposite the bust of Benvenuto Cellini, under the arches on the south wall, hangs a small plaque honoring Dr. Gerhard Wolf, placed there in 2007 by city officials (albeit citing incorrect dates of birth and death) to honor the man who worked so valiantly to save the city. Gerhard Wolf had come to the city as the Consul of Germany; by virtue of his actions, he departed as the Consul of Florence.

Dedicated technicians in Padua continue their painstaking work reassembling fragments of the war-damaged frescoes painted by Mantegna on the walls of the Ovetari Chapel. Dr. Clara Baracchini devoted fifteen years to the repair of the Camposanto; the work continues today. Other reminders of the Monuments Men may be found in the most surprising places, such as the off-limits sign that still hangs on the wall of the Castello di Masino, near the town of Ivrea in the Piedmont region, exactly where it was placed by Monuments officer Captain Rodrick E. Enthoven almost seventy years ago.

Milan bore the brunt of the Allies' effort to bomb Italy out of its alliance with Nazi Germany. The Poldi Pezzoli Gallery had to be completely rebuilt. Repairs to La Scala allowed the theater to reopen on May

11, 1946, with a performance directed by Arturo Toscanini. The Duomo still has a few pockmarks and discolorations from Allied bombs that nicked its façade during the summer of 1943. The paintings of the Brera and Ambrosiana Picture Galleries survived, despite multiple moves during the war. They returned to their respective museums, home to some of the most important and beautiful paintings in the world, but only after extensive reconstruction of both buildings.

The Last Supper survived the August 1943 bombings—barely. When the last of the sandbags that supported the north wall were removed, Monuments officer Perry Cott observed, "The *Last Supper* may be getting worse and it surely isn't getting any better. It is a miracle that it was saved at all." The Refectory reopened to the public on June 19, 1945. Newspaper accounts cited just one four-inch square on the tunic of St. James the Greater as being problematic. Lurking unseen, however, was the problem that has bedeviled the north wall since Leonardo painted on it: humidity.

On February 12, 1946, Fernanda Wittgens, the sole dissenting voice in May 1945 concerning the painting's condition, accompanied Superintendent Ettore Modigliani for a detailed inspection of the mural. Her report was shocking: "The surface was inflated with humidity; its appearance was rubbery and would move by the slightest touch up . . . to the second layer of plaster base." In addition to the changes in climate caused by the sudden loss—and then reconstruction—of the walls and roof, the sandbags that had stabilized the fresco side of the north wall had become rotted with moisture. The close quarters between the sandbags and the painted wall created a thick layer of mold on the surface.

By December 1946, the condition of the painting was dire. "The head of Christ has nearly vanished," wrote a correspondent for *Time* magazine. "The faces of Philip and James the Elder appear to be completely corroded and are covered by a layer of saltpetrous calcinate which threatens to spread over the entire fresco [*sic*].* From a few feet away,

* *The Last Supper* is not a true fresco, as it was painted on dry plaster, not wet.

the apostles are an indiscriminate blur. The landscape originally visible in the background has disappeared." Professor Emilio Lavagnino, who played such a critical role in transporting so many of the nation's artistic masterpieces to the safety of the Vatican, commented that another in a continuous series of restorations "offers a possible guarantee to keep the picture in some recognizable form for another 30 years—not more."

Today, limited groups of visitors gain entry into the Refectory by passing through a glass-enclosed passageway just fifty or so feet from the impact site of the bomb that landed in the cloister. Upon entering the climate-controlled space, they will discover that Lavagnino's assessment proved wrong. *The Last Supper* survived its postwar humidity problems. Thanks to the dedication of Dr. Pinin Brambilla Barcilon, who spent twenty years standing on scaffolding restoring the painting, centimeter by centimeter, it has been restored to a condition not seen in hundreds of years. Her work, uniting state-of-the-art technology with the knowledge gained from failed experiments of the past, has preserved this masterpiece for future generations.

The Refectory is in fact a microcosm of the wartime events in Italy: local art officials and volunteers taking measures to protect their cultural legacy; an Allied bombing policy that initially gave no consideration to the consequences of nighttime firebombing of a cultural capital; the miraculous survival of one of the great examples of man's creative genius; a revised Allied policy that aimed to avoid such damage; and the introduction of a new kind of soldier charged with saving, not destroying, what lay in the path of the conquering army. It serves as a physical reminder that the creative genius of man must somehow be reconciled with his capacity for destruction.

In September 1945, Monuments officer John Bryan Ward-Perkins presciently stated, "The process of restitution and reparation is likely to be long drawn-out." Almost two years would pass before the paintings and sculpture belonging to the Naples museums were turned over to Italy's designated representative, Rodolfo Siviero.

The Monuments Men followed the tip from Pietro Ferraro and found

seven hundred crates containing the library and photographic collection of the Kunsthistorisches Institut of Florence hidden in a German salt mine in Kochendorf, near the town of Heilbronn. The collections of the Kunsthistorisches Institut and the Hertziana Library in Rome, which the Monuments officers found in three different repositories, were eventually returned to Italy, but not until 1953.

Fred Hartt's May 1945 inventory of the two German repositories in the Alto Adige region revealed that ten paintings from the Villa Bossi-Pucci at Montagnana were missing and presumed stolen. Eighteen years would pass before the first one surfaced. The small pair of panel paintings by Antonio Pollaiuolo, perhaps the most important works of art from Italy that eluded recovery by the Monuments Men, were found in the possession of Johannes Meindl, a German waiter working in Pasadena, California, in 1963. Meindl had been a veteran of the Wehrmacht 362nd Infantry Division. The paintings were returned to the Uffizi Gallery by Rodolfo Siviero and Luisa Becherucci, Director of the Uffizi, after intervening assistance by U.S. Attorney General Robert F. Kennedy.

The story that emerged shed some light on how such lootings occurred. At the end of June 1944, Meindl and other soldiers from his division were removing works of art from the Tuscan repository when they came across a crate that had been split open. Upon seeing the contents—paintings from the Uffizi Gallery and the Pitti Palace—Meindl commented, "These are worth something!" He and another soldier then took some of the paintings.

A subsequent investigation led prosecutors to a man in Munich who served with Meindl. In his possession were five paintings that he had taken from the same crate. The remaining three paintings from that particular crate remain missing. The whereabouts of two of the paintings, School of Van Dyck (*Madonna with Child and Saints,* Palatine Gallery inventory #282), and School of Bronzino (*Christ on the Cross*, Palatine Gallery inventory #263), remain unknown. The most important of the three, Dutch Master Jan van Huysum's *Flowers and Fruit* (Palatine Gallery inventory #462), is in the possession of a European private col-

lector. It remains one of many complicated cases where the person possessing the work of art has ownership, but not clear title.

Almost seven decades later, the search for missing works of art continues. By mid-2012, the Cultural Heritage Division of the Carabinieri was still on the hunt for more than two thousand works of art stolen or lost during World War II. This figure doesn't begin to cover works of art that were taken out of Italy during the chaos of war, in violation of the nation's export laws, that have since found new owners. The fate of the missing art and other cultural treasures forms a significant part of a yet-to-be-written history of World War II.

ONE MYSTERY PUZZLED the Monuments Men well after the war ended. When did Giovanni Poggi learn about the location of the two Alto Adige repositories, and why didn't he provide that information to Hartt, Keller, or one of the other Monuments officers? This issue fell outside the scope of DeWald and Cooper's investigation.

Poggi had faithfully discharged his duties to protect the extraordinary wealth of Tuscany, even when threatened by a German officer for his lack of cooperation. The Monuments Men admired Poggi's dedication, but not without some criticism of his methods. Fred Hartt, who understood the importance Florence might play in his postwar career, held Poggi in reverence: "Both sides, at the end of the war, recognized Poggi as being, 'the most authoritative and esteemed Superintendent in Italy.'" Hartt added, "He is a person of immense learning, of unassailable taste and judgment in matters of restoration and repair, and of infinite capacity for hard, devoted labor."

Deane Keller saw Poggi as a peer and was more measured in his assessment than the enthusiastic Hartt. While he recognized Poggi as a man of "devotion and loyalty, integrity and intelligence," Keller questioned his judgment on two important matters. "One thing is the carelessness of . . . letting the Florentine pictures out on a long trip without proper crating and packing," he wrote in his June 7, 1945, report. "This

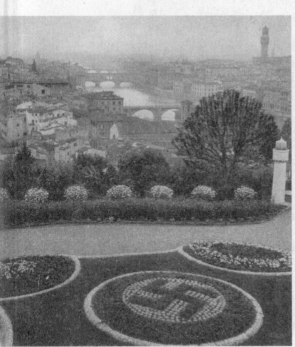

To welcome Hitler and his entourage to Florence for his May 1938 visit, city officials made extensive preparations, including this floral design in the Piazzale Michelangelo. Six years later, the city's bridges lay in ruins. Note the "Bailey bridge" built atop the surviving stone prows of the Ponte Santa Trinita. [Top: Bayerische Staatsbibliothek Munich/Heinrich Hoffman; Bottom: Pennoyer Papers, Department of Art and Archaeology, Princeton University]

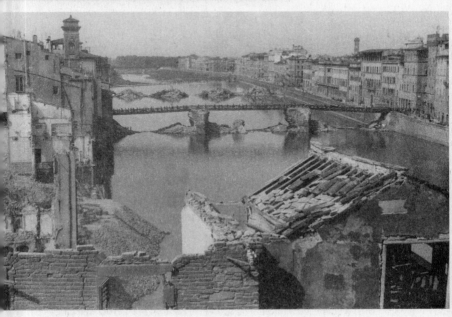

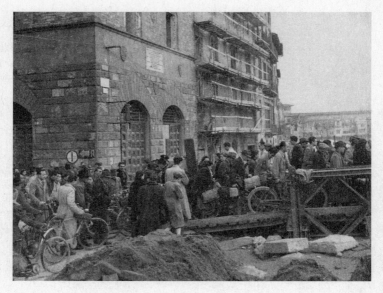

The "Bailey bridge," which opened on August 17, 1944, reunited the northern and southern parts of the city. This photo, taken on December 2, 1944, shows the crush of foot traffic and bicycles. Note the R (ricoveri) on the corner of the Palazzo Spini Feroni, marking the nearest bomb shelter. Today the building is the world headquarters and flagship store of Ferragamo. [Pennoyer Papers, Department of Art and Archaeology, Princeton University]

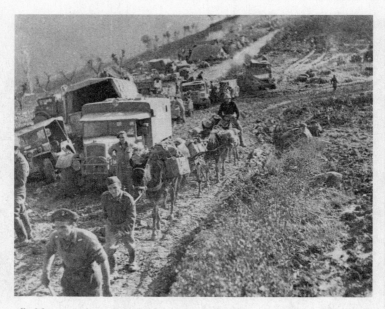

Allied forces in Italy constantly battled the weather, in addition to the enemy. Rain turned roads, like these near the Gothic Line, into mud so thick that vehicles often had to be abandoned in favor of pack mules to move supplies. [Pennoyer Papers, Department of Art and Archaeology, Princeton University]

Deane Keller entered the Piazza dei Miracoli in Pisa on September 3, 1944, to discover the Camposanto (upper photo, far right) without its roof. Within days, experts from Florence arrived in Pisa to gather the shattered fragments that fire and sun had baked off the walls. [Both photos: National Archives and Records Administration, College Park, MD]

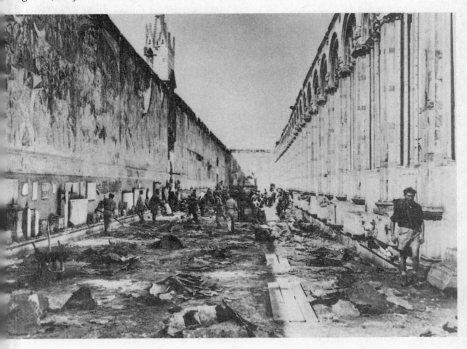

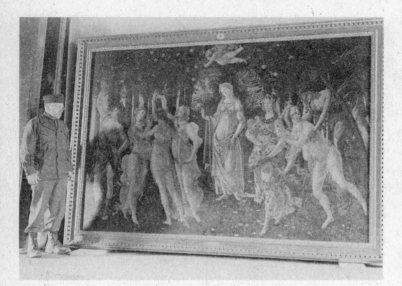

Monuments officer Captain Deane Keller visited the Florentine repository at Montegufoni during the winter of 1944/45. The paintings found by Fred Hartt in early August 1944, including Botticelli's masterpiece, Primavera, were still there. [Deane Keller Papers, Manuscripts & Archives, Yale University]

The Primavera was but one of 246 paintings at Montegufoni, including an early thirteenth-century Pisa school crucifix (foreground), today in the Uffizi Gallery. The fourth work (from left to right) was painted by Domenico Ghirlandaio in 1493. It, along with the early fourteenth-century crucifix to the right, today hangs in Florence's Accademia, around the corner from Michelangelo's sculpture of David. [Pennoyer Papers, Department of Art and Archaeology, Princeton University]

On February 16, 1945, Fred Hartt, standing next to Lucky 13, watched as Deane Keller and local workers maneuvered the statue of Cosimo I de' Medici and his horse, by Giambologna, back into position in Florence's Piazza della Signoria. [Deane Keller Papers, Manuscripts & Archives, Yale University]

Shortly before Christmas 1944, Don Anelli—"the flying priest"—departed Rome, after a month of meetings at the Vatican, aboard this American C-47 transport plane arranged by OSS Captain Alessandro Cagiati. Don Anelli is standing on the far right, wearing a helmet and the parachute he used to return to his parish in northern Italy. [Sergio Giliotti Collection]

Open-top trucks loaded with some of the Florentine treasures, including this painting from the Uffizi—Luca Signorelli's Crucifixion—began arriving in the northern Italian town of San Leonardo on August 13, 1944. German soldiers transported the uncrated paintings over hundreds of miles of poor-quality roads with little more protection than straw. [National Archives and Records Administration, College Park, MD]

Filippo Rossi, Director of the Galleries of Florence, arrived in San Leonardo and, to his relief, found both of the stolen paintings by Lucas Cranach—Adam and Eve (pictured here)—in good condition. [Frederick Hartt Papers, National Gallery of Art, Washington, DC, Gallery Archives]

Fred Hartt reached Campo Tures on May 13, 1945. The following day, Lieutenant Colonel John Bryan Ward-Perkins (far right) arrived to begin his interrogations of SS Colonel Alexander Langsdorff (center right) and Captain Schmidt (center left). [Frederick Hartt Papers, National Gallery of Art, Washington, DC, Gallery Archives]

The triumphant return of the Florentine treasures took place on July 22, 1945. This truck first passed before the review stand under the Loggia dei Lanzi. Then it stopped in front of the Palazzo Vecchio, where, seven years earlier, thousands of Florentines had greeted the arrival of German leader Adolf Hitler. [National Archives and Records Administration, College Park, MD]

In 1942, Florentine officials, concerned about Allied bombing, entombed Michelangelo's sculpture David, and his other works, known as The Slaves, in brick. Three years later, Deane Keller and Charley Bernholz visited the Accademia to watch workmen completing the removals. Keller himself chiseled away a piece of the brick that protected The Slaves.

should be explained by him. Further, he knew the stuff was in the Alto Adige all during the winter of '44 and '45 and hedged on the questions."

Keller's assertion that Poggi knew the Germans had stashed the Florentine artworks at Campo Tures and San Leonardo as early as December 1944 was, in part, wrong. We now know that Poggi became aware of the Campo Tures repository by November 15, 1944. He may have known even sooner. A series of notes handwritten by Poggi that record precise details about the transport of the works have been found in his papers, but they are difficult to date with any certainty. The first of Poggi's notes is dated "July 4, 1944," but includes details that transpired months afterward. Other notes are dated "July 20–30–31, August 11," "August 20," "August 22," and "August 23 and 26" and record further details of the shipments to the two repositories. We are left to wonder whether some were written on the indicated dates, or whether this was Poggi's own attempt to construct a timeline after the fact.

By 1946, Poggi and his team had reopened most of the Florentine museums. He spent much of his time promoting cultural events with museums and other institutions in the United States in an effort to generate funds for restorations. Three years later, after serving the cause of Italian art and culture for almost fifty years, through two world wars, Poggi retired. Despite a remarkable career, he always lamented the works of art he could not save during the war. Giovanni Poggi died on March 27, 1961.

ANOTHER MAN WHO risked his life to locate and secure the two repositories was Don Guido Anelli, "the flying priest." His story reveals how Allied forces and Italian art officials in Venice arrived at the two locations so quickly. Had it not been for Marchese Serlupi Crescenzi, who later insisted that Anelli write a summary of his activities and provide it to Poggi, perhaps to set the record straight, Anelli's service to Italy and its art would have remained unknown. He ended his note to Poggi by saying, "I am grateful for this opportunity to convey to you my sense of great esteem and regard."

On May 11, 1945, the unpretentious Anelli was presented with a Certificate of Appreciation, signed by OSS leader General William Donovan, expressing official gratitude for his "selfless help to this office and to the United States of America Army in the fight for the liberation of Italy."

As a hard-line Christian Democrat in postwar Italy, Anelli was outspoken against Communism. His stance, especially as a priest, became increasingly uncomfortable for Catholic Church officials as well as some of his colleagues and parishioners. Tired of the bickering, Anelli accepted a position at an important parish in Maracay, Venezuela, in March 1955. Two years later, "the flying priest" suffered a stroke and died at the age of fifty-six. On May 10, 1990, his remains were returned to Italy and buried near those of his parents in the town of Orzale Neviano degli Arduini.

Alessandro Cagiati, who recruited both Don Anelli and Pietro Ferraro, performed heroically in the service of two nations. He was decorated by the United States and by Italy, where he received the Knight Officer of the Order of the Crown of Italy. Before returning to his adopted American homeland, Cagiati interceded to defend his friend and father figure, "Pippo"—Marchese Filippo Serlupi Crescenzi—from accusations that his wartime activities as a diplomat, which placed him in contact with various Fascist leaders, somehow constituted collaboration. In an effort to clear Serlupi's name, Cagiati wrote to Italian officials, stating that Serlupi's activity "was aimed at protecting the lives of Allies, of the Italians and of their properties from the Nazi-Fascist attempts to damage them. . . . The successful efforts . . . necessitate the highest gratitude from both the Allies and the Italians."

THE FIRST MONUMENTS officer stationed in Italy—Mason Hammond—was transferred to London in early 1944. There he worked with Francis Henry Taylor, Vice-Chairman of the Roberts Commission, to develop a restitution policy for postwar Germany. In August 1945, Hammond

established the MFAA office in Berlin, where he struggled to stay ahead of the constant personnel needs posed by the discovery of tens of thousands of works of art and other cultural objects stolen by the Nazis. His service led to decorations from France (Legion of Honor), the Netherlands, and Italy.

Returning to Harvard in 1946, Hammond resumed a teaching career that continued for another twenty-seven years, including nine as master of Kirkland House. From 1936 to 1986, with the exception of his war years and sabbaticals, Hammond's voice became familiar to graduates and the audience at Commencement. But that record was dwarfed by one even more remarkable: from 1921, as a Harvard freshman, until the mid-1990s, with the exception of his war service, he attended Morning Prayers six days a week. "I am not a holy man," Hammond once remarked, "but I am a creature of habit, and Morning Prayers is a good habit to cultivate." In addition to his prodigious career at Harvard, Hammond served as head of classical studies at the American Academy in Rome on three occasions, and twice as Acting Director of Bernard Berenson's enduring legacy, Villa I Tatti—The Harvard University Center for Italian Renaissance Studies.

On October 13, 2002, just four months shy of his one-hundredth birthday (which fell on Valentine's Day), Mason Hammond died. One of his three daughters summed up her father as "a model of moral integrity," a sentiment shared by those with whom he served in Italy and northern Europe.

Tubby Sizer, the man who encouraged Deane Keller to apply for service as a Monuments officer, never fully recovered from the illness that had forced him to leave the European Theater in 1944. In 1945, Sizer was named Commendatore of the Order of the Crown of Italy for his service as a Monuments officer. He resumed his duties as director of the Yale University Art Gallery until 1947 and retired from teaching in 1957. He lived another ten years before his death at the age of seventy-five.

John Bryan Ward-Perkins performed the work of a Monuments officer in North Africa before the formal creation of a cultural preserva-

tion unit. His leadership proved so instrumental to the success of the operation in Italy that Norman Newton, Monuments officer for British Eighth Army, recommended that he be decorated by the United States. "The work of both MFAA officers with the Armies throughout this campaign was signally aided by this officer," wrote Newton. "[His] intervention frequently prevented the insistent demands of American, British, and Italian civil sentimentalism from interfering with the practicality of operations in the field." Ward-Perkins, Deputy Director of the Monuments operation in Italy beginning in March 1944, subsequently received the Medal of Freedom from the United States. He was also appointed Commander of the Most Excellent Order of the British Empire (CBE).

In 1945, Ward-Perkins left the MFAA to become the Director of the British School at Rome, a position he held for twenty-nine years. During that time, he assembled more than fifty thousand prints and negatives amassed during his years of study of archaeology and architecture, in particular that of the Roman world. Also included were photos he and others took of wartime damage to Italian monuments. His contribution to the arts survived his death; in 1981, the Ward-Perkins family generously donated the remainder of this priceless archival resource to the British School, where it remains available to scholars and students alike.

Norman Newton served as Director of the MFAA after the departure of Ward-Perkins. He returned to Harvard in 1946 and resumed his teaching career as a professor of landscape architecture. In 1967, the year after his retirement, he accepted a one-year position as resident landscape architect at his beloved American Academy in Rome. But perhaps Newton's lasting legacy, and fittingly so, surrounds the base of the Statue of Liberty, where the crosswalks and lawns he designed welcome thousands of visitors each year. Norm Newton died in 1992 at the age of ninety-four.

Perry Cott, one of the first Monuments officers to arrive in Sicily— and the first to see *The Last Supper* freed of its sandbags, departed Milan for his new assignment in Austria in August 1945. Only he, Teddy Croft-

Murray, and Norman Newton had traversed the length of Italy, landing in Sicily shortly after Mason Hammond and then working their way northward to Milan and the Alto Adige area.

Cott resumed his position as Associate Director of the Worcester Art Museum from 1946 until 1949, when he left to become the Assistant Chief Curator, and shortly thereafter Chief Curator, of the National Gallery of Art in Washington, DC. His role in the National Gallery's 1967 acquisition of *Ginevra de' Benci*, the only painting by Leonardo da Vinci to grace a collection outside of Europe, was the signal achievement of his two decades of service at the National Gallery.* Perry Cott died in Vevey, Switzerland, in 1998.

Cott remained lifelong friends with Ward-Perkins, Croft-Murray, and Ernest DeWald, the man who had selected him for service as a Monuments officer. DeWald continued his leadership in Austria, where he commanded some of the same Monuments officers who had served with him in Italy. After returning home in 1946, DeWald became the Director of the Princeton University Art Museum until his retirement in 1960. Even then, his service to Italy continued. Following the epic November 1966 flood in Florence, DeWald served on the Advisory Committee for the Rescue of Italian Art. Two years later, at the age of seventy-seven, he collapsed and died after watching Princeton crush Columbia in their annual football rivalry. DeWald received decorations for his leadership from Italy (the Star of Italian Solidarity), England (Order of the British Empire), and the United States (Legion of Merit).

AFTER RECEIVING A touching farewell note signed by Giovanni Poggi, Filippo Rossi, Ugo Procacci, and other museum officials, a very sad Fred Hartt departed Florence in late August 1945 for reassignment to Austria. Not even the Bronze Star, which he received for his role in "saving for

*As this book goes to press, a newly discovered painting by Leonardo—*Salvator Mundi*—is being offered for sale by a group of art dealers in the United States.

posterity irreplaceable objects of art," could assuage the disappointment of leaving the city. "Here I am in this sodden hole [Salzburg]," he wrote his idol, Bernard Berenson, "under the eternal rain. It was a terrible wrench leaving Florence after all this time. That last night the moon on the city and the river was past belief wonderful, and the next morning as the car took me inexorably up the long road it was hard to keep from crying as I looked back at the *cupolone* under the shifting, cloudy light."

Hartt considered the work in Austria "awfully dull after Italy—a waste of time for most of us." He spent some of the time contemplating writing a book about his wartime experiences. "I feel I must write the thing to get it off my chest," he informed Berenson. "So much of the heritage of Italian art is bound up in those months of my work." The winter months would pass before Hartt learned that, after more than two and a half years of military service in Italy and Austria, he was finally headed home.

There was another piece of news, this one quite unexpected. The City of Florence had decided to make Hartt an honorary citizen for his "tireless energy, scrupulous zeal and perfect spirit of sacrifice during and after the war, rescuing, recovering, and restoring countless works of art and monuments of the city and of the region." After arriving home, Hartt wrote Berenson to tell him that the award "means a great deal to me, as I love that town more than I can say." He also informed Berenson that his return to the United States had "been attended by great confusion, much trouble & delay in getting out of the Army." This was one occasion on which Fred Hartt grossly *understated* the situation.

While in Miami, Florida, processing out of military service, Hartt had a one-night stand with a male junior officer. The officer subsequently reported the incident, which led to Hartt's discharge from military service pursuant to U.S. Army Regulation 605-275, stating that class II homosexual acts on the part of officers may be resolved by providing the officer the option of resignation "for the good of the service in lieu of trial by court-martial." Hartt failed to recognize—or chose to ignore the risks— that his promiscuous behavior in Italy, which had been ignored during the

war, would be judged very differently in the United States. On this occasion, his disregard of U.S. Army rules proved an embarrassing and muted end to an otherwise remarkable and event-filled military career.

Following his discharge, Hartt rejoined his wife, Peggy, in New York City, writing Berenson to report, "The reunion has been wonderful." Initially, finding a job proved difficult, even for a Bronze Star recipient with impeccable academic credentials. He spent the 1946 academic year as Acting Director of the Art Museum and a lecturer at Smith College, then returned to New York University, where he completed his doctoral work while finishing the book about his experience as a Monuments officer. *Florentine Art Under Fire* was published in 1949, the year Hartt accepted his first full-time teaching position at Washington University in St. Louis, Missouri. Students there remembered him for the portable pink typewriter he used as a teacher. "I don't know what narcissistic streak in my nature prompts me to bite off twice as much work as I can chew," he wrote Berenson, "but I seem to be always doing just that."

In 1960, Hartt accepted a new position as Professor of the History of Art at the University of Pennsylvania, but the sexual divide and the years commuting back and forth to Manhattan to be with Peggy had taken their toll. After eighteen years of marriage, Fred and Peggy divorced. Hartt's career from 1967 to 1984 included two more academic positions: Chairman of the Department of Art and professor at the University of Pennsylvania and then the University of Virginia, from which he retired as professor emeritus.

In November 1966, Hartt took a leave of absence to aid Florence once again when the rising waters of the Arno threatened the city. Even after the flood waters receded, Hartt traveled throughout the United States to raise money to cover the cost of restoring damaged works of art as a board member of the Committee for the Rescue of Italian Art. The Italian government once again recognized his efforts, awarding him the title of Knight Officer of the Order of Merit of the Italian Republic.

Hartt published eighteen books during his career, including four books on his favorite artist, Michelangelo. *The History of Italian Renais-*

sance Art, first published in 1969, remains by far the most successful and enduring among them, still a widely used textbook on the subject. But the great regret of his professional career remained the position he could not secure: director of Harvard's Villa I Tatti facility. He considered moving to Florence anyway, but Florentine friends dissuaded him. "You'll always be an outsider," some warned.

Peggy never remarried; she died on December 7, 1989. She and Fred had remained lifelong friends, certainly his most stable and loving relationship with a woman. For years he had made a point of traveling to New York City each month to visit with her. Each time, he brought her a check for the alimony payment; each time, she tore it up.

Two years after Peggy's death, Fred Hartt died at the age of seventy-seven, from complications after triple-bypass surgery. His friend and companion of thirty-three years, Eugene Markowski, a student of Hartt's at Washington University and one of the first resident fellows at the Harvard Villa I Tatti program, later observed: "Fred was a very complicated man, whose gifts were enormous, and his ambition grand beyond what could be accomplished in any one lifetime."

What eluded Fred Hartt during his life was given to him after his death, but only after Markowski overcame numerous bureaucratic obstacles to honor Fred's last wish. On a bitterly cold Friday, March 5, 1993, the city of Florence welcomed home Lieutenant Frederick Hartt—"Tenente Hartt," as he had come to be known. Gene arrived at the eleventh-century San Miniato al Monte Church, carrying an urn containing his friend's ashes. Among those waiting to greet him were both of Hartt's wartime drivers, Franco Ruggenini and Alessandro Olschki; the Corsini family, in whose home Hartt lived while stationed in Florence; Gian Carlo Zoli, the Mayor of Florence; and Antonio Paolucci, Superintendent of Fine Arts for Florence.

Hartt always had a special affection for San Miniato, known for its stunning view of the city. He even wrote a book about one of its chapels. For a man whose life was defined by the creators of Florence—its artists, sculptors, and architects—there could have been no more fitting resting place.

After a special Mass, Hartt's friends followed Gene to the adjacent cemetery, past the family plot of the Lorenzini family and their most famous son, Carlo Collodi, author of *Pinocchio*, and laid down Fred's ashes.

DEANE KELLER'S GREATEST assets—reliability, competency, and indigenous knowledge of Italy—proved also to be a curse. General Edgar Hume wanted the Yale professor to move with his headquarters to Austria and write the history of U.S. Fifth Army, Allied Military Government. Kathy wanted him home and did not shy from saying so in her letters. Much as he wanted to return to her and Dino, Keller also felt a strong sense of duty to finish the job, especially after learning in early August 1945 that he was going to be awarded the Legion of Merit. The months passed but the work persisted. Keller became increasingly discouraged about any prospect of returning home during 1945. "As far as I can see there is nothing short of a death in my family that could get me home any sooner than the regular channels will." The departure of his friend and driver, Charley Bernholz, in late October only added to his sense of gloom.

By December 1, 1945, there were no Monuments officers left in Italy. All responsibility for monuments and works of art by that time had been turned over to Italian authorities. The formal work of the Allied Monuments, Fine Arts, and Archives Subcommission in Italy—which had numbered twenty-three American officers and enlisted men and seventeen British officers—had concluded its business. Only then did Keller get his promotion. The triumphant news became bittersweet after the discovery that General Hume had submitted the recommendation fourteen months earlier, a month or so after Keller's gallant work at Pisa's Camposanto, but then failed to follow up on its status.

On May 24, 1946, after two and a half years of military service overseas, *Major* Deane Keller was finally on his way home. His letter to Kathy and Dino, written from the port of Bremerhaven, Germany, brimmed with enthusiasm: "Dearest Ones: I'll be on the boat and near

home when you get this. All is ready to clear. They say it is a good ship. . . . Next thing will be a telephone call and next will be me looking you and Deane in the eye!!!" He didn't return home empty-handed: in addition to the Order of the Crown of Italy and the U.S. Legion of Merit, Keller also received honors for his service from England (Member of the Order of the British Empire), and the Vatican (Order of St. John Lateran), among others.

Keller resumed teaching at Yale, becoming a full professor with tenure in 1948. But the world was changing. In 1950, leaders of Yale's School of Fine Arts swept aside what they considered an old method of teaching, steeped in the tradition of the Beaux Arts, and embraced a more expressive and experimental mode of art theory. Modern artists, with their abstract and conceptual use of color and shapes, had captured the imagination of collectors and the viewing public. Robert Rauschenberg and Cy Twombly, among others, would become the new rage. Their former professor, Josef Albers, took the helm at Yale's Department of Design. Keller continued teaching art to graduate students of other schools at Yale, but he was no longer allowed to instruct advanced graduate art students.

Through this bitter adjustment, Keller remained a creature of habit and discipline. He taught class in what he referred to as his "uniform": dark slacks, white shirt with sleeves rolled up, and tie. He rarely mentioned his service overseas. One of his students, a fellow veteran named Leonard Fisher, shared Keller's view that "the guys who really mattered were the guys who didn't come back, because they were all buried in the ground. So how could you talk about your experience over there?" Keller did have a constant reminder: his uniform hung proudly in a corner of his classroom. Fisher noted that Keller "tried to hide his humanity and soul with his gruffness, but those of us who had served in uniform could see he was a pussycat underneath." Each day he ate lunch at the same time and place, reading the *New York Daily News*; people always knew where and when to find him. For years it was The Pub on Chapel Street, where the waitresses didn't bother bringing him a menu, just his

standard lunch: beef bouillon (he called it "beef tea") followed by vanilla ice cream smothered with coffee.

During the 1950s, Keller became Yale's unofficial portrait painter, capturing the likenesses not only of numerous school officials but also of other prominent figures, including Senator Robert A. Taft, whose portrait hangs in the Senate Reception Room of the Capitol in Washington, DC. In 1959, he briefly considered the idea of collaborating on a book with his wartime driver and lifelong friend, Charley Bernholz. They settled on a working title—*Charley and the Captain*—and exchanged a few letters about it, but little more. Keller painted a portrait of Charley wearing his army uniform and service medals. In the background is a map of Italy with a five-pointed figure over Anzio, representing the battle in which Charley earned his Bronze Star.

The Kellers welcomed a new addition to the family in 1950, a son they named William ("Bill"). By that time, the relationship between Keller and Dino, now ten years old and called "Deanie" by the family, had become intensely close. Drawing had been the medium of their communication during Keller's years overseas; this continued once he returned home. Dino's growing interest in art proved a welcome distraction from Keller's disappointments at Yale.

In 1965, while Dino was in Florence pursuing his studies in art, the family took its first trip to Italy, just as Keller had promised Kathy back in November 1944. They walked the streets of Naples, where Keller had purchased the street-vendor–made Fifth Army patch he had sewn on his own uniform; enjoyed seeing Duccio's *Maestà* in Siena, which Keller had discovered among wounded soldiers in a makeshift battlefield hospital; and strolled across a peaceful Piazza dei Miracoli in Pisa as he described the horror of seeing the Camposanto without a roof, its storied frescoes shattered. The highlight of their visit to Milan was standing in front of the famous painting he at one point had feared "may be in ruins."

In 1976, Keller suffered a stroke. Although unimpaired in thought, he had some paralysis on his right side that forced him to give up portrait painting. He stayed active and close to family, friends, and former

students until his death in 1992. Kathy and Dino agreed to apportion his remains. She wanted to bury her husband in the family plot in New Britain, Connecticut, but Dino had another place in mind—one they'd visited as a family in 1965.

In May 2000, after eight years of effort, Dino, Bill, and their spouses entered the Camposanto, where representatives of the Italian government, the United States Army, the Vatican, the City of Florence, and the Church of Pisa greeted them. (Kathy was too fragile to make the trip.) The American Consul General of Florence, Hilario Martinez, also attended. After they all gathered on the north side of the Camposanto, near the frescoes by fifteenth-century artist Benozzo Gozzoli, Dino placed the small urn, covered with the Stars and Stripes and a laurel crown, in the floor tomb.

Deane Keller had once said, "My years in the army were the most useful of my life. I loved the Italians and respected them. . . . we were just doing a job. We're not so noble." But those gathered to honor him knew otherwise. "He had the hand of an artist and the heart of an Italian," one person later wrote. Pisa Mayor Paolo Fontanelli said, "The people of Pisa are bound to this figure, who used his military role to rescue a patrimony belonging to everyone." An inscription on the white gravestone marking his final resting place ends with the Latin words *"Amicissimus ad amicus"* (The very dear friend returned to his friends). A local newspaper heralded, *"L'ultimo saluto al capitano Keller"* (The Last Goodbye to Captain Keller).

Dino returned home and continued his work as an artist and teacher, but he missed his father terribly. Sometime during the night of January 4, 2005, he died. Although the official cause of death was a massive heart attack, Dino's wife, Dorothy, later recalled, "Dino died of a broken heart, it was like a wound that wouldn't heal; a part of him died that day." Bill added, "My brother mourned Dad's loss to his death. He never got over it."

The relationship between Fred Hartt and Deane Keller mellowed with time. True friendship eluded them, but a mutual respect of a defin-

ing shared experience materialized. In Hartt's September 1945 trans-
mittal letter to Keller that accompanied a copy of his final report on
Tuscany, he wrote, "You are mentioned often and glowingly. I hope it
will be something of a reminder, if you need one, of a long and fruit-
ful period of cooperation between us." Hartt could empathize uniquely
with what Keller had endured upon entering the gutted remains of Pisa.
"The heaviest, and in a way the most tragic job, fell to the lot of Capt.
Keller," wrote Hartt. "His report on the damage to Pisa . . . is the most
appalling document of the whole history of MFAA work in Tuscany."
Even ten years later, Hartt wrote Keller, noting, "I don't suppose anyone
who didn't go through the actual experience of fighting and persuading
and maneuvering that you did can ever realize what it meant."

In the end, Hartt and Keller were buried no more than fifty miles
apart, the distance between San Miniato al Monte in Florence and the
Camposanto in Pisa.

THE WAR IN Italy and its contribution to the success of the Allied invasion
of Western Europe can be measured in many ways. Sicily and the Italian
mainland served as the testing ground that forged the MFAA operation
in Europe. Sometimes the importance of the Monuments officers' mis-
sion was measured by near misses (most prominently *The Last Supper*),
in other instances by the things they saved, such as the Camposanto. The
precision of the bombing raid on Santa Maria Novella train station, in
the center of Florence, demonstrated new possibilities in the air cam-
paign. However, the overarching achievement of the Monuments Men
occurred at ground level, where the Allies won the loyalty of townspeo-
ple who watched these scholar-soldiers set about trying to repair their
damaged churches and preserve their works of art.

The experience gained in Italy transferred to Shrivenham, England,
as the Allies prepared to invade Western Europe. General Eisenhower's
historic order concerning the protection of cultural property in Italy
had been issued almost six months *after* the invasion of Sicily. Eleven

days *before* the Normandy landings, a similar order was in the hands of his commanders. While the U.S. Army failed to address all the needs of the newly arriving Monuments Men, it did endorse their mission. This was certainly no accident. The trial-and-error experiences—and subsequent achievements—of Hammond, Keller, Hartt, Croft-Murray, and the others had paved the way.

Is it worth risking a person's life to save a work of art? This question crossed the minds of the Monuments Men and others who safeguarded cultural treasures during wartime. Keller's answer to this question made an important distinction: that of dying to save an object versus dying while defending a cause. Neither the methodical and cautious Keller nor the occasionally freewheeling and reckless Hartt wanted to lose his life, but both men accepted the risks because they believed in the cause.

The final words on the work of the Monuments Men in Italy should come from the man who served there longest, Major Deane Keller. Not only do they define a nation's responsibility to respect cultural property, they also reflect the noble purpose for which these men and women served.

> *Since Fine Arts are not edible, nor do they give heat to the cold, light to those in darkness, or water to those who wish to cook and wash, a reason beyond the primal needs of man must be found for concern for them in wartime. . . . It is hoped by Capt. Keller that the work of this [Monuments, Fine Arts, and Archives] Section has helped to sustain in the eyes of Americans and the Allies their sense of civilization and their sensibility for some of the greatest productions of the human mind and emotions. . . . To have been permitted to serve [my] country and in a small way civilization as an officer of a great Army with the mission of caring for a treasure belonging to not only the Italians but to the world at large is enough honor for one man.*

ACKNOWLEDGMENTS

Before emerging onto Centre Court at Wimbledon, players walk through a passageway beneath an excerpt from Rudyard Kipling's poem "If," which reads: " . . . If you can meet with Triumph and Disaster and treat those two impostors just the same. . . ." I thought of Kipling's words almost daily during the research and writing of this book. The sacrifices made along this journey taxed my abilities in every possible manner. What a glorious challenge; what a worthy undertaking; but what loneliness.

Rarely are such achievements singular. I have benefited from the hard work and goodwill of many people, all committed to the excellence of this book and the sanity of its author. I am in debt to them all.

Elizabeth Hudson, my senior researcher, who has worked with me on all three of my books, performed brilliantly. Her attention to detail and superior project-management skills guided an extremely complex undertaking smoothly to completion. Watching her grow in this position over these past years has been a joyous experience for me.

Christy Fox has supported every aspect of the Monuments Men project, almost since its inception. For this book, she assisted with key archival research; located and then interviewed several key participants; and contributed to each phase of development. Her admiration of the Monuments Men and women has sustained this project, the work of the Monuments Men Foundation—and my efforts—through some difficult stretches.

My executive assistant, Michele Brown, exemplifies grace under fire, with a smile, every single day. I couldn't maintain such a daunting sched-

ule and heavy workload without her. Assisting her are James Early, who manages the Foundation's extensive film and image database and its website activity, and Anne Jones.

Dorothee Schneider once again read thousands of German documents, and dozens of German-language books, to assess the most relevant details; then she translated them for my review. Through her contacts, we gained access to never-before-seen records that proved critical to deciphering these complicated events. My trust in her judgment speaks for itself. The newest member of our research team, Anna Bottinelli, spent countless hours in archives in Rome, Milan, and her hometown of Florence. She even conducted an interview while taking notes on someone's porch in the rain! Both demonstrated patience with my endless requests for additional information. Credit also goes to Natalie Ward, Giulia Mezzi, and Alessandra Montioni, who assisted us on this project.

W. W. Norton has been enthusiastic about this book from the outset. The company's commitment to excellence and entrepreneurial approach to publishing perfectly suited this important project and book. Tom Mayer, my editor, provided a steady hand throughout the two years of writing and editing. On more occasions than I can recall, he encouraged changes that demonstrated attention to detail. He inspired me to write well. I am proud of our collaboration. Starling Lawrence read the manuscript with great enthusiasm. Simply stated, his comments made the book better. I also want to recognize others at Norton, including John Glusman, Jeannie Luciano, Bill Rusin, Elizabeth Riley, Nancy Palmquist, copyeditor Kathleen Brandes, and production manager Louise Mattarelliano. Special thanks go to Ryan Harrington.

People who work behind the scenes are essential to such an ambitious endeavor. I am grateful for the continued guidance of my skilled attorney and friend Michael Friedman, and the team at Foundry Literary & Media, particularly Peter McGuigan, Stéphanie Abou, Kirsten Neuhaus, and Matt Wise. Very special thanks go to Michelle Weiner, my agent at Creative Artists Agency. Michelle has believed in the story of the Monuments Men (and women) since reading *Rescuing Da Vinci* in

2006. Her unwavering efforts to find just the right production studio for a film based on my last book led us to George Clooney, Grant Heslov, and their team at Smokehouse Pictures.

The Trustees and supporters of the Monuments Men Foundation have been a constant source of encouragement. They supported my vision of how *Saving Italy* and *The Monuments Men* could be used to create visibility for these heroes and thereby help complete their mission. The announcement of the film has validated that approach. I want to acknowledge those who have helped nurture the Foundation—in particular, Tom and Kim Schwartz, Bob and Patty Hayes, Carol and Terry Wall, Edith and Peter O'Donnell, Aubrey and Katie McClendon, Jim and Nancy Edsel, Alfred Glassell III (whose late father was a World War II veteran), Claire and Jim Woodcock, Allen Cullum, and Mrs. Margaret McDermott. I would also like to thank two longtime friends of the Foundation, Susan Eisenhower and Dr. Bruce Cole.

Authors benefit from the ability to contact experts on short notice, sometimes making a large call on their time, on other occasions simply needing guidance on a particular point. Four people—Carlo d'Este, Keith Christiansen, Donald Miller, and Joe Persico—each distinguished in his respective field, agreed to read portions of the manuscript and share their comments with me. This book is better as a result. I am profoundly appreciative to each of them for helping me.

Those who provided less involved but important assistance during the writing include Joseph Robert White, PhD, Thomas Kline, Nancy Yeide, Ennio Caretto with *Corriere della Sera*, Thomas Rupprath, Dr. Guenter Bischof, and Joshua Weikersheimer. A special word of thanks goes to Dr. Birgit Schwarz, an outstanding scholar and accomplished author who has been generous in sharing her expertise on Adolf Hitler and his art-collecting ambitions. I also want to recognize the entire team at The National World War II Museum, especially cofounder and President Dr. Nick Mueller, Vice-President Stephen Watson, and its dedicated Board of Trustees, all of whom are committed to fulfilling the dream of the museum's other cofounder, the late Dr. Stephen Ambrose.

This book wouldn't have been possible without the sharing of information and guidance from the families and friends of some of the key figures in the story. Several fielded numerous questions and e-mails from me with the same level of devotion they showed to the memory of their loved one. What success attends this book I share with each of them. Space precludes a full listing of names, but I would be remiss in not singling out Bill Keller, Eugene Markowski, Dorothy Keller, Leonard Fisher, Lola Scarpitta Knapple, Lizzie Boo Llewellyn, Anthony Cagiati, Spencer Seymour, Margaret Hildson, Bryan Ward-Perkins, Walter Gleason, Charles Bernholz, Mareile Langsdorff Claus, Luigina Anelli, Sergio Giliotti, Anna Magrini, and my friend the late and dear Alessandro Olschki. Special thanks go to Ken Scott.

My researchers and I visited dozens of archives, all of which housed valuable information included in this book. The following individuals merit special recognition for their assistance: Greg Bradsher at the National Archives; the staff of the Manuscripts and Archives Division at Yale University Library; Karl Weisenbach and his staff at the Eisenhower Presidential Library, especially Valoise Armstrong and Elinor Haas; Tom Czekanski at The National World War II Museum; James Moske at the Metropolitan Museum of Art; Jean Henry at the National Gallery of Art; Holly Wright at the Nelson-Atkins Museum of Art; Charles Greene and Shari T. Kenfield at the Princeton University Library; Padre Agostino Selva at Santa Maria delle Grazie, Milan; Maria Liberatrice Vicentini at the Siviero Archive, Rome; Attilio Tori from the Museo Casa Rodolfo Siviero, Florence; Giuseppe Bentivoglio and Diego Guidi from the Opera della Primaziale Pisana; Alexa Mason and Ilaria Della Monica at Villa I Tatti in Florence; Ivana Novani at the archive of the Soprintendenza per i Beni Architettonici e del Paesaggio in Milan; Simona Pasquinucci at the Archivio Catalogo Beni Storico Artistici in Florence; Luca Brogioni and Francesca Gaggini from the Archivio Storico of Florence; Alessandra Giovenco from The Photographic and Historic Archive of the British School at Rome; Antonio Palladino from the American Academy at Rome. A word of thanks also goes to Pietro Bonardi and Marco Meschini.

The solitude of writing was assuaged by two places that provided measures of support and encouragement, each in its own way. The team at Al Biernat's Restaurant in Dallas regularly provided me with the best-lit table in the restaurant when I needed a safe place to write, surrounded by people and noise. Thanks go to Al, Brad, Victor, Audra, Ellen, Nichole, Michael, and the Rachels.

For years I have been fortunate to spend time at the Palace Hotel in St. Moritz, Switzerland. I wrote a large portion of the manuscript there while conducting research forays across the Alps into northern Italy to key places in our story. Time spent in the Engadine inspired me. From the moment I arrived—with twelve boxes of research papers and dozens of reference books—everyone from senior management to the seasonal staff knew why I was there. Many had a sense of the challenge I faced, far from home. I thank them all, in particular my friend Giuseppe Pesenti, for acting as family during my many solitary months reading, thinking, and writing.

My friends cared for me during this long process, several at the most critical of times. Some preferred to cheer me on from the balcony; others played a more active role. My son, Diego, a gifted musician, constantly encouraged me, even when my work kept us apart. He remains my role model for selflessness.

My mom, Norma, and aunt, Marilyn Wright, are my biggest supporters. To them—and to all my friends—I extend thanks and my love, particularly to Michael Madigan, June Terry, Khanh Dao, Boyd Lyles, Drew and Susan Gitlin, Blake and Tom Stephenson, Linda and Mike Buchanan, Ken and Betty Boome, George and Fern Wachter, Ginger and Ian Russell, Alan Christopher, Rod Laver, John and Roberta McDonald, Martha Snider, Marco Bonini, Michelle Rapkin, Bret Witter, Mike Bylen, and Bobby Zorn. And to Simonetta Brandolini, whose leadership of the Friends of Florence organization makes her a modern-day "Monuments woman." To Erin, and the memory of jumping in puddles.

I lament the recent passing of dear friends Dr. Ted Pillsbury, who would have been so proud of me for writing this book, and his wife,

Mireille; and Mary Laver. Since the publication of my last book, five Monuments officers have died. I counted each of them as a "friend": Robert Koch, James Reeds, Mary Regan Queesenberry, Seymour Pomrenze, and Mark Sponenburgh.

One other friend, a man I admire and love, deserves special mention: Monuments Man Harry Ettlinger. He and the other Monuments Men and women—the few still with us and those who have departed— remain the inspiration behind my continued efforts.

HAVE YOU SEEN
THESE WORKS OF ART?

The Monuments Men Foundation for the Preservation of Art continues the mission of the Monuments Officers by bringing visibility to cultural objects still missing from World War II and assisting those seeking to return such items. If you have information about a Monuments man or woman, or you possess a work of art, document, or other cultural item you believe was stolen or "liberated" during the war, please contact us at www.monumentsmenfoundation.org.

The following works of art are among the most prominent of the more than two thousand documented as stolen from Italy during the war.

1. Raphael
Madonna of the Veil
Property of the Uffizi Gabinetto Disegni
 e Stampe, Florence
Stolen from Villa Reich, Barberino di Mugello

2. Sandro Botticelli
Portrait of an Unknown Young Man
Property of the Filangieri Museum, Naples
Stolen from Villa San Paolo di Belsito, Nola

3. El Greco

Copy of Correggio's "Night"
Property of the Contini Bonacossi Collection
Stolen from Villa di Trefiano, Poggio a Caiano

4. Peter Paul Rubens

Three Theological Virtues
Property of a Private Collection, Rome
Stolen from the EGELI (Institute for
　　Management and Sale of Property,
　　Ministry of Finance) Repository

5. Hans Memling

Portrait of a Young Man
Property of the Uffizi Gallery, Florence
Stolen from Castello di Poppi

6. Bernardo Bellotto

View of the Grand Canal in Venice
Property of the Borbone-Parma
　　Collection
Stolen from Villa delle Pianore, Lucca

7. Bernardino Luini

Madonna and Child and Sister Alessandra
Bentivoglio
Property of The Filangieri Museum, Naples
Stolen from Villa San Paolo di Belsito, Nola

8. Jan van Huysum

Vase of Flowers
Property of the Palatine Gallery, Pitti Palace,
Florence
Stolen from Montagnana

9. Pietro Rotari

Portrait of a Girl
Property of the Contini Bonacossi Collection
Stolen from Villa di Trefiano, Poggio a Caiano

10. Unknown Salzburg Goldsmith

Gold Plated Silver Tray
Property of the Silver Museum,
Pitti Palace, Florence
Stolen from the Abbey of Monte
Cassino

MONUMENTS MEN AND WOMEN SERVING IN THE MEDITERRANEAN THEATER

Maj. Paul Baillie Reynolds, British

Maj. H. E. Bell, British

T/5 Charles Bernholz, American

Pfc. Paul O. Bleecker, American

Fanny Bonajuto, Italian

Maj. John Bromwich, British

Capt. T. Humphrey Brooke, British

Lt. Col. Stanley Casson, British (Killed in transit)

Maj. J. M. Cook, British

Squadron Leader Douglas Cooper, British

Lt. Comdr. Perry B. Cott, USNR, American

Capt. Edward "Teddy" Croft-Murray, British

S/Sgt. Nicholas L. Defino, American

Lt. Col. Ernest DeWald, American

Sgt. D. L. Donn, British

Lt. Glanville Downey, American

Lt. Col. Dunbabin, British

Capt. Roger H. Ellis, British

Capt. Rodrick E. Enthoven, British

Capt. Thomas Worden French, British

Maj. Paul Gardner, American

Lt. Col. Mason Hammond, American

Lt. Col. N. C. L. Hammond, British

Lt. Frederick Hartt, American

Sir Hilary Jenkinson, British

Pfc. R. J. Jennings, American

Maj. Deane Keller, American

Maj. Bancel LaFarge, American

Lt. Kenneth O. Lippman, American

Angelo P. Lucia

Capt. Basil Marriott, British

Capt. Fred H. J. Maxse, British

Capt. William D. McCain, American

Lt. Col. Norman T. Newton, American

Cpl. D. Pascale, American

S/Sgt. Bernard Mann Peebles, American

Capt. Albert Sheldon Pennoyer, American

Capt. Cecil R. Pinsent, British

Salvatore C. Scarpitta, American

L. A. Sheppard, British

Fred W. Shipman, American

Lt. Col. Theodore Sizer, American

Capt. G. F. T. Wagstaff, British

Lt. Col. John Bryan Ward-Perkins, British

Capt. Sidney Blehler Waugh, American

Lt. Col. Mortimer Wheeler, British

Cpl. Edward N. Willard, American

Lt. Col. Sir Leonard Woolley, British

NOTES

The history of the Monuments, Fine Arts, and Archives Section and the work of the Monuments Men has been an underresearched area of World War II. There are tens of thousands of books about World War II—thousands about just D-day and the Normandy landings. By comparison, very little has been written about this group of men and women and their accomplishments, which made researching this, my third book on the subject, both exciting and fulfilling.

The challenge of reconstructing events that took place almost seventy years ago has at times been daunting. Adding to the difficulty are incongruities in various individuals' accounts of the same event. In instances of substance, I have provided a more expanded endnote to identify the differing accounts and, where possible, reconcile the disparity. Gathering the personal stories of the Monuments Men and their family members has been of primary importance. Even on the rare occasions when a complete chain of correspondence exists, as in the case of Deane Keller, whose family assiduously kept his wartime letters and cartoons, I have also interviewed others who knew Keller in order to provide a fuller perspective on his experience.

In contrast, no wartime letters home from Fred Hartt survived. In all likelihood, Fred's wife, Peggy, destroyed them. Fortunately, however, Hartt did write a book in 1949 about his wartime experiences. Using that account, combined with his extensive reports during the war, I was able to reconstruct his experience overseas. Conveying a full picture of Hartt would have been impossible without the cooperation of his companion and partner of thirty-three years, Eugene Markowski.

Assessing SS General Karl Wolff and his role during these events posed a particularly difficult problem. Some have characterized Wolff as an unreliable witness, noting his penchant for self-promotion. This is at times not inaccurate. But the abundance of documentation in the OSS records about the general's activity during Operation Sunrise, including secretly taped conversations after his arrest, postwar interrogation reports, sworn testimonies and affidavits, when combined with Wolff's autobiography and the work of others who interviewed him—in particular, German biographer Jochen von Lang—provide great insight into this intelligent, clever man. Even accounting for Wolff's extraordinary self-preservation skills, there is a consistency in the body of information that allowed me to describe his role in this story with confidence.

Most recently, distinguished German scholar Dr. Kerstin von Lingen has written two outstanding works on Wolff and his degree of guilt for war crimes. She, like British Professor Michael Salter, presents compelling case studies involving Wolff's wartime activities and his role during Operation Sunrise that put to rest any doubt that Wolff was shielded from prosecution by his friends among the Western Allies.

The absence of postwar strategic bombing surveys of Italy by the United States and Great Britain also caused some difficulty, forcing me to delve into individual reports of bombing missions and personal accounts of the pilots and bombardiers. Contemporaneous newspaper accounts proved enormously helpful in confirming what had taken place at ground level.

In this book I have tried to footnote every material fact. No authorial license has been taken with quotes. A detailed account of sources—archives, personal interviews, private files, and so on—follows.

AUTHOR'S NOTE

xiii **Cecil Pinsent** "Candidate's Separate Statement," Cecil Pinsent Application, Fellow, Royal Institute of British Architects.

xiv **"Life is full of mysteries"** Leonard Fisher, Eulogy for Deane Keller, 1992.

xiv **"I'm only sorry"** Salvatore Scarpitta (Monuments Man), interview with the author, 2006.

xiv "I was a very critical young kid" Ibid.

xv "I'm going to come back . . . thank you brother" Ibid.

EPIGRAPH

xxv "In wartime when the thoughts" Deane Keller, "Fine Arts Section," Deane Keller Papers, MS 1685, Manuscripts & Archives, Yale University Library, Yale University, New Haven, CT, Box 19, Folder 10, 1.

PRELUDE

1 At half past midnight Rosa Auletta Marrucci, ed., *Bombe sulla città: Milano in guerra 1942–1944* (Milan: Skira, 2004), 70–71.

1 lunar eclipse "Continuano i bombardamenti terroristici: il Duomo di Milano colpito," *Corriere della Sera*, August 17, 1943, 1. Eclipse: http://eclipse.gsfc.nasa.gov/5MCLEmap/1901–2000/LE1943-08-15P.gif.

1 hundreds of thousands By the end of 1943 in Milan, 250,000 people were without homes, 300,000 were evacuated, 687 had died,113 were injured, and 65 percent of monuments were seriously damaged or destroyed. Of 273 protected buildings in the city, 183 had been damaged. Marrucci, ed., *Bombe sulla città*, 70–72, 169.

2 * Marrucci, ed., *Bombe sulla città*, 243. Fra Pietro Lippini OP, "Furono i Domenicani a salvarlo dopo il bombardamento dell'agosto 1943," in *L'Ultima Cena di Leonardo da Vinci: Una lettura storica, artistica e spirituale del grande capolavoro* (Milan: Dominican Friars of the Church of Santa Maria delle Grazie, n.d.).

2 "go early in the morning" Ludwig Heinrich Heydenreich, *Leonardo: The Last Supper* (London: Allen Lane, 1974), 16.

3 "Verily I say unto you" Matthew 26:21 (King James Bible).

3 "the movement of men" Heydenreich, *Leonardo: The Last Supper*, 57.

3 The bomb had slammed Mario Frassineti et al., *Santa Maria delle Grazie* (Milan: Federico Motta, 1998), 114–15; Marrucci, ed., *Bombe sulla città*, 245.

3 relocated his fellow Dominicans Lippini, "Furono i Domenicani a salvarlo dopo il bombardamento dell'agosto 1943," 15.

3 The explosion reduced the east wall Marrucci, ed., *Bombe sulla città*, 243–44.

4 three years to complete Frank Zöllner, *Leonardo Da Vinci, 1452–1519* (Cologne: Taschen, 2003), 53.

4 almost the entire width The Refectory measures 116.47 feet (35.5 m) by 29.1 feet (8.87 m) and its height is 37.73 feet (11.5 m). Heydenreich, *Leonardo: The Last Supper,* 16.

4 Too often, such efforts Pinin Brambilla Barcilon and Pietro C. Marani, *Leonardo: The Last Supper*, trans. Harlow Tighe (Chicago: University of Chicago Press, 1999), 21.

4 **"There is no work"** Fernanda Wittgens, "Il restauro in corso del Cenacolo di Leonardo," in *Atti del convegno di Studi Vinciani; indetto dalla unione Regionale delle Province toscane e dalle Università di Firenze, Pisa e Siena 15–18 gennaio 1953* (Florence: Leo Olschki, 1953), 42.

4 **The bomb blast had also dislodged** Lippini, "Furono i Domenicani a salvarlo dopo il bombardamento dell'agosto 1943," 16.

4 **A summer rainstorm could easily** Soprintendenza ai Monumenti di Milano, "Relazione sui provvedimenti presi dopo il 16 agosto 1943 dalla Soprintendenza ai Monumenti di Milano," May 1945. National Archives and Records Administration (hereafter NARA), RG 331, 10000/145/97.

5 **Allies landed in Sicily** Rick Atkinson, *The Day of Battle: The War in Sicily and Italy, 1943–1944* (New York: Henry Holt, 2007), 75.

5 **"Never, never, never believe any war"** Winston S. Churchill, *My Early Life* (New York: Touchstone, 1996), 232.

SECTION I: INCEPTION

7 **"Works of art are not"** "Preservation of Works of Art in Italy," 8 May 1944. NARA, M1944, Roll 63.

Chapter 1: Changing of the Guard

9 **Scheduling the July 19, 1943, meeting** Albert N. Garland and Howard McGaw Smyth, *US Army in WWII: Sicily and the Surrender of Italy* (Washington, DC: U.S. Government Printing Office, 1965), 242.

9 **surrendering in such numbers** Atkinson, *The Day of Battle*, 115.

9 **Commander-in-Chief South** Kerstin von Lingen, *Kesselring's Last Battle: War Crimes Trials and Cold War Politics, 1945–1960* (Lawrence: University Press of Kansas, 2009), 31.

9 **"half-clothed Italian soldiers"** Ralph Francis Bennett, *Ultra and Mediterranean Strategy* (London: William Morrow, 1989), 225.

9 **one million German soldiers** Max Hastings, *Inferno: The World at War 1939–1945* (New York: Alfred A. Knopf, 2011), 315.

10 **"most catastrophic defeat"** Anthony Beevor, *Stalingrad: The Fateful Siege* (New York: Penguin Books, 1998), 398.

10 **The meeting . . . Feltre** F. W. Deakin, *The Brutal Friendship: Mussolini, Hitler and the Fall of Italian Fascism* (London: Phoenix Press, 1962), 400–402.

10 *Mein Kampf* The second volume of *Mein Kampf* was published on December 11, 1926. Othmar Plöckinger, *Geschichte eines Buches: Adolf Hitlers "Mein Kampf": 1922–1945* (Munich: Oldenbourg Verlag, 2006), 121.

10 **"profoundest admiration for"** Adolf Hitler, *Mein Kampf*, trans. Ralph Manheim (New York: Houghton Mifflin, First Mariner Books, 1999), 681.

10 **"remarkable self-control"** "ITALY: Benito's Birthday," *Time*, August 6, 1923.

10 **"like the one that Providence"** Pope Pius XI, "Vogliamo Anzitutto," *Libreria Editrice Vaticana*, 13 febbraio 1929. On February 11, 1929, Pius XI and Mussolini signed the Lateran Pacts. Two days later, on February 13, 1929, the pope spoke those words during a speech to students and professors at the Università Cattolica del Sacro Cuore in Milan. The official Vatican website has scripts of speeches, http://www.vatican.va/holy_father/pius_xi/speeches/documents/hf_p-xi_spe_19290213_vogliamo-anzitutto_it.html.

10 **He considered Hitler's racial theories** Greg Annussek, *Hitler's Raid to Save Mussolini: The Most Infamous Commando Operation of World War II* (Cambridge, MA: Da Capo Press, 2005), 45.

10 **By November 1 of that year** It was delivered in Milan six days after the birth of the Rome–Berlin Axis, at the Piazza Duomo from 3:55 p.m. to 4:25 p.m. before 250,000 people. Benito Mussolini, *Scritti e discorsi dell'Impero: Novembre 1935–XIV—4 Novembre 1936—XV* (Milan: Hopeli Editore, 1936–XV), 200.

11 **Food riots . . . unemployment** Stephen Harvey, "The Italian War Effort and the Strategic Bombing of Italy," *The Italian War Effort* 70, no. 228 (February 1985), 36.

11 **"tore their sons from the plough."** Salvatore Satta, *De profundis* (Milan: Adelphi, 1980), 113.

11 **"The sacrifice of my country"** Garland and Smyth, *US Army in WWII*, 242.

11 **11 a.m. . . . "determine the fate of Europe."** Deakin, *The Brutal Friendship*, 402–3.

11 **Sometime after 11:30 a.m.** Cesare De Simone, *Venti angeli sopra Roma: I bombardamenti aerei sulla Città Eterna: 19 luglio e 13 agosto 1943* (Milan: Mursia, 1993), 248. Deakin, *The Brutal Friendship*, 404, says around noon.

12 **"At this moment the enemy"** Deakin, *The Brutal Friendship*, 404.

12 **with barely a pause** De Simone, *Venti angeli sopra Roma*, 248.

12 **After Mussolini failed . . . "give us liberty of action?"** Deakin, *The Brutal Friendship*, 407–8.

12 **Although Mussolini . . . attacks would be seen by Romans** Ibid.

12 **appeared over Rome at 11:03 a.m.** De Simone, *Venti angeli sopra Roma*, 143.

12 **An enormous formation** Denis Richards and Hilary St. G. Saunders, *Royal Air Force: 1939–45: The Flight Avails* (London: Seven Hills Books), 318; Harvey, "The Italian War Effort and the Strategic Bombing of Italy," 40. Note that De Simone, *Venti angeli sopra Roma*, 160, says there were 930 planes. The official Italian report said, "between 500 and 600."

12 **virtually the entire** Wesley Frank Craven and James Lea Cate, *Army Air Forces in World War II, Vol. II, Europe: Torch to Pointblank, August 1942–December 1943* (Chicago: The University of Chicago Press, 1949), 463.

12 **From an altitude of more than twenty thousand feet** De Simone, *Venti angeli sopra Roma*, 8, 143–44.

12 **two million pounds** "Headquarters Northwest African Air Forces A-3 Sec-

tion Operations Bulletin No. 5, Period from 1 August to 31 August 1943," Lauris Norstad Papers, Eisenhower Presidential Library, Box 12, p. 70. Littorio and Ciampino Airdromes: Headquarters Northwest African Air Forces Operational and Intelligence Summary Number 150 for Period ended 1800 Hours, 20th July, 1943, Norstad Papers, Box 12.

12 **seventy seconds** De Simone, *Venti angeli sopra Roma*, 8, 143–44.

13 **Plumes of smoke . . . bomb Rome.** Harold H. Tittmann Jr. and Harold H. Tittmann III, *Inside the Vatican of Pius XII: The Memoir of an American Diplomat During World War II* (New York: Doubleday, 2004), 163.

13 **More than two thousand people . . . most were civilians** The Fascist government changed the data immediately and on Wednesday, July 21, communicated that civil casualties totaled 176, plus 1,659 injured, while on Ambrosio's desk there was already a report that the deaths were at least 2,000. On the morning of Friday, July 23, the newspaper *Il Messaggero* published a short communication from the Ministry of Internal Affairs, saying that the deaths were 717, and 1,599 injured. On that same night, the General Commando of the Carabinieri had sent to the government a short report stating that the number of victims "cannot be considered inferior to 2,000 or 2,200 people." Soon after, "757 registered corpses" became the "official" number of casualties for the bombing of July 1943. Cesare De Simone believes the number of people killed during the bombing of July 19 were between 2,800 and 3,200, probably closer to around 3,000 or more; the injured were likely to be around 11,000 or 12,000. De Simone, *Venti angeli sopra Roma*, 262–64.

13 **"death . . . comes"** Claudia Baldoli and Marco Fincardi, "Italian Society Under Anglo-American Bombs: Propaganda, Experience, and Legend, 1940–1945," *The Historical Journal* n. 52, vol. 4 (December 1, 2009): 1036.

14 **"Your Holiness. . . ."** Tittmann, *Inside the Vatican of Pius XII*, 157–58.

14 **"The more I think"** Owen Chadwick, *Britain and the Vatican during the Second World War* (Cambridge, UK: Cambridge University Press, 1986), 216.

14 **"Good! Now also our old Mussolini"** De Simone, *Venti angeli sopra Roma*, 249.

14 **For the duration . . . study** Ronald J. Rychlak, *Hitler, the War, and the Pope* (Huntington, IN: Our Sunday Visitor Publishing Division, 2010), 221.

14 **through binoculars** De Simone, *Venti angeli sopra Roma*, 246.

14 **"carry out his pastoral duties"** Tittmann, *Inside the Vatican of Pius XII*, 166.

14 **comfort the survivors** "Il Santo Padre tra i fedeli della Sua Diocesi di Roma colpiti dall'incursione aerea," *L'Osservatore Romano*, 19 July 1943, 1.

14 **Ignoring security concerns . . . black Mercedes** Robert Katz, *The Battle for Rome: The Germans, the Allies, the Partisans and the Pope, September 1943–June*

1944 (New York: Simon & Schuster, 2004), 15. Antonio Spinosa, *Pio XII, un Papa nelle tenebre* (Milan: Oscar Mondadori, 2004), 218, says that the pope was in a Fiat Topolino because his other car, a Graham Paige 837, wouldn't start that morning.

14 **accompanied only by Monsignor Montini and their driver** Tittmann, *Inside the Vatican of Pius XII*, 166; Fabrizio Bettelli and Francesco Arlanch, *Sotto il cielo di Roma*. Video, Christian Duguay (31 October 2010; Rome, Lazio, Italy: Rai Fiction, Lux Vide, Eos Entertainment, Tellux, Bayerischer Rundfunk e Rai trade, 2010).

14 **"Holiness" and "Peace"** Katz, *The Battle for Rome*, 15.

14 **"His face pale with grief"** Tittmann, *Inside the Vatican of Pius XII*, 166–67; "Il pontefice si inginocchia sulle macerie di San Lorenzo," *Corriere della Sera*, 21–22 July 1943, 1; De Simone, *Venti angeli sopra Roma*, 252–53.

15 * Rychlak, *Hitler, the War, and the Pope*, 221.

15 **first time in three years** Tittmann, *Inside the Vatican of Pius XII*, 166; Katz, *The Battle for Rome*, 15; De Simone, *Venti angeli sopra Roma*, 253.

15 **white cassock stained** John Cornwell, *Hitler's Pope: The Secret History of Pius XII* (New York: Penguin Books, 2008), 298.

16 **5 p.m. on Saturday, July 24 . . . three years without a meeting** Deakin, *The Brutal Friendship*, 437, 457.

16 **concealing pistols and grenades** Ibid., 440.

16 **At 2:40 a.m.** Deakin, *The Brutal Friendship*, 440–53, says the vote was 19–7 with one abstention. Cornwell, *Hitler's Pope*, 298, says the vote was 19–8.

16 **"There was a silence"** Deakin, *The Brutal Friendship*, 470.

16 **the king had arranged** Ibid., 469.

17 **As Mussolini exited . . . "protect your person"** Ibid., 471.

17 **Within hours, tens of thousands** Katz, *The Battle for Rome*, 23.

17 **"The supply of wine"** Allen W. Dulles, *From Hitler's Doorstep: The Wartime Intelligence Reports of Allen Dulles, 1942–1945*, ed. Neal H. Petersen (University Park: Pennsylvania State University Press, 1996), 90.

17 **"The Duce has resigned"** Helmut Heiber, ed., *Lagebesprechungen im Führerhauptquartier, Protokollfragmente aus Hitlers militärischen Konferenzen 1942–1945* (Stuttgart: Deutscher Taschenbuchverlag, 1963), 152.

17 **Because of Hitler's order** André Brissaud, *Canaris: The Biography of Admiral Canaris, Chief of German Military Intelligence in the Second World War* (New York: Grosset & Dunlap, 1974), 305.

17 **"Undoubtedly, in their treachery"** Heiber, ed., *Lagebesprechungen im Führerhauptquartier*, 155.

17 **Allied bombing of Hamburg . . . destruction of the city** Sir Charles Webster and Noble Frankland, *The Strategic Air Offensive Against Germany 1939–1945, Volume II: Endeavor* (London: Her Majesty's Stationery Office, 1961), 150, 261.

18 **sixty thousand** *Wehrmacht* Carlo D'Este, *Bitter Victory: The Battle for Sicily, 1943* (New York: HarperCollins, 1988), 607.

18 **2.1 million soldiers** Giorgio Rochat, *L'esercito italiano in pace e in guerra: studi di storia militare* (Milan: R.A.R.A., 1991), 285. As of May 31, 1943.

18 **With the exception of** Deakin, *The Brutal Friendship*, 483

18 **"give the commander of the 3rd Panzergrenadier Div."** Heiber, ed., *Lagebesprechungen im Führerhauptquartier*, 156.

18 **However, Generalfeldmarschall Kesselring** Gilbert, *Hitler Directs His War*, 31.

19 **"I am going into the Vatican immediately"** Said during the night July 25–26. Heiber, ed., *Lagebesprechungen im Führerhauptquartier*, 171.

19 **"macaroni eaters"** Richards and Saunders, *Royal Air Force*, 311.

19 **Goebbels knew** Josef Goebbels, *The Goebbels Diaries: 1942–1943*, ed. and trans. Louis P. Lochner (New York: Doubleday, 1948), 409.

19 **Most of Hitler's advisers agreed** Ibid., 416.

19 **"master of all the concentration camps"** Jochen von Lang, *Der Adjutant, Karl Wolff: Der Mann zwischen Hitler und Himmler* (Munich/Berlin: F. A. Herbig Verlagsbuchhandlung, 1985), 11.

19 **"The *Signores* [*sic*] get another reprieve"** Ibid., 199.

19 **He had joined the Imperial German Army . . . started his own firm.** Lang, *Der Adjutant*, 14–21; Karl Wolff CVs, 7 October 1931, 5 March 1932, 23 September 1943, BArch, SS-F.P. 10-C. (microfilm), Bundesarchiv, Berlin.

19 **Although Wolff did not come . . . added to his self-image of nobility.** Lang, *Der Adjutant*, 15.

20 **They considered him a "Septemberling"** Ibid., 13.

20 **Wolff, in fact, waited . . . for the SS** Lang, *Der Adjutant*, 16; Karl Wolff SS Admission Form, 7 October 1931, BArch, SS-F.P. 10-C (microfilm), Bundesarchiv, Berlin.

20 **Beginning in November 1936** Lang, *Der Adjutant*, 45–46; Michael H. Kater, *Das "Ahnenerbe" der SS 1935–1945: Ein Beitrag zur Kulturpolitik des Dritten Reiches* (Munich: Oldenbourg Wissenschaftsverlag, 2001), 41.

20 * Joan Clinefelter, *Artists for the Reich: Culture and Race from Weimar to Nazi Germany* (Oxford: Berg, 2005), 105.

20 **"Himmler's eyes and ears"** Lang, *Der Adjutant*, 130.

20 **"Faith has put me"** Ibid., 193.

20 **In July 1941, Wolff accompanied Himmler** Dan Kurzman, *A Special Mission: Hitler's Secret Plot to Seize the Vatican and Kidnap Pope Pius XII* (Cambridge, MA: Da Capo Press, 2007), 24; Kerstin von Lingen, *SS und Secret Service, "Verschwörung des Schweigens": Die Akte Karl Wolff* (Paderborn: Ferdinand Schöningh, 2010), 201.

20 **The following summer, he interceded** Lingen, *SS und Secret Service*, 190.

20 **"I notice with particular pleasure"** Ibid.

21 **During their late-July meeting** Lang, *Der Adjutant*, 198–99.

21 **Wolff had fourteen days** Ibid., 199.

21 **"specimen of a noble German"** Ibid., 297–98.

21 **Wolff had also won favor** Ibid., 70, 199.

21 **"was to consider himself the Führer's governor"** Ibid., 206.

21 **"that those fellows intend"** "Testimony of Erwin Lahousen taken at Nurnberg, Germany, 1 February 1946," NARA, RG 238, Entry 7A, Box 11.F: Lahousen, Erwin (Vol. 2, Nov–March 46) I, 6.

21 **"Such a dirty trick"** Ibid., 7.

22 **On July 29** War Diary of Lahousen, NARA, RG 238, Box 18, Entry 2; Cesare Amè, *Guerra segreta in Italia 1940–1943* (Rome: Casini, 1954), pages 181–84 say the meeting in Venice took place August 2–3, 1943, not July 29, as per Lahousen.

22 **"Be careful and watch out"** "Testimony of Erwin Lahousen taken at Nurnberg, Germany, 1 February 1946," NARA, RG 238, Entry 7A, Box 11.F: Lahousen, Erwin (Vol. 2, Nov–March 46), I, 8.

22 **After lunch, Canaris and Amè** Amè, *Guerra segreta in Italia*, 182–83.

22 **"to review the political situation"** David Alvarez and Robert Graham Sr., *Nothing Sacred* (London: Frank Cass, 1997), 84.

22 **"warned his audience" . . . floors of the Papal Palace** Ibid.

22 **Nineteen days later . . . "confidential documents"** Tittmann, *Inside the Vatican of Pius XII*, 183.

22 **"wanted to kill him"** Alvarez and Graham, *Nothing Sacred*, 84; "Testimony of Erwin Lahousen taken at Nurnberg, Germany, 1 February 1946," NARA, RG 238, Entry 7A, Box 11.F: Lahousen, Erwin (Vol. 2, Nov–March 46) I, 9. Renowned war correspondent and historian William Shirer was present when Major General Erwin Lahousen entered the courtroom in Nuremberg on November 30, 1945. Lahousen was the first prosecution witness of the trial, so his credibility made quite an impression. "At last a German—and a general at that . . . has had the guts to stand up publicly before the world and brand Nazi Germany and the Nazis for what they were!" William Shirer, *End of a Berlin Diary: 1944–1947* (Norwalk, CT: Easton Press, 1991), 322.

Chapter 2: A New Type of Soldier

23 **"The via del cuore"** Deane Keller, "American Impressions of Italians and Italian Customs," NARA, RG 331, 10000/145/1.

23 **"short, stocky blond chap"** newspaper clipping, Keller Papers, Box 1, Folder 2.

24 **1.1 million Soviet casualties** Beevor, *Stalingrad*, 394.

24 **Sugar and coffee** Ronald Bailey, *The Home Front: U.S.A.* (Morristown, NJ: Time-Life Books, 1977), 112.

24 **By 1943, the ration list** Ibid.

24 **Americans planted more than** Ibid., 108.

24 **The military deployment of so many men** Ibid., 85.

24 **Three million kids** Ibid.

24 **women comprising almost a third of the nation's work force** Ibid.

25 **"leads an artist to all the possibilities"** Interview with William Keller (son of Deane Keller), 2005, courtesy of Actual Films.

26 **sandbags covered the windows** Charles Seymour, "Yale at War: An American University Accepts the Challenge," *Life*, June 1942, Yale During World War II, MS 1212, Manuscripts & Archives, Yale University Library, Box 4, Folder 60. "Yale University News Bureau to Yankee Magazine," Yale During World War II, Box 4, Folder 60.

26 **He first tried the Marines** Letter to Parents, Keller Papers, Box 5, Folder 24.

27 **"Dear Deane"** Letter from Sizer, 30 May 1943, Keller Papers, Box 12, Folder 99.

27 **By August, however . . . "no word as yet"** Letter to Parents, 18 August 1943, Keller Papers, Box 5, Folder 24.

28 **"longed for her"** Eugene Markowski (companion and partner of Fred Hartt), in discussion with the author, May 22, 2012.

28 **Fred's emotional connection . . . for many years.** Carole Dick, "Hart to Hartt: A Family History" (unpublished manuscript, 2005), 163.

28 **"working with his hands"** Markowski, in discussion with the author, May 22, 2012.

28 **Fred's later efforts . . . was abandoned** Ibid.

29 **In 1942 . . . education, art, and travel** Margaret Hildson (niece of Frederick Hartt), in discussion with the author, May 22, 2012.

29 **He first traveled there** Eddie DeMarco, "After 17 years as professor, Hartt reflects on art, life," Frederick Hartt Papers, National Gallery of Art, Gallery Archives, RG 28, Box 23, Folder 1.

29 **"I lost my heart"** Letter, 28 February 1968, Hartt Papers, Box 18, Folder 7.

Chapter 3: "Bombs and Words"

31 **Commander-in-Chief, Allied Forces in North Africa** D'Este, *Bitter Victory*, 584.

31 **"the German intruders" . . . "We should stimulate this process"** Churchill to Eisenhower, 27 July 1943, Bedell Smith Papers, Dwight D. Eisenhower Presidential Library, Abiline, Kansas, Box 16.

31 **"bombs and words"** Memo, 31 July 1943, C. D. Jackson Papers, Eisenhower Presidential Library, Box 24, Folder 1.

32 **"We are coming to you as liberators"** Churchill Telegram to Gen. Eisenhower (Algiers) re Telegram FDR to Churchill, 28 July 1943, Churchill Archives Centre, Cambridge, UK, CHAR 20/247, T.1130/3 re No. 327 (T.1125/3).

32 **"played for time" . . . "will resume"** United Press. "Italian Fleet Under Steam, Set to Flee: Fear Germans will Seize Warships if Peace Made," August 1, 1943.

32 **list of bombing targets . . . "effect on our campaign"** Draft Memo on Morale Purposes of Bombing Italian Cities, C. D. Jackson Papers, Box 24, Italian Situation (1).

32 **"We have not bombed Northern Italy"** Churchill Telegram, 29 July 1943, Bedell Smith Papers, Box 17.

32 **"I cannot see any reason"** Churchill Memo to UK Foreign Secretary, 1 August 1943, Churchill Archives Centre, Cambridge, UK; CHAR 20/247, M.557/3.

33 **"I never briefed [air]crews"** Conrad C. Crane, *Bombs, Cities, and Civilians: American Airpower Strategy in World War II* (Lawrence: University Press of Kansas, 1993), 94.

33 **864,000 leaflets** D'Este, *Bitter Victory*, 428.

33 **PWB also aired radio messages** Memo, 31 July 1943, C. D. Jackson Papers, Box 24, Folder 1.

34 **"It should be emphasized"** Mark Connelly, *Reaching for the Stars: A New History of Bomber Command in World War II* (New York: I. B. Tauris, 2002), 115; Harris to Portal and Sinclair, 25 October 1943, Public Records Office, AIR 2/7852.

34 **"Night bombing does not"** *Foreign Relations of the United States: Diplomatic Papers 1942, Vol. III: Europe* (Washington, DC: United States Government Printing Office, 1961), 794.

34 **thirty thousand Londoners** Don Miller, *Masters of the Air: America's Bomber Boys Who Fought the Air War Against Nazi Germany* (New York: Simon & Schuster, 2006), 51.

34 **Standing on the roof . . . "fire below."** Sir Arthur Harris, *Bomber Offensive* (Barnsley, Yorkshire: Pen & Sword Military Classics, 2005), 51.

34 **"The Nazis entered this war"** *Air Marshal Arthur Harris Speaks About RAF Bomber Command's Strategic Offensive Against Germany*, Imperial War Museum, London, RAF Film Production Unit, June 3, 1942.

34 **The late July 1943 bombings** Miller, *Masters of the Air*, 184.

35 **The hundreds of tons of high explosives** Jörg Friedrich, *The Fire: The Bombing of Germany, 1940–1945* (New York: Columbia University Press, 2006), 1.

35 **"The [4,000-pound blockbuster] bomb"** Friedrich, *The Fire*, 14.

35 **"Small fires united into"** Harris, *Bomber Offensive*, 174.

35 **"The idea was to keep on"** Ibid., 77.

35 **The first bombs dropped on Italy** Baldoli and Fincardi, "Italian Society Under Anglo-American Bombs," 1018.

35 **"the Italian 'psychology'"** Gabriella Gribaudi, *Guerra totale. Tra bombe alleate e violenze naziste. Napoli e il fronte meridionale, 1940–1944* (Turin: Bollati Boringhieri, 2005), 48.

35 **"maximum political and military pressure"** Telegram, Churchill to Roosevelt, August 4, 1943, Churchill Archives Centre, Cambridge, UK, CHAR 20/247, t. 1202/3.

35 **people would revolt** Baldoli and Fincardi, "Italian Society Under Anglo-American Bombs," 1020.

35 **Bombs fell on Genoa** Harris, *Bomber Offensive*, 140–41.

35 **An October 24 daylight raid** Bomber Command, "Campaign Diary: October 1942," *Royal Air Force Bomber Command 60th Anniversary*, April 6, 2005, http://www.raf.mod.uk/bombercommand/oct42.html.

36 **Mussolini's order** Baldoli and Fincardi, "Italian Society," 1037; Benito Mussolini, *Opera omnia di Benito Mussolini: dal discorso al direttorio nazionale del P.N.F. del 3 gennaio 1942 alla liberazione di Mussolini*, ed. Edoardo and Duilio Susmel (Florence: La Fenice, 1960), 126.

36 **"the Milanese ignored"** Smith, *Bombing to Surrender*, 78. He cites *Time, Newsweek*, and OSS Reports.

36 **"the aim of the Combined Bomber Offensive"** Norman Longmate, *The Bombers: The RAF Offensive against Germany, 1939–1945* (London: Hutchinson, 1983), 369.

36 **the city center of Milan.** Marrucci, ed., *Bombe sulla città*, 68–69. On buildings destroyed, see: Roberto Cecchi, from "Il Novecento," *TRECCANI Enciclopedia*, chap. II, "Distruzioni Belliche e opera di ricostruzione" (1945–1960).

36 **Damage to its water mains** Keller, "Fine Arts Section," Keller Papers, Box 19, Folder 10, 66.

36 **Citizens of the Swiss city of Lugano** "Britain's Bombers Deal Heavy Blows," *New York Times*, August 16, 1943.

36 **"building was gutted by fire."** Keller, "Fine Arts Section," Keller Papers, Box 19, Folder 10, 68.

37 **Milan's two principal art museums** Field Report, 12 May 1945, Keller Papers, Box 21, Folder 33.

37 **In all . . . "badly damaged"** Richards and Saunders, *Royal Air Force 1939–45*, 325.

37 **"the hardships, suffering"** "Text of Premier Mussolini's Address to the Italian People on the War," *New York Times*, February 24, 1941.

37 **The *Regia Aeronautica*** Harvey, "The Italian War Effort and the Strategic Bombing of Italy," 41–42.

37 * Ibid., 37.

37 **"public services in disarray"** Ibid., 41–42.

38 **The Italian inclination . . . "drove with full lights."** Baldoli and Fincardi, "Italian Society," 1026.

38 **Royal Air Force navigator . . . "by their men"** Don Charlwood, *No Moon Tonight* (Manchester, UK: Crécy Publishing, 1956), 142.

38 **"Smaller [British RAF] forces"** Richards and Saunders, *Royal Air Force*, 325.

39 **"the frequent and intense bombing"** "La funzione terroristica dei bombardamenti Anglo-Americani," *Corriere della Sera*, August 18, 1943. The article in the *Corriere della Sera* quotes the Rome newspaper *Il Popolo di Roma*.

39 **"again brilliantly lighted"** "Lights on in Cairo; Long Blackout Ends," *New York Times*, August 21, 1943.

39 **"after the war"** United Press, "Telegrams by Light Hinted for Post-War," *New York Times*, August 21, 1943.

39 U.S. GROUP IS NAMED "U.S. Group is Named to Save Europe's Art," *New York Times*, August 21, 1943.

40 **"No one there could". . . . "aware of its importance."** "Report on Conversation with Herbert Matthews," NARA, M1944, Roll 57.

40 **"specialist in planning"** Harry L. Coles and Albert K. Weinberg, *Civil Affairs: Soldiers Become Governors* (Honolulu, HI: University Press of the Pacific, 2005), 87.

Chapter 4: The Experiment Begins

41 **President Roosevelt had, in fact, signed** *Report of The American Commission for the Protection and Salvage of Artistic and Historic Monuments in War Areas* (Washington, DC: United States Government Printing Office, 1946), 3.

41 **Aware that the Commission. . . . The first candidate** Mason Hammond, "Remembrance of Things Past: The Protection and Preservation of Monuments, Works of Art, Libraries, and Archives during and after World War II," *An Offprint from the Proceedings of the Massachusetts Historical Society*, vol. 92, 1980, 87.

42 **"My qualifications were not in art"** Hammond, "Remembrance of Things Past," 87.

43 **"the assignment for which I was destined"** "Protection of Monuments in North Africa," 3 July 1943, NARA, RG 165, NM-84/Entry 463, Subseries I, Box 1, Folder: CAD 000.4.

43 **"It is unfortunate . . . what not to hit"** Hammond to Reber, July 24, 1943. NARA, RG 165, NM-84/Entry 463, Subseries I, Box 1, Folder: CAD 000.4.

44 **Knowing that the army . . . captured in Libya** Mason Hammond, "Copy of Report of Professor Mason Hammond on his Work in Italy," NARA, RG 239, M1944, Roll 22, Frames 88–115, 7.

44 **Not until July 28, almost three weeks after** Ibid.

45 **"methods too devious"** "Progress Report for the Month of September of the Office of Fine Arts and Monuments," October 7, 1943, NARA, RG 331 10000/145/24.

45 **Hammond found a car** Ibid.

45 **"small and decrepit"** "Copy of Report of Professor Mason Hammond," 11.

45 **A Lancia, "model about 1927"** "Report on the Advisers on Fine Arts and Monuments in AMGOT, for October 1943, November 1, 1943," NARA, RG 331, 10000/145/24.

45 **"None of these has endured"** "Activities of Advisers on Fine Arts and Monuments, AMGOT, 5 November 1943," NARA, RG 331, 10000/145/24.

45 **clipping from** *The New York Times* Letter to Finley, undated, NARA, RG 239, M1944, Roll 14.

45 **first official Adviser** Hammond Report on Italy, NARA, RG 239, M1944, Roll 22.

46 **The most significant monuments of Sicily** "Activities of Advisers on Fine Arts and Monuments," NARA, RG 331, 10000/145/24.

46 **"One has the ever present spectacle"** Letters to Florence, 17 August 1943 and September 1943, Mason Hammond Papers, Private Collection, London.

46 **Most of the German forces** D'Este, *Bitter Victory*, 608.

47 **Even while Marshal Badoglio** Deakin, *The Brutal Friendship*, 500.

47 **only a matter of time before Italy double-crossed** Heiber, ed., *Lagebesprechungen im Führerhauptquartier*, 197–98.

47 **Rudolf Rahn, was meeting with Badoglio in Rome** Rudolf Rahn, *Ruheloses Leben* (Düsseldorf: Peter Diederichs Verlag, 1949), 228. Rahn said it was 11 a.m., Deakin said it was noon.

47 **On September 8** Ibid., 229

47 **"continue the struggle"** Deakin, *The Brutal Friendship*, 529. Note that in Rahn's *Ruheloses Leben*, 229, he added, "Marshal Badoglio is an honorable soldier whose assurances can be fully trusted."

47 **fifty-five thousand Allied troops** Atkinson, *The Day of Battle*, 199.

47 **"The Italian government has surrendered"** Ibid., 195.

47 **"threw their weapons away"** Richards and Saunders, *Royal Air Force*, 331.

47 **German forces. . . . Within twenty-four hours** Deakin, *The Brutal Friendship*, 530–31.

48 **The pope had instructed** Chadwick, *Britain and the Vatican during the Second World War*, 272.

48 * http://msgrhughoflaherty.50webs.com/chapter2.html/#white.

48 **The Germans posted guards** Chadwick, *Britain and the Vatican during the Second World War*, 272.

48 **On September 12** Deakin, *The Brutal Friendship*, 537.

48 **"Duce, the Führer has sent me". . . . "I knew my friend Adolf Hitler"** Annussek, *Hitler's Raid to Save Mussolini*, 228.

48 **Standing by to greet him** Lang, *Der Adjutant*, 216. Goebbels says they met at the Wolfsschanze.

48 **Mussolini would be the titular head** Ibid., 218.

48 **Wolff had returned** Karl Wolff, *Mit Wissen Hitlers: Meine Geheimverhandlungen über eine Teilkapitulation in Italien 1945: Der persönliche Bericht des "Höchsten SS- und Polizeiführers" sowie "Bevollmächtigten General der Deutschen Wehrmacht in Italien"* (Stegen am Ammersee, Germany: Druffel & Vowinckel-Verlag, 2008), 17.

49 **"You vouch for the Duce"** Lang, *Der Adjutant*, 210.

49 **"I now have a special order for you, Wolff"** Karl Wolff, "Niederschrift über meine Besprechungen mit Adolf Hitler September bis Dezember 1943

über die Anweisungen den Vatikan zu besetzen und über die Verschleppung des Papstes Pius XII" (hereafter referred to as Wolff, Wolff Affidavit), March 28, 1972, Munich, accessed at http://www.ptwf.org/Downloads/Wolff%20 Affidavit.pdf. The affidavit may also be found on pp. 53–62 of Wolff's auto-biography, *Mit Wissen Hitlers*. Wolff provided this affidavit in conjunction with proceedings relating to the Vatican's beatification of Pope Pius XII.

49 **"Yes, my Führer!"** Wolff, Wolff Affidavit.

49 **"As soon as possible I want you and your troops"** Wolff, Wolff Affidavit.

49 **"There will be quite an uproar worldwide"** Lang, *Der Adjutant*, 210.

49 **"How long might it take you"** Wolff, Wolff Affidavit.

49 **"I am quite frankly not sure"** Ibid.

49 **"This seems too long" . . . "I would prefer"** Ibid.

50 **"If one wants a first class result"** Lang, *Der Adjutant*, 210.

50 **On October 1, 1943** Sir Leonard Woolley, *The Protection of the Treasures of Art and History in War Areas* (London: His Majesty's Stationery Office, 1947), 7.

50 **"The first ships left"** Ibid.

Chapter 5: Growing Pains

51 **On September 25, Deane Keller** "Status of Officer," 4 January 1945, Keller Papers, Box 21, Folder 33.

53 **"is a big sacrifice for you"** Letter from Mother, 7 October 1943, Keller Papers, Box 5, Folder 30.

53 **"prisoner rations & tight quarters" "The convoy arrived"** Letter to Kathy, 2 November 1944, Keller Papers, Box 7, Folder 50.

53 **open barracks with a dirt floor** Letter to Kathy, 22 November 1944, Keller Papers, Box 7, Folder 50.

53 **"we are in North Africa"** Letter to Kathy, 25 November 1943, Keller Papers, Box 7, Folder 42.

53 **Keller spent the first week** "Status of Officer," 4 January 1945, Keller Papers, Box 21, Folder 33.

53 **train to Algiers . . . card marked** SECRET Letter to Kathy, 22 November 1944, Keller Papers, Box 7, Folder 50.

53 **two-month course focused on** Thomas B. Turner, "Chapter II: Selec-tion and Training of Civil Public Health Personnel," *Preventative Medicine in World War II, Volume III: Civil Affairs/Military Government Public Health Activities*, ed. John Lada (Office of the Surgeon General, Department of the Army: Washington, DC, 1976), 29.

54 **"From the beginning of the conquest"** Dwight D. Eisenhower, *Crusade in Europe* (Garden City, NY: Doubleday, 1948), 191–92, 434.

54 **bow tie and flowing cape . . . survived at least one fall** "Theodore Sizer, Art Teacher and Heraldist, Dies," *New York Times*, June 22, 1967.

54 **"misconceptions of my military prowess"** Elise Kenney, "From the

Archives: Theodore Sizer, 1892–1967: 'A Teacher, an author, and a craftsman of infinite perfection,'" *Yale Art Gallery Bulletin*, 2006, 155–60.

55 **"extremely restive"** Sizer to Emerson Tuttle, 11 October 1943, Theodore Sizer Papers, MS 453, Manuscripts & Archives, Yale University Library, Box 11, Folder 167.

55 **"You would laugh"** Ibid.

55 **British Monuments officer. . . . "What on Earth". . . . Neither man. . . . "Deplorable lack". . . . As the reality. . . . "Priority I"** Lionel Fielden, *The Natural Bent* (London: Andre Deutsch Limited, 1960), 258–60.

56 **After explaining. . . . "Well, well, we know"** Ibid., 260.

56 **Days later, Fielden. . . . "were filled"** Ibid., 262–64.

57 **He also kept up his drawing** Letter from Everett Meeks, 29 January 1944, Keller Papers, Box 9, Folder 63.

57 **"I have fired a carbine"** Letter to Parents, 21 December 1943, Keller Papers, Box 5, Folder 24.

57 **"feel a little less like a lost sheep"** Letter to Parents, 28 December 1943, Keller Papers, Box 5, Folder 24.

57 **"Dearest Kathy. . . . As I write"** Letter to Kathy, 25 December 1943, Keller Papers, Box 7, Folder 42.

57 **"Still, I talked to a British GI"** Ibid.

57 **"Toozy Woozy"** "Dear Deane: This Is Daddy's History," Keller Papers, Box 6, Folder 33.

57 **"I hear there is a lot to do in Italy"** Letter to Kathy, 23 January 1944, Keller Papers, Box 7, Folder 43.

Chapter 6: A New Order

59 **"Military channels are like"** Hammond Letter to Finley, NARA, RG 239, M1944, Roll 14.

59 **"It's a curious city of poverty"** Sizer to Tuttle, 24 November 1943, Sizer Papers, Box 11, Folder 157.

60 **"Everything worthwhile has been"** Letter to Emerson Tuttle Esq., 10 November 1943, Sizer Papers, Box 11, Folder 157.

60 **"No Keller as yet."** Ibid.

60 **"M.H. [Hammond] literally worked"** Letter to Paul J. Sachs, 2 December 1943, NARA, M1944, R-57.

60 **Besides exhaustion, Hammond also** Mason Hammond, "Copy of Report of Professor Mason Hammond on his Work in Italy," NARA, RG 239, M1944, Roll 22, Frames 88–115, 24.

60 **"the mess at Syracuse"** Ibid.

60 **"He ran into a WAC". . . . "Mason Hammond has done"** Letter to Paul J. Sachs, 11 January 1944, NARA, M1944, R-57.

60 **A new organization** Hammond, "Copy of Report of Professor Mason

Hammond on his Work in Italy," NARA, RG 239, M1944, Roll 22, Frames 88–115, 22.

61 **"I was told in Sicily"** Hammond, "Remembrance of Things Past," 88.

61 **British Professor Solomon "Solly" Zuckerman** "Air Mission," NARA, RG 331, 10000/145/259.

61 **156 bombs** "Final Report: Campania," Keller Papers, Box 23, Folder 51, 4.

62 **"half demolished". . . "serious losses to the collection."** Ibid., 26.

62 **August 24** Louise Zarmati, "Amedeo Maiuri: In Search of the 'Dark Side,'" *Teaching History: Journal of the History Teachers' Association of NSW*, vol. 40, December 2006.

62 **"If the whole of Italy"** "Air Mission," NARA, RG 331, 10000/145/259.

62 **the revised list, containing the names of forty-six** Ibid.

62 **he accepted a position** Today the museum is known as the Nelson-Atkins Museum of Art.

63 **Gardner received orders to report to Ischia** "Final Report General," Headquarters Allied Commission, Subcommission for Monuments, Fine Arts, and Archives, 1 January 1946, Keller Papers, Box 23, Folder 52, 3.

63 **Gardner didn't reach Naples** Ibid.

63 **The city lay in ruins** Atkinson, *The Day of Battle*, 241–42.

63 **"Some German patrolmen"** "Translation of a speech delivered by Dr. Adolfo Omodeo, Rector of the University of Naples on 14 October, 1943 at a Convocation for the reopening of the University after the burning by the Germans on 12 September, 1943," NARA, RG 239, M1944, Roll 62, AMG-4.

64 **"personal immortality"** "Preservation of Ancient Monuments," 23 September 1943, RG 331, 10000/145/199.

64 **inscribing their names** Theodore Sizer, "A Walpolean at War," *The Walpole Society Notebook* (1946), 77.

64 **"a locked door is an irresistible challenge"** Ibid., 76.

64 **"The continued requisitioning and pillage"** Memorandum to Hume, 18 November 1943, NARA, RG 331, 10000/145/31.

65 **"Protection of artistic and historic monuments"** George C. Marshall, "Protection—Artistic Historic Monuments in Italy, 14 October 1943, Dwight D. Eisenhower Papers, Pre-Presidential, 1916–52, Eisenhower Presidential Library, Box 132, CABLES OFF. (GCM/DDE July 29, 1943–February 19, 1944) (3).

65 **made an inspection of Palermo and Naples** "The Commandeering of the Naples Museum for Military Purpose," 7 December 1943, Woolley Memo, NARA, RG 239, M1944, Roll 62; Woolley letter to Dinsmoor, March 2, 1944, NARA RG 239, M1944, Roll 60; First Monthly Report for November 1943, December 4, 1943, NARA, RG 239, M1944, Roll 62, AMG-5.

65 **since 1941 he had also. . . . On three separate occasions** H. V. F. Winstone,

Woolley of Ur: The Life of Sir Leonard Woolley (London: Secker & Warburg, 1990), 228.

66 **He returned to Allied Force Headquarters** Woolley, *The Protection of the Treasures of Art and History in War Areas*, 27.

66 **"I suggest . . . a General Order"** "The Commandeering of the Naples Museum for Military Purpose," 7 December 1943, Woolley Memo, NARA, RG 239, M1944, Roll 62.

66 **"Crimes are being committed"** "Memorandum for General Eisenhower," 13 December 1943, Eisenhower Presidential Library, Eisenhower Pre-Presidential, Box 75, Folder 3.

67 **"To: All Commanders"** Woolley, *The Protection of the Treasures of Art and History in War Areas*, 22.

67 **"made it clear that the responsibility"** Ibid.

67 **"The weakness of the Monuments and Fine Arts organization"** Ibid., 24.

Chapter 7: A Troubled Bunch

69 **On August 25, 1914** Paul Clemen and Gerhard Bersu, "Kunstdenkmäler und Kunstpflege in Belgien," *Kunstschutz im Kriege, Bericht über den Zustand der Kunstdenkmäler auf den verschiedenen Kriegsschauplätzen und über die deutschen und österreichischen Massnahmen zu ihrer Erhaltung, Rettung, Erforschung, Erster Band*, ed. Paul Clemen (Leipzig: Verlag von E. A. Seemann, 1919), 18.

69 **248 citizens** Alan Kramer, *Dynamic of Destruction: Culture and Mass Killing in the First World War* (Oxford: Oxford University Press, 2007), 11.

69 **The blaze destroyed** Paul Clemen und Gerhard Bersu, "Kunstdenkmäler und Kunstpflege in Belgien," *Kunstschutz im Kriege*, 20.

70 **Otto von Falke** Otto von Falke, "Die Einrichtung des Kunstschutzes auf den deutschen Kriegsschauplätzen," *Kunstschutz im Kriege*, 11–16.

70 **Clemen's role as Provincial Conservator** Landschaftsverband Rheinland, ed.,*"Der Rhein ist mein Schicksal geworden," Paul Clemen. 1866–1947. Erster Provinzialkonservator der Rheinprovinz* (Cologne: Rheinisches Amt für Denkmalpflege in Verbindung mit dem Rheinischen Landesmuseum Bonn, 1991), 19.

70 **On January 1, 1915** Otto von Falke, "Die Einrichtung des Kunstschutzes auf den deutschen Kriegsschauplätzen," *Kunstschutz im Kriege*, 12.

70 **"Cultural goods and art"** Paul Clemen, "Die Denkmalpflege im Urteil des Auslands" (refers to article in *Berliner Lokal Anzeiger*, 8.X.1914), *Kunstschutz im Kriege*, 121.

70 **the University of Louvain Library** E. Lousse, *The University of Louvain During the Second World War* (Bruges: Desclée, de Brouwer, 1946).

70 **Sedes Sapientiae non Evertetur** Phillip A. Metzger, "Catholic University of Louvain," *Journal of Library History* 15, no. 3 (Summer 1980): 329.

71 **The appointment, less than a week earlier** Franz Graf Wolff-Metternich,

"Concerning my activities as Adviser on the Protection of Works of Art to O.K.H. from 1940–1942 (Kunstschutz)," NARA, RG 239, M1944, Roll 89, Frames 352–72, 3.

71 **Beginning in May 1938** Birgit Schwarz, *Geniewahn: Hitler und die Kunst* (Vienna/Cologne/Weimar: Böhlau Verlag, 2009), 221–28.

71 **Hitler was infuriated** Ibid., 208.

72 **"Certain people's eyes"** Ibid. For entire speech see: http://www.kunstzi tate.de/bildendekunst/manifeste/nationalsozialismus/hitler_haus_der_kunst_37.htm.

72 **Hitler's taste ran toward** Ibid., 35, 53, 102, 152.

72 **collectors in France, including David-Weill, Rothschild** *Trial of the Major War Criminals before the International Military Tribunal, Nuremberg, 14 November 1945–1 October 1946,* Volume XXV, Documents and other material in evidence, Numbers 001-PS to 400-PS, Document 014-PS (Nuremberg, Germany, 1947), 48–49.

72 **ERR staff then created elaborate, brown leather-bound albums. . . . allowed Hitler to select** Birgit Schwarz, *Geniewahn,* 26.

73 **"Perhaps one of my weaknesses"** Leon Goldensohn, *Nuremberg Interviews: An American Psychiatrist's Conversations with the Defendants and Witnesses* (New York: Knopf, 2004), 128.

73 **But his collecting became indiscriminate** Nancy H. Yeide, *Beyond the Dreams of Avarice: The Hermann Goering Collection* (Dallas: Laurel Publishing, 2009), 17.

74 **From November 1940 through 1942** "Report No. 1, Activity of The Einsatzstab Rosenberg in France," August 1945, O.S.S. Art Looting Investigation Unit Consolidated Interrogation Reports, NARA, M1782, 6.

74 **"It used to be called plundering"** *Trial of the Major War Criminals Before the International Military Tribunal,* Volume IX (Nuremberg: 1947), 633.

74 **"not since the time of Napolean Bonaparte"** Francis Henry Taylor, "Memorandum for Submission to the President of the United States: Protection and Conservation of Artistic Monuments in Europe and Establishment of Machinery to Salvage and Return to Lawful Owners Works of Art and Historic Documents Looted by the Enemy," November 24, 1942, NARA, RG 239, M1944, Roll 56.

74 **first official state visit** Hitler arrived in Rome but traveled from there to Naples. Then he returned to Rome for his tour, followed by his trip to Florence.

74 **"the jewel of Europe,"** Jodl letter, 12 May 1944, Archivio Storico delle Gallerie di Firenze, Giovanni Poggi Archive. SERIE VIII. 154; Nicolas Petrescu Comnène, *Firenze "città aperta"* (Florence: Vallecchi Editore, 1945), 32–33.

74 **open-top Lancia Astura Cabriolet limousine** Photo no. 37.158, *Giostra del Saracino* in "Archivio Storico Fotografico—Foto Club 'La Chimera'" (1938), http://www.fotoantiquaria.it/.

75 **some 4,340 in all** Archivio Storico del Comune di Firenze, ed. *Firenze. 9*

Maggio 1938. Small collection of essays on occasion of the exhibition "Il ritorno all'ordine. 1938—L'immagine di Firenze per la visita del Fuhrer," 25 September–31 October 2012, Archivio Storico del Comune di Firenze, Florence (Florence: P.O. Archivi e Collezioni Librarie Storiche, 2012), 38.

75 **The motorcade route** "Il Viaggio del Fuhrer in Italia," produced by Istituto Luce, 1938, http://www.youtube.com/watch?v=FXz8ombIvtU.

75 **almost two hours** *Il Fuhrer in Italia* (Agenzia Stefani, n.d.). Tutaev's account in *The Consul of Florence* refers to Hitler's "four hour tour of the Uffizi" (p. 11). This has been repeated by numerous writers since, including me. However, my research unearthed a rare publication, *Il Fuhrer in Italia*, printed shortly after his visit. It contains a detailed chronology of each day's activities. The art tour began in the Pitti Palace, continued through the Vasari Corridor, and ended after a visit to the Uffizi Gallery. "The two statesmen spend a little less than two hours in this visit."

75 **Director of Florence's** *Kunsthistorisches Institut* Ludwig Heinrich Heydenreich, "In Memoriam—Friedrich Kriegbaum," Mitteilungendes Kunsthistorischen Institutes in Florenz, Siebzehnter Band, Heft II, August 1953 (Düsseldorf: Verlag L. Schwann), 145, 146.

75 **point out to the Führer the beauty and importance** David Tutaev, *The Consul of Florence* (London: Secker & Warburg, 1966), 11.

75 **Kriegbaum, however, had recently concluded. . . . "last gift to his native city"** Giovanni Poggi, "Relazione sulla ricostruzione del Ponte a Santa Trinita," 22 February 1951, Giovanni Poggi Papers, Archivio Storico delle Gallerie di Firenze, Florence, Serie VIII, Protezione antiaerea e danni di guerra, n.157, 12; Friedrich Kriegbaum, "Michelangiolo e il Ponte a S. Trinita," *Rivista d'arte* 23 (1941), 145.

76 **his favorite bridge** Tutaev, *The Consul of Florence*, 11.

76 **"Italy has too much art and too few babies"** "Fine Arts Section," Keller Papers, Box 19, Folder 10.

76 **"Mussolini was bored"** Ranuccio Bianchi Bandinelli, *Dal Diario di un borghese e altri scritti* (Milan: Il Saggiatore, 1962), 189–90.

76 **Such pieces, designated** *notoficati* "Works of Art Exported to Germany by the Fascists," 10 January 1946. National Archives, Kew, Richmond, Surrey, T/209/27/2.

76 **Italian authorities vigorously objected** Rodolfo Siviero, *L'Arte e il Nazismo: esodo e ritorno delle opere d'arte italiane, 1938–1963* (Florence: Cantini, 1984), 8.

77 **"an irreplaceable monument for our knowledge"** Rodolfo Siviero, ed., *Seconda mostra nazionale delle opere d'arte recuperate in Germania* (Florence: Sansoni, 1950), 34.

77 **the sculpture departed for Germany** Siviero, *L'Arte e il Nazismo*, 7–8.

77 **Reichsmarschall Göring then got in on the act** "Works of Art Exported

to Germany by the Fascists," 10 January 1946, National Archives, Kew, Richmond, Surrey, T/209/27/2.

77 **the contents of the German libraries** "Looting," NARA, RG 331, 10000/145/397.

78 **On September 30, a band of German soldiers** Riccardo Filangieri, "Report on the Destruction by the Germans, September 30, 1943, of the Depository of Priceless Historical Records of the Naples State Archives," *American Archivist* 7, no. 4 (October 1944), 252.

78 **The fire burned the museum's priceless collection** *Works of Art in Italy: Losses and Survivals in the War, Part II* (London: His Majesty's Stationery Office, 1946), 81.

78 **perhaps the richest collection** John L. Kirby, "The Archives of Angevin Naples—A Reconstruction," *Journal of the Society of Archivists* vol. 3, no. 4 (1996), 191.

78 **obliteration of eighty-five thousand archival documents** Kirby, "The Archives of Angevin Naples—A Reconstruction," 191–94; Filangieri, "Report on the Destruction by the Germans, September 30, 1943, of the Depository of Priceless Historical Records of the Naples State Archives."

78 **dating from the year 1239** Christopher Norris, "The Museo Filangieri," *The Burlington Magazine*, vol. 84, no. 492 (March 1944), 72.

78 **Kesselring ordered his Intelligence Branch. . . . He deployed personnel** Douglas Cooper and Ernest DeWald, "Report on the German Kunstschutz in Italy between 1943 and 1945," 30 June 1945, NARA, RG 239, M1944, Roll 71, 2.

78 **Dr. Bernhard von Tieschowitz, head of the Kunstschutz based in Paris,** Bernhard von Tieschowitz, "Zusammenfassender Bericht über die Einrichtung des Kunstschutzes in Italien," late February 1944, Deutscher Militärischer Kunstschutz Papers, Ministero degli Esteri, archive of the ex-delegation for Restitution, Siviero Archive, Rome.

78 **Protecting buildings and works of art** Douglas Cooper and Ernest DeWald, "Report on the German Kunstschutz in Italy Between 1943 and 1945," 30 June 1945, NARA, RG 239, M1944, Roll 71.

78 **In an effort to begin operations quickly** Tieschowitz, "Zusammenfassender Bericht über die Einrichtung des Kunstschutzes in Italien," Kunstschutz Papers, Siviero Archive.

Chapter 8: Gifts

81 * "Footnote to Chapter X," excerpts from interrogations held in 1945, NARA, RG 226, Entry 190C, Box 9; Lingen, *Kesselring's Last Battle*, 35.

81 **Of the two paths** David Hapgood and David Richardson, *Monte Cassino: The Story of the Most Controversial Battle of World War II* (Cambridge, MA: Da Capo Press, 1984), 23–24.

82 **"All roads lead to Rome"** Atkinson, *The Day of Battle*, 253.

82 **Becker's enthusiasm** Hapgood and Richardson, *Monte Cassino*, 4.

83 **"If we're supposed to do all that"** Maximilian Becker, "Memoriale Becker Sullo Sgombero Di Montecassino," Dublin, 18-2-1964, found in *Il Bombardamento Di Montecassino—Diario Di Guerra*, Pubblicazioni Cassinesi—Montecassino (1997), 240.

84 **"*Dottore!*" . . . speaking in a hushed tone** Hapgood and Richardson, *Monte Cassino*, 15.

84 **187 crates of artworks** Emilio Lavagnino, "Migliaia di opere d'arte rifugiate in Vaticano," *Strenna dei romanisti* VII (1946), 83.

84 **The shipment included** *Works of Art in Italy: Losses and Survivals in the War, Part II*, 80.

84 **"Do you mean to Germany?"** Becker, "Memoriale Becker sullo Sgombero di Montecassino," 260.

85 **The abbey's holdings included** *Libraries Guests of the Vaticana During the Second World War* (Vatican City: Apostolic Vatican Library, 1945), 11.

85 **Becker and Schlegel began by relieving** Hapgood and Richardson, *Monte Cassino*, 32.

85 **By November 3** Ibid., 57.

86 **chief adjutant—and an adviser—to Reichsmarschall Göring** Yeide, *Beyond the Dreams of Avarice*, 260; "Mr. von B" from Becker, "Memoriale Becker sullo Sgombero di Montecassino."

86 **Becker read the letter in shock** Hapgood and Richardson, *Monte Cassino*, 54.

86 **"The responsibility of the Germans"** "Unique Collection of Art Treasures Taken Away by Germans in Italy," *New York Times*, November 10, 1943.

86 **"not for himself or for Italy"** Ibid.

86 **"There's some unbelievably shitty business"** Hapgood and Richardson, *Monte Cassino*, 60.

87 **"We didn't get [the collection]"** Ibid., 68.

87 **"You're upsetting our whole applecart!"** Ibid.

87 **"had not complied"** Lingen, *SS und Secret Service*, 34.

88 **"easy hand policy"** Wolff, Wolff Affidavit.

88 **Wolff had studied the many approaches** Ibid.

88 **Shifting blame to others** Ibid.

88 **"The Führer and I spoke the same language"** Lang, *Der Adjutant*, 191–92.

88 **"We were both"** Ibid.

88 **"The mood of the Italian population"** Wolff, Wolff Affidavit.

88 **"After I recognized this, I immediately"** Ibid.

89 **"give up your Vatican Plan"** Ibid.

89 **"I have to hold you responsible"** Ibid.

89 **On December 8, with German cameras rolling** Andrea Carlesi, *La protezi-*

one del patrimonio artistico italiano nella RSI (1943–1945) (Milan: Greco&Greco editori, 2012), 37–38.

89 **Officials watched as each truck** Hapgood and Richardson, *Monte Cassino*, 71.

90 **"say no more than three sentences"** DeWald Diary notes on Interrogations, Ernest DeWald Papers, Princeton University, Box 4.

90 **On January 4** Emilio Lavagnino, "Diario di un salvataggio artistico," *La Nuova Antologia*, August (1974), 518–19.

90 **Central Inspector of the General Direction** Chiara Lombardo, *Pasquale Rotondi: quando il lavoro è un'arte—Storia di un Soprintendente solo e senza soldi custode dei tesori italiani durante la seconda guerra mondiale* (Caserta: Vozza, 2008), 99.

90 **Everything proceeded smoothly** Lavagnino, "Diario di un salvataggio artistico," 518; Ernest DeWald, "Works of Art Formerly Stored at Montecassino and Later Transferred to the Vatican," 20 July 1944, NARA, RG 331, 10000/145/400.

90 **But their destination had been Berlin** *Report of the American Commission for the Protection and Salvage of Artistic and Historic Monuments in War Areas*, 75.

SECTION II: STRUGGLE

91 **"What happens when this dense fabric"** Frederick Hartt, *Florentine Art Under Fire* (Princeton, NJ: Princeton University Press, 1949), 3.

Chapter 9: The First Test

93 **"the first official ground"** DeWald Diary, Dec. 23–Jan. 9, 1944, Ernest DeWald Papers, Princeton University, Box 2.

93 **"brought with him no copies"** "Travel Orders and Attachment of Captain Deane Keller," 7 February 1944, NARA, RG 331, 10000/145/160.

94 **"I could write you fifty pages". . . . "I am quartered"** Letter to Kathy, 6 February 1944, Keller Papers, Box 7, Folder 44.

94 **"I carried my". . . . "I feel I am on"** Letter to Kathy, 7 February 1944, Keller Papers, Box 7, Folder 44.

94 **"I have been here before"** Letter to Kathy, 6 February 1944, Keller Papers, Box 7, Folder 44.

94 **"We had a trip"** Letter to Kathy, 7 February 1944, Keller Papers, Box 7, Folder 44.

94 **"light-hearted" Neapolitans** Keller, "American Impressions of Italians and Italian Customs," NARA, RG 331, 10000/145/1.

94 **twenty thousand civilians** Renata Picone, "Danni bellici e restauro a Napoli, il complesso del Palazzo Reale tra bombardamenti e occupazione militare,"

in Lorenzo de Stefani, ed., *Guerra monumenti ricostruzione: Architetture e centri storici italiani nel secondo conflitto mondiale* (Venice: Marsilio Editori, 2011), 368.

94 **105 Allied bombing raids** Carlo de Frede, *Il decumano maggiore da Castelcapuano a San Pietro a Maiella. Cronache napoletane dei secoli passati* (Naples: Liguori, 2005), 126.

94 **"great cavernous excavations"** Coles and Weinberg, *Civil Affairs*, 326.

94 **"terror, dirt, [and a] sense of impotence"** Lucia Monda, "Napoli durante la II guerra mondiale ovvero: i 100 bombardamenti di Napoli," *Napoli durante la II guerra mondiale*. Essay for conference I.S.S.E.S Istituto di Studi Storici Economici e Sociali, 5 March 2005, 4.

94 **"churches are the war's innocent victims"** Salvatore Scarpitta Papers, Private Collection.

95 **typhus epidemic** Coles and Weinberg, *Civil Affairs*, 325–26.

95 **"At the hospital today"** Letter to Kathy, 18 December 1944, Keller Papers, Box 7, Folder 51.

95 **"I'll do what I can"** Letter to Kathy, 1 March 1944, Keller Papers, Box 7, Folder 45.

96 **"You must understand that the Italians"** Keller, "American Impressions of Italians and Italian Customs," NARA, RG 331, 10000/145, 1.

96 **"There is a quiet seriousness"** Letter to Parents, 19 July 1944, Keller Papers, Box 5, Folder 25.

97 **"The big work lies ahead"** Letter to Kathy, 29 February 1944, Keller Papers, Box 7, Folder 44.

97 **U.S. Fifth Army spent. . . . The town of Cassino** Atkinson, *The Day of Battle*, 328, 337.

97 **"one of the strongest natural defensive positions"** Harold Alexander, *The Memoirs of Field-Marshal Earl Alexander of Tunis: 1940–1945*, ed. John North (London: Cassell & Company, 1962), 121.

97 **ten thousand additional casualties** Fred Majdalany, *Cassino: Portrait of a Battle* (London: Cassell & Co., 2000), 90.

98 **"All the way up this mountain ridge"** Young Oak Kim (most-decorated Korean American World War II veteran), interview courtesy of Actual Films, 2002.

98 **"The centre of resistance is Monte Cassino."** Majdalany, *Cassino: Portrait of a Battle*, 86.

98 **"The fortified mountain and the building"** Ibid., 118.

98 **Fifth Army commander Lieutenant General Mark Clark** Atkinson, *The Day of Battle*, 432.

99 **"no practicable means available"** Ibid., 412.

99 **"Germans in the courtyard"** Ibid., 433.

99 **"no signs of activity"** Ibid.

99 **"been looking so long"** Hapgood and Richardson, *Monte Cassino*, 169.

99 **involved the entire chain of command** Carlo D'Este, *Fatal Decision: Anzio and the Battle for Rome* (New York: HarperCollins, 1991), 259.

99 **On the morning of February 15** "Air Intelligence Weekly Summary no. 66," 21 February 1944, Norstad Papers, Box 8, 9.

100 **Hundreds of displaced persons** Hapgood and Richardson, *Monte Cassino*, 136.

100 **230 were dead** Ibid., 211. The exact number of dead was never determined; 230 is the best estimate.

100 **No Germans died** Ibid., 212

100 **Abbot Diamare. . . . They and some thirty refugees** Ibid., 216–18.

100 **press conference** John H. Crider, "President Upholds Shelling of Abbey," *New York Times*, February 16, 1944.

100 **"The loss of some temporary". . . . "Does the Archbishop". . . . "May I inquire if any"** "War in the Treasure House," *Time*, February 21, 1944.

100 **"destruction of the Abbey"** "Final Report General," 1 January 1946, Keller Papers, Box 23, Folder 52.

100 **"It was necessary more"** Alexander, *The Memoirs of Field-Marshal Earl Alexander of Tunis: 1940–1945*, 121.

Chapter 10: Close Call

103 **On January 22** D'Este, *Fatal Decision*, 119.

103 **army of more than ninety-five thousand men** Ibid., 451.

103 **preparing to launch a counterattack** Percy Ernst Schramm, ed., *Kriegstagebuch des Oberkommando der Wehrmacht (Wehrmachtführungsstab), Band IV: 1. Januar 1944–22. Mai 1945. Erster und Zweiter Halbband* (Frankfurt am Main: Bernard & Graefe Verlag für Wehrwesen, 1961), 129, 151–59.

103 **"Anzio was a fishbowl."** Atkinson, *The Day of Battle*, 370.

103 **nineteen hundred American soldiers died** Ibid., 431.

104 **In an effort to change the dynamics** "The Present Tasks and the Evolution of Allied Air Power in the Mediterranean," Lauris Norstad Papers, Eisenhower Presidential Library, Box 14, Air Power in the Mediterranean, November 1942–February 1945.

104 **Fifteenth Air Force. . . . The Twelfth Air Force** Ibid.

104 **The lists designating towns** "Air Mission," NARA, RG 331, 10000/145/259.

104 **To rectify this** H. C. Newton, "Report on Status of Monuments, Fine Arts, and Archives in the Mediterranean Theater of Operations," 20 August 1944, NARA, RG 331 10000/145/205.

104 **Peter Shinnie . . . February 1944** Woolley, *The Protection of the Treasures of Art and History in War Areas*, 29.

104 **Norstad also issued** "Historic Monuments: Preface," February 23, 1944, Norstad Papers, Box 14, The Ancient Monuments of Italy, Part I (I).

104 **Group A included** "Fine Arts Section," Keller Papers, Box 19, Folder 10, 47.

105 **"it should be made quite clear"** "Historic Monuments," 23 February 1944, Lauris Norstad Papers, Eisenhower Presidential Library, Box 14, The Ancient Monuments of Italy, Part 1 (1).

105 * Paolo Paoletti, Mario Carniani, et al., Firenze, *Guerra & Alluvione: 4 Agosto 1944/4 Novembre 1966* (Florence: Saverio Becocci), 37, 77; Marchese Filippo Serlupi Crescenzi, "Lettera a S.E. il Principe Carlo Pacelli," 13 November 1943, Private Collection, Italy; Giovanni Poggi, "Memo," 25 September 1943, Poggi Papers, Serie VIII, n.154, 4; Poggi, "Relazione sui Monumenti e le Opere d'Arte di Firenze durante la Guerra 1940–1945," 5 June 1945, Poggi Papers, Serie VIII, n.157, 12; Poggi, "Descrizione giorni immediatamente precedenti e immediatamente successivi la distruzione del Ponte," Poggi Papers, Serie VIII, n.159, 23.

105 **"necessary to meet critical military requirements"** "Bombing Directive," 2 March 1944, Lauris Norstad Papers, Eisenhower Presidential Library, Box 1, Bombing of Targets in Southern Europe (1).

105 **"It is appreciated that"** Ibid.

105 **Pilots, navigators, and bombardiers. . . . "Gentlemen". . . . "We've been hitting"** NARA, film ID 107.370.

106 **"Sure got a lot of things"** Benjamin C. McCartney, "Return to Florence," *National Geographic*, vol. 87, no. 3 (March 1945), 275.

106 **"northwest marshaling yard," or "main marshaling yard"** Aerial Photo, Attack damage by 49 Martin B-26s on 11 March 44—War Theatre #12 (Florence, Italy)—Bombing, NARA, RG 342; "Air Intelligence Summary Report no. 70, 20 March 1944," Norstad Papers, Box 8.

107 **"gave a beginning to beautiful attitudes"** Giorgio Vasari, *Lives of the Artists: Volume I*, trans. George Bull (London: Penguin Books, 1987), 124.

108 **one of his final works** John T. Spike, *Masaccio* (Milan: Rizzoli Libri Illustrati, 2002), 198.

108 **"First time Florence has been bombed"** Bomb Tag, Roy Seymour Papers, Private Collection, United States.

108 **Seventy-eight B-26 Marauders** "Air Intelligence Weekly Summary no. 70, 20 March 1944," Norstad Papers, Box 8, 13.

108 **"No flak or [enemy aircraft]"** "Central Mediterranean Operational Summary Number 79, for period ended 1800 hours 11 March 1944," Lauris Norstad Papers, Eisenhower Presidential Library, Box 9, Central Mediterranean Operational Summaries, March 1944 (2).

108 **March 11, more than one hundred** "Air Intelligence Weekly Summary no. 70, 20 March 1944," Norstad Papers, Box 8, 12.

108 **"The main concentrations of bombs fell"** Ibid.

108 **Hartt had arrived in Italy** "Recommendation for Promotion," NARA, RG 331, 10000/145/159.

109 **photographic interpreter for the 90th Photo Wing Reconnaissance** Ernest DeWald, Report of Damaged Monuments, 26 April 1944, NARA, RG 331, 10000/145/259.

109 **"Chapel of Mantegna obliterated"** Frederick Hartt, "Notes on Bomb Damage to Cultural Monuments in Enemy-Occupied Italy," NARA, RG 331, 10000/145/7.

109 **"I just couldn't continue working."** Eddie de Marco, "After 17 years as professor, Hartt reflects on art, life," Hartt Papers, Box 23, Folder 1.

110 **"The Eremitani has been very badly hit"** Hartt to DeWald, 6 April 1942 [*sic*], DeWald Papers, Box 4.

110 **"With Florence, Rome & Venice"** Ibid.

111 **"Neighboring Dominican convent"** Hartt, "Notes on Bomb Damage," NARA, RG 331, 10000/145/7.

Chapter 11: Refuge

113 **In May 1944, the last of the shipments** Emilio Lavagnino, "Migliaia di opere d'arte rifugiate in Vaticano," *Strenna dei romanisti* VII (1946), 88.

113 **"The provisions arranged for the protection"** Minister Marino Lazzari, "Lettera a Giovanni Poggi sulla salvaguardia del patrimonio artistico nazionale," 5 June 1940, Poggi Papers, Serie VIII, n.154, 12.

113 **remote storage facilities** Ibid.

114 **Within its thick walls** Lombardo, *Pasquale Rotondi: quando il lavoro è un'arte—Storia di un Soprintendente solo e senza soldi custode dei tesori italiani durante la seconda guerra mondiale*, 72–73.

114 **First to arrive** Pasquale Rotondi, "Capolavori d'arte sottratti ai pericoli della guerra ed alla rapina tedesca. Estratto da una Relazione del Prof. Pasquale Rotondi Soprintendente alle Gallerie delle Marche, presentata il 18 ottobre 1945 alla R. Accademia Raffaello," *Urbinum*, July–August 1945, 10.

114 **Masterpieces from the Borghese Gallery** Rotondi, "Capolavori d'arte sottratti ai pericoli della guerra ed alla rapina tedesca," 14.

114 **Brera and Poldi Pezzoli Galleries** Ibid.

114 **By summer's end** Rotondi's remarks during an interview in the television documentary "La lista di Pasquale Rotondi," episode in the series *RAI La storia siamo noi*, 6 June 2005. Rome: RAI Educational.

114 **He concealed the most important paintings** Lavagnino, "Diario di un salvataggio artistico," *La Nuova Antologia*, August (1974), 515.

114 **compelled Rotondi to hide paintings** Rotondi, "Capolavori d'arte sottratti ai pericoli della guerra ed alla rapina tedesca," 19.

115 **"That was a moment when"** Rotondi's remarks during an interview in the television documentary "La lista di Pasquale Rotondi," episode in the series *RAI La Storia siamo noi*, 6 June 2005. Rome: RAI Educational.

115 **Pope Pius XII had offered sanctuary** Lutz Klinkhammer, "Arte in Guerra:

tutela e distruzione delle opera d'arte italiane durante l'occupazione tedesca 1943–45," in Giuseppe Masetti and Antonio Panaino, eds., *Parola d'ordine Teodora* (Ravenna: Longo Angelo, 2005), 69.

115 **In December 1943** Rotondi, "Capolavori d'arte sottratti ai pericoli della guerra ed alla rapina tedesca," 26; Lavagnino, "Diario di un salvataggio artistico," 515–17.

115 **At one point, Rotondi's wife. . . . "For what you did to me"** Story told by Rotondi's daughter in interview in the television documentary "La lista di Pasquale Rotondi."

115 **forced into retirement on January 1, 1944** Alessandra Lavagnino, *Un inverno 1943–1944* (Palermo: Sellerio, 2006), 35.

115 **By January 17, 1944** Lavagnino, "Diario di un salvataggio artistico," 521.

115 **On eighteen occasions . . . "by car, truck, and pickup truck"** Lavagnino, "Migliaia di opere d'arte rifugiate in Vaticano," 87.

116 **Six hundred miles away, a caravan of trucks** Schwarz, *Geniewahn*, 299.

116 **Workers had been converting the mines** Emmerich Pöchmüller, *Weltkunstschätze in Gefahr* (Salzburg: Pallas-Verlag, 1948), 13.

116 **Hitler's concern for the safety** Schwarz, *Geniewahn*, 296–99.

116 **"whether everything humanly possible"** Ibid, 297.

116 **"had asked again whether the monasteries"** Ibid.

117 **On Christmas Day in 1943** Ibid., 299.

117 **"one of the most powerful Gauleiters of the Reich"** Pöchmüller, *Weltkunstschätze in Gefahr*, 50.

117 **he became acquainted with** Alexander Langsdorff, "Lettera a Giovanni Poggi," 18 June 1944, Carlo Anti Papers, Biblioteca Civica, Padua, Serie 2, Salvaguardia patrimonio artistico italiano/Opere d'arte toscane trasferite dalle Autorità Germaniche in Alto Adige n.2, 3.

117 **He joined the Nazi Party** SS-Stammrollenblatt des Langsdorff, Alexander, Stammrollennummer R 4/6 129, 28 February 1934, BArch R 601–1816, Bundesarchiv Berlin.

117 **"personal artistic and cultural consultant"** Sebastian Brather, Dieter Geuenich, Christoph Huth, eds. *Historia archaeologica: Festschrift für Heiko Steuer zum 70. Geburtstag* (Berlin: De Gruyter, 2009), 681.

117 **During that time, he worked** Michael H. Kater, *Das "Ahnenerbe" der SS 1935–1945: Ein Beitrag zur Kulturpolitik des Dritten Reiches* (München: Oldenbourg Wissenschaftsverlag, 2001), 67.

118 **at Himmler's instigation** Jürgen Klöckler, "Verhinderter Archivalienraub in Italien; Theodor Mayer und die Abteilung 'Archivschutz' bei der Militärverwaltung in Verona 1943–1945," *Quellen und Forschungen aus italienischen Archiven und Bibliotheken*, vol. 86 (Rome: Deutsches Historisches Institut Rom, 2006), 504; Wolff-Metternich, "Concerning my Activities as Adviser on the Protection of Works of Art to O.K.H. from 1940–1942 (Kunstschutz)," NARA, RG 239, M1944, Roll 89.

118 **"I experience Italy as never before"** Langsdorff Diary, Alexander Langsdorff Papers, Private Collections. Switzerland.

118 **old rail tunnel near the town of Incisa** Telegram, Langsdorff to Heydenreich, 3 May 1944, Kunstschutz Papers, Siviero Archive.

118 **German troops had previously assisted** Ludwig Heinrich Heydenreich, "Bericht Betr. Räumung des im Eisenbahntunnel S. Antonio bei Incisa untergebrachten Bergungsdepots von wertvollsten Kunstwerken," 4 May 1944, Kunstschutz Papers, Siviero Archive.

118 **Now Kesselring needed the tracks** Poggi, "Relazione sui Monumenti e le Opere d'Arte di Firenze durante la guerra 1940–1945," 5 June 1945, Poggi Papers, Serie VIII, n.157, 12.

118 **"undeniably perfect in every way"** . . . **"must rank as the finest masterpiece ever created"** Vasari, *Lives of the Artists: Volume I*, 120.

118 **required the use of cranes, fifteen train cars** . . . **"in very scary conditions"** Poggi, "Relazione sui Monumenti e le Opere d'Arte di Firenze durante la guerra 1940–1945," 5 June 1945, Poggi Papers, Serie VIII, n.157, 12.

119 **he celebrated at a beer garden in Fiesole** Langsdorff Diary, Alexander Langsdorff Papers, Private Collection.

119 **"clandestine origin"** Salvatore Scarpitta Papers, Private Collection.

119 **One attack in late March** Michael Salter, *Nazi War Crimes: US Intelligence and Selective Prosecution at Nuremberg* (New York: Routledge-Cavendish, 2007), 55.

119 **Acting on Hitler's orders** Hastings, *Inferno*, 445.

120 **Wolff learned from his assistant** Eugen Dollmann, *The Interpreter: Memoirs of Doktor Eugen Dollmann*, trans. J. Maxwell Brownjohn (London: Hutchinson & Co., 1967), 301.

120 **only meeting between** Wolff, *Mit Missen Hitlers*, 46.

120 **as long as Wolff held his position** Wolff, Wolff Affidavit.

120 **Father Pankratius Pfeiffer** "Wolff's statement, 1972," in Giorgio Angelozzi Gariboldi, *Pio XII, Hitler e Mussolini: il Vaticano fra le dittature* (Milan: Mursia, 1995), 252. This deposition was provided in conjunction with a defamation lawsuit brought by a relative of Pope Pius XII against historian Robert Katz. Dollmann suggests the request for the prisoner release took place after Wolff's meeting ended, an "epilogue" per *The Interpreter*, 302. Jochen von Lang writes that Dollmann was used as the "go-between" for the request. *Top Nazi: SS General Karl Wolff, the Man Between Hitler and Himmler* (New York: Enigma Books, 2005), 248.

120 **"expressed my firm belief"** . . . **"for the objective just expressed"** Gariboldi, *Pio XII, Hitler e Mussolini: il Vaticano fra le dittature*, 252–53.

121 **"the Axis propagandist[s] [who] are trying"** "Casablanca Conference, February 12, 1943," The Avalon Project Database, Yale University Law Library, http://www.avalon.law.yale.edu, accessed August 6, 2012.

121 **"an obstacle on the path to peace"** Wolff, *Mit Wissen Hitlers*, 48.

121 **This extraordinary meeting** Lang, *Der Adjutant*, 233. No photographs or transcripts of their conversation are known to exist.

121 **"instinctively raised my arm"** Gariboldi, *Pio XII, Hitler e Mussolini: Il Vaticano fra le dittature*, 253. Antonio Spinosa, *Pio XII, un Papa nelle tenebre* (Milan: Oscar Mondadori, 2004), 262–63, says that Wolff raised his arm at the beginning of the meeting, not at the end. He also notes that the conversation was carried out in German.

121 **"For years I had lost the habit"** Gariboldi, *Pio XII, Hitler e Mussolini: Il Vaticano fra le dittature*, 253.

Chapter 12: Life on the Road

123 **"a fairyland of silver and gold"** Atkinson, *The Day of Battle*, 446.

123 **In a city where those** Ibid., 449.

123 **more than ten percent** Ibid.

123 **"My patience has been"** Letter to Parents, 6 April 1944, Keller Papers, Box 5, Folder 25.

124 **"Two of my British Capt. companions"** Letter to Kathy, 6 April 1944, Keller Papers, Box 7, Folder 46.

124 **"If I have to pass"** Letter to Parents, 6 April 1944, Keller Papers, Box 5, Folder 25.

124 **On May 18, Allied Forces** Hapgood and Richardson, *Monte Cassino*, 247.

124 **remaining defenders** Atkinson, *The Day of Battle*, 532.

124 **When the cost of "victory" was calculated** Tom Gibbs (Historian, The National World War II Museum), in discussion with the author, June 18, 2012.

124 **Monuments officer Norman Newton** Norman Newton, "Inspection of Abbey of Montecassino," 19 May 1944, NARA, RG 331, 10000/145/45.

124 **"mostly leveled to ground floor". . . . "Reconstruction of entire Abbey"** Norman Newton, "Montecassino Abbey," 18 May 1944, NARA, RG 331, 10000/145/45.

124 **who originally fought . . . "the situation of the Allied troops"** Ward-Perkins letter to Richardson, 16 September 1977, John Bryan Ward–Perkins Papers, British School at Rome, Rome, Box B, Folder 1.

125 **Fifth Army included soldiers** Hapgood and Richardson, *Monte Cassino*, 26.

125 **"I haven't worn my ribbon"** Letter to Kathy, 18 March 1944, Keller Papers, Box 7, Folder 45.

125 **he had bought it on the streets of Naples** Keller, Handwritten account, Keller Papers, Box 22, Folder 39, 4.

126 **"Kiss Mommie for me."** V-mail to Dino, 29 May 1944, Keller Papers, Box 6, Folder 33.

127 **"I have been as happy"** Letter to Kathy, 2 June 1944, Keller Papers, Box 7, Folder 47.

127 **"mousy Venus Fixers"** Gerald K. Haines, "Who Gives a Damn about Medieval Walls?" *Prologue* 8, no. 2 (1976), 101.

127 **" 'scholarly mouse' type"** Coles and Weinberg, *Civil Affairs*, 422.

127 **Keller had departed Naples . . . "a tent city in olive groves"** "AMG Fifth Army," Keller Papers, Box 20, Folder 16, 3.

127 **"sounded more like a noise than a name"** "The Autobiography of a 'Jeep'" United Films, 1943, http://archive.org/details/autobiography_of_a_jeep (accessed December 14, 2012).

127 **"Good Lord, I don't think"** Ernie Pyle, *Washington Daily News*, June 4, 1943.

128 **ambush-and-retreat strategy** Atkinson, *The Day of Battle*, 534.

128 **"beauty and desolation"** Letter to Kathy, 5 June 1944, Keller Papers, Box 7, Folder 47.

128 **"The road was bumpy and dusty"** Handwritten account, 25 August 1945, Keller Papers, Box 22, Folder 39.

128 **At the side of the main road** "Sectional History—Fine Arts," Keller Papers, Box 23, Folder 56, 3.

129 **"A middle-class Italian told me"** Keller, "American Impressions of Italians and Italian Customs," NARA, RG 331, 10000/145/1.

129 **He lugged pipe** "Fine Arts Section," Keller Papers, Box 19, Folder 10, 8.

129 **"When I see a little boy"** Letter to Kathy, 5 May 1944, Keller Papers, Box 7, Folder 47.

130 **"have but one aim"** "Selvagge distruzioni dell'aviazione nemica nella città di Firenze," *Nuovo Giornale*, March 25–26, 1944.

131 *impiegatucci* Keller, "American Impressions of Italians and Italian Customs," NARA, RG 331, 10000/145/1.

131 *fare una bella figura* Ibid.

131 **"Maybe I am getting"** Letter to Kathy, 14 June 1944, Keller Papers, Box 7, Folder 47.

131 **The town of Itri** "Fine Arts Section," Keller Papers, Box 19, Folder 10, 12.

131 *"Chi entra dopo di noi non troverà nulla"* "Fine Arts Section," Keller Papers, Box 19, Folder 10, 14.

131 **Temple of Jove Uxor** "Fine Arts Section," Keller Papers, Box 19, Folder 10, 13.

132 **"doing it by the numbers"** Interview with William Keller, 2005, courtesy of Actual Films.

132 **He thought about Valmontone** "Fine Arts Section," Keller Papers, Box 19, Folder 10, 18.

132 **first dead American infantryman** Deane Keller, "Letter to the Editor," April 1, 1948, *The Hamden Chronicle*, Keller Papers, Box 2, Folder 18.

132 **"the life of one American boy"** Letter to Kathy, 25 June 1944, Keller Papers, Box 7, Folder 47.

132 **"an admirable example of French Gothic"** Salvatore Scarpitta Papers, Private Collection.

133 **"a very capable fellow"** "Sectional History—Fine Arts," Keller Papers, Box 23, Folder 56, 5.

Chapter 13: Treasure Hunt

135 **He first submitted recommendations** Ernest F. Fisher Jr., *United States Army in World War II: The Mediterranean Theater Operations: Cassino to the Alps* (Washington, DC: Center of Military History, United States Army, 1977), 203.

135 **"considerable historical and artistic merit"** Percy Ernst Schramm, ed., *Kriegstagebuch des Oberkommando der Wehrmacht (Wehrmachtführungsstab), Band IV: 1. Januar 1944–22. Mai 1945, Erster Halbband* (Frankfurt am Main: Bernard & Graefe Verlag für Wehrwesen, 1961), 514.

135 **On June 3 . . . "Führer decision"** D'Este, *Fatal Decision*, 391.

135 **"continued imagining the possibility"** Bandinelli, *Dal Diario di un borghese e altri scritti*, 183.

135 **disastrous propaganda** Atkinson, *The Day of Battle*, 568.

136 **"the first army in fifteen centuries"** Ibid., 549.

136 **Among them was** "Report for June 1944," July 9, 1944, NARA, RG 239, M1944, Roll 63.

136 **career as a singer** Richard Krautheimer and Kurt Weitzmann, "Memoirs of Fellows and Corresponding Fellows of the Mediaeval Academy of America: Ernest DeWald," *Speculum*, vol. 44, no. 3 (July 1969), 526–27.

136 **"walking stick in hand"** Markowski, interview with the author, 2010.

136 **"the first officer"** Hammond, "Copy of Report of Professor Mason Hammond on his Work in Italy," NARA, RG 239, M1944, Roll 22, Frames 88–115, 26.

136 **Colleagues found him charming** Bryan Ward-Perkins (son of John Bryan Ward-Perkins), in discussion with the author, 2012.

136 **Ward-Perkins and Lieutenant Colonel Sir Mortimer Wheeler** *Report of the American Commission for the Protection and Salvage of Artistic and Historic Monuments in War Areas*, 47.

137 **DeWald arranged for three Monuments officers** Eighth Monthly Report, for June 1944, July 9, 1944, NARA, RG 239, M1944, Roll 63, AMG-23.

137 **"Despite widespread damage" . . . "no further damage"** Hartt, "Damage to Cultural Monuments in Rome."

137 **After receiving his undergraduate** Walter Gleason (close friend of Perry Cott), interview with the author, May 9, 2010.

137 **Cott had orders to verify** Eighth Monthly Report, for June 1944.

138 **He spent his first night** Walter Gleason, interview with the author, May 9, 2010.

138 **De Rinaldis informed Cott** Perry Cott, "Report on activity for first two days of occupation," 11 June 1944, NARA, RG 331, 10000/145/48.

138 **With the temporary addition of** "MFAA Inventory No. 31: Art Objects from Carpegna, Sassocorvaro, Urbino actually in the Vatican," John Bryan Ward-Perkins Papers, British School at Rome, Inventories of Art Deposits.

138 **Joining its remarkable collection. . . . Never before or again** Giovanni

Morello, "Il ruolo della Santa Sede nell'azione di salvaguardia del patrimonio culturale e artistico italiano durante la Seconda guerra mondiale" *Quaderni della Fondazione Bellonci*, November 4, 2006, 13.

139 **DeWald's subsequent audiences** H. C. Newton, "Report on Status of Monuments, Fine Arts, and Archives in the Mediterranean Theater of Operations," 20 August 1944, NARA, RG 331, 10000/145/203, 17.

139 **first of six separate inspections** Ernest DeWald, "Works of Art Formerly Stored at Montecassino and Later Transferred to the Vatican," 20 July 1944, NARA, RG 331, 10000/145/400.

139 **when trucks of the Hermann Göring Division** Lavagnino, "Diario di un salvataggio artistico," 518–19.

139 **although a German officer** DeWald, "Works of Art Formerly Stored at Montecassino and Later Transferred to the Vatican," 20 July 1944, NARA, RG 331, 10000/145/400, 2.

139 **"delayed" . . . "almost all the boxes"** Lavagnino, "Diario di un salvataggio artistico," 522.

139 **The sudden news of the Allied landings** Ibid., 523.

139 **Crate no. 1. . . . Case No. 3: "completely missing". . . . "The evidence therefore"** DeWald, "Works of Art Formerly Stored at Montecassino and Later Transferred to the Vatican," 20 July 1944, NARA, RG 331, 10000/145/400, 2.

140 **were likely in Germany** *Report of the American Commission for the Protection and Salvage of Artistic and Historic Monuments in War Areas*, 75.

Chapter 14: Surprises

141 **officials in Rome had lists** Hartt, *Florentine Art Under Fire*, 16.

141 **"In smaller towns"** "Will Lang Cable #358 for LIFE, War & Art in Italy," 7 July 1944, NARA, RG 239, M1944, Roll 40, 7.

142 **"I am getting more careful"** Letter to Kathy, 7 July 1944, Keller Papers, Box 7, Folder 48.

142 **"I shook my pants"** Letter to Kathy, 8 July 1944, Keller Papers, Box 7, Folder 48.

142 **He made arrangements** Letter to Kathy, 16 July 1944, Keller Papers, Box 7, Folder 48.

142 **In the early morning hours. . . . "artistically bypassed"** "Fine Arts Section," Keller Papers, Box 19, Folder 10, 27.

142 **"open city"** Kesselring, *The Memoirs of Field-Marshal Kesselring* (London: Greenhill Books, 2007), 309. The OKW Diary, *Kriegstagebuch des Oberkommando der Wehrmacht*, p. 529, also notes that on July 2, "the enemy had gotten close to the city border in the southwest and southeast of Siena. In order to preserve (spare) the city and its art treasures the order was given to evacuate it during the night."

142 **Keller arrived the following day. . . . "We were called"** "Fine Arts Section," Keller Papers, Box 19, Folder 10, 26.

143 **Keller entered the palace. . . . Imprisoned inside the crates. . . . "The French captain in charge". . . . The doctor hurriedly added. . . . After examining the unprotected paintings** Field Report, 11 June 1944, Keller Papers, Box 21, Folder 31.

144 **protected-monuments sign posted** "Fine Arts Section," Keller Papers, Box 19, Folder 10, 29.

144 **"I am really very fortunate"** Letter to Kathy, 23 July 1944, Keller Papers, Box 7, Folder 48.

144 **Giovanni Poggi received a summons** Cooper and DeWald. "Report on the German Kunstschutz," NARA, RG 239, M1944, Roll 71, 16.

144 **With barely a greeting . . . "if Villa Bossi-Pucci"** Poggi, "Relazione sui Monumenti e le Opere d'Arte di Firenze durante la guerra 1940–1945," 5 June 1945, Poggi Papers, Serie VIII, n.157, 12.

145 **fluent in both German and French** Elena Lombardi, ed., *L'Archivio di Giovanni Poggi (1880–1961): soprintendente alle Gallerie fiorentine* (Florence: Edizione Polistampa, 2011), 40.

145 **thirty-eight art repositories** Thirty-eight repositories and a summary of their contents are listed in Hartt, "Report on Deposits of Art-Treasures in Tuscany," December 3, 1944, NARA, RG 239, M1944, Roll 67. This list includes repositories for works of art, archives, and church property throughout Tuscany. Hartt later noted only thirty-seven repositories in *Florentine Art Under Fire*. Fasola listed twenty-four in *The Florence Galleries and the War*. Poggi's lists are inconsistent in the names and numbers of repositories.

145 **which housed close to three hundred** Cesare Fasola, *The Florence Galleries and the War: History and Records* (Florence: Monsalvato, 1945), 79–94.

145 **"a character who walked out"** Lombardi, ed., *L'Archivio di Giovanni Poggi*, 41.

145 **The following year, he helped recover** Press release of the Commune of Florence, dated 4 January 2005, for a meeting on the role of Giovanni Poggi in the retrieval of the *Mona Lisa*. *"Il Ritrovamento della Gioconda a Firenze." Un convegno in onore del sovrintendente Giovanni Poggi*, 26 January 2005, Florence.

146 **"due to agreements". . . . "We are not rejecting"** Poggi, "Relazione sui Monumenti e le Opere d'Arte di Firenze durante la guerra 1940–1945," 5 June 1945, Poggi Papers, Serie VIII, n.157, 12.

146 **"frenzied lucidity"** (Lombardi). **. . . almost six hundred major works** (Poggi) Lombardi, ed., *L'archivio di Giovanni Poggi*, 36; Poggi, "Prima relazione sulla protezione delle opere d'arte mobili," 20 June 1940, Poggi Papers, Serie VIII, n.154.

146 **With the dramatic increase in Allied bombing** Poggi, "Relazione sui Monumenti e le Opere d'Arte di Firenze durante la guerra 1940–1945," 5 June 1945, Poggi Papers, Serie VIII, n.157, 12.

147 **The groupings of art** Ibid. Lists of the repositories also appear in various documents in Poggi Papers, Serie VIII, n.154, 3–4 and n.156, 31–42.

147 **Villa di Torre a Cona** Hartt, *Florentine Art Under Fire*, 29.

147 **The Castle of Montegufoni** Ibid., 18.

147 **But Poggi made the decision** Cesare Fasola, "Perchè non abbiamo impedito l'esodo delle opere d'arte Fiorentine?" *Il Ponte*, May (1945), 141–46.

148 **transported from Florence uncrated** Field Report, 7 June 1945, Keller Papers, Box 21, Folder 33, 2.

148 **On June 18, 1944, Poggi had attended** Poggi, "Relazione sui Monumenti e le Opere d'Arte di Firenze durante la guerra 1940–1945," 5 June 1945, Poggi Papers, Serie VIII, n.157, 12.

148 **"It is too late"** Carlo Anti, "Agenda 1944," 18 June 1944, Anti Papers, Serie 1, n. 2.

148 **Poggi shrewdly parried the request with the Medici Family Pact . . . "never be removed"** Poggi, "Relazione sui Monumenti e le Opere d'Arte di Firenze durante la guerra 1940–1945," 5 June 1945, Poggi Papers, Serie VIII, n.157, 12.

149 **loaded 291 paintings** "Report on Deposits of Art-Treasures in Tuscany," 3 December 1944. NARA, RG 239, M1944, Roll 67. Not surprisingly, accounts vary on the actual number of objects taken from Montagnana, from 257 (Poggi, "Relations dei Soprintendente alle Gallerie e Musei di Firenze," 1 April 1945) to 297 (Hartt's *Florentine Art Under Fire*).

149 **"At one blow"** Hartt, *Florentine Art Under Fire*, 20.

149 **Gerhard Wolf requested that Langsdorff** Poggi, "Relations dei Soprintendente alle Gallerie e Musei di Firenze," 1 April 1945, NARA RG 331, 10000/145/363; Poggi, "Lettera a Carlo Anti," 19–20 July 1944, Anti Papers, Serie 2, n.2, 9.

149 **three German trucks** Tutaev, *The Consul of Florence*, 195.

149 **"that since the castle of Oliveto"** Poggi, "Relations dei Soprintendente alle Gallerie e Musei di Firenze," 1 April 1945, NARA, RG 331, 10000/145/363.

149 **The unloading of paintings commenced** Ibid.

150 **Conti then shared** Ibid.

150 **Poggi began by informing Langsdorff** Cooper and DeWald, "Report on the German Kunstschutz," NARA, RG 239, M1944, Roll 71, 7.

150 **June 18 meeting** Poggi, "Relazione sui Monumenti e le Opere d'Arte di Firenze durante la guerra 1940–1945," 5 June 1945, Poggi Papers, Serie VIII, n.157, 12.

150 **prepare a memorandum** Poggi, "Promemoria per il Col. Langsdorff" (no

date), Poggi Papers, Serie VIII, n.154, 4; Cooper and DeWald, "Report on the German Kunstschutz," NARA, RG 239, M1944, Roll 71, 7.

150 **"The rescue of art objects by the troops"** Armeeoberkommando 14, Chef des Generalstabes an Deutsche Botschaft, z.Hd. Gesandtschaftsrat Berger, Betr.: Bergung von Kunstgegenständen, 14 July 1944, Kunstschutz Papers, Siviero Archive.

151 **"bishops of Bologna or Modena"** Ibid.

151 **German troops had in fact attempted** Langsdorff, "Bericht über Bergungsfahrten von Kunstwerken aus dem Frontbereich bei Florenz der Abt. Kunst-, Archiv- und Bibliothekenschutz des Bevollmächtigten Generals der Deutschen Wehrmacht in Italien in der Zeit vom 16.7.–14.8.44," 21 August 1944, Kunstschutz Papers, Siviero Archive.

151 **the bishops had turned them away** Renato Bartoccini, "Promemoria per l'eccellenza il Ministro," 31 July 1944, Anti Papers, Serie 2, n.2, 15; Antonino Sorrentino, "Lettera a Carlo Anti," 20 August 1944, Anti Papers, Serie 2, n.2, 27; Alfredo Barbacci, "Lettera a Carlo Anti," 21 August 1944, Anti Papers, Serie 2, n.2, 28. Telex/Telegram, Langsdorff to Regierungspräsident Kanstein, 17 July 1944, Kunstschutz Papers, Siviero Archive.

151 **"Some art deposits in villas"** Cooper and DeWald, "Report on the German Kunstschutz," NARA, RG 239, M1944, Roll 71, 7. Also see Telex/Telegram Langsdorff to Regierungspräsident Kanstein, 17 July 1944, Kunstschutz Papers, Siviero Archive.

151 **report that he had inspected the castello** Poggi, Handwritten Memo, 17–18 July 1944, Poggi Papers, Serie VIII, n.155, 5.

151 **his promise to find and return** Poggi, Handwritten Memo, 19 July 1944, Poggi Papers, Serie VIII, n.155, 5.

151 **"handed over by the troops"** Langsdorff, "Bericht über Bergungsfahrten von Kunstwerken," 21 August 1944, Kunstschutz Papers, Siviero Archive.

152 **"separated from the rest"** Cooper and DeWald. "Report on German Kunstschutz," NARA, RG 239, M1944, Roll 71, 7.

152 **receipt for "two undamaged pictures"** Ibid.

152 **Langsdorff had already checked out** Ibid.; Poggi, Handwritten Memo 19 July 1944, Poggi Papers, Serie VIII, n.155, 5.

Chapter 15: Guardian Angels

154 **"the past contending with the present"** Samuel Rogers, "Florence," lines 5–6.

154 **"represented the pledge of love"** "Manifesto del Comitato per la raccolta dei fondi," in Comitato per la ricostruzione del ponte a S. Trinità, *Il ponte a S. Trinità* (Florence: Tip. E. Rinaldi, 1957), 15.

155 **"Florence is too beautiful"** Tutaev, *The Consul of Florence*, 94. In Rahn's memoirs, *Ruheloses Leben*, pp. 260–61, he dated this meeting to late July 1944,

but Tutaev's book, written in 1966, relied upon documents and extensive discussions with Rahn and other key participants in an effort to reconstruct the timeline of the events.

155 **first suggested by** Fasola, *The Florence Galleries and the War*, 56.

155 **But for a city to be declared "open"** Elia Dalla Costa, "Storia vera su Firenze "città aperta," in Comnène, *Firenze "città aperta." Contributo per la storia dell'occupazione tedesca in Italia*, 69–70.

155 **German forces had positioned** Ibid., 71.

156 **German leaders referred to Florence** Tutaev, *The Consul of Florence*, 134–35; Schramm, ed., *Kriegstagebuch des Oberkommando der Wehrmacht (Wehrmachtführungsstab), Band IV: 1. Januar 1944–22. Mai 1945, Erster Halbband*, 533.

156 **After four years of service** Tutaev, *The Consul of Florence*, 17.

156 **Seeking to distance himself** Ibid., 21.

156 **During Hitler's 1938 visit** Archivio Storico del Comune di Firenze, ed. *Firenze. 9 Maggio 1938*. Small collection of essays on the occasion of the exhibition "Il ritorno all'ordine. 1938—L'immagine di Firenze per la visita del Fuhrer," 25 September–31 October 2012 (Florence: P.O. Archivi e Collezioni Librarie Storiche, 2012), 15.

156 **"any other cross, if not that of Christ"** "Biography of Elia Dalla Costa," Archivio Storico Diocesano, Florence.

157 **"His Eminence Cardinal Elia Dalla Costa"** Filippo Serlupi Crescenzi Report, "La difesa dei tesori artistici e culturali fiorentini," undated, Private Collection, Italy.

157 **While he pleaded with the German commanders** Cardinal Dalla Costa, "Lettera al Maresciallo Kesselring," 1 July 1944, Elia Dalla Costa Papers, Archivio Storico Diocesano, Florence.

157 **"in order to truly protect Florentine works of art"** Serlupi Crescenzi Report, "La difesa dei tesori artistici e culturali fiorentini."

157 **"I had to ask Serlupi" . . . "to turn the interest"** Poggi, "Relazione sui rapporti intercorsi tra la R. Soprintendenza alle Gallerie e il marchese avv. Filippo Serlupi Crescenzi, nel periodo antecedente la liberazione di Firenze," 28 June 1945, Poggi Papers, Serie VIII, n.154, 4.

157 **"Marchese Serlupi did not miss one chance"** Bernard Berenson, "Per la verità," June 20, 1945, Private Collection, Italy.

157 **Carlo Steinhäuslin, a native Florentine. . . . particularly concerned with protecting the city's water pipes** Paolo Paoletti, "Il console svizzero Charles Steinhauslin," in Giorgio Mollisi, *Svizzeri a Firenze: Nella storia, nella cultura, nell'economia dal Cinquecento ad oggi* (Lugano: Ticino Management, 2010), 406–14; Carlo Steinhäuslin, "Che cosa ho fatto per Firenze. Appunti giornalieri per i miei figli" (bound manuscript by Carlo Steinhäuslin, consul of Switzerland in Florence during the German occupation: notes on the

events between 26 July and 25 August 1944, with copies of documents), Deutsches Historisches Institut, Rome, Archiv, N 9 Gerhard Wolf, IV. Schriften Dritter, no. 61.

158 **"an official declaration"** Tutaev, *The Consul of Florence*, 118.

158 **"never realised what it was like"** Ibid., 120.

158 **"I therefore have to say"** Alfred Jodl letter to Nicola Comnène, 12 May 1944, Private Archive, Italy.

158 **Working out of a home** Tutaev, *The Consul of Florence*, 126.

158 **"tables laden with thick whips"** Ibid., 127.

158 **Rahn gently ordered his friend** Tutaev, *The Consul of Florence*, 207.

158 **German Embassy at Fasano** Jürgen Klöckner, "Verhinderter Archivalienraub in Italien, Theodor Mayer und die Abteilung 'Archivschutz' bei der Militärverwaltung in Verona 1943–1945," in *Quellen und Forschungen aus italienischen Archiven und Bibliotheken*, vol. 86 (Rome: Deutsches Historisches Institut, 2006), 501.

159 **Gerhard Wolf left the city . . . "ashamed of what the German soldiers"** Steinhäuslin, "Che cosa ho fatto per Firenze. Appunti giornalieri per i miei figli," 31 July 1944, Deutsches Historisches Institut, Rome, Archiv, N 9 Gerhard Wolf, IV. Schriften Dritter, no. 61, note 4.

159 **On Saturday, July 29, German commanders** Tutaev, *The Consul of Florence*, 221.

159 * Comnène, *Firenze "città aperta,"* 49.

159 **Poggi, Dalla Costa, and Steinhäuslin composed a letter** Letter signed by Dalla Costa, Poggi, and others, July 30, 1944, in Comnène, *Firenze "città aperta,"* 86.

159 **"For me a bridge is just a bridge"** Tutaev, *The Consul of Florence*, 208.

159 **"quite impossible for any one"** Ibid., 199.

160 **On July 30, Ambassador Rahn. . . . "It is vital for Allied troops"** Ibid., 289; Comnène, *Firenze "città aperta,"* n.p.

160 **"psychological pressure"** Tutaev, *The Consul of Florence*, 245.

160 **"to pursue his retreat"** Deakin, *The Brutal Friendship*, 711.

160 **"Their artistic and historical value"** Schramm, ed., *Kriegstagebuch des Oberkommando der Wehrmacht (Wehrmachtführungsstab)*, 534.

160 **"it was only the enemy"** Ibid.

161 **"prepare *Feuerzauber*"** Paoletti and Carniani, *Firenze: Guerra & Alluvione: 4 Agosto 1944/4 Novembre 1966*, 56.

161 **"in and near Florence"** Tutaev, *The Consul of Florence*, 228.

161 **The only civilian** Paoletti, "Il console svizzero Charles Steinhauslin," 410.

161 **"While we argue[d] with the guards"** Steinhäuslin, "Che cosa ho fatto per Firenze. Appunti giornalieri per i miei figli," 31 July 1944, Schriften Dritter, no. 61, 9.

161 **"5 separate rows of boxes"** Tutaev, *The Consul of Florence*, 233. Steinhäus-

lin's diary account of this incident is not entirely consistent with the description in Tutaev's book. Because Tutaev had the benefit not only of seeing the diary but also of interviewing a number of the firsthand participants, I have relied on his interpretation.

162 **"The enemy artillery fire"** Schramm, ed., *Kriegstagebuch des Oberkommando der Wehrmacht (Wehrmachtführungsstab)*, 535.

162 * Fisher, *United States Army in World War II*, 292.

162 **"I could not accede"** Albert Kesselring, *The Memoirs of Field-Marshal Kesselring*, 309.

162 **At 2 p.m., Thursday** Tutaev, *The Consul of Florence*, 238.

162 **"It seemed that the earth"** Ibid., 239.

162 **"the Neronian spectacle"** Bernard Berenson, *Rumor and Reflection* (New York: Simon & Schuster, 1952), 382.

162 **Around 2 a.m. on August 4, the genius** Tutaev, *The Consul of Florence*, 243.

163 **"heave its shoulders"** Ibid.

163 **"At dawn, from my house"** Poggi, "Descrizione giorni immediatamente precedenti e immediatamente successivi la distruzione del Ponte," Poggi Papers, Serie VIII, n.159, 23.

163 **"stunned silence"** Tutaev, *The Consul of Florence*, 253.

163 **"I'd rather be dead than see"** Ibid., 32.

Chapter 16: "Little Saints, Help Us"

165 **On July 31, while at British Eighth Army AMG Headquarters** Hartt, *Florentine Art Under Fire*, 16.

165 **Major Eric Linklater** Magnus Linklater, "The Man Who Kissed the Primavera," *Scottish Review*, January 2006.

165 **"armed and helmeted"** Hartt, *Florentine Art Under Fire*, 16.

165 **"battered" jeep. . . . "Its windshield was shattered"** Ibid., 9.

166 **"The hills beyond"** Ibid., 17.

166 **"a tall, eager, bespectacled"** Eric Linklater, *The Art of Adventure* (London: Macmillan and Co., 1947), 268.

166 **Linklater, who had been commissioned** Ibid., 255–57.

167 **"But they're very good!"** Ibid., 257.

167 **"They must be copies!"** Ibid.

167 **"The whole house is full"** Ibid., 258.

167 **The group then wandered** Ibid., 259.

167 **"Botticelli!". . . . a short middle-aged man** Ibid., 260–61.

167 **Cesare Fasola, Librarian of the Uffizi** Fasola, *The Florence Galleries and the War: History and Records*, 57.

167 **"The packing-cases had all been opened"** Ibid., 58–59.

168 **German soldiers' use of fifteenth-century** Hartt, *Florentine Art Under Fire*, 19.

168 **"Little Saints, help us!"** Fasola, *The Florence Galleries and the War*, 60.

168 **"the thunder"** Hartt, *Florentine Art Under Fire*, 18.

168 **Hartt knew every work of art** Ibid.

168 **"A description of these pictures"** Ibid., 19.

168 **From Montegufoni, the group** Ibid., 22.

169 **"Five deposits located"** Hartt, Telegram, 31 July 1944, NARA, RG 331, 10000/145/362.

169 **He then prepared a memo. . . . "The fate of these priceless treasures"** Hartt Memo, "Secret," Hartt Papers, Box 3, Folder 8.

169 **"be assigned the job"** Hartt, *Florentine Art Under Fire*, 24.

169 **"everything possible [to safeguard the works of art]"** Newton to Keller, August 5, 1944, Keller Papers, Box 21, Folder 21.

169 **At 5 a.m. on August 4** Ludwig Reidemeister, "Beitrag zum Rechenschaftsbericht des militärischen Kunstschutzes in Italien 'Bergungsfahrten im Frontraum,'" 5 June 1945, Hartt Papers, Box 2, Folder 8.

169 **While crossing the Po River** Ibid.; Langsdorff, "Bericht über Bergungsfahrten von Kunstwerken aus dem Frontbereich bei Florenz im Juli und August 1944," 11 May 1945, Hartt Papers, Box 2, Folder 8.

170 **"rescue operations of art objects"** Telex/Telegram Langsdorff to Regierungspräsident Kanstein, 17 July 1944.

170 **On the afternoon of July 21** Siviero, *L'Arte e il Nazismo: esodo e ritrovo delle opere d'arte italiane, 1938–1963*, 73–74.

170 **Villa Besana** Silvano Vinceti, *Salò capitale: breve storia fotografica della RSI* (Rome: Armando Editore, 2003), 30.

170 **Wolff's pending appointment** Lang, *Der Adjutant*, 247.

170 **"go and remove whatever could be saved"** Cooper and DeWald, "Report on the German Kunstschutz," NARA, RG 239, M1944, Roll 71, 7.

170 **"which the Führer greatly admired"** Karl Wolff, Telegram to Heinrich Himmler, 25 July 1944, BArch NS 19/3808, F.1., Bundesarchiv Berlin.

170 **"whether these art treasures"** Ibid.

170 **"which guarantees a good safekeeping"** Meine on behalf of Heinrich Himmler, telegram to Karl Wolff, 26 July 1944, BArch NS 19/3808, F.1., Bundesarchiv Berlin.

171 **On July 28, Langsdorff returned to Florence** Reidemeister, "Beitrag zum Rechenschaftsbericht des militärischen Kunstschutzes in Italien 'Bergungsfahrten im Frontraum,'" 5 June 1945, Hartt Papers, Box 2, Folder 8.

171 **"Everyone awaited numb"** Ibid.

171 **At 11 a.m., Langsdorff met with Giovanni Poggi** Poggi, "Relazione del Soprintendente alle Gallerie e Musei di Firenze," 1 April 1945, NARA, RG 331, 10000/145/363.

171 **"was worried about the fate"** Ibid.

171 **"to provide for their safety"** Ibid.

171 **On August 5, meeting again** Cooper and DeWald, "Report on German Kunstschutz," NARA, RG 239, M1944, Roll 71, 8.

171 **"created a repository for the works of art"** Alexander Langsdorff, "Lettera a Giovanni Poggi," 18 June 1944, Anti Papers, Serie 2, n.2, 3.

171 **"The Borromean Islands"** Bevollmächtigter General der Deutschen Wehrmacht in Italien an Chef d.Mil.Verw.Abt.Kunstschutz, Leitkommandatur Mailand, Mil.Kdtr. Novara, "Betr.: Belegung der Isola Borromea," 3 August 1944, Kunstschutz Papers, Siviero Archive.

171 **finalizing it during a phone call** Cooper and DeWald, "Report on the German Kunstschutz," NARA, RG 239, M1944, Roll 71, 9.

172 **Following the September 1943 armistice** C. F. Latour, "Germany, Italy and South Tyrol, 1938–45," *The Historical Journal* 8, no. 1 (1965), 111.

172 **"The laws of the Social Republic did not apply there"** Pietro Ferraro, "La resistenza veneta in difesa delle opere d'arte," *Il Ponte*, September 1954, 129.

172 **"uncrowned king in his own Gau"** Cooper and DeWald, "Report on the German Kunstschutz," NARA, RG 239, M1944, Roll 71, 9.

172 **"In Alto Adige one has the impression"** "Relazione al Ministro dell'Educazione Nazionale," 5 December 1944, Anti Papers, Serie 2, n.2, 72.

172 **"deadly enemy"** Wolff, *Mit Wissen Hitlers*, 142.

172 **Linklater and Vaughan Thomas entered Florence. . . . "The Florentines of the South Bank"** Linklater, *The Art of Adventure*, 270–71.

173 **"the tactical situation prevented"** Roger Ellis, "Inspection of Monuments in Florence," 11 August 1944, NARA, RG 331, 10000/145/71.

173 **"By August 12 the suspense of waiting"** Hartt, *Florentine Art Under Fire*, 36.

173 **"in a state of feverish excitement"** Ibid., 36–37.

173 **At Villa Torrigiani, temporary headquarters** Ibid.

174 **"a mass of rubble thirty feet high"** Ibid., 44.

174 **"On the south bank the wonderful old buildings"** Ibid., 45.

174 **"Santo Stefano, in Por Santa Maria"** "Damage to Monuments in Florence," 20 August 1944, Hartt Papers, Box 3, Folder 8.

175 **"German authorities have stored in Villa Reale Poggio a Caiano"** Hartt, *Florentine Art Under Fire*, 68.

Chapter 17: "The Most Beautiful Cemetery in the World"

177 **Kesselring's troops made excellent use** Fisher, *United States Army in World War II*, 270.

178 **2,376 machine-gun posts** Douglas Orgill, *The Gothic Line* (New York: W. W. Norton, 1967), 28.

178 **The longer the Germans could delay** Fisher, *United States Army in World War II*, 270.

178 **Pisa reached the height of its political power** Giuseppe Galasso, ed., *Storia*

d'Italia, Comuni e signorie nell'Italia nordorientale e centrale: Veneto, Emilia-Romagna e Toscana, Vol 7.1 (Turin: UTET, 1987), 699.

178 **The city's political and economic decline. . . . 50,000 gold florins** Giuseppe Odoardo Corazzini, *L'assedio di Pisa, 1405–1406: scritti e documenti inediti* (Florence: U. Diligenti, 1885), 84–85; Giorgio Del Guerra, *Pisa attraverso i secoli* (Pisa: Giardini, 1967), 123.

179 **"The Holy See cannot do other"** Letter to Taylor, 28 July 1944, Tittmann Papers, NARA, RG 59, Box 7.

179 **In four months, Keller had already driven** Letter to Kathy, 3 October 1944, Keller Papers, Box 7, Folder 49.

179 **"The south side was so badly destroyed"** "Fine Arts Section," Keller Papers, Box 19, Folder 10, 36.

179 **"The south side of the city was booby trapped"** Ibid.

179 **prewar population of seventy-two thousand** The data come from ISTAT, the Italian National Institute for Statistics. The census of the population in Pisa was taken in 1936 and registered, precisely, 72,468 people living in the city.

179 **Keller's AMG advance team** "Fine Arts Section," Keller Papers, Box 19, Folder 10, 36–37.

180 **hung the Stars and Stripes and the Union Jack** "Fine Arts Section," Keller Papers, Box 19, Folder 10, 37; Field Report, 7 September 1944, Keller Papers, Box 21, Folder 32.

180 **"There was little sleep"** "Fine Arts Section," Keller Papers, Box 19, Folder 10, 37.

180 **Early the next morning** Ibid.

180 **The Baptistery had sustained hits** Field Report, 7 September 1944, Keller Papers, Box 21, Folder 32.

181 **For comparison, the area of frescoes in the Camposanto** The painted area of the Camposanto was 16,145.865 sq ft and the painted area of the Sistine Chapel is slightly more than 12,972.321 sq ft. "Affreschi del Camposanto," *Opera della Primaziale Pisana*, 2003–2007, http://www.opapisa.it/it/attivita/cantieri-e-restauri/affreschi-del-camposanto.html; "Cappela Sistina," Stato della città del Vaticano, http://www.vaticanstate.va/IT/Monumenti/Musei Vaticani/Cappella_Sistina.htm.

182 **"On the floor next to the walls"** "Fine Arts Section," Keller Papers, Box 19, Folder 10, 42.

182 **Keller suspended his inspection** Ibid., 41.

183 **Farnesi watched as a few shells** Bruno Farnesi, "Cronaca della distruzione dell'incomparabile gioiello d'arte che era il/celebre Camposanto Monumentale di Pisa, Avvenuta il 27 Luglio 44 a causa di una granata di artiglieria," 28 July 1944, Hartt Papers, Box 4, Folder 6.

183 **Even from the ground** Ibid.

183 **Farnesi and a small group of volunteers** Ibid.

183 **A shell whistled in, hitting the Duomo** Ibid.

184 **"I went back to the monument"** Hartt, *Florentine Art Under Fire*, 82; Farnesi, "Cronaca della distruzione."

184 **"In the night, the Piazza dei Miracoli"** Farnesi, "Cronaca della distruzione."

184 **"I saw again"** Ibid.

185 **the town of San Miniato** Keller, Field Report 24 August 1944, Keller Papers, Box 21, Folder 32.

185 **"My assignment is MFAA officer". . . . "I am not supposed to"** Letter to Parents, 24 July 1944, Keller Papers, Box 5, Folder 26.

186 **instructed him to bar entry** Field Report, 7 September 1944, Keller Papers, Box 21, Folder 32.

Chapter 18: Whereabouts Unknown

187 **"Florence is no longer"** Herbert L. Matthews, "Old Florence Ravaged by Nazis; Much of Medieval City Destroyed," *New York Times*, August 30, 1944.

187 **"loopholes . . . through which"** Hartt, *Florentine Art Under Fire*, 46.

188 **At 6 p.m. on August 17. . . . "Trinity Bridge"** "Emergency Bridges Being Built in Florence," NARA, RG 331, 10000/145/69.

188 **"In the city there was no water"** Hartt, *Florentine Art Under Fire*, 48.

189 **life remained miserable. . . . Gaunt faces. . . . No one indulged in vanity** *Il Martirio di Firenze*, archival film, Imperial War Museum, London COI53.

190 **"The botanical gardens are now"** Martha Gellhorn, "Treasure City: The Fight to Save Florence," Keller Papers, Box 23, Folder 50.

190 **"getting constantly in each other's hair"** Letter from Hartt to Keller, 21 August 1944, Keller Papers, Box 21, Folder 32.

190 **These confrontations came to a head** "Report on Archives of La Colombaria," 4 September 1944, Hartt Papers, Box 3, Folder 9.

191 **"devouring bulldozer[s]"** "Final Report General," Keller Papers, Box 23, Folder 52, 14.

191 **"[I] made between three and five trips"** "Report on Archives of La Colombaria," 4 September 1944, Hartt Papers, Box 3, Folder 9.

191 **"Mechanical excavation and carrying away"** "5 Army Job No. 1463 Clearance of Debris," 28 September 1944, Hartt Papers, Box 3, Folder 9.

191 **"After many complaints"** Ibid.

191 **"in surprising numbers"** Hartt, *Florentine Art Under Fire*, 53.

191 **Poggi proposed a resourceful solution. . . . "wade up to the ankles"** Hartt, *Florentine Art Under Fire*, 56.

192 **"from 1907 to 1951". . . . "a princely estate"** Ethne Clarke, "A Biography of Cecil Ross Pinsent, 1884–1963," *Garden History* 26, no. 2 (Winter 1998), 176, 187.

192 **In early 1942** Tutaev, *The Consul of Florence*, 49.

192 **acting on the advice of** Elisabetta "Nicky" Mariano, *Forty Years with Berenson* (New York: Alfred A. Knopf, 1966), 282.

192 **Marchesa Serlupi and her staff** Tutaev, *The Consul of Florence*, 51.

192 **apartment near the Ponte Santa Trinita** The house, in Borgo San Jacopo, was the property of Baroness Alda von Anrep, Mariano's sister. She was married to Baron Egbert; their son was named Cecil. Mariano, *Forty Years with Berenson*, 7, 208.

193 **"had gone to Portugal"** Tutaev, *The Consul of Florence*, 49.

193 **On a mid-August day** "Bernard Berenson," 6 September 1944, Hartt Papers, Box 3, Folder 9.

193 **"still living in his own house"** Sheldon Pennoyer, "Sand, Rubble and Fine Arts," Sheldon Pennoyer Papers, Department of Art and Archaeology, Princeton University.

193 **On September 1, the first Allied soldier** Berenson, *Rumor and Reflection*, 419.

193 **"Villa [delle Fontanelle] was perforated"** "Bernard Berenson," 6 September 1944, Hartt Papers, Box 3, Folder 9.

193 **"A shell burst near the convent enclosure"** Elisabetta "Nicky" Mariano, Diary, 15 August 1944, Private Collection, Italy. Diary published in slight variation in Mariano, *Forty Years with Berenson*, 340.

194 **"After all the humanity"** Pennoyer, "Sand, Rubble and Fine Arts," Pennoyer Papers.

194 **Hofer instructed Reidemeister** Reidemeister, "Beitrag zum Rechenschaftsbericht des militärischen Kunstschutzes in Italien 'Bergungsfahrten im Frontraum,'" 5 June 1945, Hartt Papers, Box 2, Folder 8.

195 **"700 liters [185 gallons]"** Josef Ringler, "Gedächtnis-Protokoll (private Aufzeichnung des Dr. Ringler), der aus der Toscana nach Südtirol verbrachten Kunstschätze aus italienischem Staatsbesitz und ihre Betreuung durch den Denkmalpfleger in der Operationszone," NARA, RG 331, 10000/145/440.

195 **Captain Zobel, stopped in Bolzano** Zobel Diary Notes, found in Siviero, *L'Arte e il Nazismo*, 86–87.

195 **to the salt mines of Altaussee** Cooper and DeWald, "Report on the German Kunstschutz," NARA, RG 239, M1944, Roll 71, 14.

196 **"greeted as liberators"** Hartt, *Florentine Art Under Fire*, 69.

196 **"The withdrawal of these works"** "Report on German Removals of Works of Art from Deposits in Tuscany," 8 October 1944, Hartt Papers, Box 3, Folder 10.

196 **handwritten receipt** Handwritten inventory of Poggio a Caiano, Hartt Papers, Box 4, Folder 7.

196 **"Donatello's *Saint George!*"** Hartt, *Florentine Art Under Fire*, 69.

196 **"Dear Ernest: This is what they stole"** Hartt to DeWald, 7 September 1944, NARA, RG 331, 10000/145/ 71.

197 **On September 7, and again. . . .** THIS IS THE FRONT. **. . . . On August 18, a German officer. . . .** "the village was a nest". **. . . . After forcibly inspecting** Hartt, *Florentine Art Under Fire*, 71–72.

197 **"official and had been ordered"** Ibid., 73.

198 **At the Villa Landau-Finaly** Ugo Perini, "Particolari sull'asportazione di opere d'Arte compiuta dai paracadutisti tedeschi alla Villa Landau-Finaly posta in Firenze—Via Bolognese, No. 126," 21 May 1945, NARA, RG 331, 10000/145/403. Given the proximity of the villas, and because part of the Finaly collection had been hidden in the Acton villa, the Germans believed it was all one collection. War-era documents usually make reference to a "Collection Finaly-Acton."

198 **Florentine art dealer and collector** Langdorff's note on Contini, 27 October 1944, found in Siviero, *L'Arte e il Nazismo*, 89.

198 **hid his collection in a villa at Podere di Trefiano** Alessandro Contini Bonacossi, "Lettera a Frederick Hartt con elenco opere trafugate dalle truppe tedesche," 14 September 1944, Poggi Papers, Serie VIII, n.158, 16.

198 **The 16th SS Panzer Division** Cooper and DeWald, "Report on the German Kunstschutz," NARA, RG 239, M1944, Roll 71, 12.

198 **"Only the fearless conduct"** Hartt, *Florentine Art Under Fire*, 76–77.

198 **"On three separate occasions"** "Report on German Removals of Works of Art from Deposits in Tuscany," 8 October 1944, Hartt Papers, Box 3, Folder 10.

199 **"The pictures taken"** Ibid.

199 **"A grand total of 529 paintings". . . . "had suffered a robbery"** Hartt, *Florentine Art Under Fire*, 76.

Chapter 19: Resurrection

201 **pounded the city for an additional three weeks** "Fine Arts Section," Keller Papers, Box 19, Folder 10, 36.

201 **"Thirty-eight of her monumental churches"** Ibid.

202 **"The whole fresco was painted"** John B. Ward-Perkins, "Pisa: Camposanto," 17 September 1944, Hartt Papers, Box 3, Folder 9.

202 **Hume arrived the following morning. . . . Hume contacted. . . . within nine days** "Fine Arts Section," Keller Papers, Box 19, Folder 10, 42–43.

202 **"On my way home"** Letter to Kathy, 10 September 1944, Keller Papers, Box 7, Folder 48.

202 **As soon as he reached Pisa. . . . lead poisoning. . . . "the dust was terrific". . . . "a man with"** "Fine Arts Section," Keller Papers, Box 19, Folder 10, 43–44.

203 **German shells continued to fall** Field Report, 26 September 1944, Keller Papers, Box 21, Folder 32.

203 **"midnight requisition"** Leonard Fisher (friend of Deane Keller), interview with the author, December 23, 2010.

203 **"the Camposanto of Pisa is now"** Field Report, 26 September 1944, Keller Papers, Box 21, Folder 32.

203 **"The job is done, works perfectly"** Letter, 12 October 1944, Keller Papers, Box 21, Folder 32.

203 **"This is the biggest job"** Letter to Kathy, 9 October 1944, Keller Papers, Box 7, Folder 49.

203 **The nearby Leaning Tower** "Fine Arts Section," Keller Papers, Box 19, Folder 10, 45.

204 **"Without the University"** Field Report, 8 October 1944, Keller Papers, Box 21, Folder 32.

204 **On November 25** "Fine Arts Section," Keller Papers, Box 19, Folder 10, 47.

205 **"It is really necessary"** 6 October 1944, Hartt Papers, Box 3, Folder 10.

205 **"[Hartt] bores me to death"** Letter to Kathy, October 1944, Keller Papers, Box 7, Folder 49.

205 **"the young intellectual's habit"** Harris, *Bomber Offensive*, 130.

205 **A day later, he wrote a letter** Keller to DeWald, 19 October 1944, Keller Papers, Box 21, Folder 32.

206 **According to Poggi. . . . 'Neumelans in Sand'** Poggi, "Memo," 11 November 1944, Poggi Papers, Serie VIII, n.155, 5.

206 **"I could find no such place"** Hartt, *Florentine Art Under Fire*, 96.

Chapter 20: Christmas Wishes

207 **Cagiati and his travel companions** Sergio Giliotti, *La seconda Julia nella Resistenza: cronistoria di una brigata partigiana* (Reggio Emilia: Diabasis, 2010), 133.

207 **favored adviser to Pope Pius XII** Cornwell, *Hitler's Pope*, 65.

208 **"trustworthy man . . . the son"** Ennio Caretto, "Montini, una scelta Americana per l'Italia," *Corriere della Sera*, 26 August 2003, 31.

208 **"Pippo". . . . exchanged many letters** Letter, Cagiati to Serlupi, 1/12/34, Private Collection, Italy.

208 **"We should like very much"** Donovan to McCloy, 15 December 1942, NARA, RG 226, Entry 190, Box 579.

208 **During a brief posting . . . first American to enter Naples** Alessandro Cagiati, "OSS Italian Activities January 1943–June 1945," March 1947, NARA, RG 226, Entry 190, Box 73, 17.

209 **On September 1** Berenson, *Rumor and Reflection*, 419.

209 **Don Guido Anelli was the parish priest. . . . active leader—nom de guerre** Luigina Anelli (Don Guido Anelli's sister), in discussion with Anna Bottinelli, 22 December 2010, and 20 February 2011; Pietro Bonardi (historian and Resistance expert), in discussion with Anna Bottinelli, 20 December 2010; Sergio Giliotti (partisan and friend of Anelli's), in discussion with Anna Bottinelli, 22 December 2010; "Nel X anniversario l'A.P.C. ricorda

Don Guido Anelli," *Vita Nuova*, no. 10, 10 March 1979, 7; "Don Anelli, prete volante un ardimentoso partigiano," *Gazzetta di Parma*, 7 May 1990, 3; "Il prete partigiano è ritornato a casa," *Gazzetta di Parma*, 13 May 1990; "Si ricorda don Anelli a otto anni dalla morte," *Gazzetta di Parma*, 9 March 1978, 7; "Don Tito promotore della lotta di liberazione," *Gazzetta di Parma*, 14 May 1945, 2; Sergio Giliotti, "Don Guido Anelli, il prete volante e le azioni della 2° Julia," *Il contributo dei Cattolici alla lotta di Liberazione in Emilia-Romagna*, Acts of meeting held on 1, 2, 3 May 1964, in Parma and Salsomaggiore (1966), 281–88; Sergio Giliotti, *La Seconda Julia nella Resistenza: cronistoria di una brigata partigiana* (Reggio-Emilia: Diabasis, 2010), 131–34.

209 **Anelli had secretly crossed enemy lines. . . . "inform the Vatican"** Alessandro Cagiati, "Report on visit to Rome with two couriers from Parma C.L.N.," 6 December 1944, NARA, RG 226, Entry 190, Box 73, Appendix A, 2.

209 **These isolated actions became** Orgill, *The Gothic Line*, 36.

210 **Karl Wolff held responsibility** Wolff, *Mit Wissen Hitlers*, 12–13.

210 **But increasingly their attacks** Gerhard Schreiber, "Partisanenkrieg und Kriegsverbrechen der Wehrmacht 1943 bis 1945," *Repression und Kriegsverbrechen, Die Bekämpfung von Widerstands- und Partisanenbewegungen gegen die deutsche Besatzung in West- und Südeuropa* (Berlin/Göttingen: Verlag der Buchläden, 1997), 94–95.

210 **"to adopt the severest measures"** Kesselring order. [WO 204/11496] found in Richard Lamb, *War in Italy 1943–1945—A Brutal Story* (New York: Da Capo Press, 1993), 316.

210 **"Only the best troops"** Schreiber, "Partisanenkrieg und Kriegsverbrechen der Wehrmacht 1943 bis 1945," 97.

210 **The subsequent burning of villages** Ibid., 110–12.

210 **"During the interview"** Cagiati, "Report on visit to Rome with two couriers from Parma C.L.N.," Appendix A, 2.

210 **"Cagiati and the other partisan liaison officers"** Gilberta Serlupi Crescenzi diary, 28 November 1944, Private Collection, Italy.

210 **Deputy Secretary of State for Extraordinary Affairs** Cornwell, *Hitler's Pope*, 221.

210 **During those meetings. . . . "The news that large numbers of partisans"** Cagiati, "Report on visit to Rome with two couriers from Parma C.L.N.," 5.

211 **"From an OSS point of view"** Ibid., 6–7.

211 **13 million lire followed** Giliotti, *La Seconda Julia nella Resistenza*, 132.

211 **"That money saved our squads"** "Don Anelli, prete volante un ardimentoso partigiano," *Gazzetta di Parma*.

211 **noticed a prayer book in Anelli's abandoned seat. . . . As the plane reached the drop point,** Giliotti, *La Seconda Julia nella Resistenza*, 133.

212 **On December 9, Fascist Radio** Fascist Radio, "Messaggio sull'ispezione

fatta dal Direttore Generale delle Arti, prof. Carlo Anti," 11 December 1944, Poggi Papers, Serie VIII, n.155, 5.

212 **"I am choking"** Elena Franchi, "Vertrauen und Misstrauen: die schwierigen Beziehungen zwischen der Italienischen Sozialrepublik und dem 'Kunstschutz.' Einige umstrittene Fälle," in *Kunsthistoriker im Krieg. Deutscher Militärischer Kunstschutz in Italien 1943–1945*, ed. Christian Fuhrmeister et al. (Cologne/Weimar/Vienna: Böhlau Verlag, 2012), 121.

212 **The following day, Dr. Josef Ringler. . . . While Ringler didn't know. . . . Their trip took them. . . . The inspection was brief** Ringler, "Gedächtnis-Protokoll (private Aufzeichnung des Dr. Ringler)," NARA, RG 331, 10000/145/440.

213 **But he knew that Rupprecht** Ringler, "Bericht des kommissarischen Leiters des Denkmalamtes (Soprintendenza ai monumenti e gallerie) in Trient über die Bergung von Kunstgut in der Operantionszone Alpenvorland," 15 May 1945, NARA, RG 331, 10000/145/440.

213 **"the directives"** James S. Plaut, "Hitler's Capital," *Atlantic Monthly*, vol. 178, no. 4, October 1946, 75.

213 **"The present situation is to be regarded"** Stephen E. Ambrose, *Citizen Soldiers* (New York: Simon & Schuster, 1997), 208.

214 **"On entering the city hall"** Keller to Sizer, 6 December 1944, Theodore Sizer Papers, Box 11, Folder 167.

214 **"Dearest: Today is Christmas"** Letter to Kathy, 25 December 1944, Keller Papers, Box 7, Folder 51.

215 **"Downstairs the radio"** Ibid.

SECTION III: VICTORY

217 **"Absolute secrecy is essential"** Donovan to Roosevelt, "Memorandum for the President," March 8, 1945, from "Memoranda for the President: Sunrise," *Studies in Intelligence*, vol. 7, issue 2, accessed via CIA Center for the Study of Intelligence, cia.gov.

Chapter 21: Trouble in the Ranks

219 **"Now it is not a war"** Dulles, *From Hitler's Doorstep*, 429. Dulles cable, January 18, 1945.

219 **between eighty and a hundred thousand German soldiers** Max Hastings, *Armageddon: The Battle for Germany, 1944–1945* (New York: Vintage Books, 2004), 235.

220 **"Our precious reserves"** Major-General F. W. von Mellenthin, *Panzer Battles 1939–1945: A Study of the Use of Armour in the Second World War* (London: Cassell & Company, 1955), 332.

220 **19,246 American deaths. More than four times** Tom Gibbs (historian at The National World War II Museum), in discussion with the author, June

18, 2012. Official Department of the Army statistics have the exact number of casualties at 108,347 (19,246 killed in action, 62,489 wounded, 26,612 captured or missing). The Defense Department lists 89,500 casualties. The real number probably lies in between those two estimates.

220 **fourteen hundred casualties** Hastings, *Armageddon*, 235; Jean Smith, *Eisenhower in War and Peace* (New York: Random House, 2012), 414; "Recognizing the 60th Anniversary of the Battle of the Bulge During World War II," November 16, 2004, *Congressional Record*, V. 150, Pt. 17, October 9, 2004, to November 17, 2004 (Washington, DC: U.S. Government Printing Office, 2004), 23589.

220 **"is undoubtedly the greatest"** Alex Kershaw, *The Longest Winter: The Battle of the Bulge and the Epic Story of WWII's Most Decorated Platoon* (Cambridge, MA: Da Capo Press, 2004), 174.

220 **"Do not be too disappointed,"** Letter to Kathy, 20 December 1944, Keller Papers, Box 8, Folder 51.

220 **"If I had gotten the award"** Letter to Kathy, 7 January 1945, Keller Papers, Box 8, Folder 52.

220 **While standing in line** "Charley and the Captain," Keller Papers, Box 19, Folder 1.

221 **"I don't care much"** Letter to Kathy, 13 January 1945, Keller Papers, Box 8, Folder 52.

221 **"Private First Class Bernholz"** Mark Clark, "Award of Bronze Star Medal," 21 May 1944, Charles Bernholz Papers, Private Collection.

221 **"*Me ne frego*" . . . "I don't give a damn"** Letter to Kathy, 6 January 1945, Keller Papers, Box 8, Folder 52.

221 **first time in sixteen months** Letter to Kathy, 27 February 1945, Keller Papers, Box 8, Folder 52.

221 **Early in the morning of January 11, 1945. . . . "Some were digging holes"** Report, 11 January 1945, Keller Papers, Box 21, Folder 33.

222 **Keller later made a rough sketch** Drawing, Keller Papers, Box 19, Folder 1.

223 **"without exception they have all"** Edgar Erskine Hume, "Italian Decorations," 30 December 1944, Keller Papers, Box 21, Folder 33.

223 **In August 1943, local art officials** Poggi, "Relazione sui Monumenti e le Opere d'Arte di Firenze durante la Guerra 1940–1945," 5 June 1945, Poggi Papers, Serie VIII, n.157, 12; Field Report, 17 February 1945, Keller Papers, Box 21, Folder 33; "Bronze Statue of Cosimo I," 21 February 1945, Hartt Papers, Box 3, Folder 14.

223 **After several days of planning. . . . "in the manner of a Maine"** Field Report, 17 February 1945, Keller Papers, Box 21, Folder 33.

223 **"Captain, that horse is full"** William Keller interview with the author, October 22, 2010.

223 **"a driver of a *carrozza*". . . . "The implications of such a transport"** Field Report, 17 February 1945, Keller Papers, Box 21, Folder 33.

224 **Smokey had been killed** Photo, Keller Papers, Box 36, Folder 222.

224 **"The story of what has happened"** Herbert L. Matthews, "Tuscan Treasures Slowly Repaired," *New York Times*, January 2, 1945.

224 **"I am not alone in thinking"** Letter to Kathy, 28 March 1945, Keller Papers, Box 8, Folder 53.

224 **"he had forgotten to mention"** Letter to Kathy, 24 January 1945, Keller Papers, Box 8, Folder 52.

224 **"I know the Army feeling"** Letter to Col. DeWald, 21 January 1945, Keller Papers, Box 21, Folder 33.

225 **"don't like cheap publicity."** Stanley P. Hirshson, *General Patton: A Soldier's Life* (New York: HarperCollins, 2002), 303.

225 **"Very few [soldiers] shoot off"** Mauldin, *Up Front*, 61–62.

225 **"We always got along fine"** Letter to Keller, 23 January 1945, Hartt Papers, Box 3, Folder 25.

225 **"Lt. Hartt has done"**. . . . **"Sunday morning last"** Letter to Col. Mayne, 29 January 1945, Keller Papers, Box 21, Folder 33.

225 **Keller drew a cartoon** Keller to Pennoyer, "A.M.G.–5th Army and Regional Cooperation," winter 1945, Pennoyer Papers, Princeton University.

226 **Six million Red Army soldiers** Tony Le Tizier, *Durchbruch an der Oder: Der Vormarsch der Roten Armee 1945* (Augsburg: Bechtermünz Verlag, 1999), 27.

226 **less than thirty miles from Carinhall** Horst Rambusch, *Erster Oderbrückenkopf 1945—Abschnitt Kienitz–Karlsbiese—und die Folgen für die Bevölkerung* (Gross Neuendorf: Landfrauenverein "Mittleres Oderbruch," 2010), 11, http:// www.oderbrückenkopf1945.de; Le Tizier, *Durchbruch an der Oder*, 63, 70.

226 **Aware the end was near** Report No. 2, The Goering Collection, September 1945, O.S.S. Art Looting Investigation Unit Consolidated Interrogation Reports, NARA, M1782, 170.

226 **More than a year earlier.** . . . **"Under no circumstances".** . . . **Instead, Göring instructed** Ibid., 30.

Chapter 22: Switching Sides

229 **On March 8, 1945,** Wolff, *Mit Wissen Hitlers*, 89, 97–102.

230 **worth billions** Langsdorff, "Bericht über die Bergungsfahrt südlich Florenz während der Zeit vom 16.–23.7.1944 (Teilnehmer: MVA Chef Dr. Langsdorff u. Hptm. Zobel)," 17 August 1944, Kunstschutz Papers, Siviero Archive.

230 **Throughout the late summer** Anti, "Lettera ad Alexander Langsdorff," 25 August 1944; Correspondence of 23 August, 30 August, and 2 September 1944, Anti Papers, Serie 2, n.2, 33.

230 **"were safer in a German Gau"** Cooper and DeWald, "Report on the German Kunstschutz," NARA, RG 239, M1944, Roll 71, 13.

230 **German stubbornness** . . . **"that the transportation of works of art"** Anti, "Appunto per il Ministro," 4 September 1944, Anti Papers, Serie 2, n.2, 44.

230 **"Gauleiter Hofer would not allow"** Cooper and DeWald, "Report on the German Kunstschutz," NARA, RG 239, M1944, Roll 71, 16.

230 **"was showing so much interest in the Italians."** Ibid.

230 **"the Führer's Promise"** Carlo Anti, "Relazione al Ministro dell'Educazione Nazionale," 5 December 1944, Anti Papers, Serie 2, n.2, 72.

230 **Over the following two days** Langsdorff, "Vermerk über die Besichtigung der Kunstdepots in S. Leonhard in Passeier und Sand in Taufers mit dem Vertreter des ital. Ministeriums für Nationale Erziehung Generaldirektor Prof. Dr. Carlo Anti vom 27. bis 30. 11. 1944," 2 December 1944, Kunstschutz Papers, Siviero Archive; Anti, "Relazione al Ministro dell'Educazione Nazionale," 5 December 1944, Anti Papers, Serie 2, n.2, 72.

231 **Wolff explained that** Langsdorff, "Aktenvermerk: Verzeichnis der aus Villa Bossi Pucci in Montagnana geborgenen Gemälde," 2 December 1944, Kunstschutz Papers, Siviero Archive; Letter, Alexander Langsdorff to Prof. Heydenreich, Deutsches Generalkonsulat Milan, 2 December 1944, Kunstschutz Papers, Siviero Archive.

231 **"Without these my inspection was reduced to an interesting and very nice trip"** Anti, "Lettera a Reidemeister," 13 March 1945, Anti Papers, Serie 2, n.2, 92.

231 **"without a doubt, the Germans will take the art"** Antonio Sorrentino and Alfredo Barbacci, "Lettera a Carlo Anti," 12 February 1945, Anti Papers, Serie 2, n.2, 83.

231 **"wish that the confiscated articles"** For Wolff from Reidemeister, "Telephone Call from the German Embassy," 4 January 1945, NARA, RG 239, M1944, Roll 9, Part 1.

231 **"radical Nazi fanatics"** Dulles, *From Hitler's Doorstep*, 508. Dulles telegram 9099, April 21, 1945.

231 **"Innsbruck or Bavaria,"** Cooper and DeWald, "Report on the German Kunstschutz," NARA, RG 239, M1944, Roll 71, 9.

231 **"should address me personally"** Letter, Hofer to Wolff, 14 September 1944, Kunstschutz Papers, Siviero Archive.

231 **At one point, Hofer** Cooper and DeWald, "Report on the German Kunstschutz," NARA, RG 239, M1944, Roll 71, 16.

231 **"guests"** Langsdorff cover letter to Wolff, 22 August 1944, Kunstschutz Papers, Siviero Archive.

231 **"Policy Instruction"** . . . **"Based on the Führer's orders"** "Policy Instruction from Hitler to Himmler via Reichsleiter Bormann," 26 January 1945, NARA, RG 239, M1944, Roll 9, Part 1.

232 **Wolff had received instructions** Cooper and DeWald, "Report on the German Kunstschutz," NARA, RG 239, M1944, Roll 71, 16.

232 **"unable to do this"** Ibid.

232 **Wolff ordered his staff to prepare** Ibid.

232 **in a bid to save his position** Jonathan Petropoulos, *Art as Politics in the Third Reich* (Chapel Hill: University of North Carolina Press, 1996), 159.

233 **In January and February alone** Hastings, *Armageddon*, 260.

233 **the Vistula-Oder campaign** Ibid.

233 **"millions were unable to be evacuated"** Langsdorff Diary, February 1944–May 1945, Alexander Langsdorff Papers, Private Collection.

233 **"It is a situation of madness"** Ibid.

233 **Wolff knew the Allied bombings . . . "prevented the German soldier"** "An Interview with SS-Obergruppenführer Wolff," 13 June 1945, NARA, RG 331, 10000/145/440. Note that this document is not a transcript of the interview but rather a recollection of the conversation by the interviewer.

233 **"collapse of morale"** Ibid.

233 **"irretrievably lost."** Ibid.

233 **"had taken part in the spearhead"** Ibid.

233 **Wolff knew that if such armaments. . . . February 6. . . . "a straight answer"** Allen W. Dulles, *The Secret Surrender* (Guilford, CT: Lyons Press, 2006), 68.

233 **"The moment will come"** Heiber, ed., *Lagebesprechungen im Führerhauptquartier*, 276. It was a briefing on August 31 at which Westphal, Keitel, Krebs, et al., were present.

234 **Himmler and Ernst Kaltenbrunner made secret overtures** Waller, *The Unseen War in Europe: Espionage and Conspiracy in the Second World War* (New York: Random House, 1996), 368.

234 **"contemplating the liquidation of 'war-mongers'"** Ted Ryan, "Account of Sunrise," April 16, 1945, NARA, RG 226, Entry 190C, Box 9, 3.

234 **"a sign of the increasing disintegration"** Ibid. 4.

234 **"Although persons of the Himmler, Kaltenbrunner type"** Ibid.

234 **Wolff used his February 6 Berlin visit. . . . abandon the idea.** "Footnote to Chapter X," excerpts from interrogations held in 1945, NARA, RG 226, Entry 190C, Box 9.

234 **During that trip. . . . According to the plan** Dulles, *The Secret Surrender*, 68–69.

235 **Germany's most intact fighting force** Lang, *Der Adjutant*, 8.

235 **"the most important route"** Franz Hofer, "The Alpine Defense Line," B-457, NARA, RG 549, M1035, Annex 3, 3.

235 **"The Nazi theory is that"** Dulles, *From Hitler's Doorstep*, 366. Dulles cable 4471–73, August 12, 1944.

235 * Hofer, "The Alpine Defense Line," Annex 1, 1.

235 **The following month** Ibid., Annex 1, 2 and Annex 3, 1, 5.

235 **"exploiting skillfully and rapidly"** Franz Hofer, "National Redoubt," B-458, NARA, RG 549, M1035, 10.

236 **Eventually Hitler summoned him** Ibid., 11, 23. Order was dated April 20 but not issued until April 24.

236 **Believing the Redoubt to be a credible threat** Waller, *The Unseen War in Europe*, 372.

236 **"madness"** Allen Dulles and Gero von Gaevernitz, "The First German Surrender," 22 May 1945, NARA, RG 226, Entry 190C, Box 8, 16.

237 **February 25 meeting. . . . Through a series of intermediaries** Dulles, *The Secret Surrender*, 58–61.

237 **indicated a willingness to meet** Ibid., 61.

237 **Dulles received an urgent phone call** Ibid., 62.

237 **"a Chinaman's chance"** Ibid., 64.

238 **On Dulles's behalf. . . ."startled". . . . By asking for the release** Ibid., 65.

238 **In December 1944** Salter, *Nazi War Crimes*, 96.

238 **On January 31, 1945** Cable 29479, Glavin to Dulles and Donovan, 31 January 1945, Donovan Papers, Churchill Archives Centre, DOVN Acc 847, Box 12, Reel 76.

238 **"without entering [into] any negotiations"** Salter, *Nazi War Crimes*, 97.

239 **On March 8 . . . "Gero, are you standing or sitting?". . . . "Because if you're standing"** Dulles, *The Secret Surrender*, 74–75.

239 **Earlier in the day** Ibid.

239 **Dulles decided to meet with Wolff** Ibid., 78; Wolff, *Mit Wissen Hitlers*, 103.

239 **Wolff's curriculum vitae** Dulles, *The Secret Surrender*, 78.

239 **"The present Pope"** Ibid.

Chapter 23: Operation Sunrise

241 **With a grandfather and an uncle. . . . Dulles became the head** Dulles, *From Hitler's Doorstep*, 2–6.

241 **In October 1941, Dulles** Anthony Cave Brown, *The Last Hero: Wild Bill Donovan* (New York: Vintage Books, 1982), 275.

241 **Special Assistant to the Minister** Dulles, *From Hitler's Doorstep*, 5.

242 **He was shrewd, daring, and ambitious** Ibid., 5, 19.

242 **"A handsome man"** Ibid., 80–81.

242 **"At this stage we were more interested"** Dulles and Gaevernitz, "The First German Surrender," 6.

242 **Following introductions. . . . The discussions took place in German.** No handshakes: Lang, *Der Adjutant*, 269.

242 **"a crime against the German people" . . . "that from the early days"** Dulles, *The Secret Surrender*, 81.

242 **"I control the SS forces in Italy"** Ibid.

242 **225,000 troops** Dulles, *From Hitler's Doorstep*, 479. Dulles telegram 7329, March 20, 1945.

242 **Army Group C, comprising twenty-seven divisions** "German Forces OB Southwest 12 April 1945," Combined Arms Research Library, Nafziger Collection of Orders of Battle, http://usacac.army.mil/cac2/CGSC/CARL/nafziger/945GDBJ.pdf.

242 **"joint action with Kesselring"** Dulles, *From Hitler's Doorstep*, 468. Dulles telegram 6689, March 9, 1945.

243 **"would have vital repercussions."** Dulles and Gaevernitz, "The First German Surrender," 22 May 1945, 7.

243 **attacks against Italian partisans** Dulles, *From Hitler's Doorstep*, 468.

243 **oath of loyalty** Dulles, *The Secret Surrender*, 28–29.

243 **Wolff would have to persuade** Dulles and Gaevernitz, "The First German Surrender," 7.

243 **"Gentlemen, if you will be patient"** Lang, *Der Adjutant*, 269.

243 **The following day** Wolff, *Mit Wissen Hitlers*, 103.

243 **On March 8. . . . Führer appointed him Commander-in-Chief in the West** Deakin, *The Brutal Friendship*, 768.

244 **Once Wolff reached his headquarters** Wolff, *Mit Wissen Hitlers*, 103.

244 **Wolff decided to tell Kaltenbrunner** Dulles, *The Secret Surrender*, 86.

244 **He bristled at the thought** Letter, Ringler to Langsdorff, 11 November 1944, Kunstschutz Papers, Siviero Archive; Ringler, "Gedächtnis-Protokoll (private Aufzeichnung des Dr. Ringler)," NARA, RG 331, 10000/145/440.

244 **in the snow** Cooper and DeWald, "Report on the German Kunstschutz," NARA, RG 239, M1944, Roll 71, 17.

244 **"So if we want to take this responsibility". . . . "The withdrawal of many German Wehrmacht departments"** Letter, Ringler to Langsdorff, 6 March 1945, Kunstschutz Papers, Siviero Archive.

245 **"Those precious items have been rescued"** Letter, Langsdorff to Ringler, 12 March 1945, Kunstschutz Papers, Siviero Archive.

245 **"the responsibility for the entire Italian works of art"** Ibid.

245 **Wolff was prepared to act alone** Dulles, *The Secret Surrender*, 87.

245 **scorched piece of fabric** Dulles and Gaevernitz, "The First German Surrender," 11.

245 **While returning to his headquarters** Dulles and Gaevernitz, "The First German Surrender," 11. The two earliest documents describing these events—the Dulles and Gaevernitz report and that of Ted Ryan (May 25, 1945)—provide matching details of the March 9 strafing incident. However, the event recounted by Dulles in his 1966 book differs significantly by stating that the attack took place after Wolff supposedly drove to Kesselring's headquarters on March 11–12 hoping to obtain further details about the Generalfeldmarschall's appointment, a trip that makes no apparent sense. Further, there is no mention of Wolff's near-death experience in any of his secretly taped conversations, interrogations, or interviews, or in his autobiography; nor in Dulles's notes or Dulles's cables to Donovan. Dulles's cable 6969 (to Donovan in Paris), dated March 12, 1945, does summarize his meeting with Parrilli, but makes no mention of the strafing incident.

245 **"good sense of humor"** "DULLES," NARA, RG 226, Entry 190C, Box 8, 13.

245 * Dulles, *The Secret Surrender*, 3.

245 **The second meeting with Dulles** Wolff, *Mit Wissen Hitlers*, 107–10.

246 **Wolff was unaware that Dulles** Dulles, *The Secret Surrender*, 97.

246 **Wolff greeted Dulles with the news** Ibid., 98–99.

246 **"If you can give me"** Ibid., 100.

246 **"military advisers,"** Ibid., 103.

246 **The somber atmosphere marked** Ibid., 104.

246 **Wolff, anticipating the awkwardness** Ibid., 103.

246 **Wolff departed for Italy** Ibid., 106.

247 **"the Germans had a V-weapon site"** Hartt, *Florentine Art Under Fire*, 79.

247 **"All we knew was that the works of art"** Ibid., 78.

247 **When Marchese Serlupi Crescenzi** Ibid., 96–97.

248 **"may be shipped across the Swiss border"** "Visit to Switzerland," 26 March 1945, NARA, RG 331, 10000/145/297.

248 **"Works of Art Removed by Germans to North Italy". . . . "agents of OSS endeavor"** 22 March 1945, Hartt Papers, Box 4, Folder 2.

248 **"disposition of works of art"** Proctor to Hartt, "Removal of Works of Art by Germans," 25 March 1945, Hartt Papers, Box 3, Folder 15.

248 **Officer in Charge, N. Italy City Teams** "Exploitation of Intelligence in N. Italy," 27 March 1945, NARA, RG 226, Entry 190C, Box 92.

248 **some sixteen in all** "Final Operations Section Report, Period 16 April to 25 May," 26 May 1945, NARA, RG 226, Entry 190C, Box 109, Final Report of Co. D, 3 June 1945.

248 **Cagiati limited Anelli's initial assignment** Don Guido Anelli, Report to Giovanni Poggi, November 1945, Private Collection, Italy.

248 **received instructions to make contact with the Patriarch of Venice,** Ferraro, "La resistenza veneta in difesa delle opere d'arte," *Il Ponte*, September (1954), 128; Memo by Marchese Filippo Serlupi Crescenzi (no date, no signature, but Filippo Serlupi's name is handwritten at the end of the document), Poggi Papers, Serie VIII, n.154, 4.

249 **"to chase all over the place at will"** Letter to DeWald, 30 March 1945, Keller Papers, Box 21, Folder 33.

249 **"I hope you won't mind"** Ibid.

249 **"in view of Hofer's anti-Italian feeling" . . . "confessed to me". . . . Hofer apparently distrusted Ringler** Carlo Anti, "Removal of Works of Art from Tuscany to Bolzano," 23 June 1945, John Bryan Ward-Perkins Papers, British School at Rome, Box C.

250 **"the Gauleiter in agreement"** Ringler, "Gedächtnis-Protokoll (private Aufzeichnung des Dr. Ringler)," NARA, RG 331, 10000/145/440.

250 **"the farmers are tired of this"** Ringler letter to Langsdorff, 15 March 1945, Kunstschutz Papers, Siviero Archive.

250 **"Dangerous are the South Tyroleans,"** Carlo Anti, "Agenda 1945," 17 March 1945, Anti Papers, Serie 1, n.3.

250 **On March 21, Wolff set out** Wolff, *Mit Wissen Hitlers*, 111.

250 **With field telephones ringing** Dulles, *The Secret Surrender*, 109.

250 **"The idea is a good one"** Dulles, "Diary-notes of events leading to the surrender of the German armies in Italy," Notes of Wolff & Harster, 24.

251 **After another harrowing drive,** Wolff, *Mit Wissen Hitlers*, 113.

251 **Wolff had known Himmler** Lang, *Der Adjutant*, 18–19.

251 **"feeling guilty of having wasted"** Ibid., 193.

251 **"If the schoolboy Karl"** Ibid.

251 **Wolff's mistress, however** Ibid., 192, 196.

251 **"liebes Wölffchen"** Letter, Heinrich Himmler to Karl Wolff, 28 March 1944, BArch SS-F.P. 10-c, Bundesarchiv Berlin.

251 **"one of his closest and oldest associates"** Salter, *Nazi War Crimes*, 46; Lang, *Der Adjutant*, 219.

251 **"whom I have come to love as a friend"** Salter, *Nazi War Crimes*, 43.

252 **His continual prodding of Himmler to dismiss Wolff** Ibid., 36; Wolff, *Mit Wissen Hitlers*, 142.

252 **Himmler and Kaltenbrunner had been informed** Dulles, *The Secret Surrender*, 38, 86, 112.

252 **While Wolff had ready explanations. . . . The problem soon became clear** Ibid., 112.

252 **had fallen in his disfavor** Lang, *Der Adjutant*, 280.

252 **Minor bruises aside** Wolff, *Mit Wissen Hitlers*, 115.

253 **relocating his second wife. . . . He intended to get them** Ibid., 116, 134.

253 **On March 30, Wolff had arranged. . . . This message encouraged** Dulles, *The Secret Surrender*, 108.

253 **But on Monday, April 2. . . . Wolff received a distressing phone call** Ibid., 109.

253 **"This was imprudent of you". . . . Himmler added** Ibid.

253 **He also believed that Himmler** Wolff, *Mit Wissen Hitlers*, 120.

254 **"It's not half as bad"** Dulles, *The Secret Surrender*, 110.

254 **"Wolff had not sent a single word"** Ibid., 111.

Chapter 24: Complications

255 **Göring supervised the final packing. . . . Some items had to be left** Report No. 2, The Goering Collection, September 1945, O.S.S. Art Looting Investigation Unit Consolidated Interrogation Reports, NARA, M1782, 171.

255 **Göring arranged for it to be moved** Anna Maria Sigmund, *Die Frauen der Nazis* (Munich: Wilhelm Heyne Verlag, 2000), 65.

255 **Göring left orders** Yeide, *Beyond the Dreams of Avarice: The Hermann Goering Collection*, 16.

255 **On March 28** Report No. 2, The Goering Collection, September 1945, attachment 10, "Art Objects from Monte Cassino, indicated as Goering's property."

255 **thousands of paintings, drawings** Report No. 4, Linz: Hitler's Museum and Library, December 1945, O.S.S. Art Looting Investigation Unit Consolidated Interrogation Reports, NARA, M1782, 78.

256 ATTENTION!—MARBLE—DO NOT DROP Ernst Kubin, *Sonderauftrag Linz* (Vienna: ORAC Buch- und Zeitschriftenverlag, 1989), 99; Pöchmüller, *Weltkunstschaetze in Gefahr*, 54.

256 **"international Jewry"** Katharina Hammer, *Glanz im Dunkel: die Bergung von Kunstschätzen im Salzkammergut am Ende des 2. Weltkrieges* (Vienna: Österreichischer Bundesverlag, 1986), 130.

256 **he would destroy the salt mine** Kubin, *Sonderauftrag Linz*, 141–56; Pöchmüller, *Weltkunstschätze in Gefahr*, 8, 49–51.

256 **"We have received the following message"** Cagiati to Hartt, "Removal of Works of Art by Germans," April 3, 1945, Hartt Papers, Box 3, Folder 16.

256 **Ferraro had initially** Ferraro, "Memo," signed Antonio, 10 April 1945, Poggi Papers, Serie VIII, n.155, 5.

256 **In late February, Anti had contacted** Anti, "Removal of Works of Art from Tuscany to Bolzano," 23 June 1945.

257 **"A decision in this instance"** Langsdorff, "Aktenvermerk, Betr.: Bergungsdepots im Alpenvorland," 6 March 1945, Kunstschutz Papers, Siviero Archive.

257 **the following day Anti heard** Anti, "Removal of Works of Art from Tuscany to Bolzano," 23 June 1945.

257 **"All your efforts to take these masterworks away"** Anti, "Lettera ad Alexander Langsdorff," 4 April 1945, Anti Papers, Serie 2, n.2, 95.

257 **Anti then offered to send a vehicle to transport the art** Ibid.

257 **"the Italian state held him"** Anti, "Removal of Works of Art from Tuscany to Bolzano," 23 June 1945.

257 **"It is feared by the Germans"** Ferraro, "Memo," signed Antonio, 10 April 1945, Poggi Papers, Serie VIII, n.155, 5.

258 **Cagiati sent Don Anelli three urgent telegrams** Don Guido Anelli, Report to Giovanni Poggi, November 1945, Private Collection, Italy.

258 **code-named "Penance"** "Morale Operations Report for Period 1–31 May 1945," NARA, RG 226, Entry 99, Box 25, 7.

258 **Cagiati made arrangements for Don Anelli to be airlifted** Memo by Marchese Filippo Serlupi Crescenzi, Poggi Papers, Serie VIII, n.154, 4.

258 **"We interrupt this program"** Bernard Asbell, *When F.D.R. Died* (New York: Holt, Rinehart and Winston, 1961), 85.

258 **"I have lost a dear and cherished"** Ibid., 95.

258 **"We were doubtful"** Ibid., 97.

258 **"My Führer, I congratulate you!".... "It is written in the stars"** Ibid., 99.

258 **"Here, read it!"** Albert Speer, *Inside the Third Reich: Memoirs* (New York: Simon & Schuster, 1970), 463.

259 **In a letter dated April 15** "Memorandum for the President," 18 April 1945,

from "Memoranda for the President: Sunrise," Studies in Intelligence, vol. 7, issue 2, accessed via CIA Center for the Study of Intelligence, cia.gov.

259 **"Honored Mr. D"** Dulles, *The Secret Surrender,* 129.

259 **Elements of U.S. Ninth Army** Hastings, *Armageddon,* 426.

259 **two and a half million Red Army soldiers** Hastings, *Inferno,* 600. The three Soviet fronts totaled 2.5 million men.

259 **On April 13, Himmler ordered** Wolff, *Mit Wissen Hitlers,* 137.

260 **"a chance to do something"** Dulles, *From Hitler's Doorstep,* 503. Dulles cable 22949, April 18, 1945.

260 ★ Lang, *Der Adjutant,* 279; Dulles, *The Secret Surrender,* 120.

260 **"In case I should lose my command"** Dulles, *The Secret Surrender,* 132.

260 **"It appears that Himmler"** Dulles, *From Hitler's Doorstep,* 503. Dulles cable 22949, April 18, 1945.

260 **On April 17, Wolff endured** Wolff, *Mit Wissen Hitlers,* 141.

260 **Unbeknownst to Wolff** Lang, *Der Adjutant,* 273.

260 **Wolff demanded that the three. . . . In the predawn hours** Wolff, *Mit Wissen Hitlers,* 142.

261 **"If I am going to be hung"** Lang, *Der Adjutant,* 281.

261 **Wolff and Kaltenbrunner had to wait** Wolff, *Mit Wissen Hitlers,* 143.

261 **"Kaltenbrunner has announced to me"** Ibid., 146

261 **Wolff presented his best defense** Ibid.

261 **When the meeting resumed** Ibid., 147–48.

261 **"They will come with many more offers"** Ibid., 150.

261 **"Be sure no important civilian prisoners"** Dulles, *The Secret Surrender,* 150.

261 **General Wolff departed** Wolff, *Mit Wissen Hitlers,* 151.

262 **"By letter today JCS direct"** Dulles, *The Secret Surrender,* 137.

262 **"at this time on acceptable terms". . . . "complications". . . . "whole matter"** Ibid. Supporting documents to/from Alexander/AFHQ Message Center, "Operation Crossword, negotiations in Switzerland prior to surrender of Germans in North Italy: correspondence, minutes of meetings and telegrams." The National Archives, Kew, Richmond, Surrey, Public Record Office: WO 204/40.

262 **made increasingly acrimonious accusations** Lingen, *SS und Secret Service,* 71.

262 **they had been denied** Ibid., 66.

262 **"violation of our agreed principle"** Dulles, *The Secret Surrender,* 125.

262 **"for your frank explanation"** Ibid., 127.

263 **pulled the plug on Operation Sunrise** Dulles, *The Secret Surrender,* 137; Erasmus Kloman, *Assignment Algiers: With the OSS in the Mediterranean Theatre* (Annapolis, MD: Naval Institute Press, 2005), 88; Harry S. Truman, *Memoirs by Harry S. Truman: 1945: Year of Decisions* (New York: Konecky & Konecky, 1955). Truman's book says Churchill was the one who insisted the

plug be pulled and he went along, but Churchill's memoirs do not state that it was his decision.

263 **Unaware of the Western Allies' change. . . . Dulles first contacted General Alexander** Dulles, *The Secret Surrender*, 139–40.

263 **"It is more essential than ever". . . . "No negotiations"** Dulles and Gaevernitz, "The First German Surrender," 38.

263 **Three days later, news leaked** Walter Schellenberg, *The Labyrinth: Memoirs of Walter Schellenberg, Hitler's Chief of Counterintelligence* (New York: Da Capo Press, 2000), 399–402.

263 **"shrugged his shoulders"** Dulles and Gaevernitz, "The First German Surrender," 38.

263 **Aware of the threat posed** Dulles, *The Secret Surrender*, 156.

263 **convinced Gauleiter Hofer** Ibid., 132.

264 **Wolff had deliberately avoided telling** Wolff, *Mit Wissen Hitlers*, 133–34.

264 **"occupation of the Alpine region"** Hofer, "National Redoubt," NARA, RG 549, M1035, B-458, 14–15.

264 **"engaged in no negotiations"** Salter, *Nazi War Crimes*, 98.

264 **"You know the incredible difficulties"** Wolff to Husmann and Waibel, April 25 1945, NARA, RG 226, Entry 190C, Box 8.

264 **The third and fourth pages. . . . "SS families". . . . "Immediate and Preferred Protection". . . . "untouched coin collection"** Karl Wolff, "Sofortiger u. bevorzugter Schutz folg. Gebäude," 25 April 1945. NARA, RG 226, Entry 190C, Box 8.

264 **Quirinal Palace** Lang, *Top Nazi*, 307.

264 **The other two buildings. . . . "contains approximately 300". . . . "approximately 300 other oil paintings"** Wolff, "Sofortiger u. bevorzugter Schutz folg. Gebäude," NARA, RG 226, Entry 190C, Box 8.

265 **Wolff arranged for Langsdorff** Langsdorff Diary, February 1944–May 1945, Alexander Langsdorff Papers, Private Collection.

265 **"the Italian population in order to"** Don Guido Anelli, Report to Giovanni Poggi, November 1945, Private Collection, Italy; Marchese Filippo Serlupi Crescenzi, "Promemoria sull'opera svolta dal sig. Maggiore Alessandro Cagiati," Poggi Papers, Serie VIII, n.154, 4.

265 **Anelli also recruited a fellow priest** Serlupi Crescenzi, "Promemoria sull'opera svolta dal sig. Maggiore Alessandro Cagiati," Poggi Papers, Serie VIII, n.154, 4.

266 **blacked-out roads** Field Report, 26 April 1945, Keller Papers, Box 21, Folder 33.

266 **". . . death, misery, ruination"** Letter to Parents, 25 April 1945, Keller Papers, Box 5, Folder 27.

266 **"What a break to have met"** Letter to Kathy, 29 June 1945, Keller Papers, Box 8, Folder 55.

266 **But Mauldin had never met** Mauldin, *Up Front*, 215.

266 **Zampetti had since learned. . . . He immediately transcribed his notes** Croft-Murray, "Displaced Works of Art from Florence," April 27, 1945, NARA, RG 331, 10000/145/401.

267 **As a consequence** Hartt, *Florentine Art Under Fire*, 96.

267 **However, not wanting to leave anything to chance** Poggi, "Memo," 11 November 1944, Poggi Papers, Serie VIII, n.155, 5.

Chapter 25: Surrender

269 **At noon on April 28** Dulles, *The Secret Surrender*, 172.

270 **The first official meeting began at 6 p.m** Dulles and Gaevernitz, "The First German Surrender," 42.

270 **Major General Kislenko** Dulles, *The Secret Surrender*, 174.

270 **While Wenner appeared ready** Ibid., 175

270 **During the morning of April 29. . . . hostilities in Italy would end** Dulles, *The Secret Surrender*, 176–77. The surrender document says only: 1200 hours (Greenwich Mean Time), but London, and Italy, were on GMT+2, double summer time, during the war.

270 **"The German Commander-in-Chief"** Dulles, *The Secret Surrender*, 179.

270 **Unanticipated delays in their return** Ibid., 180–83.

270 **Later that morning** Ibid., 195.

271 **Lake Karer** Lang, *Der Adjutant*, 289.

271 **Four days earlier** Dulles, *The Secret Surrender*, 190.

271 **On the way, Dollmann stopped** Ibid., 191.

271 **"was very nervous of the whole thing."** CSDIC/CMF/X 168, Conversation between Wolff and Huegel, 26 May 1945, Donovan Nuremberg Trial Collection, Cornell Law Library, 3.

271 **"What will you do". . . . "You can be sure"** Dulles, *The Secret Surrender*, 192.

272 **Gauleiter Hofer's farmhouse** Wolff, *Mit Wissen Hitlers*, 177.

272 **"As soldiers we [have] to obey"** Kesselring, *The Memoirs of Field-Marshal Kesselring*, 288–89.

272 **For that reason, Kesselring** CSDIC/CMF/X 168, Donovan Nuremberg Trial Collection, 3.

272 **After departing Hofer's farmhouse. . . . "that he would no longer"** Dulles, *The Secret Surrender*, 193–94.

272 **"honor and loyalty"** Ibid.

273 **on April 28, he held a meeting** Lang, *Der Adjutant*, 288.

273 **claiming this was the first time** Dulles, *The Secret Surrender*, 195.

273 **"a constructive solution"** Hofer, "National Redoubt," NARA, RG 549, M1035, B-458, 16.

273 **Hofer then demanded** Dulles, *The Secret Surrender*, 195.

273 **"People are going over my head!"** Ibid.

273 **"unconditional surrender"** Ibid., 195.

274 **"Fight—don't think about negotiating"** Ibid.

274 **Kesselring's near-exact repetition** Lang raises the idea in *Der Adjutant*, 313, that during his incarceration at Nuremberg, SS Gruppenführer Walter Schellenberg, chief of German espionage, informed Wolff that the traitor was the Chief of the Swiss Defense, Colonel Roger Masson, Waibel's superior.

274 **"disappeared—his courage had given out completely"** CSDIC/CMF/X 168, Donovan Nuremberg Trial Collection, 4.

274 **"Kaltenbrunner is now attempting"** Dulles, *From Hitler's Doorstep*, 517. Dulles telegram 9519, April 29, 1945.

274 **Having just learned about** Dulles, *The Secret Surrender*, 184.

274 **Schweinitz and Wenner finally reached** CSDIC/CMF/X 168, Donovan Nuremberg Trial Collection, 4.

275 **Around 7 a.m. on May 1** Dulles, *The Secret Surrender*, 197.

275 **"prevent [Röttiger] from blowing out his brains"** CSDIC/CMF/X 168, Donovan Nuremberg Trial Collection, 5.

275 **Wolff the salesman went to work** Ibid.

276 **Röttiger even apologized** Dulles, *The Secret Surrender*, 198.

276 **relinquish control of Army Group C back to Schulz** CSDIC/CMF/X 168, Donovan Nuremberg Trial Collection, 6.

276 **At 6 p.m. . . . Further fighting was futile** Dulles and Gaevernitz, "The First German Surrender," 49.

276 **when Schulz and Wolff tried** CSDIC/CMF/X 168, Donovan Nuremberg Trial Collection, 6.

276 **At 9:30 p.m. . . . After placing another call** Dulles and Gaevernitz, "The First German Surrender," 49.

276 **With the arrival of warm sausages and mustard** Dulles, "Diary-notes of events leading to the surrender of the German armies in Italy," Notes of Wolff & Harster, 63.

276 **One of the subordinate commanders** Dulles, *The Secret Surrender*, 199–200.

276 **Wolff sent a second message to Alexander** CSDIC/CMF/X 168, Donovan Nuremberg Trial Collection, 7.

277 **"It is reported from the Führer's headquarters"** "Karl Doenitz: Announcement of Hitler's Death, May 1, 1945," Federal Communications Commission, http://www.ibiblio.org/pha/policy/1945/1945-05-01a.html.

277 **"At the end of his struggle"** Ibid.

277 **"breathed a sigh of relief". . . . "There were tears in our eyes"** CSDIC/CMF/X 168, Donovan Nuremberg Trial Collection, 7.

277 **"A message from Kesselring's headquarters"** Ibid.

277 **"I'm still the Supreme Commander"** Ibid.

277 **Wolff urged those still supporting surrender** Dulles, *The Secret Surrender*, 201.

278 **"who had walked up in the rain"** CSDIC/CMF/X 168, Donovan Nuremberg Trial Collection, 7.

278 **late-night snack** Dulles, "Diary-notes of events leading to the surrender of the German armies in Italy," 65.

278 **new orders arrived** Dulles and Gaevernitz, "The First German Surrender," 50.

278 **"in view of the threatening danger"** Ibid.

278 **250 troops** CSDIC/CMF/X 168, Donovan Nuremberg Trial Collection, 8; Dulles and Gaevernitz, "The First German Surrender," says 350.

278 **"as all the excitement was mounting"** CSDIC/CMF/X 168, Donovan Nuremberg Trial Collection, 8.

278 **"frightfully bad connection"** . . . **"every single telephone exchange"** Ibid., 9.

278 **went back and forth for two hours** Ibid.

278 **"It is not only a military capitulation"**. . . . **"A cease-fire now will give"** Dulles, *The Secret Surrender*, 202.

278 **"feel themselves deserted"** Kesselring, *The Memoirs of Field-Marshal Kesselring*, 279.

279 **"It is your duty to refuse"** CSDIC/CMF/X 168, Donovan Nuremberg Trial Collection, 9.

279 **"fight it out to the bitter end."** Kesselring, *The Memoirs of Field-Marshal Kesselring*, 281.

279 **he would consider the matter** Dulles, *The Secret Surrender*, 202–3.

Chapter 26: The Race

281 **"joy was unconfined"** John P. Delaney, *The Blue Devils in Italy: A History of the 88th Infantry Division in World War II*. (Nashville, TN: The Battery Press, 1988), 219.

281 **"You feel sort of let down"** *19 Days: From the Apennines to the Alps* (Milan, Italy: Pizzi and Pizio, 1945), 86. Keller Papers, Box 20, Folder 24.

282 **The front was so diffused** "Alto Adige," Keller Papers, Box 19, Folder 6.

282 **On May 4, as Keller prepared** Field Report, 12 May 1945, Keller Papers, Box 21, Folder 33.

282 **The message contained** Memo from Newton, 4 May 1945, NARA, RG 331, 10000/145/401.

282 **Keller immediately notified Lieutenant Colonel Ward-Perkins** **Keller also sent a message** Field Report, 12 May 1945, Keller Papers, Box 21, Folder 33.

282 **he and Charley had to spend a few days** Ibid.

283 **The April 15, 1944, bomb damage assessment** "Notes on Bomb-Dam-

age to Cultural Monuments in Enemy-Occupied Italy," NARA, RG 331, 10000/145/7.

283 **Keller began his work in Milan. . . . "about gone". . . . Keller's casualty list** Field Report, 12 May 1945, Keller Papers, Box 21, Folder 33.

283 **"Bomb hit of August 1943". . . . "The roof was hit"** Ibid.

283 **"Leonardo's *Last Supper* is in peril"** Letter to Kathy, 11 May 1945, Keller Papers, Box 8, Folder 54.

283 **"Leonardo's *Last Supper* may be in ruins"** Letter to Kathy, 12 May 1945, Keller Papers, Box 8, Folder 54.

284 **"Some authorities even returned"** Superintendent of Milan, "Relazione sui Provvedimenti presi dopo il 16 Agosto 1943 dalla Soprintendenza ai Monumenti di Milano," May 1945, NARA, RG 331, 10000/145/97.

284 **The night of the bombing. . . . discarded their habits for overalls** Lippini, "Furono i Domenicani a salvarlo dopo il bombardamento dell'agosto 1943," *L'Ultima Cena di Leonardo da Vinci: Una lettura storica, artistica e spirituale del grande capolavoro*, November (1999), 15; Angelo Grammatica, "Memoria storica dell'8° battaglione pontieri del genio," 3 October 1959, Legnago Private Archive, Milan.

284 **After removing the debris** Lippini, "Furono i Domenicani a salvarlo dopo il bombardamento dell'agosto 1943," 15–16.

285 **"Dearest: It seems the war in Europe"** Letter to Kathy, 8 May 1945, Keller Papers, Box 8, Folder 54.

285 **"The mission of this Allied Force was fulfilled"** Carlo D'Este, *Eisenhower: A Soldier's Life* (New York: Henry Holt, 2002), 704.

285 **"There was no celebration here"** Letter to Kathy, 8 May 1945, Keller Papers, Box 8, Folder 54.

285 **Pietro Ferraro, Alessandro Cagiati's OSS operative. . . . Days earlier, working out of a room** "Final Operations Section Report, Period 16 April to 25 May," NARA, RG 226/190, Box 109; Peter Tompkins, "The OSS and Italian Partisans in World War II: Intelligence and Operational Support for the Anti-Nazi Resistance," *Studies in Intelligence* (Spring 1998), accessed via Center for the Study of Intelligence, cia.gov.

286 **Long on information** This was Company "D," 2677 Regiment. "Final Operations Section Report, Period 16 April to 25 May," NARA, RG 226, Entry 190C, Box 109; "Operational Report of MU Detachment, 15 April to 15 May 1945," 19 May 1945, NARA, RG 226, Entry 190C, Box 109.

286 **"The whole world of art"** Ferraro, "Telegramma al Comando OSS in Firenze, comunicato inoltre per telefono da Venezia, al Comando delle truppe operanti nel settore a Nord di Verona," 3 May 1945, Poggi Papers, Serie VIII, n.155, 5. Forlati's report ["Ricognizione dei depositi delle opera d'arte della Toscano Transportate dai Germanici in Alto Adige," NARA, RG 331, 10000/145/397] confirms the date of Ferraro's communication to

Cagiati as May 3, 1945. However, in Ferraro's 1954 article in *Il Ponte*, "La resistenza veneta in difesa delle opere d'arte," he references April 25 as being the date he informed Cagiati.

286 * Macnamara to Headquarters, Allied Commission, "Art Treasures of the Uffizi," May 12, 1945, NARA, RG 331, 10000/145/401.

286 **Ferraro also sent Cagiati an important tip** Pietro Ferraro, "Relazione per Sovraintendenza ai monumenti di Firenze," Poggi Papers, Serie VIII, n.155, 5.

287 **"mistook us for American reconnaissance"** Ferraro, "La resistenza veneta in difesa delle opere d'arte, 131.

287 **they proceeded to Campo Tures** Ferraro, "La resistenza veneta in difesa delle opere d'arte," 131; Forlati, "Campo Tures," 7 May 1945, Poggi Papers, Serie VIII, n.155, 5.

287 **3rd Battalion, 339th Infantry, 85th Division** Headquarters 3rd Battalion, 339th Infantry, "Report on Operations for Month of May 1945," 6 June 1945, NARA, RG 407, 385-INF (339)-0.3, May 1945, 5.

287 * Headquarters 3rd Battalion, 339th Infantry, "Report on Operations for Month of May 1945," 6 June 1945, NARA, RG 407, 385-INF (339)-0.3, May 1945, 5; Headquarters 339th Infantry, "Report of Operations, May 1945," 8 June 1945, NARA, RG 407, 385-INF (339)-0.3, May 1945.

287 **On May 9, Gero von Gaevernitz** Lang, *Der Adjutant*, 292, 298.

287 **Wolff arranged for his car and driver** Lang says Wolff accompanied them: Lang, *Der Adjutant*, 298.

287 **But Gaevernitz's trip** Ibid., 298–99.

288 **For his part, Wolff understood** Ibid., 299.

288 **"Hundreds of square miles of country". . . . "The trees were shaved"** Hartt, *Florentine Art Under Fire*, 103.

288 **"in a flurry of dust"** Ibid.

288 **"the GI on guard". . . . He immediately recognized Caravaggio's painting** Hartt, *Florentine Art Under Fire*, 104.

289 **"cry of glee"** Ibid.

289 **In fact, it had been raining** Field Report, 22 May 1945, Keller Papers, Box 21, Folder 33, 4.

289 **"fantastic situation"** Hartt, *Florentine Art Under Fire*, 105.

290 **"The executor of the greatest single art-looting"** Ibid.

290 **"When the garage doors were unlocked"** Ibid.

290 **"the colossal arrogance"** Ibid., 103, 105.

290 **"Hitler Is My Führer."** Delaney, *The Blue Devils in Italy*, 225.

291 **"there were 250,000 fully armed crack German troops"** "Alto Adige," Keller Papers, Box 19, Folder 6.

292 **park setting of his Bolzano headquarters** Lingen, *SS und Secret Service*, 139.

292 **"hundreds of bags"** "Alto Adige," Keller Papers, Box 19, Folder 6, 8.

292 **U.S. Colonel James C. Fry** Delaney, *The Blue Devils in Italy*, 229.

292 **"Frau Wolff was indignant"** Ibid.

292 **"the birthday feast"** Ibid., 230.

292 **shot Wolff's German shepherd** Eugen Dollmann, *Call Me Coward*. (London: William Kimber, 1956), 14.

293 **"impatient and irritable."** Letter to Kathy, 18 May 1945, Keller Papers, Box 8, Folder 54.

293 **"The war is not over".** . . . **"Yes—the shells and bombs are over"** Letter to Kathy, 18 May 1945, Keller Papers, Box 8, Folder 54.

Chapter 27: The Big Move

296 **Perry Cott finally received travel orders** Perry Cott, Diary, NARA, RG 331, 11100/145/33.

296 **He had worked closely** "Final Report: Lazio," Keller Papers, Box 23, Folder 51, 3.

296 **Drawing from the extraordinary** *Report of the American Commission for the Protection and Salvage of Artistic and Historic Monuments in War Areas*, 72–73.

296 **after nearly a year in jail** *TRECCANI Enciclopedia*, 2010, vol. X, 836.

296 **Wittgens asked Cott to arrange** Perry Cott, Diary, NARA, RG 331, 11100/145/33.

296 ★ Giorgio Rumi and Adele Carla Buratti eds., *Milano ricostruisce: 1945–1954* (Milan: Cariplo, 1990), 263; Cecilia Ghibaudi, ed., *Brera e la Guerra: La salvaguardia delle opere della Pinacoteca*. Exhibition, Milan, Pinacoteca di Brera, 10 November 2009–21 March 2010 (Milan: Electa, 2009), 74–75.

297 **"generally satisfying results"** Bezzola to Giovanni Rocco, Milan, 25 May 1945, NARA, RG 331, 10000/145/97.

297 **he reluctantly posted a notice** "Refectory of Santa Maria delle Grazie," 26 May 1945, NARA, RG 331, 11000/145/39.

297 **"The static conditions of the wall"** Perulioni to Cott, "Milano—'Cenacolo' di Leonardo," 10 June 1945, NARA, RG 331, 10000/145/97.

297 **"light veil expanding"** Ibid.

298 **"expert cleaning operation"** . . . **"not outstandingly urgent"** . . . **"dry and warm air of the summer months" could "desiccate"** Ibid.

298 **Five days later, Hartt and Rossi arrived** Cott, Officer Diary 1945, NARA, RG 331, 11000/145/33.

298 **"the Refectory of S. Maria delle Grazie"** Cott, "Report on Condition of Last Supper by Leonardo da Vinci," NARA, RG 331, 11000/145/39.

298 **"This is the biggest undertaking"** "Memo to Col. Arthur Sutherland," 16 May 1945, Keller Papers, Box 21, Folder 33.

298 **Keller needed a written agreement** "Plan for moving deposits at San Leonardo and Campo Tures," 10 June 1945, Hartt Papers, Box 3, Folder 18.

299 **"Remember how crowded"** "Memo to Col. Arthur Sutherland," 16 May 1945, Keller Papers, Box 21, Folder 33.

299 **removal of the brick tomb** Filippo Rossi, "Relazione dei lavori eseguiti dalla Soprintendenza alle Gallerie nel mese di Maggio 1945," Hartt Papers, Box 4, Folder 4.

299 **"The bright spot yesterday". . . . "It was dusty and dirty"** Letter to Kathy, 19 June 1945, Keller Papers, Box 8, Folder 55.

299 **"We get along fine"** Letter to Kathy, 9 June 1945, Keller Papers, Box 8, Folder 55.

299 **"Those that like the army"** Letter to Kathy, 11 June 1945, Keller Papers, Box 8, Folder 55.

299 **"Redeployment and winning"** Letter to DeWald, 27 June 1945, Keller Papers, Box 21, Folder 34.

300 **The alternative to trucks** "Fine Arts Section," Keller Papers, Box 19, Folder 10, 76.

300 **"This wait has been worrying"** Letter to DeWald, 8 July 1945, Keller Papers, Box 21, Folder 34.

300 **"in the toilet"** Letter to Kathy, 9 July 1945, Keller Papers, Box 8, Folder 55.

300 **109 crates at San Leonardo and forty-six** "Fine Arts Section," Keller Papers, Box 19, Folder 10, 74.

300 **The inventory at San Leonardo revealed** "Inventory Check of Works of Art Removed by Germans," 31 May 1945, NARA, RG 331, 10000/145/401.

300 **"not only an unspeakable personal satisfaction"** Hartt, *Florentine Art Under Fire*, 108.

301 **fire extinguishers** "Final Report on Art Deposits," 28 July 1945, Keller Papers, Box 21, Folder 34.

301 **"who do not know a Tiepolo"** Letter to Kathy, 15 July 1945, Keller Papers, Box 8, Folder 55.

301 **"Things are rolling"** Ibid.

301 **"for my wife"** Letter to Constance Hall Jones, 19 June 1945, Keller Papers, Box 8, Folder 55.

301 **Monuments Men Teddy Croft-Murray** "Visit to Deposit of Works of Art in the Steinberg Salt Mine, Alt Aussee, Oberdonau," 27 June 1945, The National Archives, Kew, Richmond, Surrey, FO 1020/2766, C282558.

302 **"art treasures". . . . "extreme care necessary."** Freight Waybill, Hartt Papers, Box 3, Folder 19.

302 **"If there was going to be"** "Fine Arts Section," Keller Papers, Box 19, Folder 10, 78.

302 **"There were no more stops"** "Final Report on Art Deposits," 28 July 1945, Keller Papers, Box 21, Folder 34.

303 **Camaldoli Forest** Hartt, *Florentine Art Under Fire*, 109.

303 **At 4 p.m.** "Final Report on Art Deposits," 28 July 1945, Keller Papers, Box 21, Folder 34.

303 **Late the following morning** Hartt, *Florentine Art Under Fire*, 109–10.

303 **"[driving] through streets, people clapping"** Letter to Kathy, 22 July 1945, Keller Papers, Box 21, Folder 33.

305 **"That's for you, Deane."** Letter to Kathy, 25 July 1945, Keller Papers, Box 8, Folder 55.

305 **"Gen. Hume got up"** Ibid.

305 **"He has been the only member"** Hume to Seymour, 1 August 1945, Keller Papers, Box 21, Folder 35.

305 **"During the presentation ceremony"** Ralph Major to John Fulton, 20 November 1945, Keller Papers, Box 21, Folder 38.

306 **"Have you ever been in Sezze Romano"** "Fine Arts Section," Keller Papers, Box 19, Folder 10, 14–15.

306 **"Yes, I remember you very well."** Ibid.

SECTION IV: AFTERMATH

307 **"There is something in preserving"** Letter to Kathy, 30 November 1944, Keller Papers, Box 7, Folder 50.

Chapter 28: Perspective

310 **"a man with a divided soul"** Cooper and DeWald, "Report on the German Kunstschutz," NARA, RG 239, M1944, Roll 71, 18.

310 **"Had I then decided"** Karl Wolff, "Lettera a Giorgio La Pira, Sindaco di Firenze," 28 October 1956, Poggi Papers, Serie VIII, n.157, 12.

311 **"In all the stiff fighting for Florence"** "Final Report General," 1 January 1946, Keller Papers, Box 23, Folder 52, 13–14.

311 **"that with the approaching of the battlefront"** Karl Wolff, "Lettera a Giorgio La Pira, Sindaco di Firenze," 28 October 1956, Poggi Papers, Serie VIII, n.157, 12.

312 **August 3, 1944, order** "Bevollmächtigter General der Deutschen Wehrmacht in Italien, Abteilung Ia, Order re Borromean Islands," 3 August 1944, Kunstschutz Papers, Siviero Archive.

312 **"Germany has no plans for"** Anti Catalogue Files, 30 August 1944, Siviero Archive.

313 **"a strange and characteristically German tale"** "Fine Arts Section," Keller Papers, Box 19, Folder 10, 71.

313 **"a clear case of attempted"** Cooper and DeWald, "Report on the German Kunstschutz," NARA, RG 239, M1944, Roll 71, 18.

314 **"The surrender of the German armies"** Waller, *The Unseen War in Europe*, 390.

314 **No. 346 on "List 7"** Salter, *Nazi War Crimes*, 123.

314 **one of the two most senior SS leaders** Ibid., 4.

315 **"none of my so-called looting"** Goldensohn, *Nuremberg Interviews*, 132.

315 **"One cannot be sure that"** Kerstin von Lingen, "Conspiracy of Silence," *Holocaust and Genocide Studies* 22, no. 1 (Spring 2008), http://hgs.oxfordjour nals.org, accessed 19 August 2010, 93.

315 **"Although I have no information"** Ibid.

316 * Ibid., 74.

316 **In March 1948** Ibid., 92.

316 **"minor offender"** Ibid., 93.

316 **desk-murderers** Ibid., 95.

316 **"one of the salon officers"** Ibid.

317 **he knew nothing about the Holocaust** Lang, *Der Adjutant*, 303, 331.

317 **He was released in 1969** Lingen, *SS und Secret Service*, 206, 213.

317 **Prien on Lake Chiemsee** Lingen, *SS und Secret Service*, 219; Lang, *Der Adjutant*, 352.

317 **Gauleiter Franz Hofer** "CV, Franz Hofer, NS-Politiker, 1902–1975," Deutsches Historisches Museum, Berlin, http://www.dhm.de/lemo/html /biografien/HoferFranz/index.html, accessed October 16, 2012.

317 **"the battle for Italy"** Kesselring, *The Memoirs of Field-Marshal Kesselring*, 222.

317 **"embarrassed both sides intolerably,"** Ibid., 289.

317 **"to kill Italian civilians as reprisals."** "Case 44: The Trial of Albert Kessel ring," in United Nations War Crimes Commission, *Law Reports of Trials of War Criminals, Volume VIII* (London: His Majesty's Stationery Office, 1949), 9.

318 **"testimony in favor of the accused."** Hans Laternser, "An Seine Eminenz den Herrn Erzbischof von Florenz," 19 January 1947, Elia Dalla Costa Papers.

318 **"Dear Counselor . . . I must declare"** Elia Dalla Costa, "Lettera a Hans Laternser," 10 February 1947, Elia Dalla Costa Papers.

318 **The British Military Court** Lingen, *Kesselring's Last Battle*, 119.

318 **Believing this outcome too severe** Ibid., 129.

318 **By September 1945** Dulles, *From Hitler's Doorstep*, 16.

319 **"incurred through the handling"** Lingen, "Conspiracy of Silence," 93.

319 **"Between you and me,"** Ibid.

Chapter 29: The Heroes and Their Legacy

322 **Dr. Clara Baracchini devoted fifteen years** Giuseppe Bentivoglio (Pisa Superintendent Office), in discussion with Anna Bottinelli, 2012.

323 **"The *Last Supper* may be getting worse"** "Art: War Casualty," *Time*, December 9, 1946.

323 **Newspaper accounts cited** "La Chiesa delle Grazie a Milano riapre al pub blico," *L'Osservatore Romano*, 3 July 1945, 1.

323 **"The surface was inflated with humidity"** Wittgens, "Il restauro in corso del Cenacolo di Leonardo," 40.

323 **"The head of Christ has nearly vanished". . . . "The faces of Philip and James"** "Art: War Casualty," *Time*, December 9, 1946.

324 **"offers a possible guarantee"** Ibid.

324 **"The process of restitution"** Ward-Perkins, "Restitution and Reparation of Works of Art," 10 September 1945, NARA, RG 331, 10000/145/170.

325 **The small pair of panel paintings. . . . The paintings were returned** Siviero's finding of Pollaiuolos from Massimo Becattini, "Siviero 007. Inchiesta su arte e nazismo. Il cacciatore di opere d'arte," *Archeologia Viva*, September–October (1998): 48; "Nazi Loot Pops Up in Pasadena," *Life* (January 25, 1963), 43–44.

325 **"These are worth something!"** Ernst Kubin, *Raub oder Schutz? Der deutsche militärische Kunstschutz in Italien* (Graz, Austria: Leopold Stocker Verlag, 1994), 185–91.

325 **The whereabouts of two of the paintings** Galleria degli Uffizi, *Gli Uffizi: Catalogo generale* (Florence: Centro Di, 1979); Marco Chiarini, ed., *Palazzo Pitti: guida alle collezioni e agli Appartamenti Reali. Catalogo completo della Galleria Palatina* (Florence: Becocci/Scala, 1995); *L'opera ritrovata: omaggio a Rodolfo Siviero* (Florence: Cantini edizione d'arte, 1984).

326 **It remains one of many complicated cases** Mario Lolli Ghetti ("General Direction for Landscape, Fine Art, Architecture and Contemporary Art"), in discussion with the author, 2010.

326 **By mid-2012, the Cultural Heritage Division of the Carabinieri** "Prosegue il recupero delle opere d'arte sottratte all'Italia durante il secondo conflitto mondiale," 27 June 2005. From Carabinieri official website, http://www.nicola-bono.it/nicolabono.it/index.asp?PageTypeRef=3&IDLingua=1&IDScheda=685&IDsezione=32&Categoria=93&principale=0. Since 2005, few items have surfaced.

326 **"Both sides, at the end of the war,"** Lombardi, ed., *L'Archivio di Giovanni Poggi (1880–1961)*, 37.

326 **"He is a person of immense learning"** Frederick Hartt, "Final Report: Toscana Region," Keller Papers, Box 23, Folder 51, 11.

326 **"devotion and loyalty"** "Fine Arts Section," Keller Papers, Box 19, Folder 10.

326 **"One thing is the carelessness". . . . "This should be explained by him."** Field Report, 7 June 1945, Keller Papers, Box 21, Folder 33, 2.

327 **A series of notes handwritten by Poggi** Handwritten notes about Montagnana, Marano, Campo Tures, etc., Poggi Papers, Serie VIII, n.155, 5.

327 **By 1946, Poggi and his team had reopened. . . . Poggi died** Lombardi, ed., *L'Archivio di Giovanni Poggi (1880–1961)*, 39–41.

327 **He ended his note. . . . "I am grateful for this opportunity"** Don Guido Anelli, Report to Giovanni Poggi, November 1945, Private Collection Italy.

328 **On May 11, 1945. . . . "selfless help to this office"** "OSS Certificato di Apprezzamento a Don Guido Anelli," signed William J. Donovan, 11 May 1945, Private Collection, Italy.

328 **As a hard-line Christian Democrat** Luigina Anelli (Don Guido Anelli's sister), in discussions with Anna Bottinelli, 22 December 2010 and 20 February 2011.

328 **"was aimed at protecting"** Alessandro Cagiati, "Pratiche riguardanti il caso dell'Avv. Filippo Serlupi Crescenzi," 23 June 1945, Florence, Private Collection, Italy.

329 **"I am not a holy man,"** Beth Potier, "Classics Scholar Mason Hammond dead at 99," *Harvard Gazette*, October 17, 2002.

329 **"a model of moral integrity,"** Ibid.

330 **"The work of both MFAA officers"** Norman Newton, "Recommendation for Award," NARA, RG 331, 10000/145/170.

331 **"saving for posterity irreplaceable objects of art,"** "Citation for Bronze Star Medal," Hartt Papers, Box 18, Folder 7.

332 **"Here I am in this sodden hole"** Hartt to Berenson, 24 August 1945, Bernard and Mary Berenson Papers (1880–2002), Biblioteca Berenson, Villa I Tatti—The Harvard University Center for Italian Renaissance Studies, Series IV: Correspondence, letters from Frederick Hartt.

332 **"awfully dull after Italy"** Hartt to Berenson, 14 October 1945, Bernard and Mary Berenson Papers (1880–2002).

332 **"I feel I must write the thing". . . . "So much of the heritage"** Ibid.

332 **"tireless energy"** Rodolfo Signorini, "Tumulate a S. Miniato le ceneri del grande studioso Americano, Si prodigò per salvare le opere d'arte durante il secondo conflitto mondiale, Hartt nella sua Firenze, A Mantova preparò la sua laurea su Giulio Romano," *La Gazzetta*, 13 March 1993.

332 **"means a great deal to me"** Hartt to Berenson, 6 April 1946, Bernard and Mary Berenson Papers (1880–2002).

332 **While in Miami, Florida** Eugene Markowski, interview with the author, 2010.

332 **"Class II homosexual acts"** Hartt personnel file, NARA.

333 **"The reunion has been wonderful."** Hartt to Berenson, 6 April 1946, Bernard and Mary Berenson Papers (1880–2002).

333 **"I don't know what narcissistic streak"** Hartt to Berenson, 3 November 1946, Bernard and Mary Berenson Papers (1880–2002).

334 **"You'll always be an outsider,"** Markowski, interview with the author, 2010.

334 **She and Fred had remained lifelong friends** Ibid.

334 **"Fred was a very complicated man"** Markowski, in discussion with the author, May 22, 2012.

334 **What eluded Fred Hartt. . . . laid down Fred's ashes** Markowski, interview with the author, 2010.

335 **"As far as I can see"** Letter to Parents, 5 September 1945, Keller Papers, Box 5, Folder 28.

335 **"Dearest Ones: I'll be on the boat"** Letter to Kathy, 24 May 1946, Keller Papers, Box 8, Folder 60.

336 **"the guys who really mattered"** Leonard Fisher, interview with the author, 2010.

336 **"tried to hide his humanity"** Ibid.

337 **"may be in ruins."** Letter to Kathy, 12 May 1945, Keller Papers, Box 8, Folder 54.

338 **"My years in the army"** Myra Tolchin, "Yale Portraitist Helped Save Art Looted By Nazis," *New Haven Register*, 16 July 1978, Keller Papers, Group 1685, Box 2, Folder 18.

338 **"He had the hand of an artist"** Alessandro Bernini, "La Ceremonia—L'ultimo saluto al capitano Keller—E stato tumulato nel 'suo' cimitero, alla presenza dei figli," Keller Papers, Private Collection.

338 **"The people of Pisa are bound"** Bernini, "A Pisa le ceneri del capitano Keller—martedì cerimonia al Camposanto," Keller Papers, Private Collection.

338 **"*Amicissimus ad amicus*"** Bernini, "La Cerimonia—L'ultimo saluto al capitano Keller—è stato tumulato nel 'suo' cimitero, alla presenza dei figli," Keller Papers, Private Collection.

338 **"*L'ultimo saluto al capitano Keller*"** Ibid.

338 **"Dino died of a broken heart"** . . . **"a part of him"** Dorothy Bosch Keller (daughter-in-law of Deane Keller), interview with the author, 2010.

338 **"My brother mourned"** William Keller, interview with the author, 2010.

339 **"You are mentioned often and glowingly"** Letter, Hartt to Keller, 8 September 1945, Keller Papers, Box 23, Folder 50.

339 **"The heaviest, and in a way the most tragic job"** Hartt, "Final Report: Toscana Region," Keller Papers, Box 23, Folder 50, 6.

339 **"I don't suppose anyone"** Letter, Hartt to Keller, 4 May 1955, Keller Papers, Box 13, Folder 106.

340 **"Since Fine Arts are not edible"** Keller, "Sectional History—Fine Arts," Keller Papers, Box 23, Folder 56, 30, 32, 38.

BIBLIOGRAPHY

BOOKS

Alexander, Harold. *The Memoirs of Field-Marshal Earl Alexander of Tunis: 1940–1945.* Edited by John North. London: Cassell, 1962.

Alvarez, David. *Spies in the Vatican: Espionage & Intrigue from Napoleon to the Holocaust.* Lawrence: University Press of Kansas, 2002.

Alvarez, David, and Robert Graham Sr. *Nothing Sacred: Nazi Espionage Against the Vatican, 1939–1945.* London: Frank Cass, 1997.

Ambrose, Stephen. *Citizen Soldiers: The U.S. Army from the Normandy Beaches to the Bulge to the Surrender of Germany, June 7, 1944–May 7, 1945.* New York: Simon & Schuster, 1997.

———. *Eisenhower: Volume One, Soldier, General of the Army, President-Elect 1890–1952.* Norwalk, CT: The Easton Press, 1983.

Amè, Cesare. *Guerra segreta in Italia 1940–1943.* Rome: Casini, 1954.

Anelli, Guido. *Ad occhio nudo. Fatti e commenti.* Parma: Officina Grafica Fresching, 1944.

Annussek, Greg. *Hitler's Raid to Save Mussolini: The Most Infamous Commando Operation of World War II.* Cambridge, MA: Da Capo Press, 2005.

Archivio Storico del Comune di Firenze, ed. *Firenze. 9 Maggio 1938.* Florence: P.O. Archivi e Collezioni Librarie Storiche, 2012.

Asbell, Bernard. *When F.D.R. Died.* New York: Holt, Rinehart and Winston, 1961.

Atkinson, Rick. *An Army at Dawn: The War in North Africa, 1942–1943.* New York: Henry Holt, 2002.

———. *The Day of Battle: The War in Sicily and Italy, 1943–1944.* New York: Henry Holt, 2007.

———. *The Guns at Last Light: The War in Western Europe, 1944–1945.* New York: Henry Holt and Company, 2013.

Bailey, Ronald. *The Home Front: U.S.A.* Morristown, NJ: Time-Life Books, 1977.

Bandinelli, Bianchi Ranuccio. *Dal Diario di un borghese e altri scritti.* Milan: Il Saggiatore, 1962.

Barcilon, Pinin Brambilla. *Il Cenacolo di Leonardo in Santa Maria delle Grazie: storia, condizioni, problemi.* Ivrea: Olivetti, 1984.

Barcilon, Pinin Brambilla, and Pietro C. Marani. *Leonardo: The Last Supper*. Translated by Harlow Tighe. Chicago: University of Chicago Press, 1999.

Beevor, Anthony. *Stalingrad: The Fateful Siege*. New York: Penguin Books, 1998.

Bennett, Ralph Francis. *Ultra and Mediterranean Strategy*. London: William Morrow, 1989.

Berenson, Bernard. *Rumor and Reflection*. New York: Simon & Schuster, 1952.

Berti, Luciano. *Florence: The City and its Art*. Florence: La Zincografica Fiorentina, 1982.

Bérubé, Allan. *Coming Out Under Fire: The History of Gay Men and Women in World War II*. Chapel Hill: University of North Carolina Press, 1990.

Bode, Wilhelm von. *Mein Leben*. Edited by Thomas W. Gaehtgens and Barbara Paul. Berlin: Nicolaische Verlagsbuchhandlung, 1997.

Bombe sulla città: Milano in guerra 1942–1944. Edited by Rosa Auletta Marrucci. Milan: Skira, 2004.

Bonardi, Pietro. *La Chiesa di Parma e la guerra 1940–1945*. Parma: Tipolitografia benedettina editrice, 1987.

Bond, Harold L. *Return to Cassino: A Memoir of the Fight for Rome*. Garden City, NY: Doubleday, 1964.

Bourke-White, Margaret. *They Called It "Purple Heart Valley": A Combat Chronicle of the War in Italy*. New York: Simon & Schuster, 1944.

Brather, Sebastian, Dieter Geuenich, and Christoph Huth, eds. *Historia archaeologica: Festschrift für Heiko Steuer zum 70. Geburtstag*. Berlin: De Gruyter, 2009.

Breitman, Richard, Norman J. W. Goda, Timothy Naftali, and Robert Wolfe. *U.S. Intelligence and the Nazis*. New York: Cambridge University Press, 2005.

Brey, Ilaria Dagnini. *The Venus Fixers: The Remarkable Story of the Allied Soldiers Who Saved Italy's Art During World War II*. New York: Farrar, Straus and Giroux, 2009.

Brissaud, André. *Canaris: The Biography of Admiral Canaris, Chief of German Military Intelligence in the Second World War*. New York: Grosset & Dunlap, 1974.

Brown, Anthony Cave. *The Last Hero: Wild Bill Donovan*. New York: Vintage Books, 1982.

Bull, George. *Michelangelo: A Biography*. New York: St. Martin's Press, 1995.

Butcher, Capt. Harry C. *My Three Years with Eisenhower: The Personal Diary of Captain Harry C. Butcher, USNR, Naval Aide to General Eisenhower, 1942–1945*. New York: Simon & Schuster, 1946.

Campi, Paolo. *Firenze e i suoi giornali: storia dei quotidiani fiorentini dal 700 ad oggi*. Florence: Polistampa, 2002.

Captured German and Related Records: A National Archives Conference. Edited by Robert Wolfe. Athens, OH: Ohio University Press, 1974.

Carlesi, Andrea. *La protezione del patrimonio artistico italiano nella RSI (1943–1945)*. Milan: Greco&Greco, 2012.

Chadwick, Owen. *Britain and the Vatican during the Second World War*. Cambridge, UK: Cambridge University Press, 1986.

Charlwood, Don. *No Moon Tonight*. Manchester, UK: Crécy Publishing, 1956.

Che Cosa Hanno Fatto gli Inglesi in Cirenaica. Rome: Ministero Della Cultura Popolare, 1941.

Chiarini, Marco, ed. *Palazzo Pitti: guida alle collezioni e agli Appartamenti Reali. Catalogo completo della Galleria Palatina*. Florence: Becocci; Scala, 1995.

Churchill, Winston S. *My Early Life*. New York: Touchstone, 1996.

Clark, Mark W. *Calculated Risk.* New York: Enigma Books, 2007.

Clemen, Paul, ed. *Kunstschutz im Kriege, Bericht über den Zustand der Kunstdenkmäler auf den verschiedenen Kriegsschauplätzen und über die deutschen und österreichischen Massnahmen zu ihrer Erhaltung, Rettung, Erforschung, Erster Band.* Leipzig: Verlag von E. A. Seemann, 1919.

Clinefelter, Joan. *Artists for the Reich: Culture and Race from Weimar to Nazi Germany.* Oxford: Berg, 2005.

Cole, Bruce, and Adelheid Gealt. *Art of the Western World: From Ancient Greece to Post-Modernism.* New York: Summit Books, 1989.

Coles, Harry L., and Albert K. Weinberg. *Civil Affairs: Soldiers Become Governors.* Honolulu: University Press of the Pacific, 2005.

Comnène, Nicholas Petrescu. *Firenze "città aperta." Contributo per la storia dell'occupazione tedesca in Italia.* Florence: Vallecchi, 1945.

Connelly, Mark. *Reaching for the Stars: A New History of Bomber Command in World War II.* New York: I. B. Tauris, 2002.

Corazzini, Giuseppe Odoardo. *L'assedio di Pisa, 1405–1406: scritti e documenti inediti.* Florence: U. Diligenti, 1885.

Cornwell, John. *Hitler's Pope: The Secret History of Pius XII.* New York: Penguin Books, 2008.

Corvo, Max. *Max Corvo: O.S.S. in Italy: 1942–1945.* New York: Enigma Books, 1990.

Crane, Conrad C. *Bombs, Cities, and Civilians: American Airpower Strategy in World War II.* Lawrence: University Press of Kansas, 1993.

Craven, Wesley Frank and James Lea Cate. *The Army Air Forces in World War II, Vol. II Europe: Torch to Pointblank, August 1942–December 1943.* Chicago: University of Chicago Press, 1949.

D'Este, Carlo. *Bitter Victory: The Battle for Sicily, 1943.* New York: HarperCollins, 1988.

———. *Eisenhower: A Soldier's Life.* New York: Henry Holt and Company, 2002.

———. *Fatal Decision: Anzio and the Battle for Rome.* New York: HarperCollins, 1991.

———. *World War II in the Mediterranean: 1942–1945.* Chapel Hill, NC: Algonquin Books, 1990.

Davis, Richard G. *Carl A. Spaatz and the Air War in Europe.* Washington, DC: Center for Air Force History, 1993.

de Frede, Carlo. *Il decumano maggiore da Castelcapuano a San Pietro a Maiella. Cronache napoletane dei secoli passati.* Naples: Liguori, 2005.

De Simone, Cesare. *Venti angeli sopra Roma: I bombardamenti aerei sulla Città Eterna: 19 luglio e 13 agosto 1943.* Milan: Mursia, 1993.

de Stefani, Lorenzo, ed. *Guerra monumenti ricostruzione. Architetture e centri storici italiani nel secondo conflitto mondiale.* Venice: Marsilio Editori, 2011.

Deakin, F. W. *The Brutal Friendship: Mussolini, Hitler, and the Fall of Italian Fascism.* London: Phoenix Press, 1962.

Delaney, John P. *The Blue Devils in Italy: A History of the 88th Infantry Division in World War II.* Nashville, TN: The Battery Press, 1988.

Del Guerra, Giorgio. *Pisa attraverso i secoli.* Pisa: Giardini, 1967.

"Der Rhein ist mein Schicksal geworden." Paul Clemen. 1866–1947. Erster Provinzialkonservator der Rheinprovinz. Edited by Landschaftsverband Rheinland. Cologne: Rheinisches Amt für Denkmalpflege in Verbindung mit dem Rheinischen Landesmuseum Bonn, 1991.

Dollmann, Eugen. *Call Me Coward*. London: William Kimber, 1956.

———. *The Interpreter: Memoirs of Doktor Eugen Dollmann*. Translated by J. Maxwell Brownjohn. London: Hutchinson & Co., 1967

Dulles, Allen W. *From Hitler's Doorstep: The Wartime Intelligence Reports of Allen Dulles, 1942–1945*. Edited by Neal H. Petersen. University Park: Pennsylvania State University Press, 1996.

———. *The Secret Surrender: The Classic Insider's Account of the Secret Plot to Surrender Northern Italy During WWII*. Guilford, CT: Lyons Press, 2006.

Edsel, Robert M. *Rescuing Da Vinci: Hitler and the Nazis Stole Europe's Great Art, America and Her Allies Recovered It*. Dallas: Laurel Publishing, 2006

———. *The Monuments Men: Allied Heroes, Nazi Thieves, and the Greatest Treasure Hunt in History*. New York: Center Street, 2009.

Eisenhower, David. *Eisenhower at War 1943–1945*. New York: Random House, 1986.

Eisenhower, Dwight D. *At Ease: Stories I Tell to Friends*. New York: McGraw-Hill, 1988.

———. *Crusade in Europe*. Baltimore, MD: Johns Hopkins Paperbacks, 1997.

Fasola, Cesare. *The Florence Galleries and the War: History and Records*. Florence: Monsalvato, 1945.

Fest, Joachim. *Inside Hitler's Bunker: The Last Days of the Third Reich*. Translated by Margot Bettauer Dembo. New York: Farrar, Straus and Giroux, 2002.

Fielden, Lionel. *The Natural Bent*. London: Andre Deutsch Limited, 1960.

Firenze Ferita: La Guerra, Le Devastazioni dei Bombardamenti, l'arrivo degli Alleati: La Città dal 1940 al 1944. Bologna: Pendragon, 2007.

Fisher, Ernest F. Jr. *United States Army in World War II: The Mediterranean Theater Operations: Cassino to the Alps*. Washington, DC: Center of Military History, United States Army, 1977.

Flanner, Janet. *Men and Monuments*. New York: Harper & Brothers, 1957.

Foreign Relations of the United States: Diplomatic Papers 1942, Vol. III: Europe. Washington, DC: United States Government Printing Office, 1961.

Franchi, Elena. "Vertrauen und Misstrauen: die schwierigen Beziehungen zwischen der Italienischen Sozialrepublik und dem 'Kunstschutz.' Einige umstrittene Fälle." In *Kunsthistoriker im Krieg: Deutscher Militärischer Kunstschutz in Italien 1943–1945*, ed. Christian Fuhrmeister et al. Cologne/Weimar/Vienna: Böhlau Verlag, 2012.

Frassineti, Mario, et al. *Santa Maria delle Grazie*. Milan: Federico Motta, 1998.

Friedrich, Jörg. *The Fire: The Bombing of Germany, 1940–1945*. New York: Columbia University Press, 2006.

Fuhrmeister, Christian, et al., eds. *Kunsthistoriker im Krieg: Deutscher militärischer Kunstschutz in Italien 1943–1945*. Cologne/Weimar/Vienna: Böhlau Verlag, 2012.

Galasso, Giuseppe, ed. *Storia d'Italia, Comuni e signorie nell'Italia nordorientale e centrale: Veneto, Emilia-Romagna e Toscana*. Vol 7.1. Turin: UTET, 1987.

Galleria degli Uffizi. *Gli Uffizi: catalogo generale*. Florence: Centro Di, 1979.

Gariboldi, Giorgio Angelozzi. *Pio XII, Hitler e Mussolini: Il Vaticano fra le dittature*. Milan: Mursia, 1995.

Garland, Albert N., and Howard McGaw Smyth. *US Army in WWII: Sicily and the Surrender of Italy*. Washington, DC: U.S. Government Printing Office, 1965.

Ghibaudi, Cecilia, ed. *Brera e la Guerra: La salvaguardia delle opere della Pinacoteca*. Exhibition, Milan, Pinacoteca di Brera, 10 November 2009–21 March 2010. Milan: Electa, 2009.

Gilbert, Felix. *Hitler Directs His War*. New York: Oxford University Press, 1950.

Giliotti, Sergio. *La seconda Julia nella Resistenza: cronistoria di una brigata partigiana*. Parma: s.n., 1996.

———. *La seconda Julia nella Resistenza: cronistoria di una brigata partigiana*. Reggio Emilia: Diabasis, 2010.

Goebbels, Joseph. *The Goebbels Diaries: 1942–1943*. Edited and translated by Louis P. Lochner. New York: Doubleday, 1948.

———. *Tagebücher, Band 5: 1943–1945*. Edited by Georg Reuth. Munich: Piper Verlag, 1999.

Goldensohn, Leon. *Nuremberg Interviews: An American Psychiatrist's Conversations with the Defendants and Witnesses*. New York: Knopf, 2004.

Gribaudi, Gabriella. *Guerra totale. Tra bombe alleate e violenze naziste. Napoli e il fronte meridionale, 1940–1944*. Turin: Bollati Boringhieri, 2005.

Hagen, Walter. *La guerra delle Spie*. Milan: Garzanti, 1952.

Hammer, Katherina. *Glanz im Dunkel: die Bergung von Kunstschätzen im Salzkammergut am Ende des 2. Weltkrieges*. Vienna: Österreichischer Bundesverlag, 1986.

Hapgood, David, and David Richardson. *Monte Cassino: The Story of the Most Controversial Battle of World War II*. Cambridge, MA: Da Capo Press, 2002.

Harris, Arthur. *Bomber Offensive*. Barnsley, Yorkshire: Pen & Sword Military Classics, 2005.

Hartt, Frederick. *Florentine Art Under Fire*. Princeton, NJ: Princeton University Press, 1949.

Hartt, Frederick, and David G. Wilkens. *History of Italian Renaissance Art: Painting—Sculpture—Architecture*, 5th ed. Upper Saddle River, NJ: Pearson/Prentice Hall, 2003.

Hassett, William D. *Off the Record with F.D.R.: 1942–1945*. New Brunswick, NJ: Rutgers University Press, 1958.

Hastings, Max. *Armageddon: The Battle for Germany, 1944–1945*. New York: Vintage Books, 2004.

———. *Inferno: The World at War, 1939–1945*. New York: Alfred A. Knopf, 2011.

Heiber, Helmut, ed. *Lagebesprechungen im Führerhauptquartier, Protokollfragmente aus Hitlers militärischen Konferenzen 1942–1945*. Stuttgart: Deutscher Taschenbuchverlag, 1963.

Heydenreich, Ludwig Heinrich. *Leonardo: The Last Supper*. New York: Viking Press, 1974.

Hirshson, Stanley P. *General Patton: A Soldier's Life*. New York: HarperCollins, 2002.

Hobbs, Joseph. *Dear General: Eisenhower's Wartime Letters to Marshall*. Baltimore, MD: Johns Hopkins University Press, 1999.

Holland, James. *Italy's Sorrow: A Year of War, 1944–1945*. New York: St. Martin's Press, 2008.

Il Fuhrer in Italia. S.l., Agenzia Stefani, [s.n.].

Kater, Michael H. *Das "Ahnenerbe" der SS 1935–1945: Ein Beitrag zur Kulturpolitik des Dritten Reiches*. Munich: Oldenbourg Wissenschaftsverlag, 2001.

Katz, Robert. *The Battle for Rome: The Germans, the Allies, the Partisans and the Pope, September 1943–June 1944*. New York: Simon & Schuster Paperbacks, 2003.

Kershaw, Alex. *The Longest Winter: The Battle of the Bulge and the Epic Story of WWII's Most Decorated Platoon*. Cambridge, MA: Da Capo Press, 2004.

Kesselring, Albert. *The Memoirs of Field-Marshal Kesselring*. London: Greenhill Books, 2007.

Kleiner, Fred S. *Gardner's Art through the Ages: A Global History*, 13th ed. Independence, KY: Cengage Learning, 2009.

Klinkhammer, Lutz. "Arte in Guerra: tutela e distruzione delle opera d'arte italiane durante l'occupazione tedesca 1943–45," in Giuseppe Masetti and Antonio Panaino, eds., *Parola d'ordine: Teodora*. Ravenna: Longo, 2005, 61–76.

Kloman, Erasmus. *Assignment Algiers: With the OSS in the Mediterranean Theatre*. Annapolis, MD: Naval Institute Press, 2005.

Kramer, Alan. *Dynamic of Destruction: Culture and Mass Killing in the First World War*. Oxford: Oxford University Press, 2007.

Krell, Max. *Das alles gab es einmal*. Frankfurt am Main: Verlag Heinrich Scheffler, 1961.

Kubin, Ernst. *Raub oder Schutz? Der deutsche militärische Kunstschutz in Italien*. Graz / Stuttgart: Leopold Stocker Verlag, 1994.

Kurzman, Dan. *A Special Mission: Hitler's Secret Plot to Seize the Vatican and Kidnap Pope Pius XII*. Cambridge, MA: Da Capo Press, 2007.

L'opera ritrovata: Omaggio a Rodolfo Siviero. Florence: Cantini Edizioni d'Arte, 1984.

Lamb, Richard. *War in Italy, 1943–1945: A Brutal Story*. New York: Da Capo Press, 1993.

Lang, Jochen von. *Top Nazi: SS General Karl Wolff, the Man Between Hitler and Himmler*. New York: Enigma Books, 2005.

Lang, Jochen von, and Claus Sibyll. *Der Adjutant: Karl Wolff, Der Mann zwischen Hitler und Himmler*. Munich / Berlin: F. A. Herbig Verlagsbuchhandlung, 1985.

Lavagnino, Alessandra. *Un inverno 1943–1944*. Palermo: Sellerio, 2006.

Le Tizier, Tony. *Durchbruch an der Oder: Der Vormarsch der Roten Armee 1945*. Augsburg: Bechtermünz Verlag, 1999.

Libraries Guests of the Vatican During the Second World War. Vatican City: Apostolic Vatican Library, 1945.

Lingen, Kerstin von. *Kesselring's Last Battle: War Crimes Trials and Cold War Politics, 1945–1960*. Lawrence: University Press of Kansas, 2009.

———. *SS und Secret Service, "Verschwörung des Schweigens": Die Akte Karl Wolff*. Paderborn, Germany: Ferdinand Schöningh, 2010.

Linklater, Eric. *The Art of Adventure*. London: Macmillan, 1947.

Lombardi, Elena, ed. *L'Archivio di Giovanni Poggi (1880–1961): soprintendente alle Gallerie fiorentine*. Florence: Edizione Polistampa, 2011.

Lombardo, Chiara. *Pasquale Rotondi: quando il lavoro è un'arte: storia di un soprintendente solo e senza soldi custode dei tesori italiani durante la seconda guerra mondiale*. Caserta: Vozza, 2008.

Longmate, Norman. *The Bombers: The RAF Offensive against Germany, 1939–1945.* London: Hutchinson, 1983.

Lousse, E. *The University of Louvain During the Second World War.* Bruges: Desclée, de Brouwer, 1946

Majdalany, Fred. *Cassino: Portrait of a Battle.* London: Cassell & Co, 2000.

Mariano, Elisabetta "Nicky." *Forty Years with Berenson.* New York: Alfred A. Knopf, 1966.

Matthews, Herbert L. *The Education of a Correspondent.* Westport, CT: Greenwood Press, 1970.

———. *A World in Revolution: A Newspaperman's Memoir.* New York: Charles Scribner's Sons, 1971.

Mauldin, Bill. *Up Front.* New York: W. W. Norton & Company, 1945.

Mellenthin, Major-General F. W. von. *Panzer Battles 1939–1945: A Study of the Use of Armour in the Second World War.* London: Cassell & Company, 1955.

Merrill, Keith. *Keith Merrill: A Memoir.* Privately printed, 1968.

Mets, David R. *Master of Airpower: General Carl A. Spaatz.* Novato, CA: Presidio Press, 1988.

Meyer, Ahlrich, ed. *Repression und Kriegsverbrechen: Die Bekämpfung von Widerstands- und Partisanenbewegungen gegen die deutsche Besatzung in West- und Südeuropa. Beiträge zur Nationalsozialistischen Gesundheits- und Sozialpolitik 14.* Berlin/Göttingen: Verlag der Buchläden, 1997.

Milano ricostruisce: 1945–1954. Edited by Giorgio Rumi and Adele Carla Buratti. Milan: Cariplo, 1990.

Miller, Donald L. *Masters of the Air: America's Bomber Boys Who Fought the Air War Against Nazi Germany.* New York: Simon & Schuster, 2006.

———. *The Story of World War II.* New York: Simon & Schuster, 2001.

Mitchell, Arthur H. *Hitler's Mountain: The Führer, Obersalzberg and the American Occupation of Berchtesgaden.* London: McFarland & Company, 2007.

Molony, Brigadier C. J. C. *The Mediterranean and Middle East: Volume VI, Part I.* Uckfield, East Sussex: The Naval & Military Press Ltd., 2004.

Mussolini, Benito. *Opera omnia di Benito Mussolini: dal discorso al direttorio nazionale del P.N.F. del 3 gennaio 1942 alla liberazione di Mussolini.* Edited by Edoardo and Duilio Susmel. Florence, 1960.

———. *Scritti e discorsi dell'Impero: Novembre 1935-XIV–4 Novembre 1936-XV.* Milan: Hopeli Editore,1936.

Nicholas, Lynn. *The Rape of Europa: The Fate of Europe's Treasures in the Third Reich and the Second World War.* New York: Vintage Books, 1995.

Orgill, Douglas. *The Gothic Line.* New York: W. W. Norton & Company, 1967.

Paoletti, Paolo, and Mario Carniani. *Firenze: Guerra & Alluvione: 4 Agosto 1944/4 Novembre 1966.* Florence: Saverio Becocci.

Petropoulos, Jonathan. *Art as Politics in the Third Reich.* Chapel Hill: University of North Carolina Press, 1996.

Piekalkiewucz, Janusz. *The Battle for Cassino: Anatomy of the Battle.* New York: Bobbs-Merrill Company, 1980.

Plöckinger, Othmar. *Geschichte eines Buches: Adolf Hitler's "Mein Kampf": 1922–1945.* Munich: Oldenbourg Verlag, 2006.

Pöchmüller, Emmerich. *Weltkunstschätze in Gefahr.* Salzburg: Pallas-Verlag, 1948.

Rahn, Rudolf. *Ruheloses Leben: Aufzeichnungen und Erinnerungen (eines deutschen Diplomaten).* Düsseldorf: Peter Diederichs Verlag, 1949.

Rambusch, Horst. *Erster Oderbrückenkopf 1945—Abschnitt Kienitz-Karlsbiese—und die Folgen für die Bevölkerung.* Gross Neuendorf: Landfrauenverein "Mittleres Oderbruch," 2010.

Rauscher, Walter. *Hitler e Mussolini. Vita, potere, guerra e terrore.* Translated by Loredana Battaglia and Maria Elena Benemerito. Rome: Newton & Compton editori, 2004.

Report of the American Commission for the Protection and Salvage of Artistic and Historic Monuments in War Areas. Washington, DC: U.S. Government Printing Office, 1946.

Richards, Denis, and Hilary St. G. Saunders. *Royal Air Force: 1939–45: The Flight Avails.* London: Seven Hills Books, 1996.

Rochat, Giorgio. *L'esercito italiano in pace e in guerra: studi di storia militare.* Milan: R.A.R.A, 1991.

Rychlak, Ronald J. *Hitler, the War, and the Pope.* Huntington, IN: Our Sunday Visitor Publishing Division, 2010.

Salter, Michael. *Nazi War Crimes: US Intelligence and Selective Prosecution at Nuremberg.* New York: Routledge-Cavendish, 2007.

Satta, Salvatore. *De Profundis.* Milan: Adelphi, 1980.

Schellenberg, Walter. *The Labyrinth: Memoirs of Walter Schellenberg, Hitler's Chief of Counterintelligence.* New York: Da Capo Press, 2000.

Schivelbusch, Wolfgang. *Three New Deals: Reflections on Roosevelt's America, Mussolini's Italy, and Hitler's Germany, 1933–1939.* New York: Picador, 2006.

Schramm, Percy Ernst, ed. *Kriegstagebuch des Oberkommando der Wehrmacht (Wehrmachtführungsstab), Band IV: 1. Januar 1944–22. Mai 1945. Erster und Zweiter Halbband.* Frankfurt am Main: Bernard & Graefe Verlag für Wehrwesen, 1961.

Schuster, Ildefonso. *Gli ultimi tempi di un regime.* Milan: La Via, 1946.

Schwarz, Birgit. *Geniewahn: Hitler und die Kunst.* Vienna/Cologne/Weimar: Böhlau Verlag, 2009.

Serlupi Crescenzi, Maria and Teresa Calvano, eds. *1940–1945 Arte in fuga, arte salvata, arte perduta: le città italiane tra Guerra e Liberazione.* Vatican City: Edizioni Musei Vaticani, 2012.

Shirer, William. *End of a Berlin Diary: 1944–1947.* Norwalk, CT: The Easton Press, 1991.

Sigmund, Anna Maria. *Die Frauen der Nazis.* Munich: Wilhelm Heyne Verlag, 2000.

Siviero, Rodolfo. *L'Arte e il Nazismo: esodo e ritorno delle opere d'arte italiane, 1938–1963.* Florence: Cantini, 1984.

———. *La Difesa delle Opere d'Arte: testimonianza su Bruno Becchi.* Florence: Accademia delle arti di disegno, 1976.

———, ed. *Seconda mostra nazionale delle opere d'arte recuperate in Germania.* Florence: Sansoni, 1950.

Smith, Bradley F., and Elena Agarossi. *Operation Sunrise: The Secret Surrender.* New York: Basic Books, 1979.

Smith, Jean. *Eisenhower in War and Peace.* New York: Random House, 2012.

Smith, Philip A. *Thesis: Bombing to Surrender: The Contribution of Air Power to the Collapse of Italy, 1943.* Maxwell AFB, AL: The School of Advanced Airpower Studies, 1997.

Speer, Albert. *Inside the Third Reich: Memoirs.* New York: Simon & Schuster, 1970.

Spinosa, Antonio. *Pio XII, un Papa nelle tenebre.* Milan: Oscar Mondadori, 2004.

Spike, John T. *Masaccio.* Milan: Rizzoli Libri Illustrati, 2002.

Spoils of War. Edited by Elizabeth Simpson. New York: Harry N. Abrams, 1997.

Spotts, Frederic. *Hitler and the Power of Aesthetics.* Woodstock, NY: The Overlook Press, 2003.

Srodes, James. *Allen Dulles: Master of Spies.* Washington, DC: Regnery Publishing, 1999.

Tittmann, Harold H. Jr., and Harold H. Tittmann III. *Inside the Vatican of Pius XII: The Memoir of an American Diplomat During World War II.* New York: Image Books/ Doubleday, 2004.

Toland, John. *The Last 100 Days: The Tumultuous and Controversial Story of the Final Days of World War II in Europe.* New York: Modern Library, 2003.

Tompkins, Peter. *Italy Betrayed.* New York: Simon & Schuster, 1966.

———. *Una Spia a Roma, 1944: La Liberazione della Capitale nel Racconto di un Agente Americano.* Milan: Il Saggiatore, 2002.

Trial of the Major War Criminals Before the International Military Tribunal: Nuremberg 14 November 1945–1 October 1946. Nuremberg, 1947.

Truman, Harry S. *Memoirs by Harry S. Truman: 1945: Year of Decisions.* New York: Konecky & Konecky, 1955.

Tutaev, David. *The Consul of Florence.* London: Secker & Warburg, 1966.

United Nations War Crimes Commission. *Law Reports of Trials of War Criminals, Volume VIII.* London: His Majesty's Stationery Office, 1949.

U.S. War Department. *Handbook on German Military Forces.* Baton Rouge: Louisiana State University Press, 1990.

Vasari, Giorgio. *Lives of the Artists: Volume I.* Translated by George Bull. London: Penguin Books, 1987.

Vinceti, Silvano. *Salò capitale: breve storia fotografica della RSI.* Rome: Armando Editore, 2003.

Waller, John H. *The Unseen War in Europe: Espionage and Conspiracy in the Second World War.* New York: Random House, 1996.

Webster, Sir Charles, and Noble Frankland. *The Strategic Air Offensive Against Germany 1939–1945, Volume II: Endeavor.* London: Her Majesty's Stationery Office, 1961.

Weinberg, Gerhard L. *A World at Arms: A Global History of World War II.* New York: Cambridge University Press, 1994.

Weizsäcker, Ernst von. *Erinnerungen.* Munich/Leipzig/Freiburg i. Br.: Paul List Verlag, 1950.

Wighton, Charles. *Hitler's Spies and Saboteurs: Based on the German Secret Service War Diary of General Lauhousen.* Lexington, KY: Charles Wighton and Günter Peis, 1958.

Winks, Robin W. *Cloak & Gown: Scholars in the Secret War.* New York: William Morrow and Company, Inc., 1987.

Winstone, H. V. F. *Woolley of Ur: The Life of Sir Leonard Woolley*. London: Secker & Warburg, 1990.

Wolff, Karl. *Mit Wissen Hitlers: Meine Geheimverhandlungen über eine Teilkapitulation in Italien 1945: Der persönliche Bericht des "Höchsten SS- und Polizeiführers" sowie "Bevollmächtigten General der Deutschen Wehrmacht in Italien."* Stegen am Ammersee, Germany: Druffel & Vowinckel-Verlag, 2008.

Woolley, Lt. Col. Sir Leonard. *The Protection of the Treasures of Art and History in War Areas*. London: His Majesty's Stationery Office, 1947.

Works of Art in Italy: Losses and Survivals in the War, Part II. London: His Majesty's Stationery Office, 1946.

Yeide, Nancy H. *Beyond the Dreams of Avarice: The Hermann Goering Collection*. Dallas: Laurel Publishing, 2009.

Zöllner, Frank. *Leonardo da Vinci: The Complete Drawings and Paintings*. Cologne: Taschen, 2003.

Zuckerman, Solly. *From Apes to Warlords 1904–46: An Autobiography*. London: Hamish Hamilton Ltd., 1978.

ARTICLES

"Art: War Casualty." *Time*, December 9, 1946. http://www.time.com/time/printout/0,8816,793256,00.html, accessed January 4, 2011.

Baldoli, Claudia, and Marco Fincardi. "Italian Society Under Anglo-American Bombs: Propaganda, Experience, and Legend, 1940–1945." *The Historical Journal* (December 1, 2009): 1017–38.

Becattini, Massimo. "Siviero 007. Inchiesta su arte e nazismo. Il cacciatore di opere d'arte." *Archeologia Viva* (1998): 38–51.

Becker, Maximilian. "Memoriale Becker sullo Sgombero di Montecassino," Dublin, 18 February 1964, In *Il Bombardamento di Montecassino—Diario di Guerra*. Montecassino: Pubblicazioni Cassinesi, 1907: 235–78.

Caretto, Ennio. "Montini, una scelta americana per l'Italia." *Corriere della Sera*, August 26, 2003.

Cecchi, Roberto. "Distruzioni Belliche e opera di ricostruzione (1945–1960)," in *Storia di Milano: Il Novecento*. Milan: Fondazione Treccani degli Alfieri per la Storia di Milano, 1966.

Clarke, Ethne. "A Biography of Cecil Ross Pinsent, 1884–1963." *Garden History* 26, no. 2 (Winter 1998): 177–91.

Commune of Florence. "Il Ritrovamento della Gioconda a Firenze." *Un convegno in onore del sovrintendente Giovanni Poggi*. Florence, January 26, 2005. Press release, January 4, 2005.

Corriere della Sera. "La funzione terroristica dei bombardamenti anglo-americani." August 18, 1943.

———. "Il pontefice si inginocchia sulle macerie di San Lorenzo." July 21–22, 1943.

———. "Continuano i bombardamenti terroristici: il Duomo di Milano colpito." August 17, 1943.

———. "I danni alle Grazie, si spera di salvare il Cenacolo." August 18, 1943.

Crider, John H. "President Upholds Shelling of Abbey." *New York Times*, February 16, 1944.

Esterow, Milton. "Europe is Still Hunting its Plundered Art." *New York Times*, November 16, 1964.

Fasola, Cesare. "Perchè non abbiamo impedito l'esodo delle opere d'arte fiorentine?" *Il Ponte*, May (1945): 141–46.

Ferraro, Pietro. "La resistenza veneta in difesa delle opere d'arte." *Il Ponte*, September (1954): 127–32.

Filangieri, Riccardo. "Report on the Destruction by the Germans, September 30, 1943, of the Depository of Priceless Historical Records of the Naples State Archives." *American Archivist* 7, no. 4 (October 1944): 252–55.

Gazzetta di Parma. "Don Tito promotore della lotta di liberazione." May 14, 1945.

———. "Si ricorda Don Anelli a otto anni dalla morte." March 9, 1978.

———. "Don Anelli, prete volante un ardimentoso partigiano." May 7, 1990.

———. "Il prete partigiano è ritornato a casa." May 13, 1990.

Giliotti, Sergio. "Don Guido Anelli, il prete volante e le azioni della 2° Julia," in *Il contributo dei Cattolici alla lotta di Liberazione in Emilia-Romagna*, Atti del 2° convegno di Studi tenuto nei giorni 1, 2, 3 Maggio 1964, Parma-Salsomaggiore (1966): 281–88.

Haines, Gerald K. "Who Gives a Damn about Medieval Walls?" *Prologue*, 8, no. 2 (Summer 1976): 97–106.

Hammond, Mason. "The War and Art Treasures in Germany." *College Art Journal* (March 1946), 205–18.

———. "Remembrance of Things Past: The Protection and Preservation of Monuments, Works of Art, Libraries, and Archives during and after World War II," *An Offprint from the Proceedings of the Massachusetts Historical Society*, vol. 92, 1980.

Harvey, Stephen. "The Italian War Effort and the Strategic Bombing of Italy." *The Italian War Effort* 70, no. 228 (February 1985): 32–45.

Heydenreich, Ludwig Heinrich. "In Memoriam—Friedrich Kriegbaum." *Mitteilungen des Kunsthistorischen Institutes in Florenz, Siebzehnter Band, Heft II*, August 1953. Düsseldorf: Verlag L. Schwann.

Kenney, Elise. "From the Archives: Theodore Sizer, 1892–1967: 'A Teacher, an author, and a craftsman of infinite perfection.'" *Yale Art Gallery Bulletin* (2006): 155–60.

Kirby, John L. "The Archives of Angevin Naples—A Reconstruction." *Journal of the Society of Archivists*, vol. 3, no. 4 (1996): 191.

Klinkhammer, Lutz. "Die Abteilung 'Kunstschutz' der deutschen Militärverwaltung in Italien 1943–1945." *Quellen und Forschungen aus italienischen Archiven und Bibliotheken*. Vol. 72. Rome: Deutsches Historisches Institut, 1992.

———. "Arte in Guerra," in Giuseppe Masetti and Antonio Panaino, eds., *Parola d'ordine Teodora*. Ravenna: Longo Angelo, 2005, 61–76.

Klöckner, Jürgen. "Verhinderter Archivalienraub in Italien, Theodor Mayer und die Abteilung 'Archivschutz' bei der Militärverwaltung in Verona 1943–1945." *Quellen und Forschungen aus italienischen Archiven und Bibliotheken*. Vol. 86. Rome: Deutsches Historisches Institut, 2006.

Krautheimer, Richard, and Kurt Weitzmann. "Memoirs of Fellows and Corresponding Fellows of the Mediaeval Academy of America: Ernest DeWald," *Speculum*, vol. 44, no. 3 (July 1969): 526–27.

Kriegbaum, Friedrich. "Michelangiolo e il Ponte a S. Trinita," *Rivista d'arte*, 23 (1941): 137–44.

La Nazione. "Firenze nuovamente colpita dai bombardamenti dell'aviazione nemica." March 24, 1944.

———. "Un'altra feroce incursione." March 11, 1944.

Latour, C. F. "Germany, Italy and South Tyrol, 1938–45." *The Historical Journal*, vol. 8, no. 1 (1965): 95–111.

Lavagnino, Emilio. "Diario di un salvataggio artistico." *La Nuova Antologia*, August (1974): 509–47.

———. "Migliaia di opere d'arte rifugiate in Vaticano." *Strenna dei romanisti* VII (1946): 82–88.

Life. "Nazi Loot Pops Up in Pasadena." January 25, 1963: 43–46.

Lingen, Kerstin von. "Conspiracy of Silence." *Holocaust and Genocide Studies* 22, no. 1 (Spring 2008). http://hgs.oxfordjournals.org, accessed August 19, 2010.

Linklater, Magnus. "The Man Who Kissed the Primavera." *Scottish Review*, January 2006.

Lippini, Fra Pietro, OP, "Furono i Domenicani a salvarlo dopo il bombardamento dell'agosto 1943," in *L'Ultima Cena di Leonardo da Vinci: Una lettura storica, artistica e spirituale del grande capolavoro*. Milan: Dominican Friars of the Church of Santa Maria delle Grazie, n.d.

L'Italia. "Bombardamento senza precedenti. Chiese, ospedali, monumenti colpiti e danneggiati," August 15, 1943.

L'Osservatore Romano. "La Chiesa delle Grazie a Milano riapre al pubblico." July 3, 1945.

———. "Il Santo padre tra i fedeli della Sua diocesi di Roma colpiti dall'incursione aerea." July 19, 1943.

"Manifesto del Comitato per la raccolta dei fondi," in *Il ponte a S. Trinità*, ed. Comitato per la ricostruzione del ponte a S. Trinità. Florence: Tip. E. Rinaldi, 1957.

Matthews, Herbert L. "Old Florence Ravaged by Nazis; Much of Medieval City Destroyed." *New York Times*, August 30, 1944.

———. "Tuscan Treasures Slowly Repaired." *New York Times*, January 2, 1945.

McCartney, Benjamin C. "Return to Florence." *National Geographic*, vol. 87, no. 3 (March 1945): 275.

McManus, John C. "The Last Great Prize." *World War II Magazine* (May 2005): 51–56.

Metzger, Phillip A. "Catholic University of Louvain." *Journal of Library History* 15, no. 3 (Summer 1980): 326–29.

Monda, Lucia. "Napoli durante la II guerra mondiale ovvero: i 100 bombardamenti di Napoli," in *Napoli durante la II guerra mondiale*. Essay for conference I.S.S.E.S Istituto di Studi Storici Economici e Sociali, March 5, 2005.

Morello, Giovanni. "Il ruolo della Santa Sede nell'azione di salvaguardia del patrimonio culturale e artistico italiano durante la Seconda guerra mondiale." *Quaderni della Fondazione Bellonci*. November 4, 2006: 11–14.

New York Times. "Text of Premier Mussolini's Address to the Italian People on the War." February 24, 1941.

———. "Unique Collection of Art Treasures Taken Away by Germans in Italy." November 10, 1943.

———. "Theodore Sizer, Art Teacher and Heraldist, Dies." June 22, 1967.

Norris, Christopher. "The Museo Filangieri." *The Burlington Magazine*, vol. 84, no. 492 (March 1944): 72–76.

Nuovo Giornale. "Selvagge distruzioni dell'aviazione nemica nella città di Firenze." March 25–26, 1943.

———. "Firenze reagisce alla infame devastazione organizzando fraternamente l'opera di soccorso." September 27, 1943.

———. "I pirati nemici bombardano nuovamente Firenze." March 24, 1944.

Paoletti, Paolo. "Il console svizzero Charles Steinhäuslin," in *Svizzeri a Firenze: Nella storia, nella cultura, nell'economia dal Cinquecento ad oggi*, ed. Giorgio Mollisi. Lugano: Ticino Management, 2010: 406–14.

Plaut, James S. "Loot for the Master Race." *Atlantic Monthly* 178, no. 3 (September 1946): 57–63.

———. "Hitler's Capital." *Atlantic Monthly* 178, no. 4 (October 1946): 73–78.

Potier, Beth. "Classics Scholar Mason Hammond Dead at 99." *Harvard Gazette*, October 17, 2002.

Rinaldi, Simona. "L'Attività della Direzione Generale delle Arti nella Città Aperta di Roma." *Rivista dell'Istituto Nazionale d'Archeologia e Storia dell'Arte*, no. 60 (2005): 95–126.

Rotondi, Pasquale. "Capolavori d'arte sottratti ai pericoli della guerra ed alla rapina tedesca. Estratto da una Relazione del Prof. Pasquale Rotondi Soprintendente alle Gallerie delle Marche, presentata il 18 ottobre 1945 alla R. Accademia Raffaello." *Urbinum* (July–August 1945): 3–13.

Seymour, Charles. "Yale at War: An American University Accepts the Challenge." *Life*, June 1942.

Signorini, Rodolfo. "Tumulate a S. Miniato le ceneri del grande studioso americano. Si prodigò per salvare le opere d'arte durante il secondo conflitto mondiale." *La Gazzetta*, March 13, 1993.

Sizer, Theodore. "A Walpolean at War." The Walpole Society Notebook (1946): 65–89.

Taylor, Francis Henry. "The Rape of Europa." *Atlantic Monthly* 175 (January 1945): 52.

Time. "Italy: Benito's Birthday." August 6, 1923.

———. "Art: Bone and Muscle Man." September 14, 1942.

———. "War in the Treasure House." February 21, 1944.

Tompkins, Peter. "The OSS and Italian Partisans in World War II: Intelligence and Operational Support for the Anti-Nazi Resistance." *Studies in Intelligence* (Spring 1998).

United Press. "Italian Fleet Under Steam, Set to Flee: Fear Germans will Seize Warships if Peace Made." August 1, 1943.

Valli, Wanda. "Rotondi, l'eroe dell'arte: 'Così mio padre sfidò Hitler,'" *La Repubblica*, July 1, 2005.

Vita Nuova. "Nel X anniversario l'A.P.C. ricorda Don Guido Anelli." March 10, 1979.

Wittgens, Fernanda. "Il restauro in corso del Cenacolo di Leonardo," in *Atti del convegno di Studi Vinciani indetto dalla unione Regionale delle Province toscane e dalle Università di Firenze, Pisa e Siena 15–18 gennaio 1953*. Florence: Leo Olschki, 1953.

Wolff, Karl. "Ecco la verità." *Tempo*, February–March 1951.

Zarmati, Louise. "Amedeo Maiuri: In Search of the 'Dark Side,'" *Teaching History: Journal of the History Teachers' Association of NSW*, vol. 40, December 2006.

PUBLIC COLLECTIONS

American Academy in Rome

Archivio della Soprintendenza per i beni Architettonici e per il Paesaggio per le province di Milano, Bergamo, Como, Lecco, Lodi, Pavia, Sondrio e Varese, Milan

Archivio Catalogo Beni Storico-Artistici, Florence
 Giovanni Poggi Archive

Archivio di Stato, Padua
 Carlo Anti Papers

Archivio Storico, Florence

Archivio Storico Diocesano, Florence
 Elia Dalla Costa Papers

British School at Rome, Rome
 John Bryan Ward-Perkins Papers

Bundesarchiv, Berlin
 Karl Wolff and Alexander Langsdorff Papers

Churchill Archives Centre, Cambridge, UK

Civico Archivio Fotografico, Milan

Cornell Law Library, Ithaca, New York
 Donovan Nuremberg Trial Collection

Deutsches Historisches Institut, Rome
 Gerhard Wolf and Carlo Steinhäuslin Papers

Dwight D. Eisenhower Presidential Library, Abilene, Kansas
 Bedell Smith Papers
 C. D. Jackson Papers
 Eisenhower Pre-Presidential Papers
 Lauris Norstad Papers

Harvard University Archives, Pusey Library, Cambridge, Massachusetts
 Paul J. Sachs and Mason Hammond Papers

Imperial War Museum, London

Kunsthistorisches Institut der Universität Bonn
 Paul Clemen Papers

Kunsthistorisches Institut, Florence
 Friedrich Kriegbaum Papers

Ministero degli Esteri, Archive of the ex-Delegation for Restitution, Siviero Archive, Rome
> Anti Catalogue File
> Deutscher Militärischer Kunstschutz Documents
Museo Casa Rodolfo Siviero, Florence
National Gallery of Art, Washington, DC
> Gallery Central Files
> Frederick Hartt Papers
National Archives and Records Administration, Washington, DC
> M1035
> M1782
> M1944
> Record Group 190
> Record Group 226
> Record Group 238
> Record Group 239
> Record Group 331
> Record Group 342
> Record Group 407
> Record Group 549
> Personnel File Department
National Archives, Kew, Richmond, Surrey
Princeton University Archives, Princeton, New Jersey
> Ernest DeWald Papers
> Sheldon Pennoyer Papers
Smithsonian Archives of American Art, Washington, DC
> W. G. Constable Papers
Villa I Tatti, Florence
> Bernard and Mary Berenson Papers
Yale University Library, Manuscripts and Archives, New Haven, Connecticut
> Deane Keller Papers
> Theodore Sizer Papers
> Yale During World War II

PRIVATE COLLECTIONS

Charles Bernholz Papers, Washington, DC
Perry Cott Papers, Oregon
Mason Hammond Papers, London
Alexander Langsdorff Papers, Switzerland
Private Collection, Italy
Salvatore Scarpitta Papers, California
Roy Seymour Papers

AUTHOR INTERVIEWS AND CONVERSATIONS

Luigina Anelli
Mario Becattini
Giuseppe Bentivoglio
Pietro Bonardi
Alessandro and Kathy Cagiati
Anthony Cagiati
Dr. Bruce Cole
Jill Croft-Murray
Carlo D'Este
Leonard Fisher
Mario Lolli Ghetti
Sergio Giliotti
Walter Gleason
Diego Guidi
Margaret Hildson
Dorothy Keller
William Keller
Elizabeth Hammond Llewellyn
Eugene David Markowski
Don Miller
Alessandro Olschki
Martin Quigley
Salvatore Scarpitta
Ing. Horst Schober
Padre Agostino Selva and other Dominican Friars at Santa Maria delle Grazie, Milan
Attilio Tori

INTERVIEWS COURTESY OF ACTUAL FILMS

William Keller
Young Oak Kim

INDEX

Page numbers in *italics* refer to illustrations.
Page numbers beginning with 353 refer to endnotes.